Property of:
FAMILY OF FAITH
LIBRARY

W9-AOJ-278

DICTIONARY OF CONTEMPORARY PHOTOGRAPHY

FAMILY OF FAITH
P. O. Box 1442
Shawnee, OK 74802-1442

Family of Faith Library

DICTIONARY OF CONTEMPORARY PHOTOGRAPHY

by Leslie Stroebel & Hollis N. Todd

FAMILY OF FAITH
P. O. Box 1442
Shawnee, OK 74802-1442

MORGAN & MORGAN, INC., PUBLISHERS, DOBBS FERRY, NEW YORK

FOUNTAIN PRESS, LONDON

© 1974 by Leslie Stroebel and Hollis N. Todd

Second Printing 1977

All rights reserved in all countries.
No part of this book may be reproduced
or translated in any form, including
microfiling, without permission in writing
from the authors and publishers.

Morgan & Morgan, Inc., Publishers
145 Palisade Street
Dobbs Ferry, New York 10522

International Standard Book
Number 0-87100-065-2 Cloth
Number 0-87100-103-9 Paper
Library of Congress Catalog Card
Number 73-93536

Printed in the United States of America

ACKNOWLEDGMENTS

We have benefited from the advice of many persons (although we have not invariably followed that advice). Among them are: Ansel Adams, Albert Boni, C. S. McCamy, Ernest Pittaro, and Fred Spira. Our colleagues at the Rochester Institute of Technology have been exceptionally helpful, especially: Mohammed Abouelata, Brent Archer, Burt Carroll, John Carson, Lothar Engelmann, Richard Floberg, Ronald Francis, James Gleason, Joseph Noga, Milton Pearson, Herbert Phillips, Irving Pobboravsky, Reid Ray, Albert Rickmers, Hilda Sahmel, Gerhardt Schumann, and Richard Zakia. We are indebted to our students and others for the photographs. The drawings are the work of David McCumber.

L. D. Stroebel
H. N. Todd

PREFACE

This dictionary is intended to serve as a reference in the various fields of contemporary photography. It is a record of current usage in professional and illustrative photography, cinematography (including animation), and photographic engineering and science. In addition, terms have been included from disciplines that relate to photography, such as art, electronics, photomechanical reproduction, physics, psychology, television, and applied statistics.

Words and expressions have been chosen from a variety of sources: standard text and reference books; current journals, including trade publications; special-purpose glossaries; thesauruses, such as that published by *Abstracts of Photographic Science and Engineering*; publications of the American National Standards Institute; the *Military Standards Handbook of Photography*; and many private communications. The definitions are those of the authors.

The following categories of terms have been omitted:

1. obsolete expressions of only historical interest;
2. trade names and trademarks;
3. chemical terms, except those most commonly encountered by practicing photographers;
4. the names of persons, except in expressions related to a theory, principle, or law (e.g., Gurney-Mott theory).

For historical and other reasons, spelling and usage in photography are in many cases not yet standardized. Where two or more words are in use for the same concept or thing, we have frequently indicated our preference. Thus, we prefer electronic flash to "strobe" or "speedlight"; luminance meter to "brightness meter" or "reflectance meter."

We prefer one word to two words or to a hyphenated form. Thus: ultraviolet (not ultra-violet or ultra violet); workprint; footcandle. In spelling, we prefer a shorter to a longer form; e.g., pipet (instead of pipette), and catalog (instead of catalogue) photography.

In photography, the vocabulary is continuously expanding; new terms are being coined to meet new requirements. For this reason, we can hardly claim completeness. We would be pleased to receive comments and criticisms and, especially, additions for inclusion in a later edition of this work.

AAA

A

A (1) Ampere, the rate of flow of an electrical current. At constant voltage, the number of amperes is inversely related to the electrical resistance of a circuit. (2) Angstrom, a unit of wavelength of radiation. 1 angstrom is 0.1 nanometer (formerly millimicron).

a A prefix meaning "not," as in asymmetrical, aspherical.

A and B roll Applied to a system of motion-picture editing and printing whereby different rolls of related film are labeled A and B (and C, if three rolls are used) for purposes of identification. By alternating scenes and adding an appropriate length of black leader film to the other rolls, optical effects can be added without making a duplicate, an advantage over printing from a single roll. Syn.: checkerboard.

A and B wind (1) Two possible orientations of raw 16mm motion-picture stock, perforated on one edge, on a spool with the emulsion side toward the center. (2) Two possible emulsion positions on motion-picture film in a projector such that the projected image reads correctly. Also see A wind; B wind.

abaxial Identifying a point or ray that is off or away from an optical axis, as distinct from axial (on the axis) and paraxial (near the axis).

Abbè number An inverse measure of the extent to which a transparent optical material such as glass, plastic, etc., disperses light (i.e., refracts different wavelengths differently). The Abbe number is of importance in the design of color-corrected lenses. Syn.: nu-(Greek letter ν) number; v-number; reciprocal dispersive power.

aberration In geometrical optics, a general term for the failure of a lens to produce a theoretically perfect image of a point. See chromatic aberration; spherical aberration.

Abney effect The change in hue of a stimulus having a dark surround when an achromatic (colorless, e.g., white) stimulus is added to it.

Abney's law In visual perception, when lights having different spectral qualities are combined, the luminance values are additive. Although the law is valid under certain conditions, it can either underestimate or overestimate the resulting luminance due to adaptation and psychological factors.

abrasion mark Any of various types of visible defects that result from rubbing the emulsion of a photographic material. Desensitization commonly results when the rubbing occurs before exposure, whereas an increase in density typically results from post-exposure rubbing. Visible defects also result from rubbing processed materials, either from scattering of light by the roughened surface or from removal of silver (dye, etc.).

abrasive Any material used to grind or polish, as in the manufacture of lenses.

abrasive reducer A retouching material, usually in paste form, used to physically decrease the density in local areas of silver images.

abscissa In graphs plotted on rectangular coordinates, a value plotted horizontally, i.e., on the X-axis. Input data are so plotted, e.g., log exposure values on a D-log H (D-log E) curve.

absolute (1) Characterizing a temperature scale with the zero point at about -273 C, and with degree intervals equal to those of the Celsius scale. Equivalent to the Kelvin scale. (2) As applied to log H (log E), involving specifiable units (lux-seconds, or meter-candle-seconds) as distinct from relative.

absolute threshold In visual perception, the minimum luminance of a light stimulus that can be detected. Also see chromatic threshold and colorless interval.

absorption curve

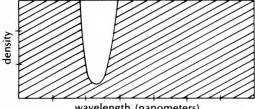

wavelength (nanometers)

achromatic (2)

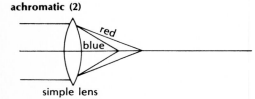

simple lens

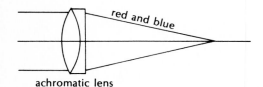

achromatic lens

absorbance The logarithm of the measured ratio of light incident upon and transmitted by a sample. Used in chemical contexts. Syn.: density.

absorptance That fractional part of incident radiation which is not reflected or transmitted. Unity less the reflectance and transmittance, i.e., absorptance = 1 - (reflectance + transmittance).

absorption (1) The assimilation of material or energy, as the absorption of a liquid by gelatin. (2) That process by which energy (especially radiant) is converted by an object into another form of energy. A red filter absorbs radiations with which we associate the colors blue and green, thereby generating heat. In latent-image formation, only that radiation which is absorbed is effective. Distinguish this term from adsorption.

absorption curve A graph obtained by plotting filter densities against corresponding wavelengths of radiation.

absorption factor (α) Absorptance.

abstract A brief summary of a technical article, such as at the beginning of each article published in *Photographic Science and Engineering*.

abstraction (1) An image that is not a reproduction of an actual object (although it may suggest such to the viewer), for example, that obtained by splashing drops of developer on flashed photographic paper. (2) An image of an actual object that has been made obscure, for example, by placing coarse fabric or textured glass on the printing paper during the exposure. (3) An image that emphasizes certain attributes of the subject and de-emphasizes others. A silhouette, for example, emphasizes shape and de-emphasizes form, texture, and color.

Abstracts of Photographic Science and Engineering (APSE) A publication of the Society of Photographic Scientists and Engineers which included summaries of technical publications in the field indicated by the title. Published from 1962 to 1972.

ac Alternating current.

Academy standards A set of specifications established by the Academy of Motion Picture Arts and Sciences for the purpose of making uniform certain procedures and measurements, such as aperture size on cameras and projectors. The Academy aperture, for example, is a film aperture in a 35mm motion-picture camera with dimensions of 0.868 x 0.631 inches.

accelerator A component of a developer, usually an alkali, that increases the rate of development. Most developing agents for silver halide materials are usefully active only in alkaline solutions.

accent In animation, an action or pause in the action

that is timed for synchronization with a beat of music.

acceptance angle See angle of acceptance.

accommodation The process by which the lens in the human eye is altered in shape for the purpose of focusing on objects at different distances.

ac/dc Signifying that an electrical device (e.g., an incandescent lamp) will function on either alternating or direct electrical current.

acetate base A film support consisting of cellulose that has been reacted with acetic acid.

acetate ink A pigment-vehicle mixture formulated to adhere to film and print gelatin surfaces, cellulose acetate and other plastic materials, etc.

acetate overlay A sheet of cellulose acetate or other clear plastic placed over a mounted photograph or other artwork and (usually) hinged at the top with tape. It is used for numerous purposes, including protection of the artwork, the addition of call-outs, etc., and the inclusion of instructions concerning changes in the artwork.

acetone A colorless, volatile, flammable liquid used as a solvent, e.g., in film cement.

achromatic (1) Specifying colors without hue, i.e., blacks, grays, and whites. Visually neutral. (2) Specifying a lens system that has been designed to reduce the defect of chromatic aberration in simple lenses. The system has the same focal length for two selected wavelengths.

acid A substance which neutralizes alkalis and which, in water solution, produces a pH below 7.0. Acetic acid, for example, is used in stop and fixing baths to stop development quickly by neutralizing the alkaline developer, and to promote hardening of the emulsion by providing an appropriate pH level for the hardening agent.

ACL Association of Cinema Laboratories.

acoustics The science of sound, including the quality of reproduced sound on motion-picture films, etc.

actinic Specifying radiation that is efficacious in producing a photographic effect. Such radiation varies in wavelength with the spectral sensitivity of the photographic material.

action (1) In motion-picture editing, a film containing the picture only, as distinct from a soundtrack or a composite containing picture and soundtrack. (2) A command, given by the director of a motion picture, to the actors to begin performing and to the camera operator to begin filming.

activator Loosely, any component of a processing system that permits or encourages development. Used especially in connection with a stabilization

process in which developing agents are contained in the emulsion, and the alkali in the first processing bath (activator) provides a pH appropriate to development.

acuity A measure of visual performance in perceiving detail, as with the Snellen chart used for eye tests. Measured acuity, like resolution, varies with the shape and contrast of the target.

acutance A numerical value usually derived from microdensitometric traces of edges, a geometrical average of slopes at different points on the edge trace divided by the density difference between the limits of the trace. Acutance is correlated to some extent with sharpness, which is the visual impression of edge quality.

adaptation A process by which a person's visual perceptual system adjusts to altered stimulus situations, such as high or low levels of illumination or a predominance of one hue. Also see brightness adaptation; color adaptation.

adapter A device for combining parts that differ in size or design, generally used to accommodate film, filters, lenses, supplementary lenses, etc., other than those for which the basic equipment was designed. Adapters are often identified more specifically, as in adapter ring, adapter lens board, and adapter back.

addenda Additions in emulsion manufacture besides the essential components, e.g. stabilizers and antifoggants. Syn.: additives.

additive (1) (adj) Specifying a color reproduction system by which colors are synthesized by combinations of red, green, and blue primaries, i.e., colored lights. Color television is an additive process. Photomechanical color halftone reproduction is additive to the extent that the dots of ink lie side-by-side without overlapping. All current photographic processes are subtractive rather than additive. (2) (noun) A nonessential emulsion ingredient, such as a stabilizer or antifoggant.

additive printer A device for exposing color materials, especially prints, in which separate blue, green, and red light exposures are given the material. Compare with subtractive printer, in which corrective filters are used to control color balance.

additive system of photographic exposure (APEX) A method of using logarithms for the lens aperture (A_v), exposure time (T_v), light level (B_v), film speed (S_v), and exposure (E_v), so that all calculations involving these factors are reduced to addition or subtraction of small integers, as indicated in the equation: $A_v + T_v = B_v + S_v = E_v$. For example, when the film speed (S_v) is 6 and the light level (B_v) is 8, the exposure (E_v) is 14. Any combination of lens aperture (A_v) and exposure time (T_v) with a sum of 14 may be used, such as 6 and 8, 7 and 7, or 8 and 6.

additivity law If exposures consisting of energies of two or more different spectral compositions are capable of giving the same densities in the same exposure times, then any fractional parts of these exposures that add to unity will, when mixed, also give this same density. Syn.: Van Kreveld's law.

adhesive A substance used to bind materials together, e.g., dry mounting tissue, rubber cement, and glue.

adjacency effects Variations in small-scale images associated with processing deficiencies. Included are edge effects, sprocket-hole effects, the Kostinsky effect, bromide streaks, tanning effects, and dimensional changes.

adjective Identifying a dye that requires the use of a mordant to hold it to another material, as opposed to substantive. See substantive.

adjustment See camera adjustment.

ad-lib To improvise part or all of a dialog or commentary during a rehearsal or a performance, especially in motion pictures and television.

adsorption The process by which a gas, liquid, or dissolved substance is held fast to a solid surface. For example, sensitizing dyes are adsorbed to surfaces of silver halide crystals.

advance In motion-picture photography, the longitudinal displacement of a picture and the corresponding sound record, necessitated by the difference in positions of the film gate and the sound head (to allow for intermittent movement of the picture and continuous movement of the sound record) on projectors. Optical sound records are placed 20 frames before the picture on 35mm films and 26 frames on 16mm films. With magnetic sound, the advances are 28 frames on 16mm films and 18 frames on super 8 films.

advancing color A hue that is in the same physical plane as another but is perceived as being closer. Red hues are sometimes classified as advancing colors and blue hues as receding colors.

advertising agency (ad agency) An organization that specializes in planning and producing layouts and other material used to promote the sale of goods, services, etc. The end product is typically the result of a team effort in which an art director or graphic designer has the responsibility for the visual aspects. Although agencies may employ photographers fulltime, it is not unusual for them to work with independent photographers on an individual job basis.

advertising photography A specialized area of professional photography concerned with making

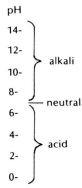

acid, alkali

aerial perspective

A. Underwood

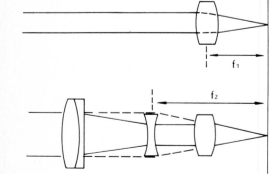

afocal lens

f_1

f_2

photographs to directly promote the sale of products, services, etc. The photographs are normally reproduced for mass distribution or viewing, as in magazine advertisements or television commercials.

AECT Association for Educational Communications and Technology.

aerate To expose to action by air, as in removing film from a processing solution. Aeration of developers may cause them to deteriorate because of oxidation of the developing agents, which in turn may produce aerial fog.

aerator A device designed to mix air with water or other liquids. Aerators are used to reduce splashing of a stream of water, to remove small bubbles of air in water, and to provide agitation in processing photographic materials, etc.

aerial Identifying a specialized branch of photography concerned with making photographs from aircraft for any of various uses, including survey, reconnaissance, ballistic, and instrumentation. Also applied to related materials and activities, e.g., aerial camera, aerial triangulation.

Aerial Exposure Index A method of determining film speed based on a point on the D-log H (D-log E) curve at which the slope is 0.6 x gamma. Also known as Air Force Speed. This method has been replaced by Aerial Film Speed.

Aerial Film Speed (AFS) A method of determining film speed based on a density of 0.3 over base plus fog. It is more precise and simpler in application than Aerial Exposure Index, which it has replaced.

aerial fog Non-image-forming density resulting from the oxidation by air of certain developing agents on the surface of an emulsion being developed. The effect is stimulated by frequent or prolonged removal of photographic material from the developing solution.

aerial image The real image formed by an optical system as observed without the aid of a viewing screen which is ordinarily needed to determine if the aerial image is in the correct position. Aerial images projected from motion-picture films may be photographed in the same way that prints or transparencies are copied, an especially useful technique when animated drawings or other images are to be added to the original motion picture.

aerial perspective The perception of depth resulting from the increasing effect of haze on the appearance of objects as the distance increases. Contrast decreases and average lightness tends to increase.

aero- A prefix meaning "aerial," as in aerotriangulation.

aerosol A dispersion of colloidal particles in a gas, e.g., mist, fog, cloud, or smoke. Developing solutions may be so dispersed and applied to exposed film; in electrophotography, toners may be carried to the electrostatic image by this method.

aesthetics (esthetics) The study of visual or other perception in relation to the sense of beauty.

AFNOR Association Française de Normalisation, a French standards organization.

afocal lens A supplementary attachment for camera lenses that changes the effective focal length without a corresponding change in back focal distance. syn.: converter.

AFS Aerial Film Speed.

afterimage A visual phenomenon in which an observer continues to see an image after the stimulus has been removed. Afterimages are momentarily positive, then change to negative with respect to both brightness and color.

afterripening A stage in the process of emulsion manufacture intended to increase sensitivity. Chemical sensitization is the preferred term. Also known as digestion.

aftertreatment General term for any alteration to a print or negative, as by retouching, reduction or intensification, ferrotyping, etc. See finishing.

AG See all-glass.

Ag The chemical symbol for silver (Latin argentum).

against-the-light Subject illumination that originates from a position generally opposite the position of the camera, as distinguished from front lighting and side lighting. Syn.: back lighting (1); contre-jour.

agency An organization that functions as a contact between photographers and clients, usually paid by the photographer on a commission basis.

agent (1) A person who serves as a sales representative for a photographer, usually on a commission basis. Syn.: representative (rep). (2) A substance that effects a change, e.g., developing agent, reducing agent, wetting agent.

agglomeration A clumping of silver particles within a photographic emulsion, resulting in an increase in graininess.

aging Changes in photographic materials over a period of time, including physical, chemical, and sensitometric characteristics. For testing purposes, materials are frequently placed in extreme environments, such as high temperature and humidity, to accelerate changes. See incubation test.

agitation In chemical processing, the action that causes a flow of processing solution with respect to the photographic material. The intent is to assure

sufficiently uniform chemical activity by replacement of spent solution with fresh.

AgX The symbol for silver halide. A silver halide is any compound of silver and a halogen, e.g., silver chloride, silver iodide, silver bromide. The radiation-sensitive particles in silver halide emulsions are crystals of such compounds.

aim curve A tone-reproduction plot representing the preferred relationship of tones, as determined by the judgment of a suitable panel of persons. The preferred tone reproduction varies with subject and with the viewing conditions, as well as with the types of persons making the judgment.

aim point In quality control, the desired process level. For example, in processing, the aim point may be a gamma of 1.2, the desired average result. A real process never meets the aim exactly, and furthermore there will necessarily be random fluctuations around the process average.

air Unused space in an illustration, layout, etc.

air bell (1) A bubble of air on the surface of photographic film or paper during processing. (2) A spot on a photographic image resulting from a bubble of air on the surface during processing. Bubbles occur most frequently when dry film or paper is placed in a developing solution, and cause areas of low density.

airbrush A device that uses compressed air or other inert gas to spray liquids (often paints or clear protective coatings) on surfaces. Commonly used to retouch photographic prints, including overall applications to protect or enhance the images.

air knife A jet of air from a slit aperture, used to remove the surface liquid from film as it leaves a processing solution or the wash. Syn.: air squeegee.

air squeegee See air knife.

Airy disk (Airy's disk) The image of a point produced by an ideal diffraction-limited lens, consisting of a relatively bright spot surrounded by alternating light and dark rings. Syn.: diffraction disk.

Albada finder A camera viewfinder in which a negative lens, partially silvered on the rear surface, is located in front of a positive lens. The viewfinder has a larger angle of view than the camera lens, but a reflection of a white frame line from the mirrored surface indicates the subject area that will be recorded on the film. Syn.: bright-line finder.

albedo In astronomical photography, the ratio of light reflected by an extraterrestrial object to that received by it.

Albert effect The reversal of a negative image to a positive by bleaching the initial image and then re-exposing and developing the remaining photosensitive material.

album A book designed to hold a number of photographs for preservation and individual viewing.

alignment field guide A punched transparent array of numbered rectangles, used to insure correct size and location of titles, and in animation.

alkali A chemical base, i.e., a substance that neutralizes acids and that, in water solution, has a pH above 7.0. Used in developers to adjust the pH to a level appropriate for the developing agent. See accelerator; activator. Examples: sodium carbonate, sodium hydroxide, ammonium hydroxide, sodium metaborate.

alkaline battery A source of electrical energy composed of cells that contain a basic (alkaline) electrolyte, as distinct from acid and metal salt electrolytes. Alkaline batteries are relatively long-lived, have a large capacity and perform well at low temperatures. They are used optionally in some flash and electronic-flash units, battery-powered motion-picture cameras, etc.

all-glass (AG) A class of very small (subminiature) flashbulbs that have approximately 1/6 the volume of miniature flashbulbs but produce about the same amount of light. Such flashbulbs are used both individually and in flashcubes. As the name implies, they do not have the conventional metal sleeve around the base.

alpha (α) Internationally-accepted symbol for absorption factor (absorptance).

alphanumeric Including letters and numerals, as applied to coding, character recognition, and test objects, as distinct from arbitrary symbols such as bars, square spots, etc.

alpha particle (α-particle) A positively-charged part of an atom that is spontaneously emitted by some radioactive materials and is capable of exposing photographic film. Materials that emit alpha particles are used in medical research, for example, to trace the movement of substances through living organisms.

alternating current (ac) A varying flow of electricity through a circuit, with a rapidly fluctuating change in direction that is specified in hertz (cycles per second). Compare with direct current.

alychne (pron. a-lik-nee) On a chromaticity diagram, the straight-line locus representing unreal colors of zero luminance. In the CIE diagram, the X and Z primaries lie on this line, hence all luminances can be associated with the Y primary.

amateur photographer One engaged in photography for pleasure rather than for profit.

amber Yellow-orange color. The term is occasionally applied to safelight filters that absorb blue and

all-glass

alphanumeric

alychne

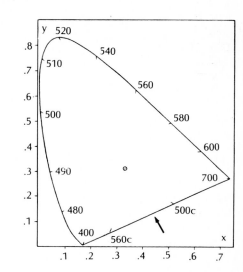

ambiguous figure

American Standard Observer

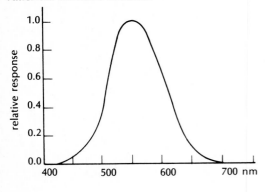

angle of convergence

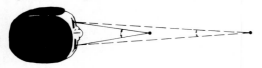

angle of coverage

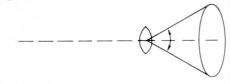

green light, such as those intended for use with variable-contrast photographic printing papers.

ambient Prevailing. Ambient light is that which is encountered at the scene, as distinct from that which the photographer provides by flashbulbs or other means. Syn.: existing light. Ambient temperature or pressure implies whatever such environmental conditions exist, without attempt to control them.

ambiguous figure In visual perception, an image that can be interpreted by the viewer in more than one way with respect to the physical reality represented. Most ambiguous figures involve alternations between figure and ground, or in depth orientation.

American National Standards Institute (ANSI) New (1970) name for the organization previously known as the United States of America Standards Institute (USASI), which before that was known as the American Standards Association (ASA). A largely voluntary organization of persons devoted to the development and publication of detailed methods of procedure and measurement in a variety of fields, including photographic testing.

American Standard Observer The luminosity (visibility) function, i.e., the relative, average response of persons with normal color vision to different wavelengths of light. It is basic to photometric and colorimetric measurement.

ametropia In visual perception, a condition in which, when accommodation is relaxed, the point for which the eye is accommodated is not at infinity. Myopia is positive ametropia and hyperopia is negative.

ammoniacal emulsions Photosensitive materials containing silver halides, in the preparation of which ammonium hydroxide is used.

ammonia print A facsimile reproduction made with the dry diazo process.

ammonium thiosulfate A rapid-acting fixing agent, often used in place of sodium thiosulfate.

ampere (A, amp) The unit for rate of flow of an electrical current. At a constant voltage, the number of amperes is inversely related to the electrical resistance of a circuit.

amphoteric Identifying a substance (e.g., gelatin) that has both acidic and basic properties.

amplify To increase a weak signal or image by any of various methods, including electronic (sound reproduction), fluorescent (x-ray photography), and chemical (intensification of silver images).

amplitude In a wave form, the maximum displacement measured from the base, or rest, level.

AN Identifying any of numerous standards published by the American National Standards Institute (ANSI), formerly the United States of America Stan-

dards Institute. Such standards, in the area of photography, describe recommended film dimensions, chemical purity, methods of processing, etc.

anaglyph A stereoscopic image consisting of two superimposed images in complementary or distinctly different colors, viewed through similar filters, one for each eye, such that only a single image is seen by each eye.

analytical density A measure of color photographic images, by which the contribution of each layer is separately estimated. Analytical densities may be spectral or equivalent neutral. The alternative measure is integral density, which see.

analytical reagent A chemical substance containing few impurities, usually in specified amounts.

analyzer In an optical system, the second of a pair of polarizing filters, prisms, or other devices.

anamorphic (1) Describing a lens or lens system containing some cylindrical surfaces or prisms, designed to produce images having different horizontal and vertical scales of reproduction. The usual application is in motion pictures, where the image is compressed laterally on the film and expanded in projection to fill a wide acreen. (2) Denoting an image having different horizontal and vertical scales of reproduction.

anamorphoser Any image-forming device that produces images having different horizontal and vertical scales of reproduction.

anastigmat Specifying a lens system designed to reduce the tendency of off-axis points to be imaged as a pair of lines separated in space.

angle of acceptance As applied to luminance (commonly called reflectance) light meters, the number of degrees within which the meter effectively receives and responds to light. Spot meters receive light over only a few degrees, whereas the angle of acceptance of conventional light meters roughly approximates the angle of view of cameras equipped with normal lenses: approximately 30 to 50 degrees.

angle of convergence In depth perception, the angle formed between lines from an object point being examined and each eye. As the object moves closer to the observer, the angle increases. Also, the angle formed between the axes of a pair of lenses in a stereo camera or other stereo device.

angle of coverage In photographic optics, the angle formed by lines connecting the rear nodal point to opposite sides of the circle of good definition, i.e., the maximum angle over which a lens is capable of forming an acceptable image. Syn.: angular field.

angle of incidence (reflection, refraction) In geomet-

rical optics, the angle between the ray of interest and a perpendicular to the surface at the intersection of the ray and the surface.

angle of view Generally, the entire angle or the half-angle between the extreme rays accommodated by an optical system. Specifically, the angle formed by lines from the rear nodal point to two opposite corners of the film image with the film located one focal length from the image nodal point. Two values, such as 27° x 40°, are occasionally determined by substituting the short and long dimensions of the film for the film diagonal.

angstrom (A) A unit of wavelength of radiation. 1 angstrom is 0.1 nanometer. The use of this unit is mainly confined to physics and chemistry; in photographic contexts, it has been superseded by nanometer (formerly millimicron).

angular field See angle of coverage.

angular magnification For a simple magnifying lens located one focal length from an object, 25cm divided by the focal length in centimeters. The angular magnification of a 6.25cm lens, for example, is 4X.

angular resolution The minimum separation (in degrees) that permits two point light sources to be distinguished. Visual angular resolution for two points, which is especially important in astronomy, is equal to 1.22 λ/d, where λ is wavelength and d is diameter of the aperture.

anhydrous Free of water, especially water of crystalization, as distinct from hydrated forms of chemicals.

animated (animation) viewer A self-contained, manually operated device that holds supply and take-up reels for processed motion-picture film and projects the image onto a small ground-glass screen; used for inspection and crude editing. A rotating prism obtains a steady image with a continuous film movement, in contrast to the intermittent movement used by conventional projectors.

animated zoom A progressive change in size of an animated image achieved by changing the size of the drawings, as distinct from using a variable focal-length lens or changing the object distance.

animation In motion pictures, the technique of simulating movement by photographing a sequence of still drawings or stationary objects, each member of the sequence showing the moving part in a position slightly different from the preceding.

animation board A drawing table used by artists to make animation drawings, typically equipped with a glass top, underneath lighting, and registration pegs, and commonly designed to permit 360-degree rotation of the image.

animation paper Translucent paper punched to fit registration pegs, used by artists to make original animation drawings that are later traced on acetate cells.

animation table A precision device designed to hold cells and other objects while they are photographed with a single-frame motion-picture camera for an animated effect. Various features to facilitate the work are often included, such as a compound table, register pegs, light sources, and a mechanism for controlled movement of the subject.

animator An artist who specializes in drawing sequential images that create an illusion of motion when viewed in rapid sequence, as in an animation motion picture.

anisotropic (1) Generally, having different properties in different directions, as a polarizing filter or stressed plastics, the converse of isotropic. (2) Applied to materials that show polarization colors when placed in a beam of light between a pair of crossed polarizing prisms or filters.

anode The positive electrode of a battery, vacuum tube, carbon arc, or other electrical device. The converse of cathode.

anomaloscope An instrument that presents monochromatic yellow and mixtures of red and green stimuli to a viewer for the purpose of studying color perception.

anomalous color vision See anomalous trichromatism.

anomalous trichromatism A chronic abnormal perception of certain colors involving a decrease in sensitivity of one of the three color vision systems and a shift in wavelength of maximum sensitivity of that system. The three types of anomalous trichromatism are: protanomaly (decreased red sensitivity), deuteranomaly (decreased green sensitivity), and tritanomaly (decreased blue sensitivity). Compare with dichromatism and monochromatism.

ANSI American National Standards Institute.

answer print A motion-picture print that contains the sound and all necessary corrections such as editing, density changes, and color changes. The approved answer print is used as a standard for production prints. Syn.: approval print; check (checking) print; sample print.

anthropomorphic In visual perception, identifying a subhuman or inanimate subject or the corresponding image that is perceived as having human attributes; e.g.,a piece of equipment having bolts, etc., in an arrangement that suggests the eyes, nose, and mouth on a human face. Compare with mechanicomorphic.

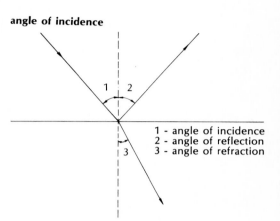

angle of incidence

1 - angle of incidence
2 - angle of reflection
3 - angle of refraction

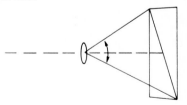

angle of view

antiabrasion

antiabrasion
emulsion

film base

anticurl

emulsion

anticurl
layer

antihalation

antihalation backing

anti- A prefix meaning against, as in anticurl.

antiabrasion layer A clear gelatin layer applied over the emulsion layer of photographic films and papers to protect the emulsion from physical damage.

anticipation In animation photography, a preliminary action used to emphasize the main action, e.g., pulling the string on a bow before shooting an arrow.

anticurl A gelatin coating applied to the back of the base of some photographic films to counteract the buckling influence of the emulsion layer due to changes in moisture content. Syn.: noncurl (abbr. NC).

antifoggant Any of a number of chemicals used in emulsions or developers to reduce the rate of development of unexposed (as compared with that of exposed) portions, e.g., potassium bromide, benzotriazole. Syn.: restrainer. (Some authorities make a distinction between organic substances such as benzotriazole and inorganic substances such as potassium bromide, referring to the former as antifoggants and the latter as restrainers.)

antihalation A light-absorbing material in photographic film, variously applied to the back surface, between the emulsion and the base, or as an integral part of the base, to reduce the reflection of light back into the photosensitive layer.

antilog (antilogarithm) The number that corresponds to a logarithm. For example, the log of 100 to the base 10 is 2, and the antilog of 2 is 100. Used to convert log exposure to exposure, density to opacity, etc.

antinewton Identifying a glass plate or a back coating on film having a slightly roughened surface, or a fine powder to be dusted on a smooth glass plate, all used to prevent the close but imperfect contact between glass and film base that produces light interference patterns (Newton's rings). Such fringes tend to occur especially with glass negative carriers for projection printers and with glass-bound transparencies.

antioxidant A chemical that reduces the rate at which another chemical combines with oxygen. Sodium sulfite serves this function in most developing solutions by combining with oxidation by-products of developing agents that would otherwise act as catalysts and increase the rate of oxidation. See preservative.

antireflection coating A thin layer of transparent material, usually magnesium fluoride, applied to a lens surface in contact with air. The effect of the coating is to reduce light reflection, and thus to lessen stray (flare) light and to improve image contrast. An additional benefit is the increased trans-mittance of the lens, and therefore greater effective lens speed.

antisludge An agent that reduces the formation of unwanted precipitate in a processing solution. Boric acid serves this function in some fixing baths.

antistatic An agent, grounding device, or electrical field intended to prevent or to eliminate accumulations of electricity on photographic material or equipment.

antivignette Applied to a neutral-density filter that decreases in density from the center outward to compensate for uneven illumination produced by some lenses.

aperture (1) Generally, an opening in a plate that otherwise obstructs radiation. (2) In optical systems, the diameter of an opening in a plate that otherwise obstructs radiation. In the case of a noncircular opening, the diameter of a circular opening with the same area. Not to be confused with effective aperture, relative aperture, effective relative aperture, f-number, or effective f-number, although aperture is often loosely used instead of f-number. (3) An opening in a plate, located close to the film plane of a camera or projector, that delimits the area of illumination. (4) An opening in a slide or microfilm mount.

aperture card A computer card containing an opening over which a microfilm is mounted, thereby permitting it to be projected for viewing or printing without removal. The computer card facilitates storing and retrieving the microfilm.

aperture mode In visual perception, a color stimulus that appears uniform in hue, saturation, and lightness, and that does not appear to be part of a specific object, i.e., the stimulus does not have identifiable object attributes such as shape, glossiness, or texture.

aperture value (A$_V$) An integer that corresponds to the logarithm to the base 2 of the f-number squared, expressed in symbol form as $A_V = \log_2 (f\text{-}N)^2$. Used in the additive system of photographic exposure, which see.

APEX See additive system of photographic exposure.

aplanat A lens system designed so as to give zero sperical aberration and coma for a specific wavelength of light and for a specific set of rays in addition to the axial ray.

apochromatic Applied to a lens system designed to have equal focal lengths for three wavelengths of radiation, as compared with an achromatic lens, which has equal focal lengths for two wavelengths. Loosely signifies a highly corrected lens.

apodization A method of altering the point spread function of an optical system by introducing appro-

priate elements at the exit pupil of the system. Examples are a central obstruction in a reflecting telescope, graded density filters or coatings, and slit or other-shaped apertures.

apostilb A unit of luminous emittance. One apostilb is applied to a surface that emits (or reflects) from 1 square meter 1 lumen of light into a hemisphere. (The apostilb is sometimes called a measure of luminance.)

apparent perspective The appearance of depth in a two-dimensional image as determined by the viewing distance. The apparent perspective increases as the viewing distance increases. The correct viewing position is identified as the center of perspective, which see.

apperception A visual or other perception that is especially distinct and vivid.

apple box (crate) A sturdy rectangular structure, typically made of wood, used on motion-picture sets, for example, to support props, furniture, actors, etc. Such boxes are made in a variety of sizes.

apprentice A person who works for little or no pay for the purpose of learning an occupation—advertising photography, for example.

approach In motion-picture photography, identifying a shot in which the image increases in size owing to either a decrease in object distance or an increase in focal length with a variable-focal-length (zoom) lens.

approval print See answer print.

apron (1) A sleeveless outer garment worn to protect the clothing from liquids, chemicals, dirt, etc. (2) Any of a variety of flexible belts used to support or transport photographic materials, such as the continuous belt on a drum dryer. (3) A flexible plastic strip sometimes used instead of reels to hold roll film in place in a processing tank.

APSA Associate of the Photographic Society of America.

APSE *Abstracts of Photographic Science and Engineering*, a publication of the Society of Photographic Scientists and Engineers from 1962-1972.

aqueous ammonia system A diazo reproduction process that uses an ammonia-water vapor for developing.

AR Analytical reagent, a chemical substance containing few impurities, usually in specified amounts.

archaeological photography The specialization of making photographs of the remains of prehistoric cultures for scientific and other uses.

architectural photography The specialization of making photographs of buildings, or selected por-

tions of them, for any of a variety of uses, including advertising, documentation, and exhibition.

archival Applied to processed images that are expected to remain relatively unchanged over long periods.

arc lamp A source of light consisting of a space between two electrodes carrying a current of electicity. The nature of the light depends on the material between the electrodes. Examples are mercury, xenon, and hydrogen. In carbon arcs, the electrodes are carbon and the arc is usually in air.

area striata The part of the cerebrum (part of the central nervous system) associated with vision. It lies at the back of the brain.

arithmetic speed A numerical system of expressing the speed of a photographic material in which the value varies inversely with the exposure required to produce the specified density. For example, values of 25, 50, 100, and 200 represent materials each of which requires half the exposure of the preceding material. Compare with logarithmic speed. There are both arithmetic and logarithmic ASA film speeds.

ARPS Associate of the Royal Photographic Society of Great Britain.

arrowhead A pointed sign superimposed on a photograph, etc. to direct the viewer's attention to a specific area.

arrow illusion The false perception that a straight line which is capped at both ends with outward slanting lines is longer than a straight line of equal length which is capped with inward slanting lines. Syn.: Muller-Lyer illusion.

art director (1) In motion-picture photography, a person who has the responsibility of supervising all aspects of a film production related to backgrounds, sets, props, etc. (2) In advertising and editorial still photography, a person who is responsible for layouts and who typically supervises the work of photographers, artists, typographers, printers, etc.

artificial daylight Man-made illumination that approximately duplicates the spectral quality of daylight. Blue flash lamps and some electronic-flash units, for example, can be used satisfactorily with daylight-type color film with no filtration at the camera.

artificial light Man-made illumination, as distinguished from natural illumination.

artificial midtone An 18%-reflectance gray card that is used for luminance (reflected-light exposure meter) readings.

artistic Applied to a subject or image or a related factor (e.g., arrangement, lighting, cropping) possess-

architectural photography

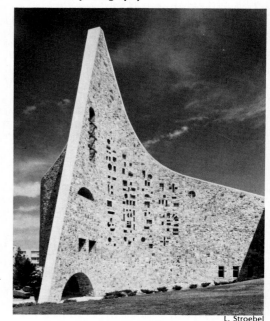

L. Stroebel

arrow illusion

aspect ratio

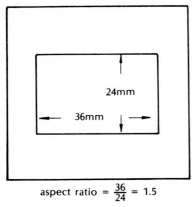

aspect ratio = $\frac{36}{24}$ = 1.5

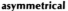

aspheric

aspheric

spherical

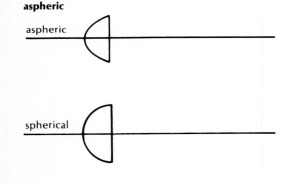

asymmetrical

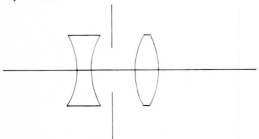

ing qualities that induce in the viewer an impression of esthetic excellence.

art photography Euphemism for nude photography.

artwork (1) Retouching, lettering, drawing, or related changes in a photograph or layout, usually in preparation for reproduction. (2) In reproduction photography, a general term for any original material other than transparencies.

ASA American Standards Association. Former name for the American National Standards Institute (ANSI). ASA is still applied to the speed of a film or paper derived according to the methods published by the Institute.

ASA speed For photographic materials, a numerical value used for determining camera or printer settings. The value is determined by methods specified in ANSI published standards: for black-and-white negative materials (pictorial), PH2.5-1972; for color negatives, PH2.27-1965; for color reversal, PH2.21-1972; for industrial x-ray photography, PH2.8-1964; for medical x-ray photography, PH2.9-1964; for black-and-white photographic papers, PH2.2-1966.

ASC American Society of Cinematographers.

ASMP — The Society of Photographers in Communications An organization for the benefit of photographers who make photographs for reproduction in periodicals and other mass-communication media. The society has an international membership and publishes a monthly magazine, *Infinity*. Formerly the American Society of Magazine Photographers, which was formed in 1945.

ASP American Society of Photogrammetry.

aspect ratio The width-to-height proportions of a format, e.g., 1.33 to 1. Commonly used in motion-picture photography and television.

aspheric Applied to lenses having one or more non-spherical surfaces, which sometimes produce better optical quality than spherical surfaces. Used in projector condenser systems and in some camera optics.

assembled negative (1) In photomechanical reproduction, a negative containing both halftone and line images, produced during the stripping process. (2) In motion-picture photography, a negative containing individual scenes that have been spliced together in the proper sequence for printing.

assembled view A photograph or other image that shows a complete, intact object, as distinct from an exploded view, a photograph of a single part, etc.

assembly In motion-picture photography, a film made up of separate shots spliced together in the desired order.

assistant A person who handles work delegated to him by his superior. The area of responsibility is often specified in the title, as in assistant cameraman or assistant director. In motion-picture photography, the duties of the assistant cameraman, for example, include loading the camera, checking it, setting it up, slating scenes, keeping the camera report, etc.

Association of Cinema Laboratories (ACL) An organization of laboratories that process motion-picture film, make prints, etc., devoted to standardizing terminology, procedures, and techniques, and to informing producers and cinematographers concerning these matters.

Association for Educational Communication and Technology (AECT) An affiliate of the National Education Association, formerly known as the Department of Audiovisual Instruction (DAVI). Publications: *Audiovisual Instruction,* published ten times a year, and *AV Communication Review,* published four times a year.

Association Française de Normalisation (AFNOR) A French standards organization.

astigmatism A lens defect that causes points off the lens axis to be imaged as two mutually perpendicular lines rather than as points. The defect often causes vertical and horizontal lines (more precisely, radial and tangential lines) in the subject to be imaged at different focal positions. Partially corrected in anastigmat lenses.

astrographic camera A relatively compact precision camera having an angle of view of a few degrees, used to measure the relative positions of stars.

astronomical photography The specialization of making photographs of extraterrestrial objects, such as the moon, sun, and stars. Syn.: astrophotography.

asymmetrical Applied to lenses made up of elements that are dissimilarly composed on either side of the diaphragm. Syn.: unsymmetrical.

atmosphere A quality in a photograph that produces a distinct emotional response in the viewer. Large, dark shadow areas, for example, can create a feeling of suspense. Syn.: mood.

atmospheric haze A condition such that small suspended particles scatter radiation from the sun and sky, thereby reducing the contrast of images of distant objects. Since scattering by very small particles is an inverse function of wavelength, scattered radiation reaching the observer or the camera from the sky is usually rich in the ultraviolet and blue regions.

atom The smallest amount of a chemical element that can exist, i.e., a unitary particle of an element.

Evidence suggests that a latent image on a halide grain consists of a small number of atoms of silver.

attensity Distinctness of a sensation (e.g., the visual sensation of color) that varies with the attention of the viewer.

attenuation Reduction of energy, as by a filter.

attitude The orientation of a camera axis or film plane with respect to the earth or other reference system.

attribute A quality of color, of an object, of an image, etc. Hue, lightness, and saturation are visual attributes of color, for example.

audio In motion pictures and television, the sound portion of the record, as distinct from the picture.

audio- Prefix: pertaining to sound.

audio frequency Vibrations that can be detected as sound. The lower and upper limits that can be detected by the human ear are approximately 15 and 20,000 hertz (cycles per second).

audiovisual (AV) Pertaining to communicating through the senses of sight and hearing, especially for educational and training purposes.

audiovisual aid Any of a variety of devices, materials, or systems designed to communicate through the senses of sight and hearing. They are used by persons engaged in educating and training others, and in self-instruction. They include motion pictures, slides, filmstrips, records, tape recordings, television, chalkboard drawings, charts, models, overhead projection, and demonstration materials. Books and conventional live lectures are generally excluded.

Audiovisual Instruction The official publication of the Association for Educational Communications and Technology (AECT), formerly known as the Department of Audiovisual Instruction (DAVI). Published ten times per year.

auditorium An area used for audiences for presentations of motion pictures, filmstrips, slides, etc.

auto- A word element meaning "same," as in autocollimator, and "self," as in autofocus.

autocatalytic Identifying a chemical reaction in which the substance formed, without being changed itself, accelerates the reaction. The silver in a latent image, for example, accelerates the formation of silver in development, which in turn further accelerates development.

autocollimator An optical device that, with the same lens system, produces parallel rays of light and then focuses the returning rays when they are reflected back along the original path. One use is to check the

alignment of the copyboard and the back of a process camera.

autocorrelation In the analysis of a complex wave form, as of a noisy signal (like a granularity trace), the measure of the degree of agreement of the values when the trace is compared with the same trace displaced in the direction of the trace. The method of autocorrelation is used to detect cycling and other repetitive characteristics of the waveform in information transfer systems as well as in photographic applications.

autofocus Applied to projection printers and other optical equipment containing a cam or other mechanical device that adjusts the position of the lens to obtain a sharp image as the positions of other parts of the system are altered, as in elevating a projection printer to obtain a larger scale of reproduction.

autogeneration Reproduction of an image on the same material used for the original.

autokinetic phenomenon A visual effect whereby a small, stationary light source in a dark environment appears to move when viewed intently for longer than a few seconds.

automatic An adjective applied to various devices and materials to indicate that some function is accomplished without specific effort by the user, as distinct from manual and semiautomatic. For example, a camera equipped with a timing mechanism that activates it to make a series of photographs at predetermined intervals may be identified as an automatic camera.

automatic shutter A protective panel automatically inserted between the light source and the film in some motion-picture projectors, to prevent heat damage when the film is stopped or is run at a slow speed. Syn.: fire shutter (1).

autopositive Characterizing a photographic material that by a single development, yields a positive image from a positive original. Distinguish from "direct" positive process, which requires two development stages and an intermediate re-exposure (or a fogging agent in the second developer).

autoradiography The photography of radioactive objects, e.g., treated biological specimens, by placing them in contact with a photosensitive material.

autoscreen Identifying film or other photosensitive material that produces a dot image of a continuous-tone original without being exposed through a ruled-line or contact halftone screen. Such material can be exposed in conventional cameras, thereby eliminating the need for a process camera.

autocollimator

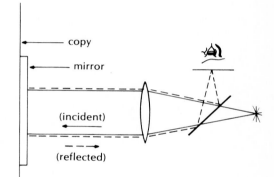

copy

mirror

(incident)

(reflected)

$$\text{average gradient} = \frac{\Delta \ D}{\Delta \ \log H}$$

density

log exposure

axis

C_2 C_1

auxiliary exposure A controlled amount of light or other radiant energy that is allowed to fall on a photosensitive material either before or after the main image-forming exposure to achieve a desired effect such as altering the contrast or density of the resulting image. See bump exposure; flash exposure; pre-exposure; fogging exposure; hypersensitization; and latensification. Syn.: supplementary exposure.

auxiliary lens Specifying a lens added to an existing camera optical system in order to change the system focal length. Syn.: supplementary lens.

A_v See aperture value.

AV Audiovisual.

available light In reference to making photographs, illumination that already exists as distinct from illumination provided by or arranged by the photographer. A relatively low level of illuminance is usually implied. Syn.: existing light; ambient light.

AV Communication Review A periodical published by the Association for Educational Communications and Technology (AECT), formerly known as the Department of Audiovisual Instruction (DAVI). Published four times per year.

average gradient (1) For the D-log H (D-log E) curve, the slope of a straight line drawn between two defined points on the curve. It is mathematically equal to the arithmetic mean of a set of slopes at various points between the defined limits, and is independent of the shape of the curve between the limits. (2) In edge analysis, the average is often a geometric average, i.e., the square root of the average of the squares of a set of slopes. The geometric average is highly dependent upon the shape of the curve.

average life The time (e.g., number of hours of operation) when half of a large sample of lamps or other equipment will have stopped functioning.

avoirdupois A system of weights commonly used in the United States, in which grains (grs.), ounces (ozs.), and pounds (lbs.) are units.

award Recognition in monetary or honorary form bestowed by any of various organizations for a photographic achievement or a contribution to photography.

A wind (1) One of two possible orientations of 16mm motion-picture raw stock, perforated on one edge, on a spool with the emulsion side toward the center. When the film leaves the spool at the top and toward the right, the perforations will be on the near side. Used by laboratories because some printing machines accept only A wind and others only B wind. (2) A designation for one of two possible emulsion positions on 16mm motion-picture film whereby the scene reads correctly through the emulsion side and the emulsion is away from the lens during projection.

axial Identifying a point or ray that is on an optical axis, as distinct from paraxial (near the axis) and abaxial (away from the axis).

axial chromatic aberration A lens defect resulting in a shift of image distance with wavelength of radiation. For a simple lens, the focal length is less for blue light than for red light. Syn.: longitudinal chromatic aberration.

axis (1) In optics, a line joining the centers of curvature of spherical lens or mirror elements. (2) In doubly refracting crystals such as quartz and calcite, a direction about which the crystal has symmetrical physical properties. Light traveling through the crystal parallel to the axis is polarized, but the two rays are not separated.

BBB

B

B (1) Obsolescent symbol for luminance. (2) Bulb, a shutter setting at which the shutter blades remain open as long as pressure is maintained on the shutter release or the cable-release plunger. (3) An identifying code for monochrome, recommended by the International Radio Consultative Committee (CCIR) for use on the leader of monochrome motion-picture films, especially those intended for television reproduction on an international exchange basis.

baby (1) A small spotlight. (2) A small tripod.

backdrop A piece of cloth or other material used as a background for a subject to be photographed.

back focal distance The distance from the rear surface of the lens to the point of best axial focus for an infinitely distant object. One application is to determine if the lens will provide clearance for the mirror in a single-lens reflex camera.

back focus See back focal distance.

background (1) That part of a scene visible beyond the main subject from the camera position. (2) The perceptual field in which a stimulus under consideration is located; also known as the surround. (3) In electrophotography, the presence of unwanted toner particles in nonimage areas. (4) In animation photography, the artwork used beneath the cells that depict the action.

background hookup In animation photography, the position on the trailing end of a pan background where the detail duplicates that at a corresponding position on the leading end, thereby permitting the background to be panned repeatedly with smooth transitions for a cyclic effect.

background noise In perception, continuous random neural activity that serves as a threshold to limit sensitivity of the sensory system. This is what is "seen" in complete darkness. Graininess is a corresponding photographic phenomenon.

background plate A motion-picture print showing landscapes or other environments made to be projected onto a screen so that objects photographed in front of the screen appear to be on location. Syn.: background print film.

background projector A device used to project images onto a screen so that objects photographed in front of the screen appear to be on location. For motion-picture photography, the shutters on the projector and the camera must be interlocked in phase. See rear projection; front projection.

background sheeting Translucent material used behind transparencies to diffuse the viewing light.

backing (1) A layer applied to the back of film or plates during the manufacturing process to absorb light that passes through the emulsion (antihalation backing) and, with film, to minimize curling (anticurl backing). (2) Cloth or other material attached to the reverse side of prints to increase their durability. (3) Material used in printing to increase pressure on the sensitized material, thereby improving contact and image sharpness. (4) Black or dark material used behind sensitized material in printing to minimize reflection of light that could degrade the image. (5) Opaque paper attached to roll film during manufacturing to protect the film from being fogged by light. (6) In motion-picture photography, any of various types of backgrounds used behind a subject to be photographed.

backlash An effect produced by loosely fitting parts in a mechanical device, such as variations in aperture size at the same setting of a badly worn iris diaphragm. The setting error associated with backlash may be reduced by always approaching the required position from the same direction.

back lighting (1) Subject illumination that originates

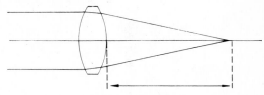

back focal distance

back projection

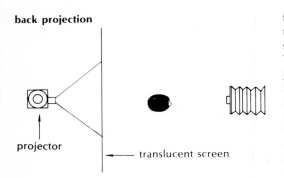

projector

translucent screen

bag bellows

barndoor

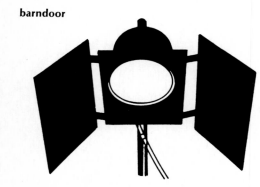

from a position generally opposite the position of the camera, as distinguished from front lighting and side lighting. Syn.: contre-jour; against the light. (2) The illumination of translucent or transparent objects with a light source located behind the object. Syn.: transillumination.

back projection The process of forming an optical image on a translucent surface for the purpose of viewing or photographing, with the projector on the opposite side of the receiving surface from the viewer or camera, as distinct from front projection, where the projector is on the viewing side of a reflective receiving surface. Syn.: rear projection.

back scatter (1) The diffuse reflection of radiation, as light from the sky, at angles greater than 90 degrees to the original direction of travel. (2) In radiography, radiation that bypasses the specimen and film and is then reflected back toward the film by a floor or wall. The film can be protected from back scatter by reducing the size of the beam of radiation or by placing a lead shield behind the film.

backward take Recording motion-picture action in such a way that it will be reversed when projected, as by reversing the direction of film movement in the camera, or by mounting the camera upside down and then reversing the scene end for end in editing. Used as an animation technique or for special effects.

baffle A part of an optical or sound system designed to obstruct the passage of light or sound in specified areas. In lens barrels, baffles are sharp-edged small projections intended to trap and absorb stray light.

bag bellows A soft, flexible accessory light seal used to connect the front and back standards on modular-type view cameras when, due to use of short focal-length lenses, conventional bellows could bind and interfere with focusing and other camera movements.

balance (1) An instrument used for weighing. Syn.: scales. (2) A compositional factor involving an analogy between distribution of psychological weights in photographs and physical weights on a beam at varying distances from the fulcrum. A small image near one edge of a photograph, for example, will balance a larger image nearer the center on the opposite side of the photograph.

balanced lighting (1) A loosely defined term implying that the distribution of light (lighting contrast) on a scene is such that satisfactory detail can be retained in both the highlight and shadow areas of the photograph. (2) In color photography, the matching of different light sources in photographic effect with respect to color rendition.

balance stripe A second band of magnetic or other coating added to the opposite edge of motion-picture film from the principal magnetic sound-recording band, to prevent uneven winding of the film.

ballast In electrical systems used for arc lamps, a device (resistance or coil) that limits the current to a reasonable level.

ballistic Applied to photographs, cameras, techniques, etc., used to study the motion of projectiles such as bullets, rockets, and satellites. A wide variety of still and motion-picture equipment and techniques are used, depending upon the nature of the information desired, e.g., velocity, direction, and effects of impact.

bandwidth (1) Generally, a range of wavelengths (of sound, light, radio, etc.) permitted to pass through a limiting device such as a filter. (2) For light filters, the range of wavelengths between those at which the transmittance is half the maximum. "Sharp-cutting" filters have small bandwidths. For filter curves in which the density of the filter is plotted vs. wavelength, the bandwidth is found between two points that have a density of 0.3 above the minimum density of the filter.

bank A number of objects arranged to function as a unit. A bank of lights, for example, is a cluster of individual lights designed to produce the effect of a large light source.

bare-bulb Applied to a technique of using a flash-bulb (tungsten lamp, etc.) without a reflector for indoor photographs so that the subject is illuminated with a combination of direct and bounce light to obtain distinct but not dark shadows.

bar gamma The slope of a straight line drawn through two specified points on a characteristic curve for a photographic paper. Obsolescent.

barium Applied to a type of optical glass to which barium oxide has been added for the purpose of increasing the index of refraction without appreciably altering the dispersion.

barndoor An adjustable attachment for studio lights used to control the distribution of light. Syn.: blinder.

barndoor wipe A gradual transition between scenes in a motion picture with the new scene starting at the center and spreading to the edges, replacing the preceding scene as it expands.

barney A blanket or quilted cover, used to muffle the sound of a motion-picture camera as a substitute for a blimp.

barrel distortion A lens condition that causes straight lines in the subject to be imaged as curved lines. Although the image lines appear to bow outward at

the center, the effect is actually an increasing inward displacement of image points with increasing distance from the center of the image. Usually considered a defect, but sometimes desired for a special effect. Characteristic of fisheye lenses. The converse of pincushion distortion, which see.

barrel mount A tube in which a lens is mounted without a shutter. A diaphragm may or may not be included.

barrier filter When photographing fluorescence, a filter used in front of the camera lens to absorb the radiation that produces the fluorescence (ultraviolet radiation, for example), while transmitting the radiant energy produced by the fluorescence. The barrier filter prevents the fluorescence from being obscured by exciting radiation to which the film is sensitive. See exciter filter.

barrier layer (1) Identifying a photovoltaic type of photoelectric cell, i.e., a cell capable of producing an electromotive force (voltage) by the absorption of radiation, especially light. (2) A thin coating of suitable material (e.g., cadmium selenide) that separates the light-sensitive material (e.g., selenium) and the coating that collects the electric current (e.g., cadmium) in a photovoltaic cell. (3) A coating of negatively-charged halide ions adsorbed to the surface of silver halide grains, that tends to repel negatively-charged developer ions, thereby depressing the rate of development. Syn.: charge barrier.

bar sheet A printed form for a frame-by-frame breakdown of a soundtrack, used by motion-picture animators in planning action.

baryta A barium sulfate coating applied to the emulsion side of photographic paper before the emulsion itself is applied, for the purpose of controlling texture, base color, and minimum and maximum densities. Generally omitted when folding without cracking or minimum thickness is an important factor for the finished product.

base (1) Sheet-like material used to support one or more photosensitive layers as in photographic film, paper, and plates. (2) An alkali, i.e., a substance which neutralizes acids and which in water solution produces a pH above 7.0.

base density The optical density of film base without contribution of the emulsion layer.

base plus fog The optical density of an unexposed area of processed film or paper.

base side The non-emulsion side of a photographic material: in film, typically the shinier side and the convex side as it curls. Converse of emulsion side.

basket A container for holding photosensitive material during processing, typically constructed of porous material to allow free access of solutions to the material.

bas-relief ("bas" rhymes with "pa") A special raised effect obtained by making a contact positive transparency from a negative, binding the two together slightly out of register, and printing from the combination.

batch (1) A quantity of photographic material in which the entire amount was produced, processed, or otherwise treated in the same operation. Since variations tend to be larger between batches than within a batch, records such as film and paper emulsion numbers are often maintained for quality-control purposes. (2) As applied to processing, involving groups of (sheet) films or papers, as contrasted with the continuous processing of motion-picture films and the like.

bath Any processing solution for photographic materials, such as developer, stop bath, or fixing bath, etc.

battery A device (group of cells) that produces electrical energy by electrochemical means.

battery capacitor (BC) A device consisting of one or more batteries and an electrical condenser that accumulates and holds electricity from the batteries for the purpose of igniting flash lamps, thus ensuring a stable source of current despite deterioration of the batteries.

bayonet mount A device consisting of two matched flanges used for quick attachment of lenses and accessories to cameras and to each other by turning through only part of a revolution.

BC Battery capacitor.

BCPS Beam candlepower-second.

beaded screen A white surface covered with small glass balls, used for viewing projected images. Image lightness is more directional with beaded screens than with mat surfaces, being lighter at small angles to the projector axis and darker at larger angles.

beam candlepower As applied to a lamp, especially one in a reflector, maximum apparent intensity.

beam candlepower-second (BCPS) A unit of the maximum light-energy output of a lamp in a reflector, commonly used to measure the on-axis output of electronic flash.

beam-light rangefinder A device that projects two spots of light onto the subject from the camera for the purpose of focusing the camera when there is insufficient illumination to focus by looking through the rangefinder. The image is in focus when the two spots coincide on the subject.

beam-light viewfinder A device that projects light

barrel distortion

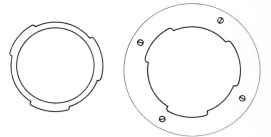

bayonet mount

onto the subject from the camera for the purpose of aligning the camera without looking through the viewfinder.

beam splitter An optical device containing one or more prisms and/or partially transmitting mirrors that transmit and reflect, along different paths, pre-determined proportions of entering light. Used for a variety of purposes, including automatic exposure control and reflex viewing on some motion-picture cameras. By reversing the direction of light, a beam splitter can combine light entering along different paths, as in a rangefinder.

beat In motion-picture photography, the interval of the musical tempo in terms of frames. For example, a 12-beat is a beat of music equal to an interval of 12 frames.

Becquerel effect The intensification of a latent image by exposure to energy to which the photographic material is normally insensitive.

bed The base of some types of cameras (especially view, press, and process) that generally supports the lens standard, back standard, and focusing tracks. Beds may be identified more specifically as monorail, folding flatbed, etc. The folding parts of beds on press cameras normally serve as protective covers when the cameras are not in use. Extension units can be attached to the beds of some cameras.

beep An audible signal used as a cue, for example, to help synchronize the projection of a filmstrip or slide series with a recorded commentary.

Beer's law For a transparent colorant of constant thickness, the spectral density is proportional to the concentration.

bee smoker A device consisting of a container (in which a special charcoal preparation is burned) and a bellows, used to create the appearance of haze, fog, or smoke on a motion-picture or other set.

behind-the-lens (BTL) (1) A designation for a shutter located between the lens and the film. Blade-type shutters are located close to the lens, whereas focal-plane shutters are located close to the film plane. (2) (also behind-lens) Identifying a built-in exposure (light) meter that samples the image-forming light at any of various positions inside the camera body, e.g., at the mirror or at the prism. Contrast with built-in external meters that have a separate opening on the front of the camera to admit light to the cell. An advantage of behind-the-lens meters is that they compensate for loss of light due to the addition of filters, increases in lens-to-film distances, etc. In addition to built-in meters, some separate meters are designed to sample light at the film plane, especially with view cameras

and other cameras equipped with a conventional ground-glass viewing system.

Belitzski's reducer A formulated chemical bath used to decrease the density and contrast of silver images, especially film negatives. The action tends to be intermediate between subtractive and proportional reduction.

bellows A flexible, light-tight enclosure between the lens plane and the film or negative plane of some cameras and enlargers. The sides are typically folded in a manner that minimizes sagging.

bellows bind A restriction on a camera movement, such as the rising front, resulting from tension on the bellows.

bellows extension (1) The lens-to-film distance for a specific situation. (2) The maximum lens-to-film distance for a camera as limited by the bellows, the bed, or the focusing mechanism.

bellows factor A number obtained by dividing the square of the image distance by the square of the focal length, used to compensate for the decrease in image illuminance as the camera is focused on closer objects and the lens-to-film distance increases. The factor represents the required increase in exposure, which can be obtained by changing the exposure time and/or the aperture. Also called bellows-extension compensation.

Ben Day (also **benday**) **process** A procedure whereby a transparent sheet containing a repetitive design or a color is placed over an original photograph or other material that is to be reproduced, typically photomechanically, to create a desired visual effect.

Benham's top A pattern of black-and-white arcs, etc. When the pattern is rotated, faint hues are seen.

betatron A device that accelerates electrons on the principle of a high-voltage transformer, used to produce x-radiation.

between-the-lens (1) A designation for a shutter or lens diaphragm whose blades operate between two elements of the lens. (2) A generic term applied to any shutter located close to the lens (in front of, between two elements, or behind), to differentiate such shutters from focal-plane shutters.

Bezold-Brucke phenomenon In visual perception, a shift of hue with intensity of the stimulus. The direction and magnitude of the shift vary with wavelength.

bichromate process Any of numerous methods used to form an image by the hardening action of light on colloids containing chromium salts known as dichromates. Commonly used for printing plates in photomechanical reproduction. Syn.: dichromate process.

beam splitter

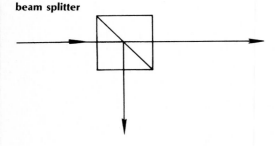

bellows

biconcave A designation for a lens with both surfaces curving inward toward the center.

biconvex A designation for a lens with both surfaces curving outward from the center.

bifocal converter An optical attachment that can either increase or decrease the effective focal length of a projector lens, depending on which end of the attachment is placed next to the lens.

big head In motion-picture photography, an extreme closeup of a person.

billboard In television, a very short spot (commercial or other advertising promotion).

bimetal plate A lithographic printing plate so constructed that the printing areas on the processed plate have an ink-receptive copper surface and the nonprinting areas have a water-receptive chromium, aluminum, nickel, or stainless-steel surface. Bimetal plates have a longer press life than conventional lithographic plates.

bin A rectangular editing barrel, lined with lintless cloth, in which motion-picture film clips can be hung for future use without becoming damaged.

binaural In motion-picture photography, identifying a sound reproduction system in which two separate recordings are made with two microphones in different locations. Sounds are reproduced through corresponding sides of headphones worn by the hearers with the intent of making sounds seem to come from appropriately different directions to create greater realism. Distinguish from stereophonic systems, which may use more than two recordings and which reproduce the sound with loudspeakers.

bind To mount a transparency between two glass plates to hold it flat and protect it from damage.

binocular fusion The combining of the two images formed by the eyes so that the viewer perceives single rather than dual objects.

binocular rivalry Any of various effects resulting from failure to combine the two images formed by the eyes to produce a unified perception, such as alternating rejection of the image formed by each eye. See retinal rivalry.

binocular vision Seeing with two eyes working in close cooperation, as distinguished from monocular vision, which involves one eye.

biocular Identifying an optical system in which both eyes use different areas of one system; e.g., a large-diameter magnifier used for retouching negatives.

biological photography The specialization of making photographs of living matter and related phenomena for any of a variety of scientific uses.

bioluminescence The production of light in a living organism through chemical reaction, as, for example, in a firefly. Also see chemiluminescence.

biomedical photography The specialization of making photographs of living matter and related phenomena associated with the field of medicine for any of a variety of uses including diagnostic, research, and instructional.

bipack Two emulsions having different color sensitivities, typically coated on separate bases, which are placed in contact and exposed as a unit. Bipacks are used in motion-picture optical printers and animation cameras for various composite effects.

bipack printing In animation photography, running a film print through the camera in contact with raw stock so that a composite image (consisting of a contact image from the film print and an optical image from the copy being photographed) is formed.

bipost (1) Identifying a type of lamp having two electrical contacts on the bottom surface of the base, in contrast to lamps that have one contact on the bottom surface and use the metal sleeve around the base for the second contact. (2) Identifying a type of electrical connecting device consisting of two rodlike projections used, for example, on some flash-synchronized shutters (to which a matching sync cord is attached).

birefringence The separation of incident light by double refraction into two components polarized at right angles to each other.

bit (1) A unit of information, defined as a choice between two equally likely alternatives. In a punch card, one bit is contained in each available space. In film coding methods, one bit is contained in each black or clear space. Ten such spaces can provide for approximately 1,000 different codes. (2) A small acting part that may or may not include spoken lines.

bitoric lens A lens having two cylindrical surfaces, as distinct from spherical and plane surfaces.

BL Behind-lens. See behind-the-lens (BTL).

black (1) Applied to a perception of low lightness (value) and indistinguishable hue. (2) Applied to an object of low reflectance, at one extreme of a gray scale. Opposite to white. (It is a common misapprehension that black is the absence of color or of light. In fact, the sensation we call black arises whenever the light level is sufficiently low. Black is one of the family of neutral colors, which includes whites and grays.)

black-and-white (b & w) (b-w) Designation for a photograph, material, or process in which the resulting image contains only tones of gray. Toned prints are commonly included for the purpose of

biconcave

biconvex

bipost (2)

distinguishing them from color prints made on color paper. (The term "monochrome," however, is more appropriate than "black-and-white" for toned prints.)

blackbody A hypothetical object which (a) absorbs completely all incident radiation; (b) considered as a source, has maximum theoretical emissivity. A blackbody is approximated by a cavity lined with an absorbing material—carbon for light. The smaller the aperture of the cavity, the better the approximation to a blackbody. For a thermal source, the radiant power and the spectral energy distribution of a blackbody are determined by the temperature of the source, independent of the nature of the material. Syn.: full radiator; complete radiator; Planckian radiator.

black-core Identifying a motion-picture traveling matte having a dark center and a clear surround. The complementary matte, which has a clear center and a dark surround, is identified as a white-core matte.

blacking Paint or other preparation that produces a dull, dark surface on objects to which it is applied. Commonly used to reduce reflection of light on interior surfaces of cameras, projection printers, and other equipment, or to conceal superficial defects on exterior black surfaces.

black light Misnomer for ultraviolet (rarely infrared) radiation. Since light is by definition visually effective radiation, black light in this sense does not exist.

blackline Identifying a print having a black image on a white background, made with a diazo process.

black patch In photomechanical reproduction, a piece of black paper or other material attached to the copy to prevent exposure in the corresponding area of a line negative. The resulting clear area serves as a window for a halftone negative that is attached to the line negative before the plate is exposed.

black point In visual perception, the stimulus luminance below which changes in luminance produce no change in appearance. Shadow detail visible on a print viewed in bright light, for example, will not be visible when the print is viewed in dim light if the luminances are below the black point. The black point varies with the adaptation level. Syn.: extinction point.

black printer A photomechanical printing plate used to apply black ink, alone or in combination with other colors, as with duotone and four-color printing processes. Since colored inks in combination rarely produce neutral tones, the use of a black printer improves the reproduction of grays. In addition, the black printer reduces the quantity of colored inks needed and hence the cost of the reproduction.

blade (1) In between-the-lens shutters, a thin piece of opaque material that moves to control the duration of the passage of light. Compound shutters contain multiple blades that open from the center outward. (2) Identifying an entire shutter of the type described above. (3) In an iris diaphragm, one of the thin overlapping pieces of opaque material that moves to control the size of the opening. Syn.: leaf. (4) A stick or thin piece of plastic used on a portable stand to hold back light in a small area. See gobo.

Blanchard brush A throwaway brush made by wrapping flannel or cotton around a piece of glass, used in laboratories to apply photographic emulsions or other liquids to supports.

blank (1) Identifying processed film that is devoid of an image, either intentionally or accidentally. (2) A piece of optical glass that has been formed to approximate the finished element but still needs grinding and polishing. (3) A strip of motion-picture film used to receive a dye-imbibition image. (4) In animation photography, a sheet of clear acetate used to maintain consistency in cell levels (and background density) as a level of action moves out of the field.

bleach To convert, by chemical means, metallic-silver photographic images to silver compounds to aid in removing the silver. Such a process is a necessary part of the production of dye images, as in color prints and transparencies. It is often preliminary to toning, intensification, and reduction of the image.

bleachout (1) A process in which color images are formed through the action of light in destroying the color of unstable dyes in proportion to the amount of light of the complementary color absorbed. (2) A process in which a tracing of the desired detail is made directly on a photographic print, after which the silver image is chemically removed, leaving the drawing.

blebs Optical inhomogeneities in film base.

bleed (1) To run a continuous-tone or halftone image off the edge of the paper or support without a border. (2) To spread beyond an original or desired position, resulting in a loss of definition of an image, especially line and dye images. (3) In motion-picture photography, an unwanted image produced when a traveling matte has insufficient density to prevent exposure in the masked areas.

bleed-through A defect in photomechanical reproduction in which an image printed on one side of a sheet of paper or other material can be detected on the opposite side.

Blanchard brush

blending magnification In the measurement of graininess, that degree of enlargement at which small-scale variations in tone are just barely not detectable. The graininess of an image is inversely proportional to the blending magnification.

blimp A sound-absorbing container for a motion-picture camera or projector, used to muffle the operating noise. Facilities are provided for manipulating the equipment controls. Also see barney.

blind A screen or enclosure used to conceal a photographer when photographing wildlife.

blinder See barndoor.

blinding In photomechanical reproduction, a condition (such as excess gum arabic) that results in insufficient ink on a plate and therefore a light reproduction.

blind shot Motion-picture action that does not show the source of the sound recorded on the soundtrack.

blind spot A small, insensitive area on the retina where the optic nerve leaves the eye.

blister A localized separation of an emulsion from the support.

blix Combined bleach and fixing bath, used in shortened color processes.

Bloch's law Different combinations of intensity and time of visual stimuli produce the same visual effect as long as the product of intensity and time remains constant. The law is valid over only a limited range of values, and is an analog of the photographic reciprocity law.

blocked up Identifying highlight areas with appreciably less than normal detail or local contrast due to any of various factors and combinations of factors, including contrasty lighting on the subject, and overexposure or overdevelopment of the film.

block out To apply opaque pigment or other opaque material to selected areas on a negative (such as the background) to eliminate unwanted detail. A similar effect is obtained by applying white opaque pigment to the print.

bloom A dark area on a televised image that results from including an excessively bright area, such as a reflection from jewelry, in the scene.

bloop (1) The sound produced by an imperfect splice of motion-picture soundtrack passing the sound pickup in a projector. (2) Identifying ink, tape, or other material applied to a splice on film bearing a positive image, to prevent the production of the sound described above. (3) Identifying a punch used to perforate the soundtrack on film bearing a negative image, to eliminate splice noise.

blotter Absorbent paper or other material commonly used to remove surface moisture from photographic prints following processing, and to hold prints flat or to otherwise shape them while drying. Blotter rolls, for example, give prints an initial reverse curl to counteract their inherent tendency to curl toward the emulsion side.

blowback An enlarged print made from a microphotograph.

blow back To make an enlarged print from a microphotograph.

blower A device to circulate air, used to prevent overheating in a projector, to facilitate removal of moisture from photographic materials in a dryer, etc. Also called a fan.

blowup An enlarged photograph.

blow up To make an enlarged photograph.

blue (1) A color which corresponds to the 400-500 nm wavelength region of the spectrum and which can be produced by removing the red and green components from white light. (2) As applied to a filter, pigment, dye, etc., absorbing red and green about equally and blue less so. (3) As applied to a motion picture, slang for obscene or pornographic.

blue flashbulb One coated with a filter that reduces the red and green light levels so that the light is appropriate for use with daylight-type color films.

blue-green See cyan (preferred term).

blueline Identifying a print having a blue image on a white background, made with a diazo process.

blueprint (B/P) A photographic printing process that uses light-sensitive iron compounds and produces blue-and white images. Used largely for making negative copies of line originals. Syn.: cyanotype; ferroprussiate.

blue-screen Identifying a motion-picture process for combining separate foreground and background images during printing. The foreground objects, e.g., actors, are photographed in front of a bright blue background on negative color film. Positive and negative opaque masks (traveling mattes) made from the color negative are used to protect the print from exposure in the foreground area while the background is being exposed, and vice versa.

blue-sensitive Specifying photographic emulsions that are sensitive only to ultraviolet and short-wavelength visible radiation, as distinct from orthochromatic and panchromatic emulsions. Syn.: color-blind.

blur (1) In animation photography, a mark on a drawing that suggests or creates the illusion of motion. (2) In still photography, unsharpness because

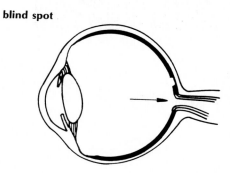

blind spot

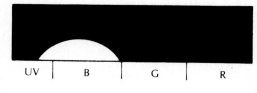

blue-sensitive

UV | B | G | R

body release

boom

border effect

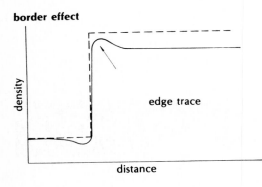

edge trace

density

distance

bounce light

the image is out of focus, or because of movement of camera or subject during exposure.

body release A device built into a camera that enables the photographer to activate the shutter with a finger while holding the camera firmly with both hands, as distinct from a cable release or a release on the lens mount.

bolometer A radiation-measuring instrument. A blackened strip of (for example) platinum absorbs radiation; the consequent rise in temperature of the strip causes a measurable change in its electrical resistance.

book holder A device that holds an open book against a glass plate to minimize aligning and focusing problems during photographic reproduction of the contents.

boom (1) A type of stand, normally used to hold a light or a microphone, characterized by a long adjustable support arm. Boom stands are used in preference to conventional stands when maximum flexibility is needed in the placement of the equipment. (2) On a large camera crane, the long movable member that carries the camera and crew.

booster Identifying a light source used on location to supplement existing lighting, usually to reduce the lighting ratio. Also see fill light.

border A distinctive strip around the margin of a photograph, variously considered a desirable adornment and an undesirable detraction. White borders are produced on prints by opaque masking devices on contact printers and easels. Borders are often added outside the edges of mounted prints with ruled lines, submounts, cutout mounts, etc.

border effect Inaccurate small-scale tone reproduction associated with processing deficiencies. The edge of a dense area adjacent to a thin area is denser than the area within the dense region. One of two edge effects, the other being fringe effect.

borderless easel A device to hold photographic paper or other material flat and stationary without covering any portion. Various designs include the use of a vacuum, a tacky adhesive and adjustable edge pegs. Used primarily for projection printing when the customary border is not wanted.

botanical photography The specialization of making photographs of plant life and related phenomena for any of a variety of scientific uses.

bottom In animation photography, identifying the cell-level position in contact with the background.

bottom-bottom In animation photography, the lowest cell layer when there are more than three levels. Syn.: double-bottom.

Bouguer-Lambert law The density of an absorbing substance is directly proportional to its thickness. The law holds for nonscattering, nonfluorescent materials, and strictly only for monochromatic radiation. Furthermore, surface effects must be negligible. An example of a rule based on the law is that the spectral transmittance of a combination of two or more optical filters is nearly equal to the product of the spectral transmittances of the filters. Syn.: Lambert's law; Bouguer's law.

bounce light Diffuse illumination produced by aiming a light source at a reflecting surface rather than at the subject. Commonly used with (but not restricted to) flash and electronic-flash light sources to create the illusion of natural or "existing" illumination. Walls and ceilings are frequently used as reflecting surfaces.

box-camera An inexpensive, nearly cubical, roll-film camera, usually with limited or no adjustments in focus, shutter speed, and aperture size.

B/P Blueprint.

BPA Biological Photographic Association.

bracket To produce two or more variations by increasing and decreasing the value of some factor from the assumed normal value in an effort to ensure success. If the best estimate of the camera exposure is 1/100 second at f/8, two additional photographs may be made at 1/50 second and 1/200 second at the same f-number. Corresponding changes are sometimes made in film-developing time, selecting a color-compensating filter, etc.

bread-and-butter Identifying photographs made for money-earning purposes as distinct from those made for expressive purposes.

breadboard A hasty assembly of optical or other parts for test purposes before a more finished construction is attempted.

break (1) An accidental separation of a strip of film into two parts, usually in a motion-picture camera, printer, or projector. (2) To stop the flow of electricity in a circuit.

breakaway Identifying props that have been prepared to be smashed or to fall apart easily, without causing injury to the performers. Bottles made of resin and furniture made of balsa wood are examples of such props.

breakdown (1) Separation of a motion-picture script into individual scenes that are then systematically regrouped to facilitate production; e.g., all scenes that involve the same actors and the same location may be grouped together and filmed in sequence even though the scenes may be widely separated in the final film. (2) In motion-picture photography, cutting a rush print into individual scenes. (3)

Dismantling a motion-picture camera at the end of a shooting session. (4) In animation photography, taking the extreme drawings and indicating how many in-between drawings should be prepared to follow the animator's plan. (5) A financial analysis of a script.

breathing An alternating forward and backward change in position of motion-picture film in a projector or camera aperture, resulting in corresponding changes in image focus.

Brewster's angle For a nonmetallic glossy surface, the number of degrees (between the incident ray and the perpendicular) for which the polarization of the reflected ray is a maximum. According to the law, that angle will be the one for which the tangent equals the refractive index. For most materials (glass, varnish, plastic, etc.), the angle will be near 55°. The principle permits a photographer to reduce glossy highlights from nonmetals by using a polarizing filter over the camera, if the angle is appropriate, and if the filter is properly oriented. Syn.: polarizing angle.

bridal Relating to a woman recently married or about to be married. A bridal portrait, for example, is a photograph of such a woman, typically in her wedding gown.

bridge (1) A scene that connects two sequences in a motion picture. (2) A musical phrase designed to connect two scenes or sequences.

brigg A proposed unit of optical density, similar to the international unit of natural logarithms, the neper.

brightener An agent (usually a fluorescent material) added to photographic papers or to coating to make the white tones appear lighter. Syn.: whitener.

brightfield In photomicrography, an illumination system used with partially transparent subjects whereby the subject is back-illuminated to produce a silhouette effect.

bright-line finder A camera viewfinder in which a negative lens, partially silvered on the rear surface, is located in front of a positive lens. The viewfinder has a larger angle of view than the camera lens, but a reflection of a white frame line from the mirrored surface indicates the subject area that will be recorded on the film. Syn.: Albada finder.

brightness (B) The subjective aspect of visual perception that is approximately correlated with the luminance of objects seen as light sources. Since brightness is a psychological concept, there are no units of measurement. The term "photometric brightness" should be replaced by "luminance." See lightness.

brightness adaptation A process by which a person's visual perceptual system adjusts to variations in the level of illumination, producing increased sensitivity with low illuminance and decreased sensitivity with high illuminance.

brightness constancy A psychophysical visual phenomenon whereby the brightness of a surface is perceived as remaining unchanged when viewed under different levels of illumination. A white object, for example, continues to be perceived as white rather than gray when a light source is moved away from the object, decreasing the illuminance. Since brightness refers to surfaces perceived as sources of light rather than as reflecting surfaces, the term "lightness constancy" is preferred.

brightness contrast Visual perception of relative luminance variations in a scene, usually described in general terms such as high, normal, or low.

brightness range (1) The visually perceived relationship between the lightest and darkest areas of a scene. (2) As commonly used by photographers, the ratio of luminances for the lightest and darkest areas of a scene. Preferably, luminance ratio. (3) A method of using a luminance ("reflection") photoelectric meter. Measurements are made of the luminances of the darkest and lightest areas of interest, and the calculator indicator is set midway between the two readings.

brightness value (B_v) An integer that represents the luminance level in the additive system of photographic exposure, which see.

brilliance A quality attributed to an image that is perceived as having a large range of tones and bright highlight areas, usually with strong gradation. Projected images of transparencies viewed in a darkened room have more brilliance than reflection prints of the same photographs viewed in normal illumination, for example. Various factors can contribute to the effect, including subject tones, lighting ratio and style, print density and contrast, paper-stock tint, and surface sheen.

British Standards Institution (BSI) An organization devoted to the development and publication of detailed methods of procedure and measurement in a variety of fields, including photographic testing. The British equivalent of the American National Standards Institute (ANSI).

broad light (1) An electrical device designed to hold an incandescent or other source of light and to reflect the light diffusely over a relatively large angle. (2) A lighting unit that contains two or more large incandescent lamps in one large reflector, used to produce relatively intense diffuse illumination. The name is commonly modified to indicate the

number of lamps. A double broad, for example, contains two lamps.

broad lighting A type of portrait lighting in which the main light is positioned to illuminate the near or broad side of the face, thereby projecting the nose shadow onto the far or narrow side of the face.

bromide drag See bromide streak.

bromide paper Photographic printing paper with an emulsion containing silver bromide as the predominant light-sensitive component, used mostly for projection printing because of its relatively high speed, as distinguished from chloride and chlorobromide papers. These categories are gradually being de-emphasized by the industry as other measures for controlling the printing characteristics of papers come into use.

bromide streak A region of lowered density in areas of a processed image adjacent to high-density areas. The cause is a flow of partially exhausted developer over the material during processing, in situations in which the agitation is inadequate. Bromide streaks are especially noticeable in motion pictures, and most especially in titles. Syn.: bromide drag.

bromine acceptor A substance, such as gelatin, that can combine with the bromine (or other halogen) produced during formation of a latent image, thereby reducing the possibility that the bromine will destroy the latent image by recombining with the photolytic silver. The term "halogen acceptor" is preferred when the emulsion contains silver chloride or silver iodide.

bromoil A once-popular but now little-used photographic printing process in which the silver image is treated in a hardening bleach that causes the shadows to become hard, dry, and ink-receptive, whereas the highlights are soft, moist, and ink-repelling. The final image is formed by applying any of various colors of ink with a brush.

bronzing An undesired change in the color of the image on photographic paper that may occur with high-temperature drying or aging of a print. Appropriate chemicals are usually added to paper emulsions during manufacture to minimize this defect. This defect can be further controlled by treating prints with an image tone stabilizing bath before drying, or by drying prints at room temperature. Also see plumming.

brownline Identifying a reproduction made on an emulsion containing iron and silver salts, whereby a brown positive image is produced from a negative original. Typically used as a proof before making a photomechanical printing plate. Syn.: vandyke.

brownprint Identifying a reproduction made on an emulsion containing iron and silver salts, whereby a brown negative image is produced from a positive original. Typically used as an intermediate for making a positive image by any of various processes. Brownprints and brownlines are made by the same process but differ in negative-positive orientation (polarity).

Brunswik ratio In visual perception, a proportional relation of a real characteristic of an object (e.g., size) to the perceived characteristic. The ratio is a measure of constancy with one, the upper limit, indicating complete agreement between real and perceived characteristics (perfect constancy) and zero, the lower limit, indicating that perception is completely determined by the retinal stimulus.

brush (1) An instrument typically constructed with a bundle of animal hairs attached at one end to a handle, used for a variety of purposes, including removing dust from negatives and applying spotting dyes to prints. (2) A technique for agitating processing solutions, recommended for tray processing of plates, in which a soft brush or cotton swab is moved across the emulsion surface. Brushes are also used in some electrostatic (xerographic) processes.

brute A powerful arc lamp, commonly used on motion-picture sets to simulate the effect of sunlight or to illuminate large areas. Also used on location to illuminate shadows or otherwise supplement existing lighting.

BSI British Standards Institution. (1) The British equivalent of ANSI (formerly USASI and ASA). (2) Applied to a film speed rating identical to an ASA rating.

BTL Behind-the-lens, which see.

bubble (1) A gaseous pocket in glass. (2) Air trapped between a print and the mount. (3) A closeup view having a circular outline, typically used in combination with a general view of the same subject in parts catalogs, instruction manuals, etc.

bubble level A device consisting of alcohol or other liquid and a small amount of air in an enclosure with a transparent top, used to determine when a surface is horizontal, i.e., when the globule of air is centered in the opening. Such devices are built into some cameras and are also made as separate accessories.

buckle (1) To (unintentionally) deform film as a result of any of various factors, including temperature, humidity, and pressure. (2) The result of film jamming in a motion-picture camera.

buckle trip A device on some motion-picture cameras that shuts off the power when it detects an abnormality in the film loop.

buffer A chemical that serves to reduce changes in

broad lighting

pH of a bath with the addition of an acid (by combining with some of the hydrogen ions) or an alkali (by dissociating to release hydrogen ions). Examples are sodium acetate, sodium carbonate, and sodium metaborate.

bulb (1) A glass enclosure for an incandescent lamp or flash lamp; also the entire incandescent lamp or flash lamp. (2) A shutter setting (usually marked "B") at which the shutter blades remain open as long as pressure is maintained on the shutter release or the cable-release plunger. Shutters can be kept open for indefinite periods on the bulb setting by using special cable releases that lock the plunger on the "in" position.

bulb release A hollow, flexible tube, with one end attached to a plunger mechanism that activates the shutter when a hollow, flexible bulb on the other end of the tube is squeezed. Used to activate the shutter from a moderately removed position from the camera and/or to minimize camera movement.

bull switch A heavy duty electrical switch, usually used as a master switch for a studio or set.

bump exposure In halftone negative making, a supplementary exposure made with light from the copy without the halftone screen. By exaggerating differences in the areas of dots representing the lighter tones of the copy, the effect of an increase in image contrast is produced. The bump exposure is used especially with low-contrast copy, with high-key photographs, and for drop outs. Compare with flash exposure, which decreases the image contrast. Syn.: no-screen exposure; highlighting exposure (not to be confused with highlight exposure).

bumper footage In animation photography, an extension in length of the first and last scenes beyond what is actually required for the final film.

Bunsen-Roscoe Reciprocity law A photochemical effect is constant if the total absorbed radiation is constant, regardless of the rate at which the radiation is supplied to the sensitive material. The law applies only to simple chemical reactions in general, and typically not to the developed image in silver halide photography. See reciprocity law.

burned-out Applied to an image area that lacks detail as a result of excessive exposure—typically a highlight area of a subject illuminated with a high lighting ratio.

burn in To give selected areas of an image, typically an enlargement, additional exposure so as to alter the density locally. Distinguish from dodging (giving less exposure locally).

burn-in In motion-picture photography, a type of lettering or animation effect produced by double-exposing the film, either in a camera or a printer.

burnout density The minimum density obtainable on a fully-processed diazo material; equivalent to fog on silver halide material.

busy Said of a photograph of many objects or tonal areas where the arrangement tends to be unorganized.

butterfly A frame covered with translucent material that is placed between a light source and the subject being photographed to diffuse the light.

butterfly lighting A type of portrait lighting in which the main light is positioned directly in front of and somewhat above the subject, thereby projecting the nose shadow straight down onto the upper lip. Syn.: high-front lighting.

butterfly shadows An effect obtained when a three-dimensional object is illuminated with two lights of approximately equal intensity placed on opposite sides of the camera so that symmetrical shadows are formed on the background, which can be perceived as wings attached to the object.

butt splice A joining of two pieces of film (or other material) whereby the edges are brought into contact with no overlapping.

buzz track Motion-picture soundtrack containing a desirable amount of noise to avoid an unnaturally quiet effect, used to fill gaps between sections of recorded dialog, etc., on films.

Bv Luminance value, an integer that represents the luminance of the subject expressed in logarithmic terms in the additive system of photographic exposure (APEX), which see.

b-w Black-and-white.

b & w Black-and-white.

B wind (1) One of two possible orientations of 16mm motion-picture raw stock, perforated on one edge, on a spool with the emulsion side toward the center. When the film leaves the spool at the top and toward the right, the perforations will be on the far side. Used by laboratories because some printing machines accept only B wind and others only A wind. (2) A designation for one of two possible emulsion positions on 16mm motion-picture film whereby the scene reads correctly through the base side and the emulsion is toward the lens during projection. Also called original emulsion position, as this orientation is produced on film exposed in a camera.

by-products In the processing of silver halide emulsions, oxidized developing agents and bromide or other halide ions, the main product being the silver image. By-products of development can affect the rate and uniformity of subsequent development, and they are used in some color processes to form dyes by reacting with couplers.

bulb release

burn in

CCC

C

cable release

calculator

C (1) Degrees Celsius, formerly centigrade. (2) Hundred. (3) An identifying code for "color" recommended by the International Radio Consultative Committee (CCIR) for use on the leader of color motion-picture films, especially those intended for television reproduction on an international exchange basis. (4) C mount, a system of matching threads that permits a lens to be attached to a camera, of a standard size commonly used for 16mm motion-picture cameras.

c The velocity of light, which is approximately 2.997924×10^8 meters per second in free space.

cable A flexible, heavy-duty electrical conductor that contains two or more insulated wires within a protective covering.

cable release A flexible encased wire, one end of which is attached to a matching socket on the shutter or camera housing, that activates the shutter when the plunger on the other end is pressed. Used to minimize camera movement and/or to enable the photographer to activate the shutter from a position moderately removed from the camera.

cadmium sulfide cell (CdS cell) A photoconductor used in some exposure meters as the light-sensing component. It has greater sensitivity than a selenium photovoltaic cell but requires a battery in the circuit.

calculated midtone Identifying a method of using an exposure (light) meter in which two luminance (reflection-type) readings are taken, one from the lightest area where detail is desired and one from the darkest. A position halfway between the two readings is used in selecting the combination of *f*-number and shutter speed. Syn.: luminance-range.

calculator A device that simplifies or eliminates the need for computations, e.g., the part of an exposure meter that contains an array of data for translating film speeds and light readings into combinations of *f*-numbers and shutter speeds.

calender (1) A machine used to control the texture of photographic paper by pressing the paper against a metal drum. Commonly used during the manufacturing process and less frequently with finished prints. (2) To press photographic paper against a drum to control the texture.

calibrate (1) To determine, check, or correct the graduation of an instrument scale. (2) In animation photography, to mark moves on the artwork or animation stand. (3) In stop-motion photography, to mark positions for the camera and the components of the scene.

calibrated focal length A calculated value for the distance from the best focus of an infinitely distant object plane to the rear nodal plane, adjusted so that the extreme positive and negative values over the useful field are equal in magnitude.

caliper The thickness of a single sheet of material, e.g., film or paper.

call In motion-picture photography, the time at which crew members, performers, etc., are to be ready for work at a studio or location.

Callier coefficient (Q) The ratio of specular to diffuse density. A ratio of 1.0 would be obtained in the absence of any scattering of the measuring light. The ratio increases with granularity, and was formerly used as a measure of granularity.

callout A number or letter, typically accompanied by an arrow, added to a photograph or other image for the purpose of identifying a part.

cam A device for·converting regular motion of one part into eccentric motion of another part. Used on autofocus enlargers to keep the image in focus as the enlarger head is raised and lowered, for example.

camel's-hair Identifying any of various types of soft

brushes made with squirrel-tail hairs, used for spotting prints, removing dust from negatives, etc.

cameo A small part of a motion picture in which a performer plays a very brief scene.

camera (1) In photography, a light-tight apparatus containing a lens (or pinhole) to form images on photosensitive materials for the purpose of making photographs. Numerous refinements are provided on various cameras, including shutters, focusing mechanisms, viewfinders, interchangeable lenses and backs, and integral light meters. Cameras designed for a specific purpose generally contain only those features needed to perform that function. An aerial camera, for example, may not have a focusing mechanism. (2) In television, a light-tight apparatus containing a lens to form images on an electron tube, where it is converted into electrical impulses for the purpose of televising or recording for televising at a later time. Refinements on various cameras include a monitoring screen, lens-and-tube-focusing mechanisms, and interchangeable lenses.

camera adjustment Any of various parts of a camera designed to allow the location or angle of the lens or the film to be changed (also a change in position of any of such parts). The purpose of camera adjustments is to modify the shape, sharpness, or placement of the image; e.g., focus, lens tilt, lens swing, back tilt, back swing, revolving back, rising-falling front, rising-falling back, front lateral shift, back lateral shift. Also known as adjustment , movement, and camera movement.

camera angle The position of the camera in relation to the subject being photographed. A "low angle" photograph, for example, is one made with the camera aimed up at the subject from a lower position.

camera choreography The planned moves for a motion-picture camera in photographing a scene.

camera club An organization composed of individuals with photographic interests, generally of a nonprofessional nature. Camera clubs tend to be more localized than photographic societies.

camera crane A rolling platform with a boom that supports one or more cameras and cameramen, used in motion-picture photography and television to provide vertical and horizontal control of the camera position.

camera dodging Reducing the exposure in selected areas of an image formed in a camera, typically by placing a black card in the corresponding position in front of the lens during part of the time the shutter is open. When precise positioning is required, a black cutout is placed on a glass plate located between the camera and the subject. See dodge.

camera exposure Applied to the time and relative aperture settings used to control the quantity of light or radiant energy received by the photosensitive material in a camera, e.g., 1/100 second at f/16. (Note that the amount of energy received by the film at each point is also affected by the corresponding subject luminance.)

camera flare Non-image-forming light in a camera, caused by the reflection of light from interior surfaces of the camera, and resulting in an increase in illuminance and a decrease in contrast of the image.

camera left A position to the left of the camera, from the operator's viewpoint. The term is used, for example, to inform an actor of a position he is to occupy.

camera log In motion-picture photography, a written record of pertinent data for a roll of exposed film, e.g., the name of the cameraman, the kind of film, and notations for the laboratory. Syn.: camera report.

camera lucida An optical apparatus that projects images of external objects onto a white surface for the purpose of tracing.

cameraman (1) A person who operates a camera. The term is used most commonly in organizations where individuals are specialists and each major function is performed by a different person. (2) In motion pictures, the director of photography or other person who supervises the photography.

camera montage A composite photograph made in a camera by separately exposing different areas of the film with a black mask, either inside the camera or in front of the lens, protecting the remaining area for each exposure.

camera move A change in position or orientation of a motion-picture or television camera while shooting a scene. Such changes are typically planned and rehearsed in advance of the actual shooting.

camera movement Any of various parts of a camera designed to allow the location or angle of the lens or the film to be changed. The purpose of camera movements is to modify the shape, sharpness, or placement of the image; e.g., focus, lens tilt, lens swing, back tilt, back swing, revolving back, rising-falling front, rising-falling back, front lateral shift, back lateral shift. Also known as movement, adjustment, and camera adjustment.

camera obscura (1) A light-tight room with a lens or small aperture on one wall that forms images on the opposite wall. (2) A camera with provisions for holding tracing paper on the back for the purpose of sketching.

camera adjustment

tilt adjustment

focusing adjustments

tilt adjustment

camera flare

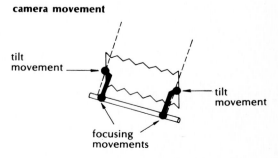

camera movement

tilt movement

focusing movements

tilt movement

camera optical Any of various special effects, including fades, dissolves, and wipes, made in a motion-picture camera as distinct from an optical effect made during the printing stage.

camera-position Identifying any of various exposure (light) meter methods in which the reading is made with the instrument held at or near the camera, but typically a reflected-light integrated reading as distinct from a reflected-light spot reading or an incident-light reading.

camera projection The use of a light source behind a camera to form an image on the subject plane of a grid (transparency, etc.) placed at the film plane. In catalog photography, for example, the projected image of a grid assists in positioning the subject. In animation photography, projected images are traced for the preparation of mattes and for other composite effects.

camera rehearsal In cinematography and television, a practice performance in the operation of a camera before shooting a scene, typically involving viewing the action through the viewfinder, focusing, and moving the camera as specified.

camera report See camera log.

camera right A position to the right of the camera, from the operator's viewpoint. The term is used, for example, to inform an actor of a position he is to occupy.

camera settings The shutter speed and *f*-number selected to control the quantity of light or radiant energy received by photosensitive material, e.g., 1/100 second at *f*/16. Also see "exposure settings."

camera sync (synchronism) The relative positions of the picture and sound components of a composite-camera original motion-picture film, i.e., a film exposed in a single-system camera.

can A metal container used to protect film. In motion-picture photography, cans are used for both raw stock and processed film.

Canada balsam A transparent, colorless resin sometimes used to bind lens elements together and to fasten cover glasses to microscope slides.

candela (cd) The unit of intensity of a source of light, derived from the obsolete candle, and now defined as 1/60 the intensity of 1 square centimeter of a blackbody radiator at the freezing point of platinum. As so defined, the physical standard is rarely used. Working substandards are carefully calibrated tungsten lamps.

candela per square centimeter (meter, inch, foot, etc.)´ (cd/cm²) A unit of measurement of luminance, i.e., the rate at which a unit area of a surface emits or reflects light in a specific direction.

candid camera (1) A popular term for a 35mm or other small still camera, especially one equipped with a fast lens. (2) Any camera that has been concealed or camouflaged for the purpose of photographing people secretly.

candid photography The specialization of making photographs of people (a) without their knowledge, or (b) with their knowledge but with little or no posing or directing by the photographer.

candle See candela.

candlepower (CP) The luminous intensity of a light source expressed in candelas, which see.

canned Identifying recorded music or other sound (on magnetic tape, for example) that is used in a motion picture, as distinct from live music, which is created and recorded at the time the action is photographed.

cans Slang for earphones or a headset.

capacitor A device, consisting basically of two conducting surfaces separated by a nonconducting material, used in electronic-flash circuits and some flash circuits for the purpose of accumulating and storing electricity. Syn.: condenser (electrical).

capstan A motor-driven cylindrical device used to transport magnetic tape pressed against its surface by a larger cylinder in some magnetic sound-reproduction units.

caption Written material related to and placed in or near a photograph or reproduction.

carbon arc A source of light consisting of a space between two electrodes carrying a current of electricity. Various materials are added to carbon electrodes to modify the quality of the light produced. The arc is usually in air as distinct from sealed arc lamps containing xenon, hydrogen, etc.

carbon step tablet A device for testing photographic material, consisting of a set of patches having different absorptions of light, in which the absorbing material is finely-divided carbon. Advantages, compared with silver step tablets, are finer grain and less selective absorption with respect to spectral characteristics.

carbon tetrachloride (carbon tet) A noninflammable, colorless, volatile liquid sometimes used as a film cleaner, a solvent for film lubricants, etc. Since it can have a toxic effect when absorbed through the skin or when the fumes are inhaled, safer substitutes are recommended.

carrier (1) In electrophotography, the solid or liquid material that conveys the toner but is not itself part of the final image — often glass beads. (2) A device (negative carrier) that holds a negative (or transparency) in a projection printer. Glass carriers hold the

negative between two pieces of glass. Glassless carriers hold the negatives by the edges between two frames.

cartography The production of maps, typically with the aid of aerial photography. Also see photogrammetry.

cartoon An animated motion-picture film, typically relatively short and of a comical nature.

cartridge A container for photosensitive or electromagnetic materials, which functions to facilitate loading the material into equipment in which it is to be used and/or to protect the material from light, dust, or other environmental hazards. Typically, film cartridges are factory-loaded; those of some manufacturers are not reusable, whereas film cassettes are reusable.

cascade development In electrophotography, the use of gravity to bring the toner into contact with the image-bearing support.

cascade washing (1) A film or print-washing system in which water is applied at an elevated position and allowed to flow down over the material being washed. (2) A washing system in which fresh water is fed into an elevated tank from which it flows to one of more lower tanks. The material being processed moves in the reverse direction, from the lowest tank to the highest.

casein A protein derived from milk, used for (a) adhesives and (b) photosensitive coatings for lithographic plates.

Cassegrain Identifying a telescope or mirror lens that employs two reflecting surfaces to form the image. The rays of light reflected from the second mirror pass through an opening in the first mirror to form the image behind the instrument, in contrast to the Schmidt design, which uses one mirror and forms the image inside the instrument.

cassette A container for photosensitive or electromagnetic materials, which functions to facilitate loading the material into equipment in which it is to be used and/or to protect the material from light, dust, or other environmental hazards. Typically, film cassettes are reusable, whereas film cartridges are factory-loaded and are often not reusable.

cast In motion-picture photography, (1) the actors for a film or (2) to assign actors to the various parts. (3) In the manufacture of film, to form film base into a sheet by pouring liquid dope onto a revolving polished drum. (4) A faint coloration, usually of one hue, over the entire image.

cast shadow The area on a surface that is shielded from direct illumination when an object is located between the surface and a light source, as distinct from the area on the object that does not receive direct illumination. Syn.: projected shadow.

cast title In motion pictures and television, text material that identifies the actors with the characters they portray.

catadioptric Applied to optical systems that use combinations of mirrors and lenses to form the image. Possible advantages over all-refractive lenses include reductions in chromatic aberration, size, weight, and cost. Distinguish from catoptric lenses, which use mirrors only, with no lenses. Also see mirror lenses.

catalog (catalogue) photography The specialization of making photographs of commercial products for catalogs. The photographs typically are reproduced photomechanically in large quantities and distributed to prospective buyers in bound volumes that include specifications, prices, etc. The objective of catalog photographers has traditionally been to represent products in an attractive, but realistic manner.

catalyst A substance that induces or accelerates a chemical reaction without being altered by the reaction. Some developer oxidation products, for example, speed up the rate of subsequent oxidation.

catchlight In portraiture, a reflection of a light source in a subject's eye.

cathode The negative electrode of a battery, vacuum tube, carbon arc, or other electrical device. The converse of anode.

cathode-ray tube (CRT) An evacuated glass tube in which deflections in an electron beam form images either on a fluorescent screen (which can be photographed for a permanent record), or directly on a photosensitive material.

catoptric Applied to optical systems that use only mirrors to form the image. Not to be confused with catadioptric systems, which use combinations of mirrors and lenses. Catoptric systems are used especially for cameras of great aperture and focal length. Such systems are free from chromatic aberration but suffer from other defects that limit angle of view. See mirror lens.

catwalk A high grid in a motion-picture studio that enables persons responsible for the lighting equipment (gaffers) to move about and rig overhead-light units.

caustic A curved surface representing the outer edge of the bundle of converging rays of light from a distant point source with a lens or mirror having spherical aberration.

cc Cubic centimeter.

CC Color-compensating.

catadioptric

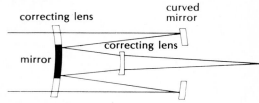

catadioptric optical system

cathode ray tube recording

L. Goldberg

caustic

C/C Cutting copy.

CCIR Comité Consultatif International de Radio.

cd Candela.

cdS Cadmium sulfide (cell).

cell (1) A sheet of cellulose acetate or other transparent material used for animation drawings so that two or more separate drawings can be superimposed and photographed as a unit. Also spelled cel. (2) An elementary source of electricity. See electric cell; photoelectric. Technically, a battery is an assemblage of cells. (3) A transparent container for liquids, used for any of various purposes, including altering the quality of light (filter cell), controlling exposure time (Kerr cell), and holding a specimen for photomicrography (microscope cell).

cell flash An unwanted reflection from an animation cell, caused by incorrect lighting, poor platen pressure, etc.

cell level In animation photography, the relative position of an acetate when two or more acetates are used, e.g., the bottom level, the middle level, and the top level.

cell paint Opaque watercolors that have been especially formulated to adhere to animation acetates (cells) without cracking or chipping.

cellpan In animation photography, moving an overlay sheet of transparent material bearing an image (a cell) to create an impression of motion, as distinct from the technique of using a series of different drawings.

cell punch A precision mechanical device designed to perforate transparent sheets used for animation drawings (cells) so that they can be registered quickly and accurately on pegs.

cellulose acetate. A chemical substance derived from wood pulp, etc., used for making film base. Cellulose acetate film is often called safety film because it ignites with difficulty and burns slowly, unlike the earlier cellulose nitrate film.

cellulose ester An organic salt obtained by treating cellulose with an acid. For example, the ester cellulose acetate (which is used for film base) is produced by reacting acetic acid with cellulose (cotton, etc.).

Celsius (C) The preferred name of the centigrade thermometer scale, on which the freezing point of water is 0° and the boiling point is 100°.

cement A viscous substance used to bind materials together. For example, film cement is used to splice motion-picture film in editing.

centerfold A center spread of which one of the pages has double width and can be unfolded for viewing.

center of perspective

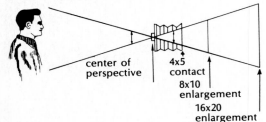

center of perspective 4x5 contact
8x10 enlargement
16x20 enlargement

center of interest The area of a scene or image that has the strongest attraction for the eye of the viewer.

center of perspective (1)When photographing a subject, the front nodal point of the camera lens. (2) When viewing an image, the position at which the image subtends the same angle to the eye as the original subject subtended to the camera lens.

center spread A reproduction of a photograph, layout, etc., that occupies the two middle (facing) pages in a publication. Typically, the two pages are printed with one plate.

center stage In motion-picture photography, a position directly in front of the camera on the lens axis.

center-weighted A through-the-lens exposure (light) meter designed so that the meter reading is determined more by subject luminances on or near the lens axis than by those nearer the edges of the field.

centi- As applied to the metric system, a word element signifying one hundredth part of a unit, e.g., centimeter.

centigrade (C) A thermometer scale (also known as Celsius, the preferred name) on which the freezing point of water is 0° and the boiling point is 100°.

centimeter (cm) A unit of length, 1/100 of a meter, equivalent to 0.3937 inch.

centimeter-gram-second Identifying a system of measurement in which the centimeter, gram, and second are the basic units of length, weight, and time.

centration (1) In optics, the alignment of the elements of a lens so that all centers of curvature lie on a single straight line known as the lens axis. Failure to achieve centration results in image degradation. (2) In visual perception, a phenomenon whereby the addition of an image that differs slightly from an original image in some attribute such as size causes the original image to be perceived as changing so as to more nearly resemble the added image. For example, adding a slightly smaller circle inside an original circle causes the original circle to be perceived as decreasing in size. When the difference between the two images exceeds a certain value, however, the effect is reversed, and the original image is perceived as changing so as to be more different from the added image, a phenomenon known as contrast.

centrifuge A device used to separate liquids and solids by spinning the combined material at high speeds. Used in the production of chemicals, for example, the separation of crystallized developing agents from chilled solvents, etc.

CFF Critical fusion frequency.

C/ft² Candelas (candles) per square foot.

cgs Centimeter-gram-second.

chainpod A chain approximately 6 feet long that is used to steady a hand-held camera by screwing one end into the tripod socket, stepping on the other end, and then raising the camera to take up the slack so the chain is under tension.

chalky Applied to an unnaturally light image area that is devoid of gradation or detail, typically a highlight area of a contrasty image.

changeable-density A popular term for photochromic, which identifies glasses containing silver or other metals that increase in light absorption and decrease in transmission when acted upon by short-wave radiation. The increase is usually reversible when the stimulating radiation ceases or when the wavelength of the radiation is altered.

changeover In motion-picture projection, the procedure of simultaneously changing the image on the screen from one projector to another, preferably without interruption of continuity. Also, a place in a film where such a change is to be made.

changeover marks In motion pictures, indications to the projectionist that the reel being shown is about to end. Such marks are printed or scratched on the release print in standard positions near the end of the reel.

changing bag A light-tight bag, fitted with elastic sleeves for the operator's arms, in which film holders and processing tanks can be loaded when a darkroom is not available.

channel (1) A longitudinal band-shaped area on magnetic tape within which a recording is made. Magnetic-tape sound-reproduction systems often use two, four, or more channels spaced across the width of the tape. (2) In communication and information theory, any recording or transmitting device or medium. Examples: electrical circuits that carry signals; radio and television broadcast bands; punched tape.

character actor In motion-picture photography, an actor who plays a supporting role but whose performance is distinctive.

character animation In cartoon animation, a highly skilled form of drawing that involves complicated facial expressions, anatomical foreshortening, etc.

characteristic The part of a logarithm that is a whole number, as distinct from the mantissa, which is the decimal part. For example, the logarithm of 20 is 1.3: the characteristic is 1 and the mantissa is .3.

characteristic curve (1) A graph obtained by plotting the logarithms of a series of exposures (quantity of light per unit area) received by a photographic material and the corresponding resulting densities. (2) A graph similar to (1), but with the logarithm of the energy (quantity of radiation per unit area) as the input. Used for photographic materials normally responsive to radiation other than light, such as x-ray films. Such graphs are used to determine information such as base-plus-fog level, speed, gamma, contrast index, useful exposure range, and maximum density. Syn.: D-log H (D-log E) curve; H and D curve; sensitometric curve.

character recognition Automatic detection and identification of symbols such as numbers and letters in a photographic (or other) image by electronic means. A branch of pattern recognition.

character sketch In animation photography, a master drawing used as a guide so that none of the drawings made by animators will appear incongruous.

charge To supply electricity to a device such as the capacitor in an electronic-flash unit, the photoconductor in an electrographic reproduction device, or a battery.

charge barrier A layer of negatively-charged halide ions adsorbed to the surface of silver halide grains. It tends to repel negatively-charged developer ions, thereby depressing the rate of development.

cheapie Slang for a low-budget motion-picture film.

cheat In motion-picture photography, to move a prop, actor, etc., to a position different from that occupied in an earlier scene, for the purpose of enhancing an effect.

checkerboard Applied to a system of motion-picture editing and printing whereby different rolls of related film are labeled A, and B (and C, if three rolls are used) for purposes of identification. By alternating scenes and adding an appropriate length of black leader film to the other roll(s), optical effects can be added without making a duplicate, an advantage over printing from a single roll. Syn.: A and B roll.

check (checking) print A motion-picture print which contains the sound and all necessary corrections such as editing, density changes, and color changes. The approved check print is used as a standard for production prints. Syn.: answer print; approval print; sample print.

cheesecake (slang) Photographs of pretty women posed to emphasize their legs or buttocks, especially for photojournalistic use.

chemical development The formation of a visible image from a latent image involving the reduction of silver ions in the silver halide grains to silver

chainpod

changing bag

characteristic curve

density | log exposure

chemical focus

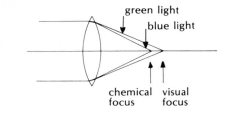

green light
blue light

chemical
focus

visual
focus

chromatic aberration (a)

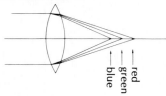

red
green
blue

chromatic aberration (b)

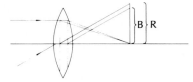

B R

by a developing agent that is simultaneously oxidized. Contrast with physical development, in which the silver that forms the image is supplied from the developer. Syn.: direct development.

chemical drag Regions of lowered density in areas of a processed image adjacent to high-density areas. The cause is a flow of partially exhausted developer over the material during processing, in situations in which the agitation is inadequate. Syn.: bromide streaks.

chemical flash Identifying a lamp consisting of a sealed glass bulb containing a combustible material in an atmosphere of oxygen and producing a single pulse of light of brief duration and high intensity, as distinct from electronic flash, which produces light repeatedly by means of an electrical discharge through an inert gas.

chemical focus The position of best focus for the short wavelengths of radiation (ultraviolet-blue) to which photographic materials are most sensitive. Chemical focus and visual focus may be significantly different with uncorrected lenses, since the eye is most sensitive to middle wavelengths in the visual spectrum.

chemical fog Density in processed silver halide photographic materials that is not attributable to the action of radiant energy. Chemical fog may be caused by the action of a developing agent, by oxygen (as when a film wet with developer is exposed to air), or by the action of chemical contaminants. Chemical fog occurs in both unexposed and exposed areas of the film, but tends to decrease as the exposure increases. Thus its deleterious effects are greatest in the low-density areas of the image, where it causes a reduction in detail and contrast.

chemical sensitization The increase in response of a (silver halide) photographic material during manufacture without change in the region of the spectrum to which the material responds. (Contrast with dye sensitization.) Gold salts, among other materials, are used for chemical sensitization.

chemical spread function A description of the manner in which processing affects the shape and size of the image formed from an ideal point of exposure. The point spread function as measured includes, besides the chemical spread function, the effect of light scatter within the emulsion during exposure.

chemical toning The direct conversion of the silver in an image into a colorant, as distinct from dye toning, in which a mordant is formed in proportion to the amount of silver in the image, and the mordant then adsorbs dye to form the colored image.

chemiluminescence The production of light at low temperatures by chemical reaction.

cherry picker A vehicle used to elevate a camera and operator to obtain a high viewpoint.

chestpod A device designed to be attached to a camera tripod socket, so as to enable the photographer to steady the camera against his chest.

chiaroscuro (kǐaȓ-ō-sk (y) ŏoȓ-ō) The composition of light and shade in a picture.

child photography The specialization of making photographs of infants and other youngsters, with an indefinite upper age limit that varies among photographers.

chill box In emulsion coating, a refrigerated enclosure through which the coated base passes for the purpose of solidifying the liquid emulsion to a gel.

chip In microfilming, a small piece of film.

chloride paper Photographic printing paper with an emulsion containing silver chloride as the predominant light-sensitive component, used mostly for contact printing because of its relatively low speed. Distinguish from bromide and chlorobromide papers.

chlorobromide paper Photographic printing paper with an emulsion containing a mixture of silver chloride and silver bromide as the light-sensitive component. Characteristics, such as speed and image tone, tend to be intermediate between those of chloride papers and bromide papers.

chopper An opaque blade or other device used to systematically interrupt a beam of light in an optical instrument. In the projection of motion pictures, for example, flicker can be reduced or eliminated by interrupting the light during the showing of each frame.

chroma An attribute of color that varies with the saturation of hue, e.g., the extent to which a red pigment departs from gray pigment of equal value (lightness). With the Munsell system of color notation, gray is numbered 0 and the numbers 1, 2, 3, etc., indicate equal increments in saturation of a hue, i.e., chroma.

chromatic aberration A lens defect by which image characteristics vary with the wavelength of light or other radiation. Two kinds of chromatic aberration exist: (a) longitudinal, the variation in focal length with wavelength, which affects the entire image; (b) lateral, the variation in magnification with wavelength, which affects the outer parts of the image.

chromatic constancy A psychophysical visual phenomenon whereby the hue and chroma (saturation) of a surface are perceived as remaining unchanged

when viewed under different colors of illumination. Chromatic constancy is one aspect of color constancy, the other being lightness constancy.

chromaticity A quality of color that includes hue and chroma (saturation) but not value (lightness), specified by X and Y coordinates in the CIE system.

chromaticity diagram A graphical display of the results of experiments in which sample colors are matched by different amounts of three primary colors added together. There are many such diagrams, CIE (Commission International d'Eclairage) and UCS (Uniform Chromaticity Scale) being the most common. The boundary involves plots for the spectral colors; neutrals plot near the center of the figure; varying lightnesses are not shown, since they would require a third dimension.

chromatic threshold In visual perception, the minimum intensity of a light stimulus at which hue becomes apparent. Also see absolute threshold and colorless interval.

chrominance The combination of hue and saturation (chroma) in a color, as distinct from luminance.

chromogenic Identifying a substance or process that produces color, e.g., couplers.

chromophore That part of a molecule which is responsible for the absorption of specific wavelengths of light and, therefore, for the color of a dye, etc.

chromoscope A device in which three color-separation positive images, illuminated through filters, are viewed by mirrors as a single image in full color.

chronophotography The specialization of making a sequence of still photographs at regular intervals for the purpose of analyzing motion through examination of the individual photographs, as distinct from high-speed and time-lapse motion-picture photography (see high-speed; time-lapse).

CI Contrast index.

CIE Commission Internationale de l'Eclairage (International Commission on Illumination).

cinch To tighten a roll of film by pulling on the free end, a practice that may produce abrasion marks.

cinch marks Abrasion defects on roll film, produced when the roll is tightened by pulling on the free end.

cine- A prefix denoting an application of or association with some aspect of motion-picture photography.

cinema (1) Motion pictures collectively, especially entertainment and expressive films. (2) A motion-picture theater.

cinemacrography The specialization of making motion pictures of small objects, not through a microscope. Various methods are used to obtain large images of small objects, including the use of supplementary lenses, lens extension tubes, and lenses especially designed for small object distances.

cinematographer A motion-picture cameraman, i.e., a director of photography.

cinematography Motion-picture photography, including planning, production, editing, and presentation.

cinéma vérité (sin'-ay-ma vay-ri-tay') Motion pictures intended to portray uncompromising reality, characterized by the use of untrained actors, hand-held cameras, available light, etc.

cinemicrography Motion-picture photography through a microscope. Syn.: cinephotomicrography.

cineradiography Motion-picture photography of x-ray images. The normal procedure involves photographing a visible image on a fluorescent screen or an amplified visible image on a cathode-ray tube.

cinex test In motion-picture photography, a strip of film incorporating systematic frame-by-frame variations (e.g., density/color balance) produced by the lab to assist the cameraman in making decisions concerning subsequent shooting.

circle of confusion The out-of-focus image formed by a lens of an object point; specifically, the diameter of the circular image. Since circles smaller than a certain size appear to a viewer as points under standardized conditions, the diameter of the maximum acceptable circle of confusion can be used in computing depth-of-field tables, etc.

circle of good definition The area in the image plane within which the lens is capable of forming an image having acceptable optical quality. For a given lens, the size of the circle tends to increase as the aperture is reduced, and the diameter increases in proportion to image distance as the lens is focused on closer objects. Among lenses, the size of the circle varies with focal length and lens design.

circle of illumination The area in the image plane formed by the entire cone of light transmitted by a lens. Vignetting by the barrel mount determines the size of the circle of illumination with conventional lenses.

circle of least confusion The smallest image of a point object obtainable by focusing a lens at a given aperture. If a lens has appreciable uncorrected spherical aberration, the size and position of the circle of least confusion will vary with the f-number.

circle wipe (CW) A motion-picture special effect in which a transition is made from one scene to another by means of a varying circular line between

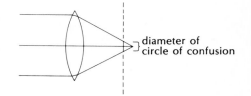

circle of confusion

diameter of circle of confusion

circle of good definition

circle of illumination

lens

circle of good definition

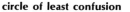

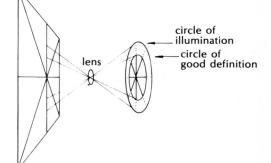

circle of least confusion

scenes. The line may either begin at the center and expand or begin at the corners and contract.

circular polarization The continuous rotation of the plane of polarized light, usually produced by quarter-wave plates of mica. The mica produces two polarized waves, of equal amplitude, and separated in phase by 90 (or 270) degrees. The recombination of these waves produces, in effect, a rotating vector.

circulation The forced movement of a processing solution, through a tank for example, for the purpose of providing agitation, replenishment, temperature control, etc.

circus layout An arrangement of photographs or other images, typography, etc., that typically has a large number of visual elements and is intentionally showy for the purpose of attracting attention. Commonly used for advertisements in newspapers and periodicals.

clamp A mechanical device designed to grip an object firmly, typically for the purpose of supporting a light source, camera, or other piece of equipment.

clamp-on Identifying a light-bulb holder having a built-in gripping mechanism so that it can be attached to a door, chair, etc., thereby eliminating the need for a stand.

clapboard (clapper board) A device consisting of two strips of wood or other material connected at one end with a hinge; the bottom strip is typically attached to a small slate. The device is photographed at the start or end of motion-picture scenes to assist the editor in identifying the scene (with information placed on the slate) and synchronizing the sound and the picture (with audible and visual cues produced when the strips are banged together).

clapsticks A device consisting of two strips of wood or other material connected at one end with a hinge, used in motion pictures as an aid to synchronization of picture and sound. Also see clapboard.

claw An L-shaped hook that moves film one frame at a time in motion-picture cameras and projectors, in step printers, and in some still cameras. In motion-picture equipment, the claw is synchronized to move the film when the shutter is closed.

Clayden effect Local desensitization that may result in partial or total image reversal when a high-intensity exposure of short duration is followed by a lower-intensity exposure of longer duration. Lightning, for example, may appear black on the print rather than white.

clean room An area where the necessary precautions are taken to prevent the entrance of impurities considered hazardous to precise photographic operations. Specifications are often in terms of the maximum size of dust particles that are admissible.

clearing bath A solution used to prevent or remove stains on photographic materials from the action of another solution, especially the bleach in some toning, intensification, and reversal processes. In some reversal color processes, the clearing bath also removes the small amount of silver halides remaining after both negative and positive images have been developed.

clearing time The length of time between immersion of photographic material in a fixing bath and disappearance of cloudiness caused by silver halides in the emulsion. Double the clearing time is commonly used as the minimum safe time of fixation for film.

clear spot An area used for critical focusing (a) on a ground glass where the grain has been reduced or eliminated, or (b) on a Fresnel lens where there are no ridges.

click (1) The sound of a shutter being released. (2) To release (a shutter).

click stop A feature on some devices whereby a sudden increase in friction is felt, often accompanied by an audible signal, as a part is moved past a calibrated position, thus making precise positioning possible without visual inspection. Commonly used on lens diaphragms, shutters, and lens turrets.

click track A soundtrack loop that has a series of short, sharp sounds (clicks) in a specified tempo, used by music composers or conductors with the pencil test or work print of an animated film to determine the musical tempo.

C-line Radiation having a wavelength of 656.3 nm, one of three wavelengths used in the computation of dispersive power. Also see D-line and F-line.

clip (1) A gripping device used to hold film during processing or drying. (2) A section of film removed from a motion picture during editing; by extension, any short length of processed motion-picture film. Syn.: cut; out; trim. (3) A patch containing tabs that engage perforations in motion-picture film, used to join strips of film temporarily until they can be spliced.

closed circuit A television system in which the camera and associated equipment are directly connected to one or more viewing sets. The signal is not broadcast or sent out by cable to other stations. Used for rehearsals and monitoring and when the intended audience can be accommodated by the system.

close down To change the f-number setting on a lens to a selected f-number that represents a smaller diaphragm opening. To change the f-number setting

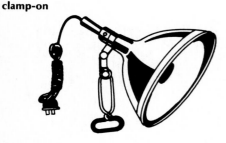

clamp-on

from f/8 to f/11, for example, would be to close down one stop. Syn.: stop down.

closed set A motion-picture studio or other filming area where only those who are directly concerned with the production are admitted.

closeup (1) In motion-picture photography, a scene in which the scale of reproduction is larger than in other scenes in a sequence, obtained either by moving the camera closer or by using a lens of longer focal length. Abbreviated CU. (2) In still photography, generally a photograph in which the scale of reproduction is larger or the angle of view is smaller than is customary. (3) In still photography, specifically a photograph that requires modification of the exposure, equipment, or other factor because of the small distance between subject and camera. For critical work, compensation is made in the exposure when the subject is closer than 10 times the focal length. When the subject is closer than 2 times the focal length, the term "photomacrograph" is preferred.

closeup attachment A positive supplementary lens that produces a combination with a shorter focal length than the basic lens. Adding the attachment *reduces* image size from the same camera position but enables the camera to focus on nearer objects, with a net *increase* in the scale of reproduction when the camera is moved closer.

club See camera club.

clutch In animation photography, a single-frame motor drive.

cm Centimeter.

c/m² Candela (candle) per square meter.

cm³ Cubic centimeter.

C mount A system of matching threads that permits a lens to be attached to a camera, of a standard size commonly used for 16mm motion-picture cameras.

coagulation In the manufacture of photographic emulsions, the precipitation of the silver halide crystals together with some of the gelatin in little beads. The coagulation step precedes washing, and is a substitute for noodling, a mechanical method of producing small strips of emulsion.

coated Identifying paper used for photomechanical reproduction that has been treated to produce a high-gloss surface. Such paper is capable of producing higher-quality reproductions of photographs than uncoated paper. Syn.: enameled.

coating (1) Lens coating: a thin layer of transparent material, such as magnesium fluoride, applied to exposed lens surfaces to reduce light reflection, thereby reducing flare and increasing effective lens speed and image contrast. (2) Any of various layers applied

to a film or paper base during the manufacture of a photosensitive material, e.g., an emulsion, antihalation, filter, or protective layer.

coating weight In the manufacture of photosensitive materials, the quantity of silver halide per unit area, variations in which influence such factors as exposure latitude and maximum density.

coaxial Identifying a type of motion-picture film magazine in which the feed and take-up spools are side by side, as distinct from a displacement magazine, in which the spools are in line.

cock To move the setting lever or knob on a shutter, which in turn puts tension on one or more springs and prepares the shutter for release. Syn.: tension.

code A set of rules, regulations, recommendations, etc., prepared by a professional society or other organization to guide its members and thereby further the aims of the organization. The code of minimum standards of the Society of Photographers in Communications (ASMP), for example, establishes minimum rates of pay for its members.

code notches On sheet films, indentations along one edge which can be felt in the dark to identify the type of film and locate the emulsion side.

code numbers Pairs of identical numerals printed at one-foot intervals on motion-picture film and the corresponding soundtrack after they have been synchronized. Distinguish from edge numbers, which are printed on film during manufacture.

coding (1) The procedure of printing edge numbers on motion-picture film for the purpose of identifying a frame or scene in editing, producing optical effects, etc. (2) The procedure of converting a photographic image into a different form, as by scanning and digitizing, for image transmission, enhancement, storage, etc.

coefficient distribution See color-mixture curves.

coherence Degree of agreement of light waves with respect to phase. A highly coherent source, such as a laser, produces light waves all very nearly in step. For this reason, such light is especially potent.

coincidence rangefinder See superimposed field.

cold-cathode lamp A rapid-start fluorescent lamp that requires high voltage, operates at a relatively low temperature, and produces highly actinic light. Used as an enlarger light source, the tube is bent in the shape of a grid to cover the negative area, thereby producing nearly uniform illumination with a minimum of added diffusion.

cold mirror A polished surface that reflects light but transmits infrared radiation, used in some projectors to reflect usable light back through the optical system while allowing heat-forming infrared radiation

closeup attachment

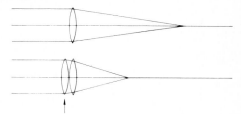

code notches

sheet film

cold mirror

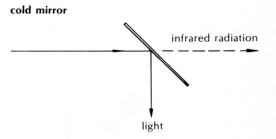

infrared radiation

light

to escape through the mirror. Syn.: diathermic mirror.

collage A composite picture made by pasting a number of images on a support, generally abstract in nature and including newspaper reproductions and other types of images, often with hand-painted or hand-drawn additions.

collimator

collimator An optical device that produces parallel rays of light for testing, adjusting, and research purposes with optical components and systems. Collimated light from a nearby source can be used as a substitute for an infinitely-distant source for calibrating a focusing scale.

colloidal particles Finely divided substances such as silver and dye, larger than most inorganic molecules, ranging in size from 1 to 100 nanometers in diameter, which will remain suspended in a fluid indefinitely.

colloquium An informal meeting or group discussion on one or more photographic or other topics, usually of an educational nature.

collotype A photomechanical reproduction process that utilizes reticulated dichromated gelatin. Since a halftone screen is not needed, the process is capable of reproducing fine detail. Syn.: photo-gelatin.

color (1) That aspect of visual perception associated with the attributes of light identified as hue, saturation, and brightness. The Munsell system of color notation with pigment samples uses the corresponding attribute terms "hue" (red, green, blue, etc.) "chroma" (difference from gray) and "value" (lightness). Only the neutral colors (blacks, grays, and whites) have no hue and zero chroma, and thus can be arranged into a scale on the basis of value (lightness) only. (2) As applied to objects, their reflection or transmission properties for different wavelengths of light. For example, yellow objects reflect little blue light and much green and red light. Red filters absorb much green and blue light and little red light. Data about the color of objects may be displayed in the form of a graph, in which absorptance (or density or transmittance) is plotted against wavelengths. (3) As applied to light sources, the energy produced at different wavelengths, often expressed in the form of a graph of energy (or relative energy) versus wavelength. The plots are called spectral energy distributions.

color-blind

UV | B | G | R

color adaptation A process by which a person's visual perceptual system adjusts to variations in stimulus color, producing decreased sensitivity to stimulus colors and increased sensitivity to complementary colors. For example, when the observer is fully adapted to the light source, either tungsten or daylight may appear white, despite the wide differences in the relative amounts of red, green, and blue light produced by these sources.

color analysis The separation of subject colors into primary color components, normally red, green, and blue; an essential procedure in all conventional color processes. With multilayer color films, each primary color is recorded on a different emulsion layer. Compare with color synthesis.

color analyzer A device that measures the primary color components of images, typically the red, green, and blue light transmitted by or reflected from an image. Such devices are commonly used in making color prints from negatives and transparencies, to assist the photographer in obtaining the correct filtration and exposure.

colorant A colored substance such as dye, pigment ink, or paint used to alter the color of other materials or objects.

color balance (1) A general term for the apparent fidelity with which a photographic image simulates the subject colors, especially neutral colors. If the image of a gray scale appears too blue, for example, the color balance is said to be blue. (2) A psychological equilibrium of the hue, value, and chroma attributes of a color image about the midpoints of the corresponding scales.

color bar A test object used as an aid in the estimation of quality of reproduction in color television.

color-blind Specifying photographic emulsions which are sensitive only to ultraviolet and blue radiation. Syn.: blue-sensitive.

color blindness Defective color vision, i.e., any of various abnormal physiological conditions including monochromatism, dichromatism, and anomalous trichromatism. The use of the term "color blindness" can cause anxiety, especially in children, and therefore should be avoided.

color coefficient The ratio of the printing gamma to the visual gamma for a negative or transparency. The ratio is 1.0 with images that are nonselective (neutral) with respect to wavelengths absorbed, but may be considerably larger or smaller with colored images due to differences in spectral response of the printing material and the eye.

color-compensating (CC) Identifying a class of filters produced in red, green, blue, cyan, magenta, and yellow hues and a variety of densities (based on the spectral region of maximum absorption) from .025 to .50. The filters are designated by the letters CC (for color-compensating), followed by the density (with the decimal omitted) and the first letter of the name of the hue, e.g., CC05Y. Color-compensating filters are commonly used on cameras and projection printers to produce controlled changes in the color balance of color photographs.

color constancy A psychophysical visual phenomenon whereby the color of a surface is perceived as remaining unchanged when viewed under illumination of different colors. A white object, for example continues to be perceived as white when viewed first under daylight illumination and then under tungsten illumination. Color constancy includes both lightness constancy (a white object continues to appear white, not gray, when the illuminance is decreased) and chromatic constancy (a white object continues to appear neutral when the color temperature of the illumination is altered).

color contrast Relative variations or perceived variations of hue or chroma in a scene or image. The perceived color contrast is typically greater when two colors are adjacent than when they are separated by a neutral area. A blue area, for example, appears to be more saturated when it is surrounded by yellow than when it is surrounded by gray, an effect known as simultaneous color contrast.

color-corrected Identifying a lens in which chromatic aberrations have been reduced, as compared with a simple lens. The phrase usually implies that the lens has equal focal lengths for two selected spectral wavelengths. Syn.: achromatic. Also see apochromatic.

color correction (1) Adjustment of the color balance of a color photograph, for example, by a change in filtration in making a color print. (2) The modification of a subject color to compensate for the unsatisfactory reproduction of the original color by the photographic process being used. For example, if a certain color appears darker on the photograph than in the subject, a lighter color (or possibly a fluorescent color) would be substituted in the subject.

color density A measure of the light-absorbing characteristics of dyes or other colorants, as distinct from silver, in a photograph or other material. With multilayer color images, measures of the net effects of the superimposed images are known as integral densities, whereas measures of each image separately are known as analytical densities.

color film A flexible, transparent support coated with photosensitive material capable of making distinguishable records of selected subject colors. Typically, color films produce positive or negative cyan, magenta, and yellow records respectively of the relative amounts of red, green, and blue light reflected or emitted by different subject areas.

color filter A layer of transparent material that reduces to different degrees the energy in different portions of the visible spectrum. Used for any of various purposes, including modifying the color balance of color photographs and lightening or darkening selected subject colors in black-and-white photographs. One of three major classes of optical filters, the others being neutral-density and polarizing.

color gamut (1) The most saturated colors, or (2) the colors that can be produced by a set of inks (for a photomechanical reproduction process) or a set of dyes (for a photographic process), typically presented in graphical form as the boundary of the color space. A color gamut, for example, may consist of the most saturated colors of a specific hue over a range of lightness values. When shown on a chromaticity diagram, however, the color gamut includes all hues, but the dimension of lightness is missing.

color harmony A pleasing effect with respect to the choice and arrangement of colors in a subject or photograph.

colorimeter (1) A device for mixing three (or more) colored lights so as to match a sample in appearance. (2) A physical device intended to accomplish the purpose of indicating an appearance match with a sample. (3) In chemistry, an apparatus used to measure the concentration of a dye, including a visual or photoelectric comparator.

colorimetric density A measure of dye deposit in terms of the amount required to produce a visual match with given amounts of three selected-colored primary lights.

colorimetric purity In color specification and measurement, the objective quality of a color that corresponds to the subjective attribute of saturation. Specifically, the ratio of the intensity of spectral light to the sum of the intensities of spectral light and white light that match the sample color when combined.

colorimetry The science and technology of specifying the amounts of three (or more) colored lights (usually red, green, and blue) that are required to make a visual match for a given sample. The results of such matches are usually displayed on a graph called a chromaticity diagram. The most usual forms of such graphs are the CIE and the UCS diagrams. (Note: These graphs do not indicate the *appearance* of a sample, which will change markedly with viewing conditions.)

colorist A person who applies dyes, paints, or other colorants to existing images. In animation photography, the terms "colorist," "opaquer," and "painter" are used interchangeably.

color key In television, a system of producing composite images based on differences in color of the components.

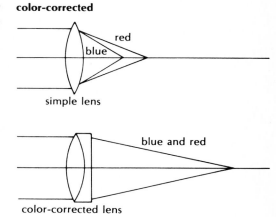

color-corrected

simple lens

color-corrected lens

color film

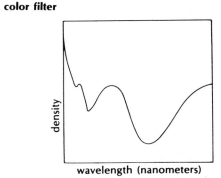

color filter

colorless (1) Without color, as air. (2) Without hue; gray, white, black. (3) Relatively weak in hue; unsaturated.

colorless interval In visual perception, the difference between the minimum intensity of a light stimulus at which hue becomes apparent (chromatic threshold) and the minimum intensity that can be detected (absolute threshold). Syn.: photochromatic interval.

color metric In visual perception, a measure of the difference in color of two stimuli.

color-mixture curves In colorimetry, graphs obtained by plotting wavelength and relative trichromatic coefficients. Such graphs can be used to determine the relative proportions of three specified primary colors required to match narrow bands of light throughout the spectrum. Syn.: coefficient distributions.

color negative A photographic image in which light subject tones are reproduced as dark and vice versa, and subject colors are reproduced as complementary colors; e.g., a blue object is recorded as yellow. The complementary relationship is partly obscured on some color negatives by the presence of color-masking dyes.

color notation The systematic designation of the attributes of colors with letters, numbers, symbols, etc. With the Munsell system of color notation, for example, the hue, value (lightness), and chroma (saturation) of a specific color may be designated as 5B 8/4.

color paper Photosensitive material on a paper base for making color prints from color negatives or color transparencies, a reversal process being used with the latter. Typically, such material is coated with three emulsion layers, which respond respectively to red, green, or blue light and form cyan, magenta, or yellow dye.

color positive A photographic image in which the colors approximate those of the corresponding areas of the subject, as distinct from color negative, in which subject colors are reproduced as complementary colors and the light-to-dark relationship is reversed.

color print A photographic color image made from another image rather than directly from the subject, for the purpose of being viewed directly or by projection or of being used as a master original from which further reproductions are made, usually for viewing by a larger audience.

color-print film Multilayer photosensitive material on a flexible, transparent support used for making color transparencies from color negatives by contact or projection printing.

color reversal Identifying a type of color film, color paper, or process whereby positive color images are produced directly from a scene or positive original, as distinct from negative, positive, and non-reversal materials, and negative-positive processes.

color scheme A plan for the choice and arrangement of colors to achieve a desired effect in a photograph. For example, a designation of harmonious background and clothing colors for a fashion photograph.

color sensitivity A measure of the response of a photographic material to a narrow band of radiation from the visible part of the spectrum. The term "spectral sensitivity" is generally preferred, especially when ultraviolet, infrared, or other invisible radiation is involved.

color sensitometry The measurement of the response of photographic color materials to radiation. See sensitometry.

color separation (1) The process of making records of (typically) the red, green, and blue light available from an original subject or color image. A necessary preliminary to color photomechanical reproduction, or to making color prints by dye transfer. Color separation usually requires the use of appropriate filters. (2) Applied to the images made for the purpose defined above, e.g., red color-separation negative.

color-slide film Multilayer photosensitive material on 35mm film base used for making transparencies by contact or projection printing.

color space A three-dimensional representation of all possible colors. With the Munsell system, for example, value (lightness) is represented on a vertical axis, hue is represented on a circle around the axis, and chroma (saturation) is represented on lines radiating from the axis.

color stimulus Radiant energy that is capable of producing the visual sensations of color.

color synthesis That stage in color photography at which the reproduction is formed. In photography, the synthesis is subtractive; i.e., the final image is composed of superimposed cyan, magenta, and yellow dye layers. In television, the synthesis is additive; i.e., the final image is composed of adjacent red, green, and blue dots that normally are fused in the observer's eye. Compare with color analysis.

color temperature A scale for rating the color quality of illumination. The color temperature of illumination being calibrated is the actual temperature in degress Kelvin (K) of a "blackbody" heated to a temperature that produces a *visual* color match. That two sources have the same color temperature by no means implies that they are equivalent photographically or physically.

color mixture curves

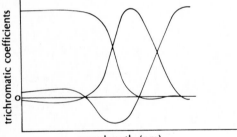
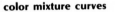

trichromatic coefficients

wavelength (nm)

color temperature meter A photoelectric instrument that compares the relative light levels (illuminances) in two or three spectral regions, typically red and blue. For a standard (blackbody) light source, the meter provides an estimation of the temperature of the source. Some meters have a scale to indicate the filtration (in terms of mired shift values) required for the standard types of color films.

color triangle A systematic representation of hue and chroma relationships of light in which the additive primary red, green, and blue hues are positioned at the points of a triangle and the respective complementary cyan, magenta, and yellow hues are positioned on the opposite sides. White is represented in the center of the triangle. Syn.: Maxwell triangle.

color vision The attribute of the sense of sight that enables detection of differences in light associated with variation in wavelength composition, a function of the cones in the retina. Defective color vision is known as anomalous color vision or color blindness (which see).

color wheel A circular or cylindrical filter holder that rotates to bring different filters into position (e.g., in the optical system of a projection printer, or in front of a spotlight) for the purpose of altering the quality of the illumination. Syn.: filter wheel.

COM Computer-output microfilm.

coma A lens aberration whereby parallel oblique rays of light that pass through different zones of the lens come to a focus at different distances behind the lens, producing comet-shaped images of object points.

combat camera A camera that has been especially designed to be used under warlike conditions. Combat cameras usually are rugged, are subdued in appearance, and can be hand-held.

combination plate A photoengraving printing plate containing both line and halftone images.

combination print A composite print made from two or more negatives or transparencies by any of a variety of techniques, including montage, multiple vignettes, sandwiched negatives, and multiple exposures.

combined print A motion-picture film containing picture and soundtrack. Syn.: composite.

comic-strip layout An arrangement of equal-size, rectangular-format photographs (or other images) in one or more straight lines, commonly used for advertisements in periodicals.

Comite Consultatif International de Radio (CCIR) An international organization concerned, among other matters, with television film standards. Commonly referred to, in the United States, as the International Radio Consultative Committee.

COMMAG A code word (derived from *composite magnetic*) used on the leader of motion-picture films that have a magnetic soundtrack added to a picture film. Especially recommended for those films intended for television reproduction on an international exchange basis.

commentary In motion-picture photography, words spoken by a narrator who is normally off-screen, as distinct from the dialog of actors. Syn.: narration; offstage voice.

commercial photography A broad area of specialization of professional photography with an emphasis on making photographs for business, sales, and advertising purposes.

Commission Internationale de l'Eclairage (CIE) An international standards organization concerned with definitions and measurements of light. The less preferred English form is International Commission on illumination (ICI).

common-law copyright The exclusive right, granted by law, to the use of unpublished photographs, literary works, etc., by the persons who created them. Such protection begins automatically upon completion of a work and continues as long as it remains unpublished, providing certain restrictions are not violated.

COMOPT A code word (derived from *composite optical*) used on the leader of motion-picture films that have an optical soundtrack added to a picture film. Especially recommended for those films intended for television reproduction on an international exchange basis.

comparator An instrument for measuring light (photometer, densitometer) whereby the user visually matches the luminance of a variable, calibrated reference field with the luminance of the subject or image area being measured.

compatible composition Arrangement of critical visual elements within the part of a motion-picture (slide, etc.) format that will not be deleted if a lower aspect ratio is imposed for viewing, as, for example, in showing wide-screen motion pictures on television.

compensating Identifying a developer that, in comparison with a conventional developer, tends to be as vigorous in developing low-density areas but less vigorous in developing high-density areas, thereby producing a less contrasty negative without appreciable loss of shadow detail.

competing Applied to a type of dye coupler (a

color triangle

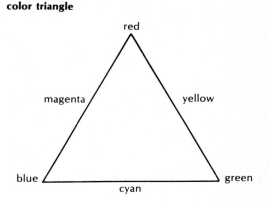

chemical that takes part in the color-forming reaction in some color photographic processes) that during development joins with and thus consumes reaction products. A competing coupler may be present in the developing bath or in the emulsion. The effect of such a process is to adjust or mask colors, and thus to improve color rendition.

competition A contest for photographs (or occasionally papers on photographic topics, etc.) in which the winners receive awards, often honorary.

complementary

complementary (1) Identifying light from two sources that can be mixed by overlapping or otherwise to produce a sensation of white. Examples: blue and yellow, red and cyan. There is an infinite number of complementary pairs. (2) Identifying two colorants (pigments, dyes, etc.) that can be physically mixed to produce a neutral (gray or black). (3) Identifying two colors that lie on opposite sides of a white point in a color map (chromaticity diagram).

complete radiator Applied to a source of radiant energy that produces the maximum output at a given temperature. Syn.: blackbody; full radiator.

composite (1) A photograph on which two or more separate images have been combined by any camera, printing, or post-printing technique. (2) A motion-picture film containing picture and soundtrack. Syn.: combined print. (3) In photomechanical reproduction, a plate that contains both halftone and line images.

composition (1) The arrangement of visual elements in a photograph or other image with respect to effectiveness of the whole image. Authorities disagree on the value of formalized rules of composition, in contrast to a subjective approach. (2) Typesetting. More specifically identified as photocomposition when the process involves photography by exposing sensitive material from a negative of type characters or other symbols.

compound A pure chemical substance composed of two or more elements, e.g., silver bromide.

compound move In animation photography, a position change that requires manipulation of more than one of the controls on the compound table, as in making a diagonal pan, which typically requires manipulation of both the vertical and the horizontal controls.

compound shutter A between-the-lens type of shutter that opens from the center outward by means of overlapping blades.

compound table A precision device designed to hold cells and other objects while they are photographed for an animated motion picture. Various features to facilitate the work are often included,

such as register pegs, light sources, and a mechanism for controlled movement of the subject.

comprehensive An advanced-stage layout that approximates the finished product but is subject to refinement, typically used for presentation purposes.

compression (1) A perspective effect whereby a subject dimension appears unrealistically small, usually the result of a long-focal-length lens on a camera placed at a relatively large distance from the subject, or viewing an image at a shorter than normal distance. (2) An actual decrease in an image dimension, as is produced by an anamorphic lens on a camera. (3) Compression of tones: the representation of a large range of subject luminances by a relatively short range of image densities in negatives, prints or transparencies.

computer enhancement A process for modifying photographic images, e.g., eliminating defects and increasing density and color differences, by converting picture elements into digital numbers that are systematically modified and converted back into picture elements.

computer-output microfilm (COM) A reproduction on 35mm or smaller film of an image (an array of numbers, for example) displayed on the cathode-ray tube of a computer.

computer processing A general term for data analysis, as of information obtained from a photograph, using high-speed calculators. Computer processing can be used, for example, to make diagnoses from x-ray medical photographs.

concave Identifying lens surfaces that curve inward (like the inside surface of a hollow sphere), as distinguished from plane and convex surfaces.

concentrated Applied to a solution that contains relatively large amounts of dissolved ingredients and is normally diluted before using. Concentrated processing solutions are also known as stock solutions.

condensation The conversion of a vapor to a liquid, e.g., the formation of small drops of water on a lens surface that is colder than the surrounding atmosphere.

condenser (electrical) A device consisting basically of two conducting surfaces separated by a nonconducting material used in electronic-flash circuits and some flash circuits for the purpose of accumulating and storing electricity. Syn.: capacitor.

condenser (optical) A lens or lens system used to change the direction of light for illumination purposes. In projectors and projection printers, the condenser lens concentrates the light at the projector lens to increase the illuminance of the projected image. In studio spotlights, the condenser

concave

serves to increase the illuminance, control the distribution of light on the subject, and increase shadow sharpness.

condenser enlarger A projection printer that uses specular light, as distinguished from diffusion enlargers that use scattered light.

conditional match For two colored samples, similar visual appearance only in specific circumstances, especially with respect to the quality (color, spectral distribution) of the prevailing light source. Syn.: metameric (pair).

cone (1) One of two basic types of light receptors in the retina, the other being rod. Each cone contains one of three different photopigments, the basis for trichromatic vision. (2) In aerial photography, an enclosure that connects the lens and camera body. Since aerial cameras are usually fixed-focus, cones are typically made of metal or other rigid material.

conference A meeting, usually of an educational nature, concerning one or more specified photographic topics, using any of various formats such as the presentation of papers or lectures, panel discussions, demonstrations, and tours.

conform To match one film to another, such as an original to a work print, or soundtrack to picture.

conjugate Applied to corresponding pairs of object and image distances to denote their interdependence and interchangeability. In the lens formula, 1/focal length = 1/object distance + 1/image distance; values for object distance and image distance can be interchanged.

console Any of various desk-like structures that contain the centralized controls for operations such as the production of television programs, sound recording, and motion-picture editing.

constancy Any of various phenomena whereby a person's perception of some aspect of a scene or object, such as brightness, color, or size, remains unchanged or resists change despite changes in the corresponding stimulus. Also see brightness constancy, color constancy, shape constancy, and size constancy.

constant agitation In chemical processing, uninterrupted action intended to cause a continuing flow of processing solution with respect to the photographic material, as distinct from intermittent agitation, where periods of action and inaction are alternated. Constant agitation is commonly recommended for tray processing of sheet film, whereas intermittent agitation is normally used for tank processing.

constant-speed Identifying a motor (on a motion-picture camera, for example) that operates at a fixed number of revolutions per minute, as distinct from a variable-speed motor.

constructive interference The combination of two waves of nearly the same wavelength such that the observed energy is greater than the sum of the energy content of the two waves.

contact paper Sensitized paper with a low speed suitable for use with other than projection printers. Higher-speed materials are used for projection printing, to avoid excessively long exposure times with the weaker illumination.

contact print A 1:1-scale photographic reproduction made with the sensitized material pressed against the image being reproduced during exposure. Compare with projection print.

contact printer (1) An exposing device containing a light source, a transparent or translucent support, and a platen to press the sensitized material (typically paper) against the material that is being reproduced (typically a negative) and the support, used to make 1:1-scale photographic reproductions. Refinements include a safelight, diffuser, border mask, dodging facility, switch, and automatic timer. (2) In motion-picture photography, an exposing device used in reproducing processed film on raw stock, in which the two films are pressed together, emulsion to emulsion, during exposure. In a step printer, the films move intermittently and each frame is exposed while the films are stationary. In a continuous printer, exposure is made as the films move at a constant rate.

contact screen In some photomechanical reproduction processes, a flexible, transparent base supporting a uniform pattern of small, unsharp dots used to convert continuous-tone images into halftone images.

contaminate To introduce an impurity. A developing solution would be contaminated, for example, by allowing drops of fixing solution to fall into it.

contingency In motion-picture production, a fund in the budget to allow for unforeseen events, such as unsuitable weather for location shooting.

continuity A quality of the scenes of a motion picture, the photographs of a picture series, etc., that tends to combine the individual parts into a unified whole. Used in reference to both the total effect and to factors such as lighting, action, mood, props, photographic quality, and written or spoken material accompanying the photographs.

continuous (1) Applied to cameras, processors, viewers, and printers in which film or paper moves at a constant rate without interruption, as opposed to the stop-and-go movement employed in conventional motion-picture cameras and projectors and in some

conjugate

constancy

contour grip

contrast filter

red light

green light

red contrast filter

contrast grades

contrast index

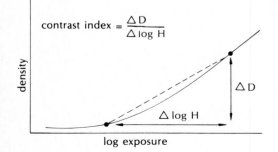

$$\text{contrast index} = \frac{\Delta D}{\Delta \log H}$$

density

ΔD

Δ log H

log exposure

automatic processors. (2) As applied to a spectrum, containing all possible wavelengths, characteristic of solid and liquid sources of radiation. Examples are tungsten and fluorescent lamps. Compare with discontinuous spectra, characteristic of vapor sources in which some wavelengths are absent.

continuous action In animation photography, photographing a moving subject with a running camera, as distinct from simulating motion with single-frame photographs of a sequence of still drawings or stationary objects.

continuous projector (1) A type of motion-picture projector designed to accommodate a film loop so that the film may be shown repeatedly without interruption. (2) A type of automatic slide projector designed to show a set of slides repeatedly through the use of a circular slide tray.

continuous tone Applied to an original or to an image in which there is a smooth gradation from light to dark, as distinct from line and halftone.

contour film A photographic copying material containing both positive and negative image-producing emulsions, designed to produce lines or areas of equal density from a continuous-tone positive or negative original. The effect is controlled with variations in exposure and filtration. Used for both pictorial and scientific purposes where it is desirable to compress some tonal differences and to expand others, as for the enhancement of Schlieren patterns. Syn.: equidensity film.

contour grip A handle for a camera, etc., designed to fit the operator's hand.

contrast (1) (noun) The actual (objective) or the perceived (subjective) variation between two or more parts of an object or image with respect to any of various attributes such as luminance, color, or size. Subjective contrast is commonly described in general or relative terms (e.g., high contrast, lower-than-normal contrast). Examples of objective contrast: (a) as applied to a scene, the ratio of highlight to shadow luminance (e.g., 160 to 1, or a log interval of about 2.2); (b) as applied to a photographic negative material, the maximum possible gamma, or contrast index; (c) as applied to a specific negative, the density difference between highlight and shadow areas (e.g., 1.0 - 0.3 = 0.7); (d) as applied to photographic paper material, contrast is inversely related to exposure scale, and very roughly related to paper-grade number; e.g., a zero-grade paper has a large exposure scale (1.70) and a 5-grade paper has a small exposure scale (0.70). (2) (adj) Applied to a type of continuity for a motion picture, filmstrip, picture series, etc., in which comparisons are made between two different subjects or the same subject at different times, e.g., a house before and after being remodeled. Syn.: parallel.

contrast filter Strongly colored transparent material that effectively absorbs red, green, blue, cyan, magenta, or yellow light. Commonly used in a camera optical system to lighten or darken selected subject colors in black-and-white photographs.

contrast grades Numbers applied to photographic printing papers as an indication (in inverse order) of their exposure scales (scale indexes). The numbers are consecutive integers, with 0 representing a high exposure scale (about 1.70) and 5 representing a low exposure scale (about 0.70). The hypothetically correct contrast grade of paper for a given negative can be selected by relating the density scale of the negative to the paper exposure scales.

contrast index (CI) The slope of a straight line connecting two points on the D-log H (D-log E) curve for a film. The points represent the maximum and minimum densities normally used to make high-quality negatives. Contrast index differs from gamma in that it is influenced by the shape of the toe portion of the curve, whereas gamma is the slope of the straight-line portion of the curve.

contrast-index curve A plot of the contrast index — average slope of the D-log H (D-log E) curve over the most-used portion — versus time of development. Syn.: time-contrast-index curve (preferred term).

contrast-index meter A transparent template that, when positioned on a D-log H (D-log E) curve, enables the user to determine the contrast index directly from two calibrated scales.

contrasty Applied to a scene or image in which tonal differences are perceived as being greater than normal. Also applied to factors contributing to such an effect, e.g., lighting, film, paper. Images identified as being "contrasty", however, commonly have *smaller* than normal tonal differences in certain areas; e.g., highlight areas and shadow areas on "contrasty" prints frequently have little or no gradation or detail so that, actually, only the middle tones are contrasty.

contre-jour Against-the-light; ie., subject illumination that originates from a position generally opposite the position of the camera, as distinguished from front lighting and side lighting. Syn.: back lighting; against-the-light.

contrived Said of a photograph that appears obviously arranged or otherwise manipulated, as distinct from a documentary or other natural-appearing photograph.

control In photogrammetry, a reference system,

such as a network of points with established coordinates, used in positioning or manipulating images, determining distances, etc.

control chart A graphical display of the performance of a process, usually in relation to time. Such charts are useful in detecting unusual process performance.

controlled-flash In halftone negative making, identifying a supplementary exposure made with non-image-forming light with the halftone screen in position. Used to form pinpoint dots in the darkest shadow areas, since the main exposure will not reproduce the entire range of tones in most photographs. The effect of the controlled-flash exposure is to lower image contrast. Compare with bump exposure, which increases contrast. Syn.: flash (4).

control room A soundproof enclosed area adjacent to a motion-picture or television studio, usually equipped with a connecting glass window, used for monitoring and recording sound, and other production activities. Television control rooms enable the director, engineers, etc., to communicate without danger of having their voices picked up by the studio microphones.

control strip A sample of photographic material, often exposed in a sensitometer, which after processing is examined to detect abnormal effects of the processing method.

convention (1) A meeting, usually scheduled once a year, for the members of a photographic society or other organization. The program typically includes educational, business, and social events. (2) An established, customary way of doing things. Example: to plot a characteristic curve with the log exposure values on the horizontal axis and the density values on the vertical axis.

convergence angle In depth perception, the angle formed between lines from an object point being examined and each eye. As the object moves closer to the observer, the angle increases. Also, the angle formed between the axes of a pair of lenses in a stereo camera or other stereo device.

converging lens A lens that bends entering parallel rays of light toward each other. Syn.: positive lens.

converging lines A perspective effect whereby parallel subject lines are represented by nonparallel lines in the image. The effect can be altered by tilting or swinging the back on cameras having such adjustments, or by tilting the easel when making a projection print.

conversion coating In photofabrication, a surface formed on (especially) metals by dipping in, for example, a weak acid; the presence of this surface improves the etching characteristics.

conversion filter An optical filter designed to alter the color temperature of light to correspond to that recommended for a color film; e.g., orange conversion filters are used when exposing tungsten-type color films by daylight.

converter A supplementary attachment for camera lenses which changes the effective focal length without a corresponding change in back focal distance. Syn.: afocal lens.

convertible lens A lens containing two or more elements or components that can be used separately or in combination to produce different focal lengths. See varifocal. Distinguish from zoom lenses, which change focal length by other means. Syn.: separable lens.

convex Identifying lens surfaces that curve outward (like the outside surface of a sphere) to distinguish them from plane and concave surfaces.

convolution In linear-system theory, the multiplication of one function by another. For example, an optical image is formed as the product of two functions, one being the light variation reaching the lens, the other the optical spread function of the lens.

cookaloris A piece of opaque or translucent material used in front of a light source for the purpose of creating a design of light and shade on a background or other surface. Syn.: cukaloris; cookie.

cookie Slang for cookaloris (cukaloris), which see.

cool (1) Applied to any color with a predominantly blue, cyan, or green hue. (2) Applied to white light having a relatively high color temperature, e.g., daylight, in comparison with tungsten light. (3) Applied to the color balance of an image that deviates from normal in the blue, cyan, or green direction.

copy (1) A photograph, document, or other two-dimensional image. (2) The act of reproducing a two-dimensional image. (3) A reproduction of a two-dimensional image. Syn.: duplicate; reproduction.

copyboard A device for holding two-dimensional material that is to be reproduced photographically. Syn.: copyholder.

copy-dot Identifying a photomechanical reproduction of a halftone image using high-contrast film and no screen.

copy lens A camera lens specifically designed to produce high-quality images at moderate and small object distances. Copy lenses designed for use in photomechanical reproduction (typically apochromatic and corrected to focus on a flat field) are known as process lenses.

copyright The exclusive right, granted by law, to the production, control and disposal of copies of photographs, etc. Also see common-law copyright.

control chart

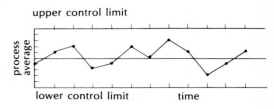

converging lens

converging lens

diverging lens

converter

f_1

f_2

convex

cord off To place strings in the perforations of a motion-picture film to indicate the part of a roll that is to be printed.

core (1) A cylinder around which motion-picture film or other flexible material is wound by the manufacturer. Such devices typically have a hole through the center to permit rotation while being supported by a spindle or mandrel. Cores do not have flanges as do reels and spools. (2) "White-core" and "black-core" identify the two complementary traveling mattes used to achieve special effects in motion-picture printing. A white-core matte has a clear center and a dark surround, while a a black-core matte has a dark center and a clear surround.

cornea The normally transparent membrane which covers the front of the human eye.

cornerer A cutting device used to produce rounded corners on photographs, album pages, printing stock, etc.

corona An electrical discharge at the surface of a conductor or between two conductors in the same line, used to produce light-sensitive charges on plates in electrostatic reproduction processes.

corporate photography The specialization of making photographs for use by a manufacturing or similar organization. Although sometimes equated with industrial photography, the term corporate photography suggests a greater emphasis on esthetic factors and less emphasis on informational factors.

correction (1) Identifying a type of filter used on cameras to obtain more realistic tonal representations of subject colors in black-and-white photography. Yellow filters are used for daylight illumination and green for tungsten. (2) The use of camera movements (swings, tilts, rising fronts, etc.) to eliminate unwanted perspective effects, such as convergence, or to improve image sharpness by altering the angle of the plane of sharp focus.

cosine-corrected Identifying a light meter designed to respond to changes in the angle of the incident light as specified by the cosine law of illumination, i.e., in proportion to the trigonometric cosine of the angle between the light path and a perpendicular to the surface.

cosine-fourth law (cos⁴) The illuminance on the film plane is decreased with the angle that the light ray makes with the perpendicular to the surface, in proportion to the cosine of the angle raised to the fourth power. At 45°, for example, the cosine is about 0.7, and the illuminance is only about 24% (0.7 x 0.7 x 0.7 x 0.7) of the illuminance at the center of the film.

cosine law of illumination The measured illuminance varies with the angle of the receiving surface (receptor) in proportion to the trigonometric cosine of the angle between the light path and a perpendicular to the surface. Light meters that so respond are called cosine-corrected.

cost-plus A pricing system in which appropriate expenses are added to the established price on a bill. A photographer's day rate, for example, may include only his labor, with the understanding that the client will be billed for additional expenses such as model fees, prop rentals, and travel.

coulomb A unit of quantity of electricty; the amount transferred in one second by a current of one ampere. Used, for example, to measure the storage capacity of condensers for electronic-flash lamps.

Cotton-Mouton Identifying the effect whereby the application of a magnetic field alters the light transmitting characteristics of a material from isotropic to doubly refracting.

counter A device that indicates the number of frames or feet of film which have been exposed or which remain to be exposed, or otherwise registers units in any of various photographic operations. Syn.: dial.

coupled meter A built-in exposure (light) meter that modifies (or allows the photographer to modify by matching needles, etc.) the lens aperture or exposure time to compensate for variations in illuminance at the meter cell. With motion-picture cameras, the adjustment is always made with the aperture.

coupled rangefinder An optical device for measuring distance, connected to a camera focusing mechanism in such a way that objects at the distance being measured are in critical focus when the double or split image in the rangefinder is brought into register.

coupler A substance that, when added to an emulsion or developing bath, will react with by-products of development to form another substance with different color characteristics. Colorless couplers are used to form colored dyes in integral-tripack color-film and color-paper materials. Some color-masking processes utilize colored couplers that can be converted into colorless or differently colored substances.

courtesy line The source of a photograph or other image printed under the reproduction in a publication, typically preceded by "courtesy of." See credit.

cover In photojournalism, identifying the front surface of a magazine (etc.), which typically includes the name of the publication and a photograph or

other image intended to attract readers. Such cover photographs are usually noncommercial, in contrast to those used on the second (inside front), third (inside back), and fourth (outside back) covers.

coverage (1) The completeness of the photographic documentation or representation of a subject or event. (2) The photographs and the story thereby produced.

cover girl Identifying a female model, photographs of whom have appeared on the front covers of a number of magazines.

covering power (1) (optical) The extent to which a lens is capable of forming a usable image off the lens axis, expressed variously as the maximum film size that can be used with the lens, the diameter of the circle of good definition, or the angle of coverage (which see). (2) (sensitometric) The ratio of the optical density of an image area to the mass of silver (or dye, etc.) per unit area of the processed image. The reciprocal of the photometric equivalent.

cover shot (1) In motion-picture photography, an extra take used for insurance purposes in case the original take is unsatisfactory. The cover shot may be either a near duplicate of the original take or a more distant view that would make minor imperfections in the action less noticeable. (2) A still photograph printed on the cover of a publication.

CP Candlepower.

crab (1) In aerial photography, a condition caused by failure to align the camera with the flight line, resulting in sideways displacement of adjacent photographs in a sequence. (2) In motion-picture photography, a sideways movement of a maneuverable rolling camera support (a crab dolly).

crab dolly A rolling platform on which all wheels can be steered to provide the operator with great maneuverability. Used to support and move motion-picture and television cameras during shooting.

craftsmanship Skill in the production of photographs, etc., especially with respect to basic factors such as camera operation, lighting, exposure, development, printing, and mounting.

crane A rolling platform with a boom that supports one or more cameras and cameramen, used in motion-picture photography and television to provide vertical and horizontal control of the camera position.

crawl A motion-picture title that moves slowly upward on the screen, used when the copy will not all fit within the screen area in a legible size. Syn.: creep; roller title.

creative Identifying a photograph, technique, etc., that represents a unique rational reorganization of familiar elements about a more powerful concept; i.e., identifying the product of functional originality. Assumed requirements for the production of creative effects are a wide range of experience and attitudes of alertness, curiosity, and flexibility.

credit (1) The name of the photographer, photographic agency, or other source printed adjacent to the reproduction of a photograph in a publication. Syn.: credit line. See courtesy line. (2) In motion-picture photography, printed acknowledgment in the film of those responsible for various aspects of the production.

creep (1) A gradual change in the relative position of a strip of material such as film or magnetic tape, due to a dimensional change or slippage. Creep is of special concern when it affects synchronism of sound and picture records. (2) See crawl.

crew The group of persons actively involved in the production of a motion-picture film, excluding actors and supervisory personnel; sometimes further specified as camera crew, lighting crew, etc.

crime photography The specialization of making photographs for the purpose of assisting the police or other law-enforcement agents in their work. Syn.: police photography; forensic photography; law enforcement photography; legal photography.

crimp Identifying a mark on photographic film produced by bending the film before development. The mark typically has a crescent shape, and may be either denser or lighter than the sorrounding area. Syn.: kink (mark).

critical angle When light approaches a medium of lesser optical density, the angle of incidence beyond which it cannot escape from the first medium. If the surface is optically excellent, the reflectance is practically 100%. The phenomenon is used in reflecting prisms and in fiber optics.

critical duration In visual perception, the maximum time period over which time and intensity of a pulse of light are reciprocally related. Also see Bloch's law.

critical focus The position at which the image of an object point formed by a lens is sharpest.

critical fusion frequency (CFF) The minimum number of fluctuations per second in luminance that will be perceived by a viewer as continuous rather than flickering. The actual value depends upon the luminance and other factors. An important concept in motion-picture photography.

critique An evaluation of a photograph by a person or group purporting to be authoritative. A criticism.

crocein scarlet A red dye used in solution form in negative retouching to absorb actinic light in printing, producing effects similar to those obtained by

covering power

cropping L

curvature of field

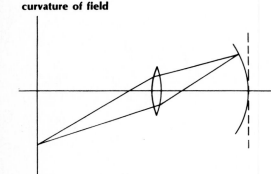

curvilinear distortion

dodging. The amount of dye deposited on the negative can be controlled by varying the concentration of the dye solution or the number of applications. Syn.: new coccine; neococcine.

crop To alter the boundaries of an image. Variously applied to limiting the area of a scene included by a camera, the area of a negative or transparency included on a print, the trimming or masking of a finished print or transparency, and the reproduction in a publication of a selected part of a photograph.

crop mark A line drawn on a photograph to indicate the boundary of the area that is to be used, e.g., when reproduced photomechanically. A grease pencil is commonly used to permit removal of the line without damage to the photograph.

cropping L A piece of cardboard or other thin material in the shape of a right angle. The size and shape of the opening formed by overlapping two such devices can easily be altered to select the most desirable area on a photograph.

crosscut (or **crosscutting**) A motion-picture editing technique whereby portions of two different scenes are presented alternately. Often used to build dramatic suspense.

cross dissolve (X-diss) In motion-picture photography, a gradual transition between scenes with one fading out and the other simultaneously fading in. Syn.: dissolve.

cross lighting Illuminating a subject from the side, as distinct from front lighting and back lighting.

crowfoot A three-pronged device used to hold tripod legs in place on slippery surfaces.

crown One of numerous types of glass used in manufacturing lenses, characterized by a relatively low index of refraction and dispersive power (high v-value).

CRT Cathode-ray tube.

crystal In motion-picture photography, identifying a sync system (or a motor or other component) that maintains synchronism between picture and sound with a radio signal of constant frequency produced by a crystal oscillator. A major advantage of crystal sync is the elimination of wires between the camera and the sound-recording unit.

crystal defects Abnormalities in the otherwise regular array of atoms (ions, etc.) in a crystal. In silver halide crystals, the defects are thought to play a role in the sensitivity of the crystal to radiation.

crystalline lens In the human eye, the part of the image-forming system that changes shape to keep images of objects at varying distances in focus on the retina. Although the crystalline lens is commonly credited with forming the image, the largest change in the direction of light takes place at the front surface of the cornea, the transparent membrane which covers the front of the eye.

CU Closeup.

cubic centimeter (cc, cm³) A metric unit of volume equal to a cube 1 centimeter on each edge. Approximately, but not exactly, equal to 1 milliliter (1/1000 of a liter). Milliliter is the preferred unit for volume measurements.

cue A signal that indicates the correct time to begin an activity. The concluding line of dialog for one motion-picture actor, for example, serves as a signal for another actor to begin his lines.

cue card A sheet of paper on a board on which are written lines for an actor to speak.

cue-down A series of markers placed on a motion-picture film to assist the projectionist in making a smooth transition from one reel to the next.

cue sheet A printed form used in motion-picture editing to identify the desired positions for all sound records.

cukaloris A piece of opaque or translucent material used in front of a light source for the purpose of creating a design of light and shade on a background or other surface. Syn.: cookaloris; cookie.

curator The person in charge of a museum or of a part of a museum such as a department of photography.

curie In radiography, a unit of radioactivity, the equivalent of 3.70×10^{10} disintegrations per second.

curl A curved shape (as distinct from flat) in photographic film and paper and other thin materials, caused by nonuniform dimensional changes. Paper prints, for example, tend to curve toward the emulsion side following processing unless pressure is applied during drying.

curtain In a focal-plane shutter, an opaque, flexible strip containing a variable slit (or several slits of varying widths) that passes in front of the film in a camera to control the exposure time.

curvature of field A lens defect in which the image of a subject plane comes to a focus on a curved surface. If a lens with this defect is focused in the center of a camera ground glass or printing easel, the corners will be out of focus, and vice versa.

curvilinear distortion A lens condition that causes straight subject lines to bow inward or outward in the image. See barrel and pincushion.

custom finishing Professional-quality processing and printing by a laboratory, usually including modifications such as forced development, dodging, and

cropping, at the customer's request. Distinguish from photofinishing.

custom lab A still-photography processing laboratory specializing in professional-quality finishing.

cut (1) In motion-picture photography, an abrupt transition from one scene to another. Also called cutaway. (2) To remove unwanted motion-picture film by editing. Also the film so removed. (3) To abruptly stop the operation of a motion-picture camera or projector. (4) Identifying an aperture, 0.868 x 0.631 in., used for 35mm motion-picture photography. Syn.: Academy aperture. See Academy standards. (5) In photomechanical reproduction, a photoengraving printing plate made from a photograph or other image. (6) The edge of the subject area included by a camera. For example, a camera (photograph, shot, etc.) may cut at the knees of the subject.

cutaway (1) In motion-picture photography, an abrupt transition from one scene to another. Also called cut. (2) A closeup that is related to, but is not part of, the preceding scene.

cutback (1) In animation photography, a procedure whereby faulty frames discovered by the photographer are rephotographed following a frame of instructions to the film editor concerning the number of preceding frames to eliminate. (2) In motion-picture photography, an abrupt transition from one scene to another with which the viewer is already familiar.

cut film Sheet film, the preferred term.

cut-in (1) A motion-picture scene inserted into another during editing. (2) A closeup that is part of the preceding scene.

cut line In a layout, the placement of a caption for a photomechanical reproduction of a photograph or other image.

cutoff (1) That part of an image which is not visible as a result of masking in a projector or television system. (2) In sound reproduction, the frequency at which response of the system suddenly decreases.

cutout An image that has been separated from its original surround by trimming, usually in order to combine it with a new surround on a paste-up print, animation film, etc.

cutout mount A method of displaying transparencies and prints, in which a hole with the desired format dimensions is cut in a piece of mount board or other stiff display material, and the photograph is attached behind the opening. See mat.

cutter (1) A device typically consisting of a ruled platform with a sharp blade attached to one edge, used to crop or trim prints, cut mount boards, etc., Syn.: trimmer; trimming board. (2) An oblong opaque or translucent panel, usually mounted on a portable boom stand, used to shade selected areas of the subject to obtain a desired lighting effect or to protect the camera from light that could cause flare or fog. Syn.: flag; gobo. (3) A motion-picture film editor or assistant who matches one film to another, such as an original to a work print.

cutting barrel In editing motion pictures, a large container with an open top used to catch film that is not wound onto a take-up reel. Syn.: film barrel; editing barrel.

cutting copy In motion-picture editing, a film print made for the purpose of being altered by having parts deleted, rearranged, etc., as distinct from the original film, which remains intact. Also called cutting print.

cutting reducer A chemical solution for treating negatives and prints that is supposed to remove equal amounts of silver from all areas. If the treatment succeeds, image contrast is unchanged and, for a negative, only the printing time would change. If a print is made darker than normal, highlight contrast is increased, since highlight tones are moved to the right on the D-log H (D-log E) curve, to a region of greater steepness. A cutting reducer may then be used to lighten the print while retaining the increased highlight contrast. Syn.: subtractive reducer.

cutting room A room provided with equipment for editing motion-picture film.

CW Circle wipe.

cyan (1) A color that can be produced by removing the red component from white light or by mixing blue light and green light. One of the three subtractive primary colors, the other two being magenta and yellow. Cyan also exists as a spectral hue, associated with wavelengths in the region of 485 nm. Syn.: blue-green. (2) As applied to a filter, pigment, dye, etc., red-absorbing. Syn.: minus red.

cyanotype A photographic printing process that uses light-sensitive iron compounds and produces blue and white images. Used largely for making negative copies of line originals. Syn.: blueprint; ferroprussiate.

cycle (1) The maximum segment of a wave (light, electric, sound) before repetition occurs, as from one crest to an adjacent crest. (2) The complete set of steps in a systematic operation such as processing film. (3) In animation photography, a series of drawings arranged so that the first drawing can be used after the last for a continuous repetition of the action as long as needed.

cycle

DD

D (1) Density, the measure of the photographic effect in logarithmic terms. (2) Dissolve, a gradual transition between scenes in a motion picture.

daily A rush motion-picture print made following a shooting session for viewing by the director and others to determine if changes are needed. Syn.: rush.

damp To reduce oscillations in a measuring instrument (the pointer on an exposure meter, for example) by any of various methods, including magnetic, electrical, and physical.

dampen To moisten. In photomechanical reproduction, for example, to apply water to a lithographic plate on an offset press to prevent ink from adhering to nonimage areas.

dance photography The specialization of making photographs of theatrical dancers, e.g., ballet and modern, for publicity, expressive and other purposes.

dark (1) Without light. (2) Without light considered dangerous to photosensitive materials, thus not excluding safelight illumination. (3) The perceived quality of material associated with high absorptance, e.g., a black subject or an excessively dense photograph.

dark adaptation A process by which a person's visual perceptual system adjusts to a low level of illumination, producing an increase in sensitivity. In complete darkness, the maximum adjustment is achieved in approximately an hour. Compare with light adaptation.

dark current In photoelectric meters (for example, densitometers), the reading of the instrument when no light is falling on the receptor. The size of the dark current affects the usefulness of the instrument in measuring feeble light levels.

dark decay In electrophotography, a decrease in sensitivity before exposure, or an image loss between exposure and development.

dark-field In photomicrography, applied to an illumination system used with transparent subjects whereby the angle at which the subject is back-illuminated is controlled so that only light refracted or reflected by the subject enters the microscope, thus producing a light image against a contrasting (dark) background.

darkline (1) Designation for a style of glassware lighting in which the edges of the object appear darker than the background. (2) In microfilming, identifying a positive image in which black type on the original, for example, is represented with a heavy density on the film.

darkness (1) The absence of light. The term total darkness is sometimes used to emphasize the danger of exposing certain photographic materials even to extremely low-intensity white light or to safelight illumination. (2) That aspect of color which applies to reflecting surfaces and which relates the appearance of such a surface to a scale of grays. Blacks are grays of high darkness and whites are grays of low darkness. (3) The converse of lightness. Technically, 100 minus lightness.

darkprint Identifying a wet process for making blueprints by contact printing on an iron-sensitized paper. Since it is a nonreversal process, dark areas on the original are light on the reproduction, and vice versa.

darkroom A room in which the illumination can be controlled or eliminated for the safe handling or processing of photographic materials.

darkroom camera A process camera installed so that its back end projects into a darkroom through a sealed opening in a wall, making it possible to place film in the camera without first loading it into a light-tight holder.

dark adaptation

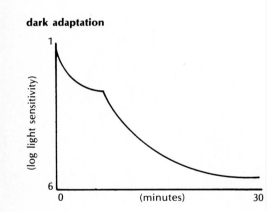

dark slide An opaque panel which seals a film holder to light but which can be removed after the holder has been attached to a camera, thereby allowing the film to be exposed.

dark stability The degree to which photographic materials remain chemically and physically stable when stored in total darkness.

data (plural of datum) Factual information. Example of exposure data: 1/200 second at f/22.

dated (1) The year and month after which aging effects on a photographic product may be significant. Commonly stamped on packages of film and paper to serve as a warning to the user. Syn.: expiration date, the preferred term. (2) Applied to photographic materials for which the expiration date marked on the package has passed. Syn.: outdated; out-of-date.

datum A single item of factual information, as distinct from data, the plural form.

Davis-Gibson filters A series of formulations of stable chemicals in water solution, used to obtain near-equivalents to various forms of daylight from tungsten lamps.

dawn (1) An outdoor lighting condition that exists between the first evidence of daylight and sunrise. (2) Identifying a photograph made under such lighting conditions.

day-for-night In motion-picture photography, the use of a filter and/or a reduction in exposure to make it appear that a scene photographed in daylight occurred in darkness.

daylight The combined illumination from the sun and sky. The color quality, intensity, and contrast vary with numerous factors, including latitude, atmospheric condition, season, and time of day. The color temperature of the combination of sunlight and clear skylight that is considered typical for photographic purposes (i.e., photographic daylight) is 5500 K.

daylight-loading (1) Applied to a device designed for the safe insertion of sensitized material into a camera, processor, printer, etc., in white light. (2) Applied to sensitized material that has been provided with an opaque leader, paper backing, or other protection against white light while it is being inserted into equipment.

daylight speed A film-speed number intended for exposure outdoors of a film that has significantly different speeds with daylight illumination and with tungsten illumination.

day rate A pricing arrangement whereby a photographer agrees to make as many photographs during a working day as the client requests, for a fixed price plus expenses.

dB Decibel, a measure of change of sound intensity.

dc Direct current.

dead Identifying an electrical circuit, or a microphone or other electrical device, that is not functioning because of a lack of electricity.

deadline The latest time established for the completion or delivery of something, e.g., a photograph for reproduction in a newspaper.

dead room An enclosed area designed to absorb a relatively high proportion of sound, used for sound-recording purposes.

dead sync (synchronization) Alignment of the separate picture and sound components of a motion picture so that corresponding points coincide, as distinct from projection sync, in which the sound is ahead of the corresponding picture. Syn.: editorial sync; level sync.

deanamorphoser An optical device designed to restore normal proportions to an image that has been compressed along one dimension, especially a projector lens for an anamorphic motion picture.

deca- As applied to the metric system, a prefix signifying a value 10 times that of the base unit, e.g., decaliter. One decaliter = 10 liters. Compare with deci-.

decamired Mired value of a filter or light source divided by 10. See mired.

decamired filters Color-temperature filters in a graduated series calibrated according to a decamired scale.

decentration In optics, the displacement of the axis of a lens element from the axis of the system. Such displacement results in image degradation.

deci- As applied to the metric system, a prefix signifying one tenth part of a base unit, e.g., decigram. One decigram = 1/10 gram. Compare with deca-.

decibel (dB) A measure of change in sound intensity and, by extension, of other forms of energy, including radiant energy. The number of decibels is 10 times the common logarithm of the ratio of the power in two cases. Thus, if the change in power is 2, the common logarithm of 2 is about 0.3, and the number of decibels change is 0.3 x 10, or 3. The decibel scale has no natural zero because of its logarithmic character.

deckle Identifying an untrimmed irregular edge produced during manufacture, or an irregular edge produced intentionally by ripping paper or by trimming it with a specially designed mechanical device.

decomposition The process by which a substance is

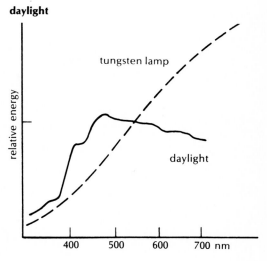

daylight

tungsten lamp

daylight

relative energy

400 500 600 700 nm

broken into two or more other substances. The formation of a latent image, for example, may involve the decomposition of silver bromide into silver and bromine.

decorative Identifying a photograph, etc., displayed for the purpose of enhancing the appearance of a room or other area.

decrement A decrease in a numerical value, the converse of increment.

deep-etch plate A lithographic printing plate constructed so that a slight relief image can be formed by chemically removing some of the surface material, thereby increasing the press life.

defective As applied to color vision, any of various abnormal physiological conditions including monochromatism, dichromatism, and anomalous trichromatism.

definition The clarity of detail of an image as perceived by the viewer. Applied both to images formed by lenses and to photographic images, although the term "photographic definition" is preferred for the latter.

defocus To intentionally reduce the sharpness of an image by altering the image distance and/or object distance for any of various purposes; for example, to obtain an abstract design from bright lights photographed at night, or to obtain a diffused effect in making an enlarged print from a portrait negative. In motion-picture photography, the unsharp image is used as a transitional effect, either alone or in combination with a dissolve or other effect.

deformation In thermoplastic recording, fine ripples on the surface of a plastic layer that scatter light, thereby making images composed of such ripples visible with an appropriate illumination system.

deformed Applied to a condition that occurs in capacitors (e.g., in electronic-flash units) when they are not used for extended periods, whereby they temporarily lose some of their ability to accept and to hold an electrical charge. A deformed capacitor can be restored to normal by alternately charging and discharging it a few times.

degausser A device used to demagnetize magnetic tape, thereby removing audio and video recordings.

degrade To lower quality. Dirt on a camera lens, for example, tends to degrade images formed by the lens.

degree (1) A unit in a scale; e.g., on the Celsius scale, 1/100 the difference in temperatures of the freezing point and the boiling point of water. (2) In photographic and other education, a title conferred by an institution of higher education upon completion of a program of study. Examples: AAS (associate in applied science), BFA (bachelor of fine arts), MS (master of science).

dehumidify To remove moisture from air or other gas, for example by cooling the air to produce condensation or by using a chemical, such as calcium chloride, that has a strong affinity for water. Excessive humidity can have an adverse effect on the keeping qualities and the physical properties of photographic materials.

deionize To purify water by removing unwanted metallic and nonmetallic ions. Water so treated is commonly used as a substitute for distilled water in the preparation of photographic solutions.

delayed action A device that produces a lapse of several seconds between initiating the release of a shutter and the actual exposure, thereby permitting the photographer to enter the scene of a photograph. Such devices may be either built-in or detachable, and the delay is adjustable on some units. Syn.: self-timer.

deliquescent Applied to a chemical that dissolves in water it has absorbed from the air. Calcium chloride, often used in dehumidifiers, is an example.

demo Abbreviation of demonstration.

demonstration (1) A presentation on the use of equipment, the execution of a process, etc., for the purpose of instructing (and sometimes entertaining) others. (2) A short film or sound recording used as a sample of a complete or a proposed production.

dense (1) Applied to a photographic image or area that is darker than is consider normal. (2) Applied to transparent or translucent material that transmits relatively little light.

densitometer An instrument used to measure the light-absorbing ability (density) of a photographic image. Densitometers may be visual (in which case the eye compares the appearance of the sample with that of a calibrated reference) or photoelectric (in which case a photocell measures the light transmitted by or reflected from the sample as compared with that light recorded when no sample is present). Densitometers are often equipped with filters, etc., to measure the density of the sample for selected wavelength bands of radiation. Automatic densitometers provide a graphic display of the data from a sample sensitometric strip.

densitometry A branch of sensitometry concerned with the measurement of density (the light-absorbing capacity of a photographic image) and the interpretation of the resulting data.

density (D) A logarithmic measure of the light-absorbing characteristics of an image, filter, etc. Density is defined as the logarithm of the ratio of the

densitometer

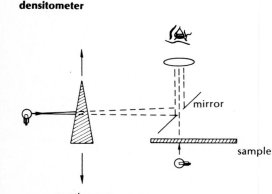

mirror

sample

continuous wedge

light falling on and transmitted by the sample (or reflected by the sample, in the case of prints, etc.). That is, $D = \log I_0/I$ (where I_0 is the light that falls on the sample, and I is the light that is transmitted or reflected). In practice, there are many types of density, depending on the optical system used and on the spectral quality (color) of the light for non-neutral samples. See specular; diffuse; doubly diffuse; analytical density; integral; spectral density; and equivalent neutral density.

density scale A measure of the tonal range of a photographic image, obtained by subtracting the minimum density from the maximum density. For negatives, density scale is the same as total contrast.

dental photography The specialization of making photographs of teeth or related subjects, usually for medical purposes.

dental radiography The specialization of making photographic images of teeth by means of x-rays for medical purposes.

depth The distance in a scene, measured parallel to the direction of view, or the perception of that distance in an image. Various clues can contribute to the illusion of depth in two-dimensional photographs, including converging lines, aerial haze, a shallow depth of field, and overlap of near and far objects.

depth localization In radiography, a method for determining the position of a defect within a material by making two exposures with the source of radiation in different positions and measuring the change in position of the image.

depth of field (DOF) The range of object distances within which objects are imaged with acceptable sharpness. Depth of field varies with numerous factors, including f-number, focal length, object distance, viewing distance, and viewer criterion. A circle having a diameter of 1/100 in. is generally considered to be the largest that will appear as a point on a print viewed at a distance of 10 in., although smaller values are used in calculations for depth-of-field scales, tables, etc., when the viewer is expected to examine the image more critically, and vice versa.

depth of focus The distance the film plane can be moved before the image of an object point appears unsharp as viewed on the photograph at the normal viewing distance. Depth of focus varies with numerous factors, including f-number, focal length, object distance, viewing distance, and viewer criterion, i.e., with the maximum acceptable circle of confusion.

derivation Any of various special effects achieved by abstracting one or more attributes from an original photograph, thereby reducing realism. Example:

making two reproductions from an original color photograph, one abstracting contour lines and the other abstracting colors (but eliminating lightness differences), and then superimposing the two abstractions to form the final image.

dermatitis An abnormal condition, characterized by an inflammation of the skin, that can be caused by contact with some photographic processing chemicals.

dermatological photography The specialization of making photographs of skin for medical purposes.

desaturate To lower the chroma of colors, i.e., to make them less vivid. A high level of ambient light in an auditorium, for example, will desaturate the colors of images projected on a screen.

describing function The equivalent of a modulation transfer function for a nonlinear input-output system such as vision; e.g., a plot of input spatial frequency versus output amplitude.

desensitizer A substance (e.g., a dye) that reduces the ability of a photographic emulsion to respond to radiant energy. A practical desensitizer is one that reduces sensitivity with minimum destruction of the latent image, thereby permitting development of panchromatic emulsions under safelight illumination.

desiccated Applied to chemicals from which all or almost all water has been removed. See anhydrous.

design An intentional arrangement of visual elements (line, color, texture, etc.) in a photograph or other image, with respect to the effectiveness of the whole image.

designer (1) A person who has the responsibility for specified visual elements in a production, such as a layout in advertising, and the costumes or sets in television and motion-picture photography. (2) In animation photography, a person having the responsibility for creating key drawings used by animators to produce the complete set of finished drawings.

desorb To release a substance that has been adsorbed to a solid surface, such as a sensitizing dye on silver halide grains.

destructive Identifying a testing procedure by which the material being tested is rendered useless, as in exposing and processing photographic film to determine the film speed. In manufacturing operations, such testing must be performed on a sampling basis, whereas nondestructive testing (e.g., for image quality of lenses) permits the testing of all items produced.

destructive interference The combination of two waves of nearly the same wavelength such that

density scale

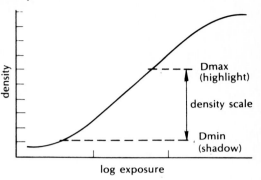

log exposure

depth of field

permissible circle of confusion

depth of field (shallow)

D. Rivera

depth of focus

permissible circle of confusion

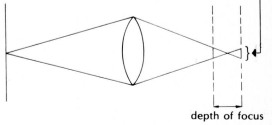

depth of focus

the observed energy is less than the sum of the energy content of the two waves. Destructive interference is observed when the two waves are out of phase, and is the cause of the colors seen in oil films and lens coatings.

detail Relatively small-scale parts of a subject or their reproduction in an image. A high degree of detail reproduction in a portrait, for example, involves the ability of the observer to detect individual hairs in the head, pores in the skin, etc. The reproduction of detail is included in the concept of definition, which also involves edge reproduction. Detail reproduction is a subjective concept closely related to the measure of resolution, an objective concept.

detail exposure In photomechanical reproduction, a white-light camera exposure from the copy to the film through a halftone screen. The detail exposure produces a dot image having a basic tonal range that can be altered with supplementary exposures (bump, flash) to increase or to lower the contrast. Syn.: main exposure; highlight exposure (not to be confused with highlighting exposure).

detail view A photograph or other image that includes only the area of special interest, typically appearing as an enlargement of a part of a more general view.

detection Visual perception such that the subject is aware of the existence of a stimulus; one aspect of visual acuity. Detection does not require any additional information concerning the stimulus as distinct from recognition, resolution, and localization.

detective quantum efficiency A measure of the performance of an actual image detector in comparison with a perfect quantum-limited image dector. Speficially, the ratio of the radiation energy required by the quantum-limited image detector to that required by the actual image detector to obtain a specified detail signal-to-noise ratio.

detectivity The reciprocal of the noise-equivalent power (NEP).

deuce Slang term for a medium-size Fresnel-type spotlight equipped with a 2,000-watt lamp.

deuteranomaly One of three basic types of defective color vision in the anomalous trichromatism category, the other two being protanomaly and tritanomaly. A person with this defect (i.e., a deutan) requires more green in a red-green mixture to match a given yellow than a person with normal color vision requires.

deuteranopia One of four basic types of defective color vision (color blindness) in the dichromatism category, the other three being protanopia, tritan-

opia, and tetartanopia. A person with this defect (i.e., a deuteranope) sees bluish red and green as gray.

Deutsche Industrie Norm (DIN) A standard established by the German counterpart of ANSI; i.e., Deutschen Normenausschuss (DNA).

developer (1) A substance (typically a formulated chemical solution) used to convert a latent image on a photosensitive material into a visible image. (2) In electrophotography, the combined toner and carrier.

developer streaks (1) Generally, nonuniformity within a uniformly exposed region, caused by a flow of developer from adjacent areas of the image. A sign of inadequate agitation. (2) Specifically, regions of higher density in areas of a processed image adjacent to low-density areas. The cause is a supply of stronger (less exhausted) developer than is available to similarly exposed regions that are adjacent to higher-density areas. Contrast with bromide streaks.

developing agent A chemical (e.g., metol, hydroquinone) that reduces exposed silver halide to metallic silver in a shorter time than unexposed silver halide, normally used in a water solution together with other ingredients.

developing-out paper (DOP) Photographic printing paper that must be treated with a chemical agent following exposure to produce a visible image, as distinct from printing-out paper, which produces a visible image upon exposure.

development The process of converting a latent image into a visible one. For conventional (silver halide) materials, the reduction of silver ions to silver by a developing agent that is simultaneously oxidized. In electrophotography, the application of toner particles to the charged surface.

development centers Discrete points on silver halide grains where the conversion of silver halide to metallic silver during processing originates.

development contrast The relationship between the density produced in two or more parts of a photographic image as affected by factors such as developer composition, time and temperature of development, and agitation. Contrast index and gamma are measures of development contrast. Development contrast is distinct from the contrast associated with subject reflectance, lighting, exposure, etc.

development effect In an image, any evidence of nonuniformity in converting the latent image into a visible image. Among the development effects are: adjacency effect, border effect, Eberhard effect, edge effect, fringe effect, interimage effect, and

Kostinsky effect. Syn.: processing effect.

development factor (1) A processing condition that affects the rate of conversion of a latent to a visible image, such as time, temperature, or agitation. (2) A measure of degree of development, such as gamma or contrast index.

deviation (1) In optics, the change in direction of a ray of light in passing from one medium to another. (2) In statistics, the difference between one of a set of values and the mean (average) of the set. Also see standard deviation.

dew point The temperature at and below which moisture from the atmosphere condenses on objects. When removing a package of photographic material from cold storage, it is important to allow sufficient time for the material to warm up above the dew point temperature before opening, to prevent condensation on the contents.

dextrorotary Identifying transparent materials which rotate plane polarized-light in a clockwise direction (as viewed against the light), as distinguished from levorotary materials which rotate it in a counter-clockwise direction.

diagonal (1) In animation photography, an oblique pan, which typically requires use of both the vertical and the horizontal controls on a compound table. (2) The dimension of a rectangular image measured between opposite corners. In a camera, the film diagonal should not be larger than the diameter of the circle of good definition.

dial A device that indicates the number of frames or feet of film which have been exposed or remain to be exposed, or which otherwise registers units in any of various photographic operations. Syn.: counter.

dialog (dialogue) In motion-picture photography, words spoken by the actors, as distinct from a commentary.

dialog track In motion-picture photography, a record of spoken words that later may be mixed with music and other soundtracks for the completed production. Syn.: voice track.

diameter A term used to indicate linear measurement as distinct from area. Thus, a 10-diameter enlargement means that linear dimensions in the subject (negative, etc.) are 10 times as large in the image, whereas subject areas are 100 times as large.

diaphragm One or more opaque plates that obstruct radiation in an optical system except through an opening that normally is centered on the optical axis. A variable diaphragm is typically a set of thin metal blades that may be adjusted to leave a symmetrical aperture of continuously changeable diameter.

diaphragm opening A hole in a plate or other opaque obstruction in an optical system. Although synonymous with "aperture," diaphragm opening is sometimes preferred to avoid confusion with such terms as "effective aperture" and "relative aperture."

diapositive (1) A positive image on a transparent or translucent support, used as an intermediate step in forming the final image. For example, a diapositive is made from an original negative to produce one or more duplicate negatives. Syn.: interpositive. (2) A transparency intended to be viewed or projected by transmitted light.

diathermic Relatively transparent to infrared radiation. Diathermic (cold) mirrors, for example, are used in some projectors to reflect usable light back through the optical system while allowing heat-forming infrared radiation to escape through the mirror. Such mirrors are a type of dichroic mirror.

diazo (1) A class of chemical compounds containing a group of two (di-) nitrogen (azo-) atoms in combination with a hydrocarbon radical. (2) Variously applied to a nonsilver reproduction process that uses photosensitive diazo compounds to form azo dye images, and to material and equipment associated with the process, such as paper, coupler, processor, and final print.

dichroic Basically, two-color. Applied to materials that change color with changes in thickness or dilution, or when viewed alternately by reflected and transmitted light. By extension, changes in invisible radiation are included. For example, dichroic mirrors that reflect light and transmit infrared radiation are used in some projectors to reduce the danger of heat damage to transparencies without reducing the lightness of the projected image. Such mirrors are also known as diathermic mirrors.

dichroic fog The non-image-forming density produced when some of the silver halide in an emulsion is dissolved during the developing process, migrates to a different location, and is subsequently reduced. The resulting silver deposit often appears to change color with changes in viewing conditions.

dichromate process See bichromate process, the popular term.

dichromatism A type of defective color vision (color blindness) whereby additive mixtures of two components, rather than three, are necessary and sufficient to match all colors.

dielectric Insulating material used for electrical purposes , such as the insulation between plates of a capacitor.

difference limen (DL) In visual perception, a stimu-

deviation (1)

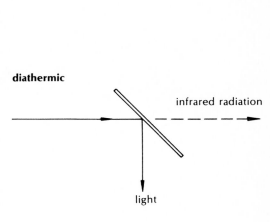

air glass

diathermic

infrared radiation

light

diffuse (3)

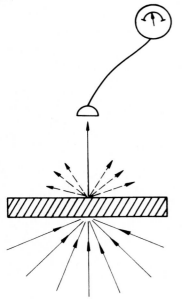

diffusion disk

lus difference that, with a number of attempts, can be discriminated half of the time. Also known as an average just noticeable difference (JND).

differential focus An effect, obtained by altering the image distance and/or object distance, combined with a shallow depth of field, whereby certain parts of the subject appear sharp on the image and others appear unsharp. Used to emphasize part of a scene, to increase the appearance of depth, etc. Syn.: selective focus.

differential hardening An image-forming process in which the solubility of a colloid, such as gelatin, is altered upon exposure to light or during the subsequent processing.

differential re-exposure In processing nonincorporated-coupler reversal color film, the procedure of making all remaining silver halides (after formation of the negative images) developable, one layer at a time, by fogging with light. For example, red light can be used to fog one layer because only one layer is sensitive to red light. After each of two layers has been re-exposed and developed in an appropriate coupler developer, the third layer can be fogged chemically.

diffraction A fundamental property of all wave motions, including light and other electromagnetic radiation, shown in the spreading of the wave after it passes through an aperture or past an edge. Diffraction limits the quality of an optical image, making the image worse as the aperture of the lens, etc., is made smaller beyond a critical point.

diffraction disk The image of a point produced by an ideal diffraction-limited lens, consisting of a relatively bright spot surrounded by alternating light and dark rings. Syn.: Airy disk.

diffraction grating A reflecting or transmitting optical element, containing narrow parallel slits, used to produce spectra in which wavelength is nearly linear with position.

diffraction-limited Applied to a lens so well designed and manufactured that no significant defects (aberrations) remain. The performance of the lens is then determined by diffraction, and the lens will perform best at its maximum aperture.

diffuse (1) Applied to light that has been scattered by reflection from a nonspecular surface or by transmission through translucent material. (2) Describing enlargers or other optical devices that utilize scattered light as distinct from specular light. Popularly, "diffusion enlargers," etc. (3) Denoting density that has been measured by one of two methods: specular (collimated) illumination, with practically all the transmitted light being collected by the receptor; and illumination over nearly a hemisphere, with

only the directly transmitted portion of the light being collected by the receptor. Diffuse density predicts well the performance of a negative in a diffusion enlarger, and is the present standard method for measuring negative density.

diffuse reflection See diffuse (1).

diffusion (1) The process of scattering light. (2) The process by which chemicals enter or leave or move through an emulsion. Diffusion is based on the random movement of molecules or smaller particles and usually involves only very small distances.

diffusion disk An optical device designed to be used in front of a camera or projection-printer lens to scatter a controlled proportion of the image-forming light, to lessen the need for or evidence of retouching or to create a soft-focus visual effect. One such device consists of a circular glass plate containing concentric ridges around a smooth area in the center so that the relative amount of scattering is reduced as the diaphragm is stopped down.

diffusion enlarger A projection printer that uses diffuse light, not specular light. Distinguish from condenser enlargers and point-source enlargers.

diffusion transfer Any of various processes by which image-forming material (silver salt, dye) moves from one surface to another through a thin liquid layer. Such processes may involve the more or less simultaneous production of negative and positive images (sometimes further identified as diffusion-transfer reversal processes) or the production of a single image. Dye transfer, in which dye moves from a relief matrix to a mordanted receiving sheet, is an example of a (non-silver) single-image diffusion-transfer process. Applications of the diffusion-transfer process include the production of rapid-access images on photosensitive materials exposed in a camera, lithographic printing plates, and office copies.

diffusion-transfer reversal (DTR) Any of various processes in which a positive image and a negative image are formed at approximately the same time, involving the movement of image-forming material (e.g., a silver salt) from one surface to another through a thin liquid layer. The following steps exemplify one such process: a negative image is developed in contact with a nonsensitized receiving sheet, undeveloped silver halides are dissolved by a solvent in the developer, and the dissolved silver halides move to the receiving sheet, where they react with a chemical to form a positive image.

digestion In the manufacture of silver halide emulsions, the second heat treatment (following washing), during which the sensitivity increases with relatively little change in grain size. Syn.: after-ripening.

digital Identifying an instrument (e.g., densitometer) or part of an instrument on which data are presented in the form of integers, in contrast to the use of a scale. Since scales typically require interpolation, they tend to produce more user errors.

digital number (DN) An integer that represents a specified difference in log exposure, corresponding to a variation in transmittance in an image. Used in computer enhancement of images.

digitize To assign integers systematically to small areas of an image for purposes of computer enhancement of the image, etc.

dilution (1) The act of adding water to a stock or other solution for use. (2) In adding water to weaken a solution, the volume ratio of stock solution to water, e.g., 1:2.

dimensional stability The ability of film, paper, or other material to remain relatively unchanged in size when subjected to aging, processing, etc.

dimmer An electrical device used to reduce the luminance of light sources for any of various reasons, including improving the effectiveness of the lighting and prolonging the life of the light source. Typically a rheostat, which see.

DIN (1) Deutsche Industrie Norm. A standard established by the German counterpart of ANSI; i.e., Deutschen Normenausschuss (DNA). (2) A method for determining the speed of photographic materials based on a small constant density (0.1) above the base-plus-fog density, and using logarithmic units.

diopter A measure of lens power equal to the reciprocal of the focal length in meters. Plus and minus signs are used to denote positive and negative lenses respectively. A + 2 lens, for example, is a converging (positive) lens with a focal length of ½ meter. To a first approximation, the power of a lens combination is the sum of the powers of the components.

dip and shake agitation A technique for agitating processing solutions used with some roll-film processing machines, in which the machine is programmed to lower the film into the solution and move the film at intervals.

dip and tilt agitation A technique for agitating processing solutions, recommended for tank processing of sheet films, in which the film and hanger are lifted from the solution at intervals and drained for a short time from alternate bottom corners.

diplopia A condition in which two separate images of a single object are seen. With normal vision, convergence of the two eyes causes the two images of a fixated object to merge. Although separate images are still formed of nearer and more distant objects, the viewer is seldom aware of them.

direct current (dc) A continuous flow of electricity in the same direction in a circuit, as contrasted with alternating current, in which the direction of flow reverses periodically. Direct current is often obtained by the use of dry or wet cells and batteries.

direct development The formation of a visible image from a latent image, involving the reduction of silver ions in the silver halide grain to silver by a developing agent which is simultaneously oxidized. Contrast with physical development, in which the silver that forms the image is supplied by the developer. Syn.: chemical development.

direct exposure In radiography, latent image formation with short-wavelength radiation (x-ray, gamma ray) without the use of a fluorescent or other intensifying screen.

direct finder (viewfinder) An optical device built into or attached to a camera to show the subject area that will be recorded on the film as distinguished from a wire-frame finder (which does not contain lenses) and a ground-glass viewing screen.

directional In sound recording, specifying a microphone that picks up sound over only a narrow cone angle. A directional microphone is used, for example, to record bird sounds in the presence of otherwise distracting noises, etc.

directional effect In continuous processing (e.g., of motion-picture film), changes in density due to a decrease in developer activity as related to the orientation of the material. Since the material follows a path through the processor, the lead end receives more development than the tail. The effect occurs on a local basis even when replenishment prevents an overall decrease in developer activity from the beginning to the end of a strip of material.

directional screen A surface used for viewing projected slides, motion pictures, etc., that produces a relatively bright image for viewers located within a moderate angle of the projector axis, but a much less bright image for viewers located at larger angles. Beaded and lenticular screens are examples.

director In motion-picture photography, a person who has the responsibility of supervising the communicative and expressive aspects of a film production, as distinct from a producer, who has more general responsibilities, including those of a business nature.

director of photography (DP) (1) In motion-picture photography, the chief cameraman, who is responsible for the lighting, camera setups, etc. The director of photography may or may not actually operate the camera. (2) In still photography for publications, corporations, institutions, etc., the person responsible for the production and/or use of photographs.

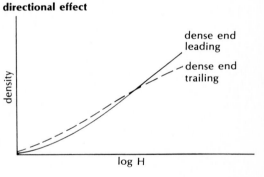

directional effect

dense end leading

dense end trailing

density

log H

dispersion (1)

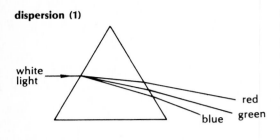

white light — red, green, blue

displacement (1)

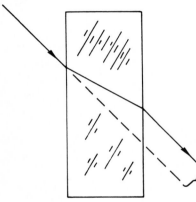

distortion

direct-positive Applied to some photosensitive materials designed to produce a positive image from a positive original, typically by means of reversal processing.

discharge lamp A light source in which light is produced by electricity flowing through a gas in a sealed transparent or translucent container, as distinct from an incandescent lamp (which produces light from a heated filament) and a flash lamp (which produces light from combustion). See fluorescent lamp; electronic flash.

disclosure An animation technique in which the artwork is covered with a black card that is gradually moved to progressively reveal the image. This method is frequently used with high-contrast line images when they are double-exposed over a background.

discontinuous spectrum A display of energy versus wavelength for a light (or other radiation) source that lacks some wavelengths; i.e., for some wavelengths the energy output is zero. Characteristic of vapor sources, such as sodium, neon, low-pressure mercury, etc.

disk shutter A flat rotating plate with an open segment, commonly used in motion-picture cameras to control exposure duration. Rarely used in some still cameras.

dislocations Crystal defects of a type by which some elements of the crystal array are out of their perfectly-ordered position. Of importance in latent-image theory, since crystal defects are believed to affect the sensitivity of silver halide crystals.

disparity In depth perception, the difference between images seen by two eyes or formed by two lenses of a stereo camera, as a result of the difference in viewpoint.

dispersion (1) The separation of light into its component colors, resulting in a spectrum. (2) A suspension of minute particles of a substance in a liquid, solid, or gaseous medium.

dispersive power (ν) The ability of a prism to separate light into its component colors, expressed quantitatively as $\dfrac{n_F - n_C}{n_D - 1}$

where n is the index of refraction and the subscripts F, C, and D idenfity the wavelengths 486.1 nm, 656.3 nm, and 589.6 nm, respectively.

displacement (1) A shift in the path of a ray of light with no change in direction of travel, as when a ray of light passes obliquely through a sheet of glass having parallel sides. (2) Identifying a type of motion-picture-film magazine in which the feed and take-up spools are in line, as distinct from a coaxial

magazine, in which the spools are side by side.

display board A sheet of cardboard having one or two finished surfaces, used for artwork, mounting photographs, etc. Produced in several thicknesses and a variety of colors, including white, black, and gray. The standard size is 40 x 60 in.

diss Abbreviation for dissolve, a gradual transition between shots in a motion picture.

dissection As applied to an image, the process of dividing it into small portions, often squares, preparatory to transmitting a signal via radio waves or other means. The image is also dissected by the use of a screen in platemaking for photomechanical reproduction.

dissemination copy An image on microfilm etc., supplied to the user. Analogous to a release print in motion pictures.

dissociation The separation of a molecule of a substance into smaller charged particles (ions). Dissociation occurs when acids, bases, and salts are dissolved in water. It is the ions which take part in chemical reactions, such as chemical development.

dissolve (1) A gradual transition between scenes in a motion picture, or between still scenes presented alternately with two slide projectors, with one scene fading out and another simultaneously fading in. Syn.: cross dissolve. (2) To mix two substances, typically a solid and a liquid, to form a solution.

dissolving shutter A two-bladed disk-type shutter with a variable opening, used in motion-picture cameras and printers. By varying the size of the opening, fade-in, fade-out, and dissolve effects can be obtained. Changes in the size of the opening can also be used to alter exposure in a motion-picture camera, and to produce images of moving objects with less than normal blur.

distilled Applied to liquids that have been vaporized and then condensed. The distillation process is used to purify liquids.

distortion (1) In general, actual or apparent inaccuracy in the representation of subject shapes in images. (2) Specifically, a lens condition that causes straight subject lines to bow inward or outward on the image (barrel distortion or pincushion). This optical effect is caused by varying magnification across the field. (3) In sound recording, a failure of the system to reproduce sounds faithfully.

distortion glass A piece of transparent glass or plastic having a rippled or otherwise uneven surface that produces local irregularities in the image when it is placed in front of a camera lens. Commonly used for pseudo-underwater effects, ripple dissolves, etc.

ditty bag A small compartmented case that is com-

monly hung on a tripod or dolly to provide safe and convenient storage for miscellaneous items used by the cameraman, such as exposure meters, lens caps, filters, and notes.

divergent Spreading apart, as a bundle of light rays. A divergent (negative) lens causes entering parallel rays to so spread. The opposite of convergent.

divided developer (1) One using two solutions, the first containing a developing agent but no alkali, the second an alkali but no developing agent. Exposed film is placed in the first solution and then in the second, producing a limited amount of complete developing solution from the carry-over. Used to obtain a lower-contrast negative without loss of shadow detail and/or to obtain a constant gamma with fluctuations in developing time. (2) Similar to (1) except that both developers are complete; the first is strong and the second is weak. (3) The same as (1) except that the two solutions are mixed immediately before using, the advantage being that the storage life is longer for developers that tend to oxidize rapidly in the mixed form. Syn.: two-bath developer; two-solution developer; split developer.

DL Difference limen.

D-line Radiation having a wavelength of 589.6 nm, one of three wavelengths used in the computation of dispersive power. Also see C-line and F-line.

D-log H (D-log E) curve (density-log exposure curve) (1) A graph obtained by plotting the logarithms of a series of exposures (quantity of light per unit area) received by a photographic material and the corresponding resulting densities. (2) A graph similar to definition (1), but with the logarithm of the energy (quantity of radiation per unit area) as the input. Used for photographic materials normally responsive to radiation other than light, such as x-ray films. Such graphs are used to determine information such as base-plus-fog level, speed, contrast index, useful exposure range, and maximum density. Syn.: characteristic curve; H and D curve; sensitometric curve.

Dmax (maximum density) (1) The largest density in an image. (2) The largest possible density that a photographic material can have.

Dmin (minimum density) (1) The smallest density in an image. (2) The smallest possible density that a photographic material can have.

DN Digital number.

doctor General term for solution added to the basic emulsion formula, such as dye, hardener, stabilizer, or wetting agent.

doctor blade (1) That part of a coating device which regulates the thickness of a liquid layer (e.g., emul-

sion) as it is applied to a support. (2) In photomechanical reproduction, a device on a printing press to remove ink from the non-image areas of gravure plates.

document (1) A sheet of paper or other material containing writing or printing, with or without illustrations. The specialization of duplicating documents photographically is known by a variety of names, including copying, reproduction photography, and reprography. (2) A body of photographs constituting a factual record of the nature or history of a subject or group of subjects.

documentary photography The specialization of making motion pictures or still photographs of a nonfictional nature with an emphasis on realism, often for formal or informal educational purposes.

dodge To reduce the exposure in selected areas of an image to alter the density, e.g., by holding an opaque object between the lens and the easel in projection printing, or by turning one or more lights off in a multiple-light contact printer. Compare with burning in (adding exposure to part of an image). Syn.: hold back.

DOF Depth of field.

doghouse A poor mechanical design, applied, for example, to an awkward or ugly housing for a projector.

dogleg A popular name for a lead line that begins parallel to the top and bottom edges of a photograph or other illustration, and then angles up or down to direct the viewer's attention to a specific area.

dolly A rolling platform used to support and move cameras and other equipment.

domestic release Identifying a motion-picture print that contains dialog in the native language of the country where the print is produced and distributed.

dominant eye The eye that tends to determine the perception when images formed by the two eyes fail to fuse. With prolonged viewing under such conditions, the perception fluctuates from one eye to the other, a process known as retinal rivalry.

dominant wavelength For a given sample color, that spectral hue which when added to white duplicates the hue of the sample. The dominant wavelength is found on a chromaticity diagram by drawing a straight line from the white reference through the position at which the sample plots to the spectrum locus.

dope (1) Film base in liquid form before removal of solvents during the manufacturing process. (2) Retouching fluid applied to negatives to increase the adherence of graphite from retouching pencils.

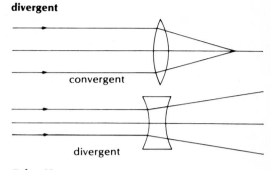

divergent

convergent

divergent

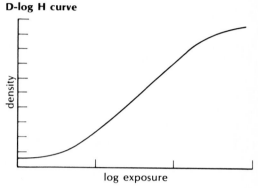

D-log H curve

density

log exposure

dodge dolly

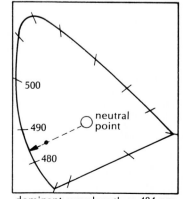

dominant wavelength

500

neutral point

490

480

dominant wavelength = 484 nm

Doppler effect An apparent change in frequency and wavelength of light, sound, etc., due to a changing distance between the source and the receiver. In astrophotography, for example, white light from a rapidly receding source appears more reddish than it would if the distance remained constant.

dose In radiography, the amount of radiation (x-ray, gamma ray) received by a photographic material, living organism, etc., typically measured in roentgens. Data are commonly specified in terms of dosage rate. For example, 0.3 roentgen per week is the maximum permissible rate of exposure for an individual.

dosimetry The measurement of radiation that presents a health hazard, to determine if an individual has received an excessive amount. With one method the person wears a light-tight holder containing film, which when processed provides a permanent record of the radiation received.

dot (1) In photomechanical reproduction, any one of the small elements into which the image is dissected by the use of a screen. The dot size varies with the tone of the copy. Dot size is commonly measured in percentage. For example, 50% dots cover half the area. Hard dots have sharp edges, and soft dots have fuzzy edges. (2) A small round gobo or net, used to shade the light from a small area of a subject.

dot etching In photomechanical reproduction, chemically reducing the size of picture elements (dots) on the halftone negative for the purpose of altering tones in the reproduction.

double anastigmat A symmetrical photographic lens having front and rear components (groups of lens elements) which are themselves relatively free of astigmatism. The components can be used separately or together, with anastigmatic imaging in each case.

double-bottom In animation photography, the lowest cell layer when there are more than three levels. Syn.: bottom-bottom.

double-coated Identifying film or other photographic material having two emulsion layers. The emulsions, which may be coated either on one side or on both sides of the support, generally have different characteristics. If the two emulsions have different speeds, the effect is to expand the range of exposures over which the material responds usefully, and thus increase the latitude in exposure (the permissible variation in camera settings).

double decomposition A reaction between two compounds involving an exchange of the negative ions. Emulsion-making typically involves such a reaction; for example, silver nitrate plus potassium bromide yields silver bromide plus potassium nitrate.

double eight A motion-picture system whereby 16mm film is run through a camera twice, with half the width being exposed on each run. After processing, the film is slit down the center and spliced end to end to produce twice the footage of 8mm film. Double eight is being superseded by super eight, which produces a larger picture area.

double expose (DX) A term used in animation photography to instruct the cameraman to rewind the film for a second run with different subject material.

double exposure The recording of two superimposed images on the same piece of photosensitive material, either by accident or by design.

double-extension Applied to bellows, tubes, and similar devices that provide a lens-to-film distance of twice the focal length of a normal lens.

double frame In animation photography, two consecutive photographs of the same drawing, for the purpose of reducing the number of drawings required or of altering the animation effect.

double-frame A 24 x 36mm format on 35mm film, with the 36mm dimension oriented lengthwise on the film. A popular format for still cameras that use 35mm film. The name indicates that it has two times the area of the standard 24 x 18mm motion-picture format.

double-jet In emulsion making, identifying a method of combining the ingredients in which separate streams of silver nitrate solution and soluble halide solution are added to a gelatin solution. Compare with single-jet and dumping methods. The size-frequency distribution of the resulting silver halide grains is in part determined by the method used to combine ingredients.

double-perf (perforation) Sixteen millimeter motion-picture film having sprocket holes along both edges (silent perforation) as distinct from film having sprocket holes along one edge (sound perforation).

double printing Intentionally recording two images on the same piece of photosensitive printing material, either in separate areas or superimposed. See combination print, montage, and sandwich.

double run Exposing the same film twice in a motion-picture camera, to add titles, create composite effects, etc.

double shutter A device consisting of two disks with open segments that rotate in opposite directions to increase cutoff efficiency of the projected light. Commonly used in 35mm theatrical projectors.

double sixteen Identifying 35mm motion-picture

double-frame

18mm
24mm
36mm

print film having 16mm perforations so that the film can be slit after processing to provide two 16mm prints. The extra 3mm is removed during slitting.

double spread A reproduction of a photograph, or a layout, etc., that occupies any two facing pages in a publication. Syn.: double truck.

double super eight (DS-8) A system that uses 16mm film in a motion-picture camera having a 0.224 x 0.166 in. (super eight) picture format. The film is run through the camera twice, with half the width being exposed on each run. After processing, the film is slit down the center and spliced end-to-end.

double system In motion-picture photography, a procedure for recording original sound on a separate film or tape, rather than on the film being exposed in the camera, as is done with the single system.

doublet (1) A compound lens containing two components, each of which may in turn contain two or more elements. (2) A compound lens component that contains two elements.

double take In motion-picture photography, the procedure whereby an actor or animated character reacts to a situation and then within a short period reacts again in a more dramatic manner.

double toning Treating a print with two toners in sequence, either locally, to obtain different colors in different areas, or overall, to obtain a color different from that produced by either toner alone.

double-top In animation photography, the highest cell layer when there are more than three levels. Syn.: top-top.

double truck See double spread.

double-weight (DW) Applied to photographic paper to designate the relative thickness of the base. Double-weight paper is thicker than lightweight, single-weight, and medium-weight papers. Paper-thickness standards vary among manufactuers.

doubly-diffuse A type of optical density in which the area being measured is illuminated with scattered light and essentially all of the transmitted light, rather than just the directly transmitted light, is recorded, as distinct from diffuse density and specular density; see diffuse; specular. Doubly-diffuse density has good predictive value for contact printing. No commercially available densitometer, however, measures negative density in this way.

douse Slang term meaning to turn off (a light).

downstage In motion-picture photography, toward the camera, as distinct from upstage (away from the camera).

downtime (1) The duration of nonoperation of equipment (e.g., a film processor) due to malfunc-

tion of the equipment or other reasons such that the usual charges are made even though the persons involved are not working. (2) Any period of non-operation of equipment, including overnight and weekend periods when operators are not scheduled for duty.

DP Director of photography, the chief motion-picture cameraman.

Dr Reflection density.

dragon's blood A resin used as an etching resist.

drape (1) (verb) To arrange fabric about the shoulders of a portrait subject to produce, for example, the effect of a formal gown. (2) (noun) The fabric used for the above purpose.

drawing disk The part of an animator's drawing table that can be rotated.

dressed As applied to a set, completely furnished with properties, ready for shooting.

drift A gradual change in output of a device, with no corresponding change in input. Example: the variation in indicated density of a sample measured on an electronic densitometer during warm-up.

driography A photomechanical reproduction process that uses a printing plate with an ink repellent coating (which is removed from the image areas). In contrast to lithographic plates, it is not necessary to apply water to the plates prior to inking.

drive The motor that activates a motion-picture camera, printer, projector, etc.

drop (1) A small quantity of liquid formed into a roughly spherical unit by the force of surface tension. Drops are commonly formed by slowly releasing a liquid from a small tube or by slowly pouring a liquid. Since drops vary in size, they are useful only as an approximate measure of quantity. (2) A background, typically one on which scenic images are painted. Syn.: backdrop.

drop bed A folding flatbed type of camera base that can be lowered beyond the normal operating position to place the lens in a lower position or to avoid interference with the view of a wide-angle lens.

drop-in Identifying a system that permits film or tape in a cartridge to be placed in operational position in compatible equipment without threading or other manipulation.

dropout In sound reproduction, a short-duration loss of sound due to an imperfection in the record.

drop out To eliminate detail in an image area (a background, for example) by any of various techniques, including opaquing and bleaching.

drop-shadows A technique for making letters appear three-dimensional, used, for example, in titles for motion pictures, filmstrips, etc.

doublet lens

doublet lens

doublet components

doubly diffuse

drop bed

drum In sound reproduction, a rotating cylinder used to transport film past the record or replay head at a constant speed, as, for example, on a motion-picture projector.

drum camera Exposing apparatus used especially in high-speed photography, in which the film is wrapped around a cylinder that is rotated past a slit or series of lenses.

drum dryer A device containing a rotating heated cylinder that removes water from photographic prints held in contact with the heated surface by a moving fabric belt. Prints may also be ferrotyped on drum dryers equipped with a polished cylinder.

drum processor A device containing a rotating cylinder that carries processing liquids onto exposed photosensitive materials and provides effective replacement of depleted solutions. Used especially for processing color-print materials.

dry-brush An effect in animation photography where the colorist produces a streaked rather than a solid color by using a paintbrush that is only slightly moist. Used to create the impression of speed, etc.

dryer A device designed to accelerate the removal of water from photographic materials. One type of print dryer uses a fabric apron to hold wet prints against a rotating heated metal drum. Film dryers commonly use circulating warm air, since film emulsions are more susceptible to physical damage.

dry ice Solidly frozen carbon dioxide, which is placed in warm water to create a white cloud effect. Dry ice evaporates from a solid to a gas above −78.5C and is an effective refrigerant.

drying mark (1) A defect on a negative or transparency in the form of a local density difference caused by uneven removal of water. (2) A defect on a photographic image in the form of a mineral deposit, resulting from evaporation of a drop or streak of water on the surface during the drying step. Both types of marks can be avoided by adding a wetting agent to the final rinse or by sponging all water drops off the surface.

dry ink In electrophotography (e.g., xerography), a fine powder of resin plus pigment, deposited to form the image. Syn.: toner.

dry mounting A process for permanently attaching photographs and similar material to a support using a heat-softenable adhesive tissue placed between the print and the mount. To obtain good contact, pressure is applied as the materials are heated, and also during the cooling stage when the adhesive hardens.

dry mounting press A device for applying heat and pressure in the process of fastening a print to a

support by the use of a heat-softenable tissue. A similar device is used for sealing transparencies in slide mounts. Syn.: mounting press.

dry mounting tissue Thin paper, impregnated with a heat-softenable adhesive, used for permanent fastening of prints to a support. Syn.: mounting tissue.

dry offset Identifying a photomechanical reproduction process that uses a blanket to transfer the ink image from a relief plate—which does not require wetting with water as do planographic (level-surface) plates—to the paper.

dry plate See plate, the preferred term.

dry process Any method of developing an image that makes use of little or no water. No completely dry process has yet been invented for silver halide images. Xerography and diazo are examples of dry processes.

dry run A practice performance of an operation without using expendable materials. In a motion-picture camera rehearsal, for example, the operator practices viewing the action through the viewfinder, focusing, moving the camera as specified, etc., but does not expose film during a dry run.

dry-to-dry (1) Identifying a processor that automatically wet-processes exposed photographic material, including the removal of water. (2) Indicating a complete processing cycle with any of various wet processes, as, for example, in dry-to-dry time.

DS-8 Double super eight.

D$_t$ Transmission density.

DTR Diffusion-transfer reversal.

DU An identifying code syllable for "dual," recommended by the International Radio Consultative Committee (CCIR) for use on the leader of motion-picture films supplied with two magnetic soundtracks (one for dialog and the other for music and effects), especially those intended for television reproduction on an international exchange basis.

dubbing In motion-picture photography, a process by which a sound record for a film is altered, e.g., by adding music as a background for dialog, or by substituting an English translation for a foreign-language dialog or vice versa. Three types of sound records are typically used: dialog, music, and effects. Syn.: re-recording.

dulling spray A transparent liquid that dries quickly with a mat finish when applied to an object with an atomizer. Typically used in commercial photography to reduce the glossiness of a surface, as on polished metal objects, and thereby eliminate glare reflections.

dummy In photomechanical reproduction, an indi-

drum processor

vidually prepared sample of the contemplated finished publication, often including photographs, used for final approval before beginning production.

dummy coupler See competing coupler.

dump In emulsion making, to quickly add the dissolved silver nitrate to the solution of gelatin and soluble halides for the purpose of controlling the size-frequency distribution of the resulting silver halide grains.

duo A system of recording two sets of microfilm images, side by side, along a roll of film.

duotone A photomechanical reproduction printing process in which two identical or complementary plates are used to superimpose a black image and a monochrome color image.

dupe Duplicate.

duplex (1) A system of simultaneously recording microfilm images of opposite sides of a document, side by side on a roll of film. Compare with simplex. (2) A system of taking two incident-light exposure-meter readings with back-lighted subjects, aiming the meter directly at the main light for one and at the camera for the other, and exposing for a value midway between the two.

duplicate A photographic reproduction of a photographic image, with both images having the same negative or positive tonal orientation. The reproduction may or may not incorporate intentional changes in cropping, contrast, color, etc.

duplicator Any of various devices designed to produce facsimiles of photographs or other images, e.g., a microfilm duplicator.

duration The length of time of an event. In visual perception, the length of time that a stimulus (an individual frame of a motion picture, for example) is presented to a viewer. For some purposes the duration is measured from established reference points, such as the half-open to the half-closed positions of shutters in measuring duration of exposure.

dusk (1) An outdoor lighting condition that exists for a short period just before the arrival of night darkness; the darker part of twilight. (2) Identifying a photograph made under such lighting conditions.

dust spot A defect on a photographic image resulting from the obstruction of light by a small particle of foreign material during the exposure.

Dutch angle In motion-picture photography, a shot in which the camera is tilted sideways so that the image on the screen is tilted in the opposite direction for a special effect.

DW Double-weight.

dwg In animation photography, abbreviation for drawing.

DX Double expose, a code used in animation photography to instruct the cameraman to rewind the film for a second run with different subject material.

dye A colorant having a variety of photographic applications, including the formation of color images, toning, sensitizing, desensitizing, spotting, and filtration. In general, dyes are distinguished from pigments by their solubility in water or alcohol and by their transparency.

dye bleaching A process in which color images are formed through the action of light in destroying the color of unstable dyes in proportion to the amount of light of the complementary color absorbed.

dye coupling In the development of a silver image, the deposition of a colored substance at or near the site of the developed silver. In many modern color photographic processes, the dyes are formed by reaction between developer by-products and other chemicals called "couplers."

dye destruction A process in which color images are formed by selectively eliminating dye by chemical means. Typically, dye is destroyed in the presence of a silver image, either during or following development. Thus a positive color image will be produced with a negative silver image.

dye imbibition In a photographic printing process, the absorption of a dissolved colorant by a coating containing an image (e.g., a layer of gelatin of varying thickness), after which the colorant is usually transferred to a receiving sheet.

dye mordant A chemical substance that adsorbs dye to a support and reduces its solubility. Often used in dye-imbibition color processes.

dye sensitization The increase in response of a photographic material to longer than normal wavelengths by addition to the emulsion of a dye that absorbs these wavelengths. Used in preparing orthochromatic and panchromatic films, for example.

dye toning A process of converting the silver image on a black-and-white photograph into a monochromatic colored image using dye mordanting.

dye transfer A color printing process in which a matrix containing a gelatin relief image is first placed in a dye solution to soak up dye in proportion to the thickness of the image, and then placed in intimate contact with a blank sheet that receives the dye image. Typically, cyan, magenta, and yellow images are superimposed to form the final image.

dynamic cutting A form of motion-picture film editing in which a rapid series of abrupt transitions is used to enhance a dramatic effect.

EE

Eberhard effect

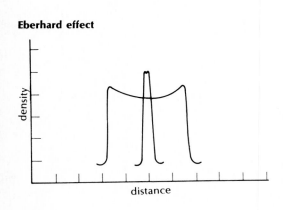

echelon lens

edge effects

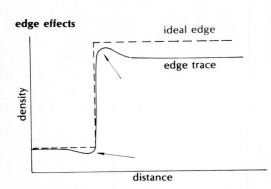

E (1) Internationally accepted symbol for illuminance (i.e., the rate at which light falls on a surface, measured in lux [lumens per square meter or meter-candles]) and irradiance (i.e., the rate at which radiant energy falls on a surface, measured in watts per square meter). Thus, the new formula for photographic exposure is written $H = E \times t$, where H is the new symbol for exposure, superseding E. Subscripts are used to provide more positive distinction between illuminance (E_v) and irradiance (E_e). (2) Nonstandard symbol for exposure, the quantity of light per unit area received by photosensitive materials, commonly expressed as exposure equals illuminance times time ($E = I \times t$).

e Energy. Subscript for symbols to indicate radiant measurement as distinct from light.

earphones A device consisting of two telephone-type receivers connected by a spring band to hold them over the ears, worn by certain motion-picture and television workers to monitor sound or receive auditory instructions. Syn.: headphones.

ease in In animation photography, to increase the speed of an action gradually, as distinct from starting abruptly.

easel (1) A device used for positioning and holding sensitized material flat and stationary in projection printing. (2) A device used to hold two-dimensional material that is to be copied with a camera.

ease out In animation photography, to decrease the speed gradually at the end of an action to avoid an abrupt stop.

east-west In animation photography, a camera motion that results in a horizontal displacement of the image on the screen.

Eberhard effect A development phenomenon whereby the developed density of two areas that have received the same exposure varies inversely with the size of the areas when they are approximately one millimeter in diameter or less.

eccentric A disk that has an off-center point of rotation. Used to convert a rotating motion into a reciprocating motion, as in the pulldown mechanism of a motion-picture camera or projector.

echelon lens See Fresnel lens.

echo chamber A device that uses physical or electronic means to repeat an audio signal with a very short delay, so that an echo effect is produced when both the original and repeated signals are recorded.

ecological photography The specialization of making photographs of the environment of living things for any of a variety of uses, including scientific, sociological, and educational.

ECPS Effective candlepower-second.

ECU In motion-picture photography, an extreme closeup.

edge In portrait lighting, to aim a light source slightly in front of (rather than directly at) the subject, thereby reducing the illuminance on the side of the face to a greater extent than on the front. This, in turn, increases the tonal gradation and the appearance of depth on the subject's face. Edging is also used to reduce the general illuminance, to achieve a desired lighting ratio, or to alleviate the subject's discomfort. Also see spill. Syn.: feather.

edge effects Anomalies at the boundary between a dense and a thin area. The edge of the dense area is denser than an area within the dense region (border effect), and the edge of the thin area is thinner than an area within the thin region (fringe effect).

edge fog A defect on photosensitive materials resulting from unintentional exposure to light or from aging, whereby unexposed margins of nonreversal materials are dark and unexposed margins of re-

versal materials are light. The defect may extend into the picture area.

edge gradient (1) (subjective) The rate of change in lightness in crossing the boundary between two areas of different lightness. The perceived sharpness of an image increases as the edge gradient increases. (2) (objective) The rate of change in density in crossing the boundary between two areas of different density. Acutance is calculated from the geometric average slope of a microdensitometer trace of an edge.

edge notches (1) On sheet films, coded indentations along one edge that can be felt in the dark to identify the type of film and the emulsion side. (2) On motion-picture films, indentations at appropriate locations along an edge for any of a variety of purposes, including providing cues or instructions for editing or printing, and locating damage. Syn.: for both (1) and (2), film notches.

edge numbers (edgenumbers) (1) Numerals typically printed as latent images by the film manufacturer at 1-foot intervals on motion-picture film, to identify frames or scenes in editing, producing optical effects, etc. Syn.: key numbers. (2) Numerals photographically printed on the edges of roll film and 35mm film for still photography, typically at intervals of one or two numbers per frame, for the identification of individual negatives on the roll.

edge printer A device containing a light source designed to form a latent image of data, a signature, etc., in the border area of photographic film or paper. The image becomes visible and permanent during processing.

edge stripe A band of magnetic sound-recording material applied lengthwise to motion-picture film outside the picture area, to record a soundtrack.

edgewave An undulating deformation along border areas of photographic material, commonly caused by expansion of these areas due to excessive humidity in storage.

edit (1) In still photography, to select photographs to be used and to make decisions concerning modifications, layout, etc. (2) In motion-picture photography, to delete or rearrange portions of the picture or sound to establish the form of a film and to improve its effectiveness.

editing barrel A large container with an open top used in editing motion pictures, to catch film that is not wound onto a take-up reel. Syn.: cutting barrel; film barrel.

editing machine A device that holds supply and take-up reels for processed motion-picture film and projects the image onto a small ground-glass screen. Used to inspect and make deletions, additions, and

other changes in a film. Professional models have numerous features that provide the operator with increased control over the film, including variable speed, precision stop, counters, and splicing and sound facilities. Syn.: editor.

editing rack A horizontal row of protruding pins used in motion-picture editing to hold strips of film.

editor (1) The person who is responsible for making decisions concerning the deletion or rearrangement of processed film and recorded sound to produce an effective motion picture. He typically functions as a supervisor except in small organizations, where he may be involved in the actual work. The counterpart in photojournalism is identified as a picture editor. (2) See editing machine.

editorial cut In motion-picture editing, an abrupt transition between two scenes on a picture film with a simultaneous transition at the same point on a separate sound film or tape. Syn.: straight cut.

editorial photography The specialization of making non-advertising photographs to be reproduced for mass viewing, usually in connection with an article or commentary.

editorial sync (synchronization) Alignment of the separate picture and sound components of a motion picture so that corresponding points coincide, as distinct from projection sync in which the sound is ahead of the corresponding picture. Syn.: dead sync; level sync.

education As applied to photography, a teaching process designed to produce in an individual an appropriate degree of competence in one or more photographic subject areas, commonly for vocational purposes. Education implies a more comprehensive process than training, involving theory, history, etc., as well as the learning of processes.

educational photography The specialization of making photographs to be used for instructional or other educational purposes. Examples: textbook illustrations; classroom filmstrips.

EE Electric-eye; electronic exposure.

effective aperture The diameter of an entering collimated (parallel) beam of light that will just fill the opening in the diaphragm in an optical system such as a camera lens. The effective aperture is the same in size as the diaphragm opening (or aperture) only when the diaphragm is located in front of the lens. Syn.: entrance pupil.

effective candlepower-second (ECPS) A unit of light-energy output of a lamp, typically electronic flash, obtained by averaging values over a specified angle of illumination.

effective exposure time The time duration between

edge gradient (2)

density (vertical axis) — *distance* (horizontal axis)

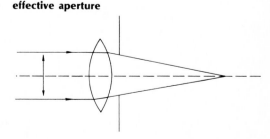

edge notches

sheet film

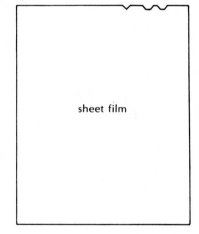

effective aperture

the half-open position and the half-closed position of a leaf-type shutter. In this context, the shutter is considered to be "open" when any specified diaphragm opening is just completely uncovered, whereas the *marked* shutter speed is based on the maximum diaphragm opening. Therefore, the effective and marked shutter speeds (on a perfectly calibrated shutter) agree only when the diaphragm is set at the maximum opening. With the diaphragm stopped down, the film receives more exposure than is indicated by the marked shutter speed.

effective f-number A number obtained (a) by dividing the image distance (as distinct from focal length) for a lens in a specific situation by the effective aperture, or (b) by multiplying the *f*-number (or relative aperture) by the ratio image distance/focal length. Used instead of *f*-number when photographing nearby objects to compensate for the loss of light as the lens-to-film distance increases. See bellows factor. Syn.: effective relative aperture.

effective relative aperture See effective *f*-number.

effective shutter speed See effective exposure time.

effects See exposure effect; optical effect; processing effect; and sound effect.

effects animation In motion-picture photography, the specialization of simulating movement of such things as smoke, fire, clouds, dust, and water ripples by photographing a series of still drawings, each of which shows the moving part in a slightly different position.

effects box A device for supporting a cutout or other mask in front of a camera lens for special effects. Such a device may also support filters, diffusers, etc., and may function as a lens hood. Syn.: matte box.

effects filter Any of a variety of optical attachments for a camera lens used to produce an effect such as fog, soft focus, or day-for-night.

effects library A cataloged collection of recordings of sounds other than voices or music (examples: thunder, wind, traffic, and whistles). Such recordings are used in making motion-picture soundtracks. Syn.: sound effects library.

effects prism A transparent optical device having multiple flat surfaces, used in front of a camera lens to obtain multiple images of the subject.

effects track In motion-picture photography, a record of sounds other than music or speech, e.g., traffic noise.

efficiency (1) Ratio of output to input. For example, luminous efficiency is the ratio of lumens emitted by a lamp to the electrical power supplied to the lamp. (2) See quantum efficiency. (3) For a shutter, the ratio of the effective operating time to the total

operating time. Leaf shutter efficiency is at least 50%, and approaches 100% for long shutter times; and it also increases as the diaphragm opening is decreased, becoming nearly 100% at the minimum opening. For focal plane shutters, the effective and total operating times are based on a point on the film, not on the movement of the opening from one edge of the film to the opposite edge.

efflux (adj.) Flowing out, as energy from a sample. In a microdensitometer, the efflux optics involves the lens that collects the light from the sample.

EFX. Code designation for "effects" in motion-picture photography. Used on the camera slate of a special-effect scene, on exposure sheets for the guidance of an animation cameraman, etc.

EI (1) Exposure index (2) Emulsion in.

eight-millimeter (8mm) One of several standard widths of film used in motion-picture photography. The term is also applied to cameras, projectors, and other equipment designed to be used with such film (although some 8mm cameras use 16mm film that is slit after processing to produce twice the length of 8mm film). Also see double eight; super eight.

eight-track (1) Identifying magnetic-tape sound-reproduction devices having the capability of making or playing eight different sound records, each in a band occupying one eighth the width of the tape. (2) A tape so recorded.

einstein That number of photons that would cause a mole (one molecular weight of a material expressed in grams) of a photosensitive material to react if every photon were absorbed and caused one molecule to change. The number is 6.023×10^{23}.

Einstein's law of photochemical equivalence A photochemical reaction will occur only if the energy associated with a single photon equals or exceeds that needed to cause a single molecule of the sensitive material to change, as to decompose. A corollary of the law is that photons cannot sum in effect.

electrical conductivity The property of a material to transmit an electrical current readily. The influence of light on the electrical conductivity of certain materials is important in electrostatic image forming processes. In latent-image theory, a distinction is made between two types of electrical conductivity: electronic (in which the current consists of a flow of electrons) and ionic (in which the current consists of a flow of ions).

electric cell An elementary source of electricity consisting of two electrodes made of different materials such as carbon and zinc, and an electrolyte that is an acid, an alkali, or a metal salt. A battery is made up of a number of cells.

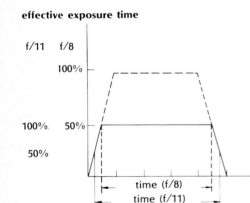

effective exposure time

f/11 f/8

100%

100% 50%

50%

time (f/8)
time (f/11)

electric-eye (1) A photoelectric cell. (2) Identifying an automatic-exposure control system used on some cameras whereby the exposure meter adjusts the aperture or shutter setting to compensate for variations in illuminance at the meter.

electrician In motion-picture photography, the person who is responsible for procuring, positioning, and operating lighting equipment, including generators, electrical cables, etc. Syn.: gaffer.

electroluminescence The direct conversion of electrical energy, in the form of an alternating current, into light. Not to be confused with incandescence and other indirect processes in which the electrical energy is first changed, for example, into heat and then into light.

electrolytic development The use of electricity to convert a latent image on a photosensitive material into a visible image. With silver halide materials, the electricity serves as a substitute for the developing agent as a source of electrons. With photoconductive systems, an electric current forms a deposit on the latent image from a solution applied to the surface.

electrolytic engraving A process that uses the electroplating principle in reverse to remove metal from the nonimage areas of letterpress printing plates.

electromagnetic radiation Energy propagated in wave form, including radio, infrared, light, ultraviolet, x-rays, and gamma rays. Short waves may exhibit the properties commonly attributed to particles.

electromagnetic spectrum The various forms of radiant energy arranged on a continuum in order of increasing wavelength from gamma rays to radio waves and including light. Syn.: energy spectrum.

electromechanical shutter A mechanically-powered shutter in which the duration of exposure is controlled electronically rather than mechanically as with conventional shutters.

electron A negatively-charged subatomic particle capable of exposing photographic film. Electrons are also used, for example, to form images in cathode-ray tubes.

electron-beam recording In motion pictures and television, a process for recording images on photographic film with electrons in a cathode-ray tube, as distinct from photographing a light image formed by phosphors on a tube face.

electronic color scanner A device used to produce separation negatives from a color original, typically for photomechanical reproduction. An integrated computer makes color-correction adjustments as the image elements are systematically reproduced.

electronic conductivity The property of a material by which it readily transmits an electrical current in the form of a flow of electrons, as distinct from ionic conductivity, in which the current consists of a flow of ions. The distinction is important in latent-image theory.

electronic engraver A device used to produce relief printing plates using a stylus that penetrates the plate to varying depths in response to signals received by photocells as the original copy is scanned.

electronic flash A light source in which a high-intensity short-duration flash is produced by passing an electrical discharge through an atmosphere of xenon or other inert gas in a sealed transparent or translucent container. Unlike flash lamps, electronic flashtubes can be used repeatedly. Syn.: speedlight; "strobe."

electronic-flash meter A time-integrating light-measuring instrument designed to indicate an appropriate aperture setting on a camera for a desired exposure effect, using electronic flash as a light source.

electronic photography The process of recording electrical signals from television cameras on magnetic tape. Syn.: electronic imaging system.

electronic printer A device for exposing photographic printing material, employing a scanning light source. An incorporated monitoring control system varies the intensity of the illumination locally to achieve dodging and contrast effects.

electronic shutter A shutter powered by an electromagnet, and in which the duration of exposure is controlled electronically. Compare with electromechanical shutters, which are mechanically powered and electronically timed, and conventional shutters, which are mechanically powered and timed.

electron micrograph A photograph produced with an electron microscope.

electron microscopy The production of photographs with an electron microscope, a device capable of higher magnifications than an optical microscope, through the use of a beam of accelerated electrons brought to a focus by electrical fields.

electronography A process by which toner is transferred from a printing plate to a receiving surface by means of electrostatic attraction, without contact between the two surfaces. An advantage of the process is that images with good definition can be printed on rough or delicate surfaces.

electron trap In the Gurney-Mott hypothesis of latent-image formation, a silver sulfide sensitivity speck on a silver halide grain, where previously-

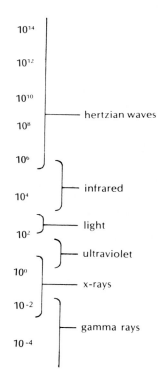

electromagnetic spectrum

10^{14}

10^{12}

10^{10}

10^{8} — hertzian waves

10^{6}

10^{4} — infrared

10^{2} — light

10^{0} — ultraviolet

— x-rays

10^{-2}

— gamma rays

10^{-4}

moving photoelectrons become immobile and neutralize silver ions (which migrate to the speck) to form silver atoms.

electro-optical (E-O) (1) Applied to an electronic image-processing device, technique, etc., such as computer enhancement of images, image formation with television or an electron microscope, and exposure control with a Kerr cell. (2) Identifying the effect whereby the application of an electrical field alters the light transmitting characteristics of a material from isotropic to double refracting.

electrophoresis The migration of particles suspended in a fluid under the influence of an electric field. The resulting arrangement is commonly photographed for research purposes. Also see photoelectrophoresis (PEP).

electrophotography A specialized area of photography concerned with the production of images by electrical means. Electrostatic photography (which see) is the most highly developed and widely used process of this type.

electroplating The use of electricity to deposit metal from a solution containing metallic ions onto a surface. Example: electrolytic development.

electrostatic Pertaining to electricity at rest, such as a stationary electrical charge on a photoconductive surface used in an electrophotographic reproduction process.

electrostatic deformation See thermoplastic recording.

electrostatic photography The formation of reasonably permanent images with processes based on local changes in electrical charge on a surface upon exposure to light or other radiant energy. Much used in office copying machines, etc. The basic steps in one such process are: (a) charge the surface of a selenium-coated plate with positive ions; (b) expose the plate to an original, producing an image of electrical charges; (c) dust the plate with a negatively charged resin, producing a visible image; (d) transfer the resin image to a sheet of electrically charged paper; and (e) heat the paper to make the image permanent.

electrotype A duplicate of a letterpress printing plate, typically produced by (a) making a mold from the original plate, (b) spraying the mold with silver nitrate solution, (c) depositing a thin layer of copper on the mold by electrolysis, and (d) reinforcing the mold on the back with lead or other material.

element (1) A single piece of glass or other transparent material that functions as a lens or a lens component. (2) A substance that cannot be separated into other kinds of substances, e.g., silver, bromine, chlorine.

elevator (1) A mechanism on a tripod, animation stand, etc., that enables the operator to move a camera smoothly up and down on one or more columns for the purpose of altering the viewpoint. (2) In motion-picture photography, a series of rollers on a developing machine that enables the operator to stop the trailing end of a strip of film so as to attach the leading end of the next roll without altering the rate of travel of the film being processed.

elongation (1) A perspective effect whereby a subject dimension appears unrealistically large. Usually the result of using a short-focal-length lens on a camera placed at a relatively small distance from the subject, or of viewing an image at a longer than normal distance. (2) An actual increase in an image dimension, as results when the easel is tilted in projection printing, or from the use of an anamorphic lens.

emboss To produce a recessed or raised effect on a surface, commonly as a border around a print or an impressed texture on a print.

emergent Identifying energy departing from a medium (as contrasted with incident upon, or reflected by), especially a ray of light departing from a lens, prism, or other piece of glass.

emissivity The flux (flow) of energy, i.e., radiation, leaving a small area of a sample divided by the area. Applied to an opaque sample with perfectly diffusing surfaces.

emittance (1) The flux (flow) of energy leaving a small surface area, divided by the area. A property of sources of light and other radiation. (2) As recommended by the Nomenclature Committee of the Optical Society of America, the ratio of the flux per unit area (defined above) to the flux from a perfect radiator, i.e., a blackbody. The Committee recommends the term "exitance" for definition (1).

Emmermann process A procedure whereby unexposed photographic paper is soaked in developer so that the image partially develops before the exposure is completed, producing a masking effect and a corresponding reduction in contrast.

emmetropia In visual perception, a condition in which when accommodation is relaxed, the point for which the eye is accommodated is at infinity. Compare with ametropia.

emulsification That stage in emulsion making where silver halide is precipitated in gelatin. Syn.: precipitation.

emulsion (1) A dispersion of silver halide crystals in gelatin or other suitable material. Preferred term: photographic emulsion. (2) A colloidal suspension of one liquid in another.

emulsion in (EI) The standard winding in the United

emboss

States for film that is to be exposed in a motion-picture camera. Some foreign cameras require film that is wound emulsion out (EO), and a few cameras can use either type.

emulsion numbers A series of integers and/or letters, usually printed on each package of photosensitive material, identifying the manufacturing batch. Some photographers prefer to purchase a quantity of material from the same batch to minimize variations in speed, color balance, and other photographic characteristics.

emulsion out (EO) A motion-picture-film winding that has the base in. The standard 35mm print position before projection is emulsion out, but after projection it becomes emulsion in (EI). Emulsion-out winding is required for some foreign cameras, although the standard raw-stock winding in the United States is emulsion in.

emulsion side The side of a photographic film, plate or paper on which the emulsion is coated. In film, typically the dull side, and concave as the film curls. The converse of base side.

enameled See coated.

encapsulation The process of placing chemicals in tiny protective enclosures so as to prevent diffusion or unwanted reaction of the chemicals. The process has been proposed for the incorporation of developers within an emulsion, and has been used for mixed emulsions and dye couplers.

END Equivalent neutral density.

endoscopic photography The production of photographs of the inside of cavities (e.g., the human stomach) with a specially designed instrument, an endoscope, which both illuminates the subject and serves as an extension of the camera's optical system.

end slate In motion-picture photography, a notation that is photographed following a scene because it was omitted at the beginning. It is customary to photograph an end slate upside-down so that the film editor will know it is not a slate for the beginning of the next take.

end title In motion pictures, the text material that closes the film.

energy spectrum See electromagnetic spectrum.

engagement The interlocking of compatible parts, such as the meshing of film sprocket holes and gear teeth in a camera, projector, etc.

enhancement A process for improving the quality of an image, e.g., with a computer by converting picture elements into digital numbers that are systematically modified and converted back into picture elements. Image enhancement may be used to reduce the effects of noise and to sharpen edges.

enlargement Any image, such as a photographic print, made by projection at a scale of reproduction larger than 1 to 1.

enlarger An optical device containing a light source used to project images of negative or positive transparencies onto sensitized material. "Projection printer" is a preferred term, since such devices are often used to produce reduced as well as enlarged images.

enlarger head The part of a projection printer comprising the light source, the negative carrier and the lens.

enlarging lens A lens designed for use on a projection printer. Typically, aberrations are minimized for relatively small object distances, the lens is mounted in a barrel without a shutter, and the diaphragm is equipped with click stops.

enlarging meter A light meter (photometer) designed to be used as an aid in determining the correct contrast grade of paper and exposure settings for projection printing.

enlarging paper Sensitized paper with a speed suitable for use with projection printers, as distinct from contact paper, which is less sensitive.

entrance pupil The diameter of an entering collimated (parallel) beam of light that will just fill the opening in the diaphragm in an optical system such as a camera lens. The size of the entrance pupil is the same as that of the diaphragm opening as seen from the front of the lens system. Syn.: effective aperture.

EO Emulsion out.

E-O Electro-optical.

equalization In sound reproduction, a process for modifying a signal to compensate for distortion elsewhere in the system.

equidensity film A photographic copying material containing both positive and negative image-producing emulsions, designed to produce a line-drawing effect from a continuous-tone positive or negative original. The effect is controlled with variations in exposure and filtration. Used for both pictorial and scientific purposes where it is desirable to compress some tonal differences and to expand others, as for the enhancement of Schlieren patterns. Syn.: contour film.

equienergy Identifying a theoretical spectrum in which all wavelengths have the same energy, as distinct from actual spectra, in which the energy varies with wavelength. The equienergy spectrum is used, for example, in predicting the amount of each of three primaries that will match a sample consisting of a mixture of spectral radiations.

equivalence In visual perception, the fact that a

entrance pupil

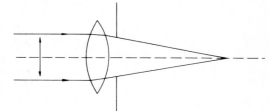

equivalent focal length

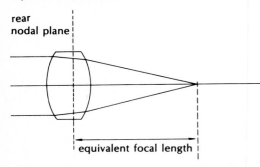

rear
nodal plane

equivalent focal length

etch factor

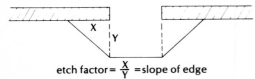

etch factor = $\frac{X}{Y}$ = slope of edge

excitation purity

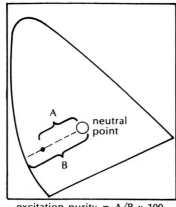

A
neutral
point

B

excitation purity = A/B x 100

photograph serves as a representation of something other than the object photographed. An abstract design of reflections on water, for example, may create an emotional response, perhaps by arousing a memory of another object or an experience. Equivalence, which may function as a psychological mirror, accounts for different responses by two people viewing the same image. Equivalence is also applied to the recalled mental image of a photograph viewed at an earlier time, as well as to the actual photograph.

equivalence factor In radiography, a number that represents the relative absorption of specified radiation by a material in comparison with an equal thickness of a standard material. For example, lead has an equivalence factor of 12 for x-rays at 220 kilovolts, in comparison with steel, which has a factor of 1.0. The equivalence factor is used, for example, to determine the exposure time required to produce a satisfactory image.

equivalent A photograph having the characteristics of equivalence.

equivalent focal length The distance from the best axial focus of an infinitely distant object to the rear nodal point. Although often referred to simply as "focal length," the word "equivalent" helps distinguish this term from such terms as "calibrated focal length," "back focal distance," and "flange focal distance."

equivalent neutral density (END) An analytical measure of a dye deposit in a color photographic image. The amount of the dye is specified in terms of the visual neutral that it would form with the proper amounts of the other two dyes of the specific color system. Thus, if a given dye deposit would form a neutral with a density of 1.0 when sufficient amounts of the other dyes are added, the END of the dye is 1.0. Equivalent neutral printing density is similarly defined, except that the neutral is that produced on a specific type of printing material.

erase To remove recorded signals from a magnetic tape or soundtrack by means of a magnetic field.

erasing head See head (1).

erect Right side up. Identifying an image that has the same vertical spatial orientation as the object it represents, as distinct from an inverted image.

erg The unit of work or energy in the centimeter-gram-second system. As a measure of electrical energy, 1 erg = 10^{-7} watt-second.

erotic photography The specialization of making photographs that tend to arouse sexual desire in the viewer.

established In motion-picture photography, identi-

fying a scene with which the viewer is already familiar.

establishing shot (1) In motion-picture photography, a relatively distant view of a new location, used to orient the viewer before medium or closeup views are presented. Also see long shot. (2) In photojournalism, a photograph that defines the context of a picture story.

esthetics (aesthetics) The study of visual or other perception in relation to the sense of beauty.

estimated midtone Identifying a method of using an exposure (light) meter in which a luminance (reflection-type) reading is taken from a subject area that appears to be halfway between the lightest and darkest areas with respect to lightness. Compare with artificial midtone and calculated midtone.

etch (1) To remove silver partially or completely from local areas of a photographic image by scraping the surface. (2) To remove by chemical means unwanted material in areas that are not protected by a photoresist, as in the production of photoengraving plates, printed circuits, etc. (3) In photomechanical reproduction, to chemically reduce the size of dots on a halftone negative for the purpose of altering tones in the reproduction.

etch factor In photofabrication, etc., a measure of the extent to which undercutting at an edge widens the image.

E_V Exposure value. Also EV.

evaporography Imaging by evaporation and redeposition of oil, usually by temperature changes caused by radiation absorption.

evolutionary operations (EVOP) A statistical method of experimentation involving a systematic series of small changes (as of developer ingredients) about the usual levels, and continual adjustment of these levels, depending on the results of the experiment.

EVOP Evolutionary operations.

excitation Elevation of a particle (e.g., an electron or dye molecule) to an active state, usually caused by the absorption of radiation.

excitation purity On a CIE chromaticity diagram, the distance from the neutral point to the sample point divided by the total distance from the neutral point to the spectrum line, multiplied by 100.

exciter filter When photographing fluorescence, a filter used in front of the source of radiation to absorb most of the radiation except that which produces the fluorescence. Also see barrier filter.

exciter lamp An incandescent lamp used to transilluminate optical soundtracks in motion-picture-projector sound-reproduction systems.

exciton A hypothetical particle that carries an ab-

normally high level of energy (excitation) through an atomic or molecular system, as by an energy wave.

exhaustion A condition of deterioration in a material resulting from use, aging, contamination, etc., whereby the intended function can no longer be performed. Commonly applied to processing solutions and electrical batteries.

exhibition A display of photographs (or photographic equipment, etc.) for any of a variety of purposes, including education and the promotion of public relations or sales.

exhibitor The owner or lessor of a motion-picture theater.

existing light The normal illumination on a subject or scene as distinct from illumination provided by or arranged by the photographer. A relatively low level of illuminance is usually implied. Syn.: available light.

exitance See emittance.

exit pupil The diameter of an emerging collimated beam of light as limited by the diaphragm opening in an optical system such as a camera lens. The size of the exit pupil is the same as that of the diaphragm opening as seen from the rear of the lens system. Distinguish from entrance pupil (see effective aperture).

EXP In motion-picture photography, an abbreviation for exposed, used especially on the outside of magazines and cans containing exposed film.

expiration date The year and month after which aging effects on a photographic product may be significant. Commonly stamped on packages of film and paper as a warning to the user.

exploded view A photograph of the component parts of an object separated so that each part is visible and correctly oriented in space in relation to its position in the assembled object. Exploded-view photographs are commonly used in repair instruction manuals and in catalogs of equipment parts.

exposure (1) The act of allowing light or other radiant energy to fall on a photosensitive material. (2) Specifically, H, the quantity of light per unit area received by photosensitive materials, commonly expressed as exposure equals illuminance times time ($H = E \times t$, formerly $E = I \times t$). Preferred term: photographic exposure. Often extended to include radiant energy other than light, such as ultraviolet and infrared. (3) Loosely, the time and relative aperture settings used to control the quantity of light or radiant energy received by photosensitive material. Preferred terms: exposure settings, camera exposure settings, and print exposure settings.

exposure calculator A device that converts relevant

exposure data into a form that is more useful to the photographer. Example: that part of an exposure meter which converts data on film speed and light measurement into corresponding combinations of shutter speeds and f-numbers.

exposure-control Identifying a filter that absorbs approximately equal proportions of all wavelengths of light—that is, a neutral density filter.

exposure counter A mechanical device on some cameras, film holders, etc., that indicates the number of frames or sheets of film or other sensitized material that have been exposed or that remain to be exposed.

exposure data (1) Quantitative information concerning illuminance, time, or a combination of illuminance and time in relation to radiant energy received by a photosensitive material. (2) Loosely, the combination of f-number and shutter-speed settings used on a camera to make a specific photograph.

exposure density The logarithm of the ratio of the exposure produced by an ideal white reference (i.e., 100% reflectance at all wavelengths) to that produced by a sample. In this sense, the "exposure" includes the effect of the quality of the light source and the sensitivity of the film. When color film is used, a given patch will have three exposure densities, one each for the red, green, and blue exposures.

exposure effect Any of a group of phenomena associated with the complex response of a photographic material to absorbed light or other radiation. Typically, a photographic emulsion (especially silver halide material) exhibits nonadditivity and nonlinearity. See reciprocity law (failure), Clayden effect, Herschel effect, intermittency effect, Sabattier effect, solarization.

exposure factor In radiography, a numerical quantity equal to milliamperes times time divided by distance squared (for x-rays), and millicuries times time divided by distance squared (for gamma rays). The exposure factor is used, for example, to determine the exposure time required to produce a satisfactory image.

exposure index (EI) A number intended to be used with an exposure meter to determine the camera settings that will produce an image of satisfactory quality. For a given material, exposure indexes may vary with the subject and the desired effect, whereas film speeds are determined in a standard way, usually sensitometrically.

exposure latitude Permissible change in camera exposure, usually expressed in stops, without significant effect on image quality. The change is affected by the definition of image quality, the usable extent

exit pupil

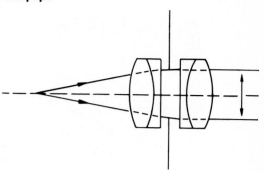

expiration date

DEV. BEFORE OCT. 1971

exposure calculator

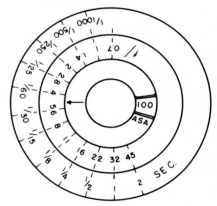

exposure latitude

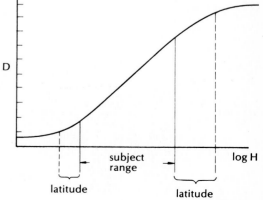

exposure meter

exposure scale

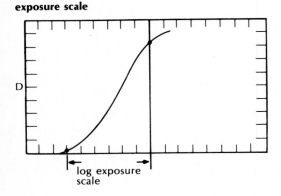

exposure table

extension

of the characteristic curve, and the subject luminance range (contrast). For images of high quality for usual subjects, the latitude in exposure is small with conventional films.

exposure meter A light-measuring instrument designed to provide appropriate time and aperture settings on a camera for a desired exposure effect. (Note: Strictly, such meters measure light only if their response equals that of the human eye in color response. Further, such meters do not measure exposure in the sensitometric sense; they measure luminance or illuminance, depending upon their acceptance angle and calibration.)

exposure range The ratio of exposures that correspond to the minimum and maximum useful densities for a photographic material with specified processing conditions. An arithmetical exposure range of 1 to 100 corresponds to a log exposure range of 2.0.

exposure scale The ratio of exposures that correspond to the minimum and maximum useful densities for a photographic paper with specified processing conditions. An arithmetical exposure scale of 1 to 20 corresponds to a log exposure scale of 1.30 (or a scale index of 1.3).

exposure settings The time (camera shutter speed, darkroom interval timer setting, etc.) and *f*-number used to control the quantity of light or radiant energy received by photosensitive material, e.g., 1 second at *f*/16.

exposure sheet (1) In animation photography, a frame-by-frame analysis used by the cameraman to identify cells, backgrounds, field sizes, etc. (2) In animation photography, an analysis of prerecorded sound, including measurements, to facilitate synchronization with the picture.

exposure table A systematic arrangement of relevant data, such as weather conditions and time of day, designed to enable a photographer to expose film correctly in a camera without directly measuring the illumination.

exposure time The period that light or other radiant energy is allowed to fall on a photosensitive material, commonly measured in seconds and fractions of seconds.

exposure value (E_v) An integer obtained by adding the light value and the speed value in the additive system of photographic exposure (APEX). Expressed in symbol form as $E_v = B_v + S_v$. Since the exposure value also equals the sum of the aperture value and the time value, it is used to determine an appropriate combination of camera aperture and shutter settings.

expressive photography The production of photographs that are intended to communicate the

photographer's thoughts, attitudes, emotions, etc., to the viewer.

extended-range Identifying a type of photographic film having an unusually large exposure latitude, obtained by superimposing two or more emulsions with dissimilar film speeds, sometimes with different spectral (color) sensitivities.

extension Applied to devices that can be attached to a basic camera or other piece of equipment to increase the length of a part or the distance between parts. An extension tube, for example, increases the lens-to-film distance, enabling the camera to be focused on closer objects.

extensity In visual perception, the attribute of a perceived image that is identified with area of the stimulus.

exterior (1) In architectural photography, identifying a photograph of the outside of a building, as distinct from interior. (2) In general, any motion-picture scene or still photograph made outdoors, as distinct from those made in a studio or other indoor location.

external Identifying a built-in exposure (light) meter that measures light through a separate opening on the front of the camera, in contrast to through-the-lens (behind-the-lens) meters, which sample the image-forming light transmitted by the camera lens. A disadvantage of external meters is that they do not compensate for loss of light due to such factors as the addition of filters and increased lens-to-film distance, as do through-the-lens meters.

extinction In visual perception, identifying the point on a stimulus luminance scale below which changes in luminance produce no change in appearance. Shadow detail which is visible on a print viewed in bright light, for example, will not be visible when the print is viewed in dim light if the luminances are below the extinction point. The extinction point varies with the adaption level. Syn.: black point.

extra In motion-picture photography, a performer who appears in a scene for the purpose of creating atmosphere but who has no lines to speak.

extraordinary In doubly refracting crystals, that one of two light rays which does not behave in a way that would be predicted by Snell's Law. The cause is a variation in velocity of light in the crystal with direction, and is the basis for many polarization phenomena. See illustration, page 69.

extrapolate To estimate the quantity for one variable (e.g., developing time) by extending its relationship with one or more other variables (e.g., developer temperature) beyond the ranges established. If a time-temperature graph includes temperatures from 50 to 80 degrees, for example, the time for 90 de-

grees can be estimated — with a considerable risk of error — by extending the line.

extreme In animation photography, a drawing that represents the most critical part of an action sequence, as distinct from in-betweeners, drawings added to complete a sequence.

extrude To form material into a desired cross-sectional shape by forcing it through an opening having the same shape. In the manufacture of film, for example, polyester base material can be formed into a sheet by this process.

eyeballing (slang) Making a judgment on the basis of an unaided visual examination as distinct from an objective measurement, e.g., estimating the exposure time for a print by visually evaluating the density of a negative.

eye camera A motion-picture camera designed to record the movements of a subject's eyes while he is viewing a photograph or other stimulus as in the study of composition or visual perception.

eyecup A flexible ring used on some cameras to form a light-tight seal between the operator's eye and the viewfinder, and to serve as a shock absorber if the camera or the operator is jolted.

eyecup diaphragm A device used on some reflex-type motion-picture cameras to prevent light from entering the viewfinder and fogging the film when the operator's eye is removed from the light seal (eyecup) on the viewfinder. Typically, the device can be opened to permit viewing by pressing the eye against the eyecup.

eyepiece The lens element or group of elements closest to the eye in optical systems designed for viewing, such as microscopes, telescopes, and viewfinders.

eyepoint See eyering.

eyering With a microscope, magnifier, optical viewfinder, etc., the position on the lens axis at which the brightest and sharpest visual image is obtained. Syn.: eyepoint.

extraordinary ray

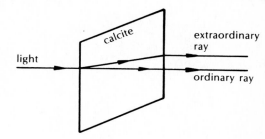

FF

F

F (3)

relative output

F

(M)

100%

50%

10 20 30 40 50 milliseconds

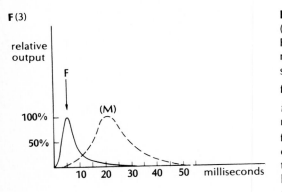

falling front

lens

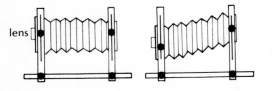

F (1) Fahrenheit, the name of a thermometer scale. (2) Farad, a measure of electrical capacitance. (3) Fast, a designation of flashbulbs that reach their maximum light output about 5 ms (thousandths of a second) after ignition.

f Focal length.

f/ Designation for *f*-number when it is expressed in numerical form, e.g., *f*/16.

face tone The appearance (lightness, hue, saturation) of an area of a subject's face that is illuminated by the main light but that does not include a specular highlight — sometimes used in preference to a gray card as a reference for evaluating and controlling the density and color balance of photographs when (a) it is inconvenient to include a gray card in the original scene, (b) it is impossible to match both tones simultaneously, or (c) it is considered more important to obtain a pleasing effect than an accurate reproduction. When it is not possible to consider individual variations, it is assumed the typical subject is Caucasian with a skin reflectance of about 36%. Syn.: skin tone; flesh tone.

facsimile (1) A copy that closely resembles the original. (2) A copying system using scanning to form electrical signals that can be transmitted over large distances by wire or radio to a place where the scanning process is reversed to re-create the image on photographic paper.

fade (1) To lose quality in a finished image in the form of a change in density, contrast, or color. (2) In motion-picture photography, to make an image gradually appear (fade-in) or disappear (fade-out) by means of a gradual change in lightness and contrast. (3) In sound reproduction, to increase or decrease a sound signal.

fadeback In photomechanical reproduction, an image in which the contrast of subordinate areas has been reduced in order to emphasize the area of interest, which has a normal range of tones.

fade-in (FI) A motion-picture exposure effect whereby an image gradually appears out of a uniformly dark field. The effect can be produced either in the camera or in printing.

fadeometer A device that simulates the long-range effects of sunlight in a relatively short time. Used for testing, as for the permanence of photographic dyes, filters, etc.

fade-out (FO) A motion-picture exposure effect whereby the lightness and contrast of an image gradually decrease until the image disappears into a uniformly dark field. The effect can be produced either in the camera or in printing.

fade-out blue In photomechanical reproduction, a light (blue) color that is visible when used on original copy to indicate margins, etc., but is not visible on the reproduction.

fader A device used to gradually change the volume of an auditory signal or the light intensity of a visual image. Used on motion-picture cameras and printers, for example, to make images gradually appear (fade-in) or disappear (fade-out).

Fahrenheit (F) The name of a thermometer scale on which the freezing point of water is 32 and the boiling point is 212.

fairing In animation photography, calibrations that gradually increase the increments in starting an action from a stop, or vice versa.

fake color Identifying a multiple-color image produced from a monochrome photograph by any of a variety of techniques.

falling (front, or **back)** On a view or other camera, an adjustment permitting the photographer to lower the lens holder or the film support to modify the cropping of the image without tilting the camera

(which would affect the parallelism of vertical subject lines). This adjustment is typically combined with a rising adjustment and referred to as a rising-falling front or back.

false color Identifying color reproduction processes in which the usual analysis-synthesis color relationships have been altered to obtain unrealistic reproduction of certain subject colors. Applications include achieving unusual pictorial effects, detecting plant disease, detecting camouflage, etc. See infrared color film.

fan A device to circulate air, used to prevent overheating in a projector, to facilitate removal of moisture from photographic materials in a dryer, etc. Syn.: blower.

farad (F) A unit of electrical capacitance equal to the change in the number of coulombs of charge per volt of change of potential. The application is to battery-capacitor electrical equipment used for electronic flash.

far distance In depth-of-field calculations, the distance to the farthest object that is imaged with sufficient sharpness.

far point The most distant object from the camera lens that is sufficiently sharp when the lens is focused for a given (different) distance.

Farmer's reducer A solution of potassium ferricyanide and sodium thiosulfate (hypo) used to lower the density of silver images.

fashion photography The specialization of making photographs of clothing and accessories, usually on a model, for any of a variety of purposes, including advertising and editorial.

fast Applied to (1) photosensitive materials having relatively high-speed emulsions; (2) lenses having small f-numbers; e.g., an $f/1.4$ lens is faster than an $f/2.8$ lens; (3) shutters having maximum speeds of relatively short duration; e.g., a 1/1,000-second shutter is faster than a 1/500-second shutter; (4) developers or other solutions requiring relatively short processing times; (5) colored substances relatively resistant to fading.

fast forward In motion-picture photography, the operation of a camera, optical printer, projector, etc., at a more rapid than normal rate to reach a desired position on the film quickly.

fast motion A special effect in motion-picture photography whereby action on the screen is more rapid than it was originally. Obtained by operating the camera at a slower than normal number of frames per second, by omitting frames at regular intervals in printing, or by operating the projector at a faster-than-normal number of frames per second. The opposite of slow motion.

fatigue (1) A reduction in sensitivity of a photoelectric cell following prolonged exposure to strong illumination; usually a temporary condition. (2) In electrophotography, failure of a photoconductive surface to operate effectively after considerable use.

fc Footcandle, a measure of illuminance.

feather (1) In portrait lighting, to aim a light source slightly in front of (rather than directly toward) the subject, thereby reducing the illuminance on the side of the face to a greater extent than on the front. This, in turn, increases the tonal gradation and the appearance of depth on the subject's face. Feathering is also used to reduce the general illuminance, to achieve a desired lighting ratio, or to alleviate the subject's discomfort. Also see spill. Syn.: edge. (2) In making a mosaic or pasteup, to reduce the thickness of print edges, commonly by abrading the base side. (3) In animation photography, to gradually increase the increments in starting an action from a stop, or vice versa.

feature (1) The main film in a motion-picture program in which two or more films are shown. (2) A picture, or two or more related pictures, given more than normal space or emphasis in a publication.

Fechner's fraction $\triangle B/B$, where B is luminance and $\triangle B$ is the smallest increase in luminance that can be detected. This ratio remains approximately constant at relatively high values of luminance, but increases for small values of luminance and for small-field angles.

Fechner's law An application to vision of the Weber law, stating that an arithmetic increase in sensation requires a logarithmic increase in the stimulus. A gray scale having equal density decrements (log luminance increments) between steps should be perceived as having equal increments in lightness. Also known as the Weber-Fechner law. Also see Fechner's fraction; Weber's law.

Fechner's paradox After accommodation of the eye to a small bright source, the addition of a second, less-bright source, placed so that the image falls on a different area of the retina, causes the pupil to enlarge even though the total amount of light has increased.

Fédération Internationale de l'Art Photographique (FIAP) An organization concerned with amateur photography, with affiliates in a number of countries.

feed Applied to a reel, spool, or other holder used to supply a piece of equipment with material such as film or paper.

feather (1)

feather (2)

feedback Identifying a sound-reproduction or other system in which some of the output energy is returned to the input for the purpose of modifying the response of the system. Feedback is sometimes unwanted, as in public-address systems.

feet per second (fps) A measure of the rate at which film moves through a processor.

female Applied to an electrical connector with one or more cylindrical cavities to accept pins on the male portion of the connector.

female matte One of a pair of complementary traveling mattes, the reverse of the male matte. The designation is usually arbitrary, but often the female matte blocks out the outer portions of the scene. Also see black-core; white-core.

Fermat's principle When light travels from one point to another, regardless of the number of refractions or reflections which take place, the time of transit between these two points for the actual ray is a minimum. This principle serves as a basis for the law of rectilinear propagation. Exceptions to the principle as stated are found in an ellipsoidal mirror, where all paths are equal, and in a spherical mirror, where the actual path is a maximum. Mathematically, Fermat's principle requires that the first derivative of the equation for the optical path be zero.

ferricyanide See potassium ferricyanide and Farmer's reducer.

ferroprussiate Identifying a photographic printing process that uses light-sensitive iron compounds and produces blue-and-white images. Used largely for making negative copies of line originals. Syn.: blueprint; cyanotype.

ferrotype A process for producing glossy surfaces on photographic prints by drying them with the emulsion side in intimate contact with a highly polished surface.

ferrotyping A defect consisting of nonuniform glossy areas on the surface of color roll film wound under tension, sometimes accompanied by adhesion. A similar defect on non-glossy photographic prints that have been framed with the print touching the glass.

Ferry-Porter law The minimum frequency at which intermittent visual images fuse is approximately proportional to the logarithm of the area times the luminance.

festoon In manufacturing photographic paper, a formation of multiple loops of paper used to facilitate drying before winding onto a core.

FF Flare factor.

FI Fade-in.

festoon

FIAP Fédération Internationale de l'Art Photographique.

fiber optics A flexible device consisting of a bundle of threadlike pieces of glass or plastic that conduct light by means of total internal reflection, so that an image formed at one end will emerge from the other end even though the bundle is curved. Used to illuminate, examine and photograph interior surfaces that are not otherwise accessible. See light pipe.

fidelity In photofabrication, the degree of accuracy of a reproduction in representing the shape of the original image.

fiducial marks Visible signs, such as crosses, used as stable reference points in some optical systems.

field (1) The entire subject area seen through an optical viewing device or imaged within a specific format for viewing or recording. Syn.: field of view (FOV). (2) The entire subject area imaged within the circle of good definition of a lens. (3) The object space within which objects are imaged with acceptable sharpness. The range between the near and far limits is identified as the depth of field (DOF). (4) The imaginary surface that represents the best focus for each point of a flat object perpendicular to the lens axis. The surface is curved with simple lenses, and the phenomenon is identified as curvature of field. (5) In television, one of two scans of the scene that are interlaced on the viewing screen.

field flattener An optical device, such as a lens or assemblage of fiber optics, intended to convert a curved focal surface into a plane one.

field guide In animation photography, a sheet of transparent plastic or a frame that contains scales for measuring subject dimensions.

field-ion Identifying a microscope that produces greatly magnified images with ions of an inert gas that travel away from a highly-charged specimen in a straight line until they strike photographic film or a fluorescent screen. The field-ion microscope is capable of greater magnification than the electron microscope, and can form images of individual atoms.

field lens (1) A positive lens placed near the focal plane of an optical system to enable the viewer to see a larger area of the image or to provide an image of more uniform brightness. Can be either a planoconvex or a Fresnel lens. (2) In an optical system, that lens (or set of lenses) which is nearest the subject. In photomicrography, the field lens is the microscope lens assembly nearest the slide. Syn.: objective lens.

field tilt A lens defect characterized by a lack of parallelism between the best image plane and the

positioning surface of the lens mount.

field range In animation photography, the smallest and largest subject areas (fields) that can be photographed by a camera on a given stand, typically specified as the widths, in inches, of the two extreme fields.

figure (1) Identifying photography of the human body, commonly unclothed, with an emphasis on esthetic factors. Such photographs are frequently referred to as figure studies. (2) In the study of perception, any stimulus of interest as distinct from ground, the perceptual field in which the figure is located. Related to a photograph, the figure corresponds with the subject, while the ground corresponds with the surround or the background and foreground. (3) A reproduction of a photograph or other image in a publication. Such illustrations are commonly numbered (e.g., Fig. 10) to assist in directing the reader's attention to each image at an appropriate place in the text.

filament A threadlike conductor in incandescent lamps that produces illumination when heated by the passage of an electric current.

filamentary Identifying developed silver that appears threadlike when greatly magnified, for example, by an electron microscope.

file A storage device in which negatives, prints, etc., can be placed, usually arranged systematically, for protection and convenient reference.

fill light (fill-in) A light source or a reflector used to illuminate the shadows created by the main light, thereby reducing the lighting ratio.

filler An illustration (e.g., a photograph) or text material used primarily to occupy space that is blank after the more important material has been included in the layout for a publication.

fillet In photofabrication, unwanted rounding of the image at the juncture of lines or edges.

film (1) A flexible, transparent support coated with photosensitive material. (2) A completed motion picture ready for showing. (3) A thin layer of material on a surface, such as an antireflection coating on a lens. (4) (verb) In motion-picture photography, to record a scene on film. (5) Cinematography.

film badge A light-tight film holder designed to be worn on clothing for the purpose of detecting and measuring harmful radiation.

film barrel A large container with an open top used in editing motion pictures to catch film that is not wound onto a takeup reel. Syn.: cutting barrel; editing barrel.

film base Flexible, transparent, sheetlike material used to support one or more emulsion layers in photographic film, commonly composed of cellulose acetate or a polyester.

film cement A liquid adhesive used to join separate pieces of motion-picture film to form a continuous strip.

film chamber The enclosed part of a motion-picture camera that contains the film, gate, and pulldown mechanism.

film cleaner A volatile liquid used to remove foreign material from the surfaces of processed photographic film. The vapors of such liquids are often toxic.

film clip (1) A gripping device used to hold film during processing or drying. (2) A section of film removed from a motion picture during editing. By extension, any short length of processed motion-picture film.

film festival A special showing of a number of motion pictures that typically are related with respect to one or more factors (time of production, producer, actor, dominant theme, etc.), usually sponsored by a motion-picture organization for any of various purposes, including judging and presenting awards, raising money, entertainment, education, and creating publicity.

film gate A mechanism in motion-picture cameras, printers, projectors, and similar optical devices that holds photographic film in a precise plane and delimits the area of illumination at the time of exposure or projection. Syn.: gate.

film hanger A device, usually a rectangular frame, designed to hold exposed photographic film during processing.

film holder A light-tight device designed to be loaded with film and attached to a camera so that the film is correctly positioned for exposure after removal of a dark slide or other protective covering. A wide variety of such devices is produced for different cameras, photographic materials, and applications. Film holders are often identified more specifically, as roll-holders, sheet-film holders, film-pack holders, etc.

film jacket A transparent envelope or sleeve used for storing microfilm frames or strips.

film leader A strip of film or other flexible material used for threading a camera, processor, printer, projector, etc. Opaque leaders are also used as protective light seals on unprocessed film.

film loader (1) Any of a variety of devices designed to assist in inserting film into cassettes, reels, etc. (2) A person who has the responsibility for putting unexposed film in a magazine, etc., and for removing exposed film.

figure study

N. Montanus

film notches (1)

film plane

filter layer

color film

before processing after processing

film lubricant Material used on motion-picture film to reduce friction during projection.

film magazine See magazine (2).

film noise Defects in sound recording caused by image granularity (nonuniformity) or physical imperfections in the recorded image.

film notches (1) On sheet films, indentations along one edge that can be felt in the dark to identify the type of film and the emulsion side. (2) On motion-picture films, indentations at appropriate locations along an edge for any of a variety of purposes, including providing cues or instructions for editing or printing, and locating damage. Syn.: for both (1) and (2), edge notches.

filmograph A semianimation technique, typically involving the copying of still photographs on motion-picture film using camera movement, zooms, pans, fades, and dissolves to create the illusion of action. Syn.: ikonograph.

film pack A light-tight assembly generally containing 16 separate pieces of thin-base photographic film with paper tabs attached to one end, arranged so that pulling the protruding tabs in sequence first moves the opaque paper cover and then each film, following exposure, from the focal plane to the back of the unit.

film packet A light-tight envelope typically containing radiation-sensitive material for a single exposure.

film phonograph In motion-picture photography, a playback device used to reproduce the sound of a film recording.

film plane The position occupied by the emulsion side of film at the time of exposure, projection, etc. A mark locating the film plane is placed on the outside of some cameras to facilitate making accurate measurements, especially film-to-subject distances in closeup photography.

film register A protruding part on a camera, projector, printer, etc., that fits into a film perforation to aid in the correct placement of the film.

film-scratch test In motion-picture photography, the procedure of running a short length of film through a camera and inspecting it for abrasion marks before exposing the entire roll.

filmsetter In photomechanical reproduction, a device that sets type by exposure on a sensitive material from a negative of type characters or other symbols. Syn.: photographic typesetter; photocomposing machine.

film speed (1) A number intended to be used with an exposure meter to determine the camera settings that will produce an image of satisfactory quality, e.g., ASA 125. Also see speed and exposure index. (2)

The rate of movement of motion-picture film through a camera, projector, etc., typically measured in frames per second. The standard sound speed, for example, is 24 frames per second.

filmstrip A coordinated series of photographs on a strip of film that is viewed by projection as a sequence of still pictures.

film transport A system or mechanism for moving film into and out of a specified position in a camera, projector, processor, printer, editor, etc.

filter (1) A layer of more or less transparent material used to modify the quality or quantity of radiation. Three basic types of modifications are selective absorption by wavelength (color filters), nonselective absorption by wavelength (neutral-density filters), and selective absorption by angle of polarization (polarizing filters). More specifically identified as optical filters. (2) A material (paper, etc.) or device used to separate solid particles from a fluid. (3). Also see spatial filter.

filter factor A multiplying number used to compensate for the absorption of radiant energy (light) by a filter. Specifically, the exposure time is multiplied by the number when a filter is added, or an equivalent change is made in the relative aperture. The intent is to reproduce neutral (gray) tones in the image in the same way with as without the filter. Since there is sometimes a contrast change in the image, a fixed density value is often used, such as 0.6. The value of the filter factor will vary with the quality (color) of the light source, the type of film and the development conditions, among other factors.

filter layer A thin coating of colorant in some photosensitive films for the purpose of absorbing certain wavelengths of light. A yellow filter layer between emulsions in some color films, for example, absorbs blue light, thereby preventing unwanted exposure of the red-record and green-record emulsions.

filter pack A combination of two or more filters superimposed for use in an optical system. Example: color-compensating filters used in a projection printer to control the color balance of color prints.

filter paper Inert, porous paper used to separate solid particles from a fluid.

filter ratio The proportional relation of the factors for two or more filters. Commonly used with color-separation filters.

filter slot A narrow opening behind the lens of a motion-picture camera, in a matte box, etc., designed to accept filters that then become part of the optical system.

filter wheel A circular or cylindrical device that rotates to bring different filters into position (e.g., in

the optical system of a projection printer, or in front of a spotlight) for the purpose of altering the color quality of the illumination. Syn.: color wheel.

final mix A motion-picture composite soundtrack, possibly including dialog, commentary, music, and effects, as it will be recorded on the finished film.

finder A viewing device on a camera designed to show the subject area that will be recorded on the film. Also known as viewfinder.

fine arts A general term for expressive disciplines characterized by a concern for the esthetic significance of that which is produced. Traditionally including painting, sculpture, architecture, and music. In recent years there has been a growing trend to include photography.

fine cut In motion pictures, a late stage in the editing process where careful attention is given to minor changes.

fine grain A master positive motion-picture film used to produce duplicate negatives.

fine-grain Applied to films or developers that tend to produce images of relatively low granularity; and to the resulting images.

fine-grained Identifying ground glass, photographic paper, or other material having a relatively smooth-textured surface.

fine-line Identifying a technique for making reproductions of line originals that produces better reproduction of thin lines and small details than conventional procedures. Specially formulated developers and no agitation after the first short time interval are often used with high-contrast films for this purpose.

fingerprint A defect resulting from touching a photographic material. Touching an emulsion before it is processed may result in either raised or lowered density in the areas of contact, whereas touching processed materials may deform the surface of the gelatin or leave a deposit that may be visible or that may react chemically with the image.

fingerprint camera A fixed-focus camera with built-in lights used to photograph fingerprints and other small objects.

finish Surface characteristics of photographic paper, specifically texture, gloss, and tint.

finishing Procedures following processing for preparing a photographic print for display or other use, e.g., ferrotyping, mounting, and spotting. See after-treatment.

fire To activate a flash lamp or electronic flashtube, typically by closing an electrical circuit. Mechanical activation is used on flashcubes that contain impact-sensitive material.

fire shutter (1) A protective panel automatically inserted between the light source and the film in some motion-picture projectors to prevent heat damage when the film is stopped or is run at a slow speed. Syn.: automatic shutter. (2) An incombustible panel suspended by a fusible link over the port in a motion-picture projection room, designed to contain a fire within the room.

first-generation As applied to an image, one step away from the original. The original may be a subject or, in copying contexts, a photograph. Thus, a first-generation copy would be a reproduction of the original photograph.

first nodal point See front nodal point.

first team The essential people involved in the production of a motion picture, including the actors and crew.

first unit In motion-picture production, that group of persons (cameramen, director, etc.) responsible for the photography of interior scenes, as contrasted with the second unit, which photographs backgrounds, exteriors, etc.

fisheye lens An extreme wide-angle lens, having an angle of coverage of approximately 180 degrees, and typically producing circular photographs with marked barrel distortion.

fisheyes Optical inhomogeneities in film base.

fishpole A lightweight rod used to hold a microphone over a scene being photographed, for the purpose of recording dialog, etc.

fix (1) To remove undeveloped silver halides from photosensitive materials to make the images permanent. (2) In electrostatic photography, to cause the toner to adhere to the substrate by heating.

fixative A liquid that produces a thin, transparent protective coating when applied (typically by spraying) to the surface of a photograph or other image.

fixed-focus Applied to cameras and other optical instruments on which the position of the lens is established by the manufacturer and cannot be altered by the user, as with some aerial, fingerprint, data-recording, and amateur cameras. Such instruments are intended to be used under standard distance conditions or they have sufficient depth of field to permit distance variation. Fixed-focus amateur cameras are typically focused on the hyperfocal distance so that objects from half that distance to infinity are sufficiently sharp.

fixer A solution of sodium thiosulfate or other silver halide solvent used in processing photosensitive materials to make the images permanent. Syn.: fixing bath; hypo.

fL Footlambert, a unit of luminous emittance.

flag

flap

flare

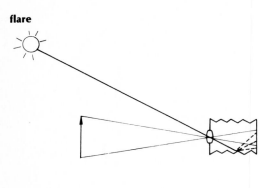

flare curve

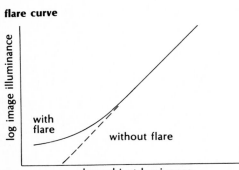

log image illuminance

with flare

without flare

log subject luminance

flag An oblong opaque or translucent panel, usually mounted on a portable boom stand, used to shade selected areas of the subject to obtain a desired lighting effect or to protect the camera from light that could cause flare or fog. Syn.: cutter; gobo.

flange A ring, rim, or the like used to hold an object in place. Examples: the ring used to hold a lens on a lens board; the rim at each end of a film spool.

flange focal distance The distance from the best axial focus of an infinitely distant object to the positioning surface of the lens mount.

flap A sheet of kraft paper, tissue paper, cellulose acetate, etc., placed over a mounted photograph or other artwork and hinged at the top so that it can be lifted from the bottom to uncover the artwork. Flaps are used for various purposes, sometimes in combination; kraft paper is typically used for protection, tissue paper for comments and instructions for changes, and cellulose acetate for protection, instructions, or the addition of callouts, etc.

flare Non-image-forming light in a camera or other optical system due to the reflection of light from lens surfaces, interior surfaces of the mechanism, etc., causing an overall or local decrease in contrast and increase in illuminance of the image. The effect of flare is most noticeable with backlighted subjects.

flare curve A graph obtained by plotting the logarithms of subject luminances and the logarithms of corresponding image illuminances, including both image-forming and non-image-forming (flare) light.

flare factor The ratio of subject luminance scale to the corresponding image illuminance scale. Since non-image-forming (flare) light reduces the image illuminance scale, the factor in practice is always larger than 1.0. For the average outdoor scene, if the flare factor is 2, the scene luminance range of 160 would be reduced to a range of 80 for the image.

flare spot Applied to a poorly-defined but generally circular area of illumination or the corresponding effect on a photograph which is caused by multiple reflections between lens surfaces. Areas which are well-defined, resembling the shape of the limiting aperture, for example, are known as ghost images.

flash (1) A sudden surge of light of brief duration. (2) Shortened form of the terms flashbulb, flash lamp, electronic flash, etc. (3) Identifying a photograph, equipment, etc., associated with illumination as defined in (1), e.g., flash photography. (4) Identifying a supplementary exposure to non-image-forming light for the purpose of altering the density or contrast of an image. Used as a basic control in making halftone negatives and positives in photomechanical reproduction processes, and as a special

control in projection printing. (5) The perception of a sudden surge of light of brief duration which in visual perception is identified as a pulse.

flashback A scene or sequence in a motion picture that portrays an earlier period of time than that established for the immediately preceding scene. Compare with flashforward.

flashbulb A light source consisting of a sealed glass housing containing a combustible material in an atmosphere of oxygen, which is ignited by an electrical current through a filament to produce a single pulse of light of brief duration and high intensity. Distinguish from electronic flash, which involves a high-voltage electric discharge through an inert gas, and which may produce many thousand pulses of light. Syn.: flash lamp; photoflash lamp.

flash cord The electrical wire that links a flash or electronic-flash unit to a camera shutter. Syn.: sync. cord.

flashcube A small, boxlike nonreusable flash holder containing four tiny flashbulbs and reflectors. Flashcubes are rotated during use on a camera so that each flashbulb is aimed toward the subject when it is fired. See illustration, page 77.

flash cut In motion-picture photography, an abrupt transition from one scene to another with an immediate abrupt return to the original scene. The second scene may be as short as a few frames lasting only a fraction of a second, sometimes in the subliminal region of perception.

flashed opal Identifying a type of diffusing glass consisting of clear glass coated on both sides with grainless translucent material. Used in illuminators, etc., to obtain uniform illumination.

flash exposure See flash (4).

flashforward (flash forward) A scene or sequence in a motion picture that portrays a future period of time, showing something that will happen or that could happen. Compare with flashback.

flash frame In motion-picture photography, an incorrectly exposed image at the beginning of a scene, caused by inability of the camera to reach full operating speed instantaneously, or occurring at the end of a take when the camera stops with the shutter partially or totally open.

flashguard A transparent device designed to be used in front of flashbulbs to contain flying glass in the event a bulb explodes.

flashgun An electrical device designed to hold and ignite flashbulbs, normally equipped with a reflector to control the distribution of the light.

flashing A printing technique in which the photographic paper, or areas of it, are exposed to light

that has not passed through the negative. Used to darken edges, to lower contrast, etc.

flash lamp See flashbulb.

flash pan A special effect in motion-picture photography obtained by moving the camera rapidly at the end of a scene, the resulting blurred image serving as a transition to the next scene, as distinct from a dissolve, wipe, cut, etc.

flash synchronizer A device to coordinate the timing of the opening of a shutter and/or the closing of an electrical circuit so that light from a flashbulb or flashtube can be used to expose film in a camera at various shutter speeds.

flash title A title that occupies one frame in a motion-picture original film. Used solely as a guide for the cutter, who will insert a full-length title.

flashtube The light source in electronic-flash units, which repeatedly produces flashes of light of high intensity and short duration by electrical discharges through an atmosphere of xenon or other inert gas.

flat (1) Having lower-than-normal contrast; variously applied to subjects, lighting, negatives, prints, etc. (2) A panel used primarily in studios and sets as a background, wall, reflector, etc. (3) A sheet of glass, plastic, or paper used to hold halftone and line negatives in position during exposure of photomechanical printing plates. (4) Level. Not curled or buckled. (5) With "optical," a surface that departs from a truly plane surface only to the extent of a few wavelengths of light or less.

flatbed Identifying a type of view camera or other large-format camera having a broad base typically equipped with dual focusing tracks, as distinct from a monorail camera.

flat copy In photomechanical reproduction, a two-dimensional original image.

flattener A device or material designed to reduce the tendency of photographic prints to curl, usually by controlling the moisture content and/or by applying a reverse curl or other form of pressure. Hygroscopic substances (e.g., glycerin) are used as the basic ingredient in print-flattening solutions.

flat tone In photomechanical reproduction, an area having dots of uniform size. In photographs, an area having uniform density.

flesh tone See skin tone.

flexography A photomechanical reproduction process that uses a rubber plate with a relief image. The process is commonly used for packages because of its ability to print on a variety of materials.

flicker The perception of a rapid variation in brightness when viewing a motion picture. Persistence of vision prevents flicker with appropriate values of image frequency and luminance (e.g., the standard sound frequency of 24 frames per second with conventional projection conditions).

flicker blade An extra closed sector on a motion-picture projector shutter that interrupts the projection of each frame for the purpose of improving fusion of the separate images.

flicker photometer A device for the visual comparison of two light sources of different spectral-energy distribution (color). The observed luminances are equal when the brightness flicker disappears. A frequency is selected that is above the critical fusion frequency for hue differences but below the critical fusion frequency for brightness differences.

flicks Slang term (derived from flicker) for motion pictures, especially those produced for entertainment.

flight strip A sequence of overlapping aerial photographs.

F-line Radiation having a wavelength of 486.1 nm, one of three wavelengths used in the computation of dispersive power. Also see C-line and D-line.

flint One of numerous types of glass used in manufacturing lenses, characterized by a moderately higher index of refraction and a considerably higher dispersive power (lower ν-value) than crown glass.

flip bar An auxiliary set of register pegs on an animation stand, hinged to the tabletop so that it can be brought into operating position when required.

flip card A title on loose-leaf rings or a similar arrangement, so that it can be quickly moved out of the way to reveal the next title.

flipover wipe In motion-picture photography, a transition between scenes in which the first scene appears to revolve about an axis to reveal the second.

flipping A manual method of looking at a series of drawings in rapid sequence, used by animators to analyze the movement.

float In motion-picture photography, a lack of steadiness of the projected image due to inconsistent positioning of the film in the camera gate during exposure or the projector gate during projection.

floating mark In photogrammetry, an artificial reference perceived as occupying a position in three-dimensional space when a pair of stereoscopic photographs is viewed.

floating lid A processing-tank cover that fits inside the tank and rests on the surface of the contained liquid, thereby reducing evaporation and oxidation.

floating pegs A set of registration pegs on an anima-

flashcube

flash lamp

flashtube

tion stand, designed with clearance underneath so that artwork can be passed through freely.

floating platen A framed glass device used to hold animation drawings flat on an animation stand, designed to allow drawings and backgrounds to pass underneath without interference.

flood (1) Shortened form of flood lamp or floodlight. (2) An adjustment position on a spotlight where the light is spread out over a relatively large area, as distinct from the spot position.

flood lamp See floodlight.

floodlight An electrical device designed to hold an incandescent lamp, electronic-flash tube, or other source of light and to reflect the light diffusely over a relatively large angle. Additional diffuseness is obtained by using a frosted or opal lamp and by adding an opaque deflector or translucent diffuser in front of the lamp. Syn.: flood; flood lamp.

floor In motion-picture photography, the shooting area of a studio stage.

floor plan A diagram of a motion-picture, television, or other set, used in planning a production.

flow camera A camera used to record documents, etc., in which the original and the film are in synchronized motion during exposure. Compare with planetary, a similar camera but involving documents at rest during exposure. Syn.: rotary camera.

flow chart A diagram that indicates the time sequence of a set of operations such as the processing of photographic color prints.

flow photography The specialization of making photographs of the movements of fluids. Example: in aerodynamics, air moving past an airplane wing.

fl oz Fluid ounce.

fluid Identifying a tripod head that utilizes hydraulic means for damping irregularities of movement.

fluid ounce (fl oz) A measure of volume equal to 1/16 pint or about 29.6 ml.

fluorescence A phenomenon whereby certain substances emit light during absorption of invisible short-wavelength radiant energy (e.g., ultraviolet, x-ray, or electrons), or convert light energy of one wavelength to a longer wavelength (e.g., blue to green).

fluorescent Identifying dye, ink, or other material that emits light when exposed to invisible short-wavelength radiation, or that converts a wavelength of light energy to a longer wavelength. (Also see Stokes' law.) A fluorescent material is added to some photographic papers to make the white areas on the print appear lighter. Many minerals and other substances fluoresce; this behavior can be used to advantage in photographic applications.

fluorescent lamp A light source in which light and invisible (ultraviolet) radiant energy are produced by electricity flowing through mercury vapor. Material (phosphor) coated on the inside surface of the transparent tube converts the ultraviolet radiation into light. The spectrum of such lamps contains, besides the continuous spectrum of the phosphor radiation, the four wavelengths typical of the mercury radiation.

fluorescent photography The process of recording images with the light emitted by certain materials when exposed to ultraviolet or other invisible short-wavelength radiation. A filter is used over the camera lens to prevent the invisible radiation from reaching the film and obscuring the fluorescent effect.

fluorography The specialization of making photographs of visible images formed on fluorescent screens when exposed to x-ray or other invisible short-wavelength radiation.

fluoroscopy The process of converting invisible x-ray images to visible images with a fluorescent screen for the purpose of visual examination, as distinct from fluorography, which involves recording the image photographically.

fluorspar Identifying a type of lens used for ultraviolet photography. Fluorspar lenses are transparent to ultraviolet radiation down to about 120 nm as compared to 180 nm for quartz lenses and 300 nm for conventional glass lenses. Also see germanium.

flush (1) (adj) Even, as, for example, the edges of two or more halftone reproductions that are aligned on a page. (2) (verb) To overflow with water, usually to remove chemicals. For example, during chemical reduction of a print, the action of the reducer can be stopped quickly by flushing the print surface.

flutter (1) A rapid variation in pitch or intensity of reproduced sound due to irregularities in movement of motion-picture film or other sound-recording medium. Flutter involves a faster variation than does wow. (2) An erratic variation in brightness of a projected motion-picture image, typically due to exposure variations in the camera or printer. Also known as picture flutter.

flux The rate of flow of energy. Luminous flux is the rate of flow of light and is usually measured in lumens. Radiant flux is the rate of flow of radiant energy and is evaluated by a (hypothetical) measuring device that responds equally to equal powers of any wavelength of electromagnetic radiation. (No equal-response device exists, except approximately, and over a limited range of wavelengths.)

floodlight

flush

flux density The rate of energy flow to (or from) a small area of a surface, divided by that area.

flying-spot scanner An image-forming device using a beam (electron, light) that systematically moves over an area. Variations in intensity of the beam form an image through local variations in exposure of a photosensitive material or a fluorescent screen, e.g., in electronic printing and in a television picture tube respectively.

flywheel A disk having sufficient weight to resist sudden changes in speed of rotation. Used, for example, on some magnetic sound-reproduction units to stabilize movement of film or tape at the recording and replay heads.

f-number A number (f/16, for example) obtained by dividing the focal length of a lens by the effective aperture, used to control the amount of light transmitted by a lens. (The image illuminance is inversely proportional to the square of the f-number. The required exposure time is directly proportional to the square of the f-number.) Selected f-numbers, usually representing the maximum aperture and consecutive whole stops, are normally printed on the lens mount. Syn.: relative aperture.

FO Fade-out.

foam A group of bubbles. In emulsion coating, such bubbles can interfere with the formation of a uniform emulsion layer. In processing, such bubbles clinging to the surface of the photosensitive material can prevent the solution from acting upon the emulsion. Syn.: froth.

focal length The distance from the best axial focus of an infinitely distant object to the rear nodal point of a lens. Preferred term: equivalent focal length.

focal plane (1) A hypothetical flat surface in image space that represents the focus of an infinitely distant flat object surface perpendicular to the lens axis. (2) A hypothetical flat surface in image space that represents the focus of a flat object surface at any distance and at any angle to the lens axis. Definition

(1) is identified as the principal focal plane. Syn.: image plane.

focal-plane (1) Applied to any shutter utilizing a strip of opaque, flexible material that is located close to the film plane and contains one or more apertures. The time of exposure is determined by the longitudinal width of the opening and the speed of movement of the strip across the film. (2) (FP) Designation of flash lamps having a comparatively long flash duration, intended for use with cameras equipped with focal-plane shutters.

focal point (1) A position in image space that represents the image of an object point. The principal focal point is defined as above, with the object at infinity and with the image formed on the lens axis. (2) In composition, the position in a photograph or other image that has (or is assumed to have) the strongest attraction for the viewer's attention .

focal spot In radiography, the area on the target of an x-ray tube within which electrons from the filament are focused. Since the sharpness of the image decreases as the size of the area increases, a small focal spot is desirable.

focal tilt In a camera or other optical system, the angle between the image plane of best definition and the plane of the ground glass, film, or other receiving surface.

focus (1) The place at which rays of light from an object point meet to form a minimum circle of confusion, or appear to form the sharpest image. In the case of a virtual image, the place at which diverging rays of light would meet or form a minimum circle of confusion if extended in the opposite direction. (2) To alter the image distance and/or object distance to obtain the sharpest image.

focusing (1) Applied to a scale, magnifier, cloth, hood, or other part of an optical device or accessory used for the purpose of obtaining a sharp image. (2) The procedure of altering the image distance and/or object distance to obtain the sharpest image.

focal plane (2)

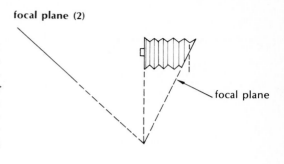

focal plane

focal point (1)

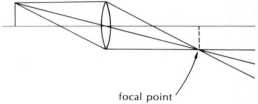

focal point

focusing (1)

camera focusing magnifier

projection printer focusing magnifier

f-number

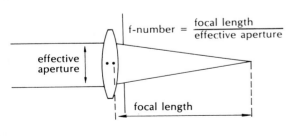

$$f\text{-number} = \frac{\text{focal length}}{\text{effective aperture}}$$

effective aperture

focal length

focal length

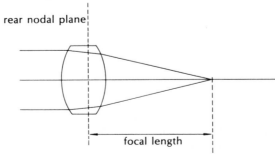

rear nodal plane

focal length

focusing scale

focusing cloth

focus shift (3)

focus shift

folded optics

correcting lens

curved mirror

mirror

image

folder

foot switch

focusing cloth A piece of opaque fabric or other flexible material that is draped over a photographer's head and part of a camera to protect the ground glass from extraneous light, thereby making it easier to examine the image.

focusing distance Object distance; the linear separation of the subject from the front nodal plane of a lens.

focus shift (1) Failure of a variable-focal-length lens to remain locked in on a given object distance as the focal length is changed. (2) In a lens not fully corrected for aberrations, a change in the position of the best-defined image with a change in the aperture (due to spherical aberration), or with the addition of a filter (due to chromatic aberration. (3) In general, a change in the position of the best-defined image due to any of various causes, including loose-fitting mechanical parts in the focusing system, a change in the position of film in a projector, and the addition of refracting material (such as a glass plate or filter) to an optical system.

fog (1) Density in processed photosensitive materials that is not attributable to the action of image-forming radiant energy. The two major types are light fog and chemical fog. Although fog is generally considered a defect, it is essential to some reversal processes and is used to alter image density and contrast in halftone negative making and photographic printing. (2) In photoresists, the adherence of the resist in areas of no exposure. (3) An atmospheric condition consisting of a cloud-like suspension of small water droplets near the surface of the ground. Light from objects photographed in fog is scattered, reducing contrast and definition of the image, although the effect is sometimes pictorially pleasing.

fog filter A diffusion device used in front of camera lenses to simulate mist.

foil A very thin and flexible sheet of metal. Aluminum foil, for example, is used in both smooth and wrinkled forms to reflect light.

folded optics An image-forming system that uses curved or plane mirrors, typically in combination with glass elements, to reverse the direction of light along the optical axis, thereby producing a compact optical system.

folder A type of mount for photographic prints, usually made of lightweight cardboard with the base sheet creased in the middle to form a book-like cover.

folding camera A hand camera equipped with a collapsible bellows for compactness and a hinged cover to protect the lens.

folding test A standardized procedure for bending photographic paper or other material until it breaks, typically to obtain information for quality control or research purposes.

folio (1) A support, with adhesive bands, for microfilm strips. (2) A sheet of paper folded to form four pages (two leaves), usually containing images and/or printing, used either as a unit or as a part of a book or other compilation.

follow focus The procedure of maintaining a sharp image in a camera by continuously adjusting the lens-to-subject distance.

follow shot In motion-picture photography, a take made from a moving vehicle so that the image of a moving subject remains unchanged in size.

food photography The specialization of making photographs of food and beverages, usually either prepared for consumption or in the process of being prepared, for any of a variety of uses, including advertising and editorial.

foot A unit of length; one-third of a yard. It is divided into 12 inches and is equal to 30.48 centimeters.

footage In motion-picture photography, film that has been exposed.

footage counter (1) A device on a motion-picture camera that indicates the amount of film (in units of feet) that has been exposed or that remains to be exposed. Some cameras also have a frame counter for more precise measurement. (2) A device used in cutting rooms to measure lengths of motion-picture film.

footcandle (fc) A unit of illuminance equivalent to that received by a point on a curved surface, all points of which are at a distance of 1 foot from a point source of light with an intensity of 1 candela.

footlambert (fL) A unit of measure of the luminous emittance into a hemisphere from one square foot of radiating or reflecting surface. For a reflecting surface, the number of lamberts is equal to the product of the reflectance of the surface and the illuminance in lumens per square foot (footcandles). For a perfectly diffusing surface, and *only* for such a surface, a luminance of one candela per square foot is equivalent to π footlamberts.

foot switch A device for closing and opening an electrical circuit, designed to be placed on the floor and operated by foot pressure, thus, when used in the darkroom, making it unnecessary to dry wet hands, and freeing the hands for other activities.

force (1) To alter a factor for the purpose of accelerating a process or increasing an effect. In forced aging tests, for example, the temperature and humidity of the environment for a sample of photo-sensi-

tive materials are increased to accelerate aging changes. In forced development, the time of development typically is extended to increase the density and contrast of the image in an underexposed negative. (2) To make an extra effort to move a mechanical part that resists movement. Forcing a focusing adjustment that has been locked in position, for example, may damage the mechanism.

forced perspective (1) Exaggerated depth cues on a miniature set, diorama, or other model which permit compression of the physical space that it occupies while creating an illusion of considerable depth. (2) An exaggerated illusion of depth in photographs, for example, because of the use of an extreme wide-angle lens at near distances.

forceps (singular and plural) An instrument consisting of two connected parts, the free ends of which can be brought together to grasp objects. Print tongs, one type of forceps, are used to manipulate photographic prints during processing.

foreground That part of a scene which is visible in front of the main subject from the camera position.

foreign release A motion-picture film that has been modified (e.g., with subtitles or dubbed dialog) for showing to audiences whose native language is different from that of the country in which the film was produced.

forensic photography The specialization of making photographs for law enforcement or related purposes.

forepiece A scenic element placed close to the camera, e.g., a tree branch used to frame a scene.

foreshortening A perspective effect whereby an object dimension or the distance between objects appears unrealistically small. Usually the result of viewing that part of the scene obliquely, using a long-focal-length lens on a camera placed at a relatively large distance from the subject, or viewing the image at a shorter than normal distance.

form The surface configuration of an object or its representation in an image. Although form and shape are sometimes used interchangeably, form refers to the three-dimensional nature of the subject, whereas shape refers to the outline.

formal Identifying a studio-type portrait for which the pose and lighting have been carefully arranged, as distinct from candid and informal portraits.

formaldehyde A pungent gas used in water solution as a preservative and hardening agent. Compounds of formaldehyde such as paraformaldehyde function as controlled sources of alkali in some special-purpose developers, especially those used for lithography.

formalin A 37-to-40 percent solution of formaldehyde gas in water, used in some emulsions and processing solutions as a hardening agent and as a preservative.

format The actual or relative dimensions of a negative, transparency, print, mount, book, etc. For example, an 8 x 10-inch format print, a square-format camera.

formula (1) A list of ingredients, quantities, and other information needed to prepare a solution. (2) A mathematical principle, often expressed in symbolic form. (3) A chemical symbol for a compound, e.g., $AgNO_3$ for silver nitrate.

forward The normal direction of travel of film through a motion-picture camera or projector, as distinct from reverse.

four-color Identifying a color reproduction process commonly used for photomechanical reproduction in which the final image is obtained by superimposing three primary-color (cyan, magenta, and yellow) images and a black image. The use of a black printer improves the reproduction of grays, since colored inks in combination rarely produce neutral tones. In addition, the black printer reduces the quantity of colored inks needed, and thus the cost of the reproduction.

Fourier analysis A mathematical technique for reducing a complex periodic function, such as an electromagnetic waveform, to the sum of sine and cosine functions, thereby simplifying the evaluation of optical images, etc.

fourth cover The outside of the back cover of a publication, as distinct from the front, second, and third covers. The second, third, and fourth covers of magazines are considered choice positions for advertisements, which commonly include reproductions of photographs.

four-track Identifying magnetic-tape sound-reproduction devices capable of making or playing four different sound records, each in a band occupying one quarter the width of the tape. Also a tape so recorded.

FOV Field of view. See field (1).

fovea (fovea centralis) A small elliptical area in the center of the retina containing a high concentration of narrow-diameter receptors (cones) that produce relatively high acuity.

FP See focal-plane (2).

fpm (1) Feet per minute . (2) Frames per minute.

fps (1) Feet per second (2) Frames per second.

FPSA Fellow of the Photographic Society of America.

frame (1) A single photograph in a motion picture,

fovea

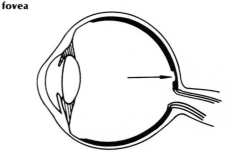

filmstrip, microfilm, or similar sequence of photographs. (2) The area within the film aperture in a camera or projector. (3) An enclosing border made of wood, metal, plastic, or other material used to enhance and protect a photograph. (4) The limiting border on a viewfinder. (5) In television, two interlaced fields. (6) To set up a camera so as to include only the desired subject area on the photograph. (7) To adjust a motion-picture projector so that the frame line does not show on the screen.

frame counter (1) A device on a motion-picture camera that indicates the number of frames of film that have been exposed. Used for animation photography and some camera special effects such as dissolves. (2) On still cameras, an indicator showing how many frames have been exposed, or remain to be exposed. Syn.: exposure counter.

frame line (1) The nonimage area that separates individual photographs in a motion picture or other sequence of photographs on a strip of film. (2) A boundary marker in a bright-line or other viewfinder to indicate the subject area that will be recorded on the film.

framer An adjustment on a projector used to center the image within the film aperture.

frames per second (fps) In motion-picture photography, the number of individual photographs exposed per second or projected per second.

frame stretch A printing technique for converting motion-picture films to higher projection speeds. A film exposed at 16 frames per second, for example, can be converted to a projection speed of 24 frames per second by printing alternate frames twice.

framing camera In high-speed motion-picture photography, an exposing apparatus using a fixed strip of film and a rotating mirror plus relay optics. Separate images of the event are produced (unlike the images made with a streak camera) at rates of up to a few million per second.

Fraunhofer lines Narrow dark bands in the spectrum of the sun caused by absorption of certain wavelengths by vapors in the sun's atmosphere.

freelance Applied to an independent photographer who produces photographs for sale, either on speculation or on request.

free-radical Identifying a nonsilver negative-working dry system in which sensitive film containing a color progenitor (e.g., an aromatic amine) and an activator (e.g., holomethane) produces a printout or optically developed image typically consisting of dye molecules. Advantages over conventional silver processes include high resolution, low granularity, low cost, and rapid and dry processing.

free-viewing In visual perception, identifying a situation in which the eye receives information directly from an object without the use of an intervening optical system. Compare with the Maxwellian-view system.

freeze (1) To form a relatively unblurred image of a rapidly moving object by any of various methods, including the use of a fast shutter speed, and of electronic-flash illumination. (2) To become immobile, as, for example, when the shutter or other moving part of a camera fails to function because of the effects of low temperature or lack of lubrication.

freeze frame A single picture from an action sequence duplicated a number of times (in motion pictures) or retained electronically (in television) so as to stop all motion. Syn.: hold frame; stop frame.

frequency The number of cycles or other complete events of a repetitive nature that occur in a given time. The frequency of an alternating electrical current, for example, may be 60 hertz (cycles per second). The frequency of light waves ranges from 10^{14} hertz to about half that number. Spatial frequency is the number of cycles per unit distance, often millimeter. Spatial frequency is applied to resolution test targets, sine-wave targets, etc.

frequency response curve A graph used to evaluate an optical or photosensitive-material imaging system, typically obtained by plotting lines or cycles per millimeter against image contrast. See modulation transfer function.

Fresnel lens (pronounced fre-nel') A plano-convex lens on which the convex side has been collapsed into a series of concentric circular steps to produce a relatively thin, lightweight lens. Used in spotlights to concentrate the light, and in contact with the ground glass in cameras as a field lens to minimize unevenness in lightness of the ground-glass image. Syn.: echelon lens.

friction drive (1) A mechanical device that includes a smooth wheel which rotates and moves along a smooth track, thereby gradually changing the position of a lens (film plane, etc.); used especially on enlargers and view cameras to focus the image. Compare with helical and rack-and-pinion focusing devices. An advantage of the friction drive is that the wheel will slip to prevent damage to the equipment if excessive force is applied. (2) In automatic processing, the use of rotating cylinders to move film and paper through the processor, simultaneously providing agitation. Syn.: roller transport.

friction head A device on a tripod that enables the photographer to pan and tilt a camera evenly by means of the movement of one smooth surface over another under controlled tension.

Fresnel lens

frilling The detachment of an emulsion layer from the base at an edge, caused by any of several factors, including insufficient hardening, high processing temperature, and excessively prolonged washing.

fringe The imperfect image of an edge. Examples: the alternate light and dark bands produced by diffraction, the unsharp image resulting from lens aberrations, and multiple images resulting from imperfect registration of the separate images in photomechanical color reproduction.

fringe effect Inaccurate tone reproduction, associated with processing deficiencies where the edge of a thin area adjacent to a dense area is thinner than the area within the thin region. One of two edge effects, the other being border effect.

frisket A piece of translucent paper temporarily attached to a photograph with rubber cement to serve as a protective mask, with sections cut out in areas that are to be airbrushed.

frisket cement Rubber cement.

front focal distance The distance from the principal focal point in object space to the front surface of the lens.

frontispiece A page containing a photograph or other image that precedes the title page in some books and other publications to serve as a visual introduction to the contents.

front lighting Subject illumination that originates from the general direction of the camera, as distinct from side lighting and back lighting.

front nodal point For an undeviated ray of light, the intersection of the entering ray with the lens optical axis. Also called first nodal point. Object distances are measured to this point.

front projection (1) The process of forming an optical image on a reflective surface for the purpose of viewing or photographing, with the projector on the same side of the receiving surface as the viewer or camera, as distinct from rear projection, where the projector is on the opposite side of a translucent receiving surface. (2) The use of a partially transmitting mirror at a 45-degree angle in front of a camera lens to reflect a projected image onto a highly reflective surface so that the shadows of objects photographed in front of the projected image are concealed behind the objects from the camera viewpoint and the relatively low-intensity projected image is not noticeable on the foreground objects.

front shutter Any shutter designed to be used between the elements of a lens, in front of a lens, or relatively close behind a lens, as distinct from a focal-plane shutter, which is located close to the film plane.

front-surface mirror A polished reflecting device having the reflecting material on that side of the support which faces the incident light. An advantage over a conventional mirror is that a source of image degradation is eliminated by not requiring the light to travel through a glass support. A disadvantage is that the reflecting surface is not protected from physical damage. Used, for example, in overhead projectors and in reflex camera viewing systems.

frosted Identifying an electric lamp on which the inside surface of the bulb has been etched chemically or has been coated with a white powder for the purpose of diffusing the light.

frost image In thermoplastic recordings, a light-scattering image on a plastic surface produced by forming an electrostatic image in a photoconductive plastic material, deforming the surface differentially (as determined by the electrostatic image) by heating the plastic, and solidifying the deformation by cooling the plastic. The deformation consists of fine ripples which scatter light and make the image visible with an appropriate illumination system. Syn.: deformation image.

froth A group of bubbles. In emulsion coating, such bubbles can interfere with the formation of a uniform emulsion layer. In processing, such bubbles clinging to the surface of the photosensitive material can prevent the solution from acting upon the emulsion. Syn.: foam.

FRPS Fellow of the Royal Photographic Society of Great Britain.

F synchronization (F for fast) In flash photography, a timing system designed so that the shutter reaches the fully open position at the appropriate time to utilize the light from flashlamps requiring 5 milliseconds to reach peak light output.

ft Foot or feet.

ft/min Feet per minute. (Also fpm.)

ft/s Feet per second. (Also fps.)

fringe effect

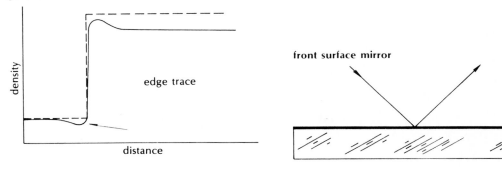

front focal distance

front nodal point

front nodal point

front projection (2)

projector

front surface mirror

fugitive Identifying relatively unstable dyes that fade quickly upon exposure to radiant energy.

full animation Identifying a process in which each frame of an animation film represents a different drawing, as distinct from semianimation techniques, in which zooms, pans, fades, etc., are used with a single drawing to create the illusion of action.

full aperture (1) In motion-picture photography, an unmasked film aperture of 0.980 by 0.735 inch in a 35mm camera. Although the full aperture is used for some special process work such as making background plates, it has been largely replaced by the smaller Academy aperture (0.868 by 0.631 inch). (2) The largest aperture of a lens.

full-coat Identifying magnetic film having a layer of sound-recording material from edge to edge, or, if so specified, between rows of perforations, as distinct from edge stripe and full stripe.

full-color Identifying a photograph made with a three-primary-color process, as distinguished from toned, hand-colored, or other photographs using processes that tend to produce less faithful reproduction of the full range of subject colors.

full frame The picture format as determined by the camera film aperture, i.e., uncropped.

full radiator See blackbody.

full shutter The widest opening on a variable two-blade shutter in a motion-picture camera.

full stop A change in an aperture that corresponds to multiplying or dividing the lens transmittance by 2 or the f-number by the square root of 2. Consecutive f-numbers in the conventional series represent full stops, for example, $f/8$, $f/11$, $f/16$.

full stripe A band of magnetic sound-recording material applied lengthwise to single-perforated 16mm motion-picture film, occupying the entire width of the unperforated edge, as distinct from edge stripe and full-coat film.

full-tone In photomechanical reproduction, a synonym for halftone. Although "halftone" is more commonly used, some authorities maintain that "full-tone" more accurately describes the perceived image.

fungus A minute growth such as mold or mildew that may occur on photographic film, lenses, leather, etc., especially in tropical climates. Fungicides are added to some emulsions to inhibit such growth.

funnel A device with a hollow stem flared at the upper end, used to pour liquids into bottles, etc., and, lined with filter paper, to separate liquids from solids.

fuse A safety device used in an electrical circuit to break the circuit when it is overloaded, thereby reducing the danger of fire or damage to equipment.

fusion The perceptual blending of separate images or other stimuli. Also see temporal fusion; binocular fusion; critical fusion frequency.

fuzzy Applied to optical and photographic images having unsatisfactory definition due to any of numerous causes, including inaccurate focus and movement of the camera.

FX Code for "effects" in motion-picture photography, used on the camera slate, exposure sheets, etc., to alert those concerned that it is an effects shot.

GGG

G Gradient, i.e., slope. Gamma is the gradient of the straight-line portion of the characteristic curve.

Ḡ Average gradient. For the D-log H (D-log E) curve, the slope of a straight line drawn between two defined points on the curve. Contrast index is an average gradient.

gm Gram. Also g. Not to be confused with gr (grain).

gadget bag A small carrying case, typically equipped with a handle or shoulder strap, used by photographers to transport miscellaneous items such as film, lenses, filters, and exposure meters.

gaffer In motion-picture photography, the person who is responsible for procuring, positioning, and operating lighting equipment, including generators, electrical cables, etc. Syn.: electrician.

gaffer tape Heavy-duty adhesive tape used, for example, on the wall of a set to hold a small light when a light stand would be in the way.

gag In motion-picture photography, identifying a shot planned to produce laughter, commonly involving horseplay, surprise, incongruity, etc.

gage (gauge) The width of film, e.g., 70mm, 35mm, and 16mm.

gain The output of a reproduction system or component in relation to the input, commonly expressed as a ratio of output energy to input energy.

gain screen A surface for projection that produces, in a given direction, a luminance greater than that from a perfect diffuser. The gain of a screen is found by comparing the luminance reading of a standard (often magnesium oxide) to a reading of the screen from the same position.

gal Gallon.

gallery (1) An area devoted to the exhibition of photographs or other images or objects, especially works of art. (2) Identifying a self-contained process camera that uses a light-tight film holder rather than an attached darkroom.

gallon (gal) A unit of liquid measure. The U.S. standard gallon contains 4 quarts or 128 ounces, and is equal to 3.7853 liters in the metric system.

galvanometer recorder A device containing a moving-mirror type of light modulator, used to record sound photographically as on a motion-picture optical soundtrack.

gamma (γ) The slope of the straight-line portion of a D-log H (D-log E) curve, used as a measure of the degree of development. Contrast index is preferred to gamma for some purposes, since gamma is not influenced by the shape of the toe portion of the curve that is commonly used in making photographs. Furthermore, some photographic materials have no straight line and, therefore, no gamma value.

gamma infinity (γ_∞) The maximum obtainable gamma for a photosensitive material. Unless otherwise indicated, it is assumed that the developer and temperature remain constant and time is the independent variable.

gamma rays Electromagnetic radiation shorter in wavelength than x-rays, used in radiography.

gammeter A transparent template containing calibrated markings. Used, by positioning it on a D-log H (D-log E) curve, to determine the slope of the straight-line portion, i.e., gamma.

gamut (1) (adj) Identifying the most saturated color of a specific hue and lightness that can be produced by a set of inks (for a photomechanical reproduction process) or a set of dyes (for a photographic process). (2) (noun) The range, especially the extremes of the colors that can be produced by a color photographic or photomechanical reproduction process, typically presented in graphical form as the boundary of the color space. When represented on a

gamma

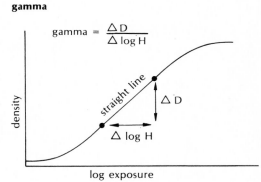

$$\text{gamma} = \frac{\triangle D}{\triangle \log H}$$

straight line

$\triangle D$

$\triangle \log H$

density

log exposure

Gaussian

Gaussian optics

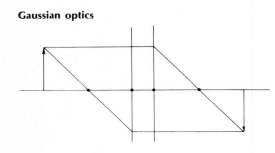

generation

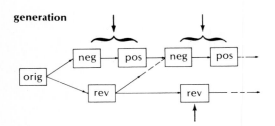

chromaticity diagram, however, all hues are included, but the dimension of lightness is missing.

gang (1) An arrangement of a number of negatives or other images combined for the purpose of being reproduced simultaneously. (2) Identifying a reproduction of the arrangement of images described above, e.g., gang proof print, gang negative. (3) A sprocket wheel on a motion-picture film synchronizer. A three-gang synchronizer, for example, has three sprocket wheels, enabling the operator to handle three strands of film simultaneously.

gaseous-burst Applied to a processing agitation method using an array of perforated pipes at the bottom of a tank. Admission of an inert gas to the pipes at appropriate intervals causes mixing of the processing bath, and the rising bubbles agitate the solution near the material being processed. See nitrogen-burst.

gaseous development The conversion of a latent image into a visible image through the action of an agent in vapor form, e.g., the processing of diazo material with ammonia vapor.

gas-filled Applied to a flashbulb that contains a relatively large primer in an oxygen atmosphere as the sole source of light, in contrast to flashbulbs that contain a small primer which in turn ignites combustible wire or foil (also in oxygen).

gate A mechanism in motion-picture cameras, printers, projectors, and similar optical devices that holds photographic film in a precise plane and delimits the area of illumination at the time of exposure or projection. Also known as film gate.

gate float A defect in motion-picture projection whereby inconsistent positioning of the individual frames produces unsteadiness of the projected images.

gate time Duration of use of a photographic image, especially a color transparency, in a printer, projector, or other viewer. The gate time determines in part the extent of dye fading and other image deterioration.

gauge (gage) The width of film, e.g., 70mm, 35mm, and 16mm.

Gaussian Identifying a frequency distribution that is symmetrical and has a specific shape. The distribution of density variations from the average density of a uniformly exposed and processed image area is nearly Gaussian. Syn.: normal.

Gaussian optics A method for studying image formation in which principal points and planes are substituted for the lens.

gauze Diffusing material used in front of a camera lens to produce a soft-focus effect.

gear head A type of tripod head that enables the photographer to tilt and pan a camera smoothly by turning a crank attached to meshed gears.

gear train A system of interlocking gears used in shutters to control the action of the shutter blades to provide appropriate exposure times and to synchronize the shutter opening with the peak output of light from flash lamps.

Geiger counter In radiography, an instrument used to detect and measure small quantities of short-wavelength radiation (x-ray, gamma ray), based on the principle that such radiation ionizes air, making it electrically conductive.

gel (1) Short for gelatin. (2) To set into a firm form, as by cooling a mixture of gelatin and water. Also jell. (3) Short for gelatin filter, a term used especially for material placed in front of a spotlight to alter the color of the light.

gelatin (1) A colloidal protein obtained by processing skins, bones, and other selected parts of animals. Used as a medium to hold silver halide crystals in suspension in photographic emulsions, as a protective layer over emulsions, as a carrier for dyes in filters, etc. The desirable characteristics include transparency, flexibility, permeability by processing solutions, and ease of conversion from liquid to solid. Some gelatins increase the sensitivity of the silver halide crystals to light. Gelatin also serves to protect the crystals imbedded in it. (2) Short for gelatin filter, a term used especially for material that is placed in front of a spotlight to alter the color of the light. Syn.: gel.

gelatin-transfer Identifying a process in which gelatin containing color formers is differentially hardened. When brought into contact with the receiving sheet, unhardened gelatin adheres and the final image is produced by the contained color former. Used for office copying.

generation One of a sequence of images of the same subject (e.g., first-generation, second-generation, etc.) in which each image is made from the next lower generation image except for the first, which is made directly from the subject. Each generation typically includes both a negative image and a positive image, or a reversal image. It should be noted that if a first-generation *copy* is a reproduction of an original photograph, it is a second-generation image. Second and higher-generation images are made for any of various reasons, as to obtain multiple copies and to alter size, contrast, or other attribute of the image.

generator A device that changes mechanical energy into electrical energy. Used in motion-picture photography, for example, to supply electricity for

lighting equipment, especially when photographing on location.

genre photography (zhän´-re) The specialization of making photographs of scenes from daily life, that is, of people engaged in conventional activities in their normal surroundings.

geodetic control In photogrammetry, a reference system consisting of a network of ground positions with established coordinates that can be identified on aerial photographs. Used in positioning or manipulating images, determining distances, etc.

geological photography The specialization of making photographs of mineral material for any of a variety of uses, including scientific, engineering, and educational.

geometric enlargement In radiography, an image that is larger than the object, produced when the object is not in contact with the photographic material. Since the image is a shadow of the object, the size, shape, and sharpness of the image depend upon such factors as the position of the object between the source of radiation and the film, the size of the source, and the angle at which the radiation strikes the film.

geometrical center A point on a lens axis midway between the front and rear outside surfaces. Compare with optical center.

geometrical optics That branch of the study of the physics of light which uses the ray treatment for the propagation of light, as distinct from physical optics and quantum optics.

germanium (1) Identifying a type of lens used for ultraviolet photography. Germanium lenses transmit shorter wavelength ultraviolet radiation than conventional glass, quartz, or fluorspar lenses. (2) A metal from which semiconductors can be made. Semiconductors are used, for example, in photocells.

gestalt The perception of images as organized configurations rather than as a collection of independent parts.

GG Ground glass.

ghost (1) Applied to an image consisting of a well-defined area of illumination or the corresponding effect on a photograph which is caused by multiple reflections between lens surfaces and which resembles the limiting aperture in shape. Less well-defined areas are known as flare spots. (2) Applied to an image of an opaque object that makes the object appear transparent. The effect can be either intentional or accidental, and can be produced in any of a variety of ways, including double exposure and the use of a partially-transmitting mirror.

ghosting In photomechanical reproduction, selec-

tively reducing the contrast of part of an image in order to emphasize the area of interest, which is reproduced with a normal range of tones.

GHz Gigahertz.

gigahertz (GHz) A billion (10^9) cycles per second, a measure of wave frequency.

gimbal head A camera mount that provides a floating action for the part attached to the camera, thereby reducing the transmission of unsteadiness from an unstable support, such as a boat, to the camera.

glamor photography The specialization of making photographs of attractive women using various techniques to enhance their attractiveness in a refined manner. Such photographs are made for a variety of uses, including advertising, promotional, and editorial.

glare (1) Intense light. (2) Identifying a specular (mirrorlike) reflection as distinct from a diffuse reflection.

glass A hard, brittle, and generally transparent material produced by fusing selected substances, typically silicon compounds, with varying additions of alkalis, metallic oxides, etc., to modify its characteristics. Glass intended for use in lenses may be further identified as optical, crown, flint, etc. Glass is used as a substrate for some photographic materials, especially when dimensional stability is important, and for filters.

glassine Smooth, translucent paper, commonly used for negative envelopes.

glass plate A sheet of clear glass coated with photosensitive material, used in preference to film when flatness of the emulsion surface and dimensional stability are important. Before the invention of flexible film, most negatives were made on glass plates.

glass screen A flat sheet of glass containing cross-ruled opaque lines, used in photomechanical reproduction processes to make halftone reproductions from continuous-tone images.

glass shot A special effect, used especially in motion-picture photography, whereby an image on transparent material is placed a short distance in front of the camera lens so that on the processed film it appears to be a part of the scene being photographed. For example, a tree painted on a glass plate could be used to hide an incongruous modern building in a historical film. Also see Schufftan process.

glassware Slang for photographic lenses.

glassware photography The specialization of making photographs of transparent or translucent objects, typically made of glass or plastic.

glare reflection

D. Rivera

gobo

gradation

E.A. McGee

gradient

$$\text{Gradient} = \frac{\triangle D}{\triangle \log H}$$

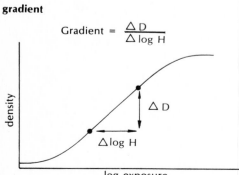

gloss A surface characteristic that causes light to be reflected in a specular rather than a diffuse manner. Produced on photographic prints by ferrotyping. Syn.: polish. Also see sheen.

glossy (1) Applied to a photographic or other paper surface that is smooth and shiny, as distinguished from luster, mat, and other less shiny surfaces. (2) Applied to a photographic print that has been ferrotyped.

glow-lamp Applied to very small, typically arc-light sources (containing neon, argon, etc.) used for signal lamps and indicators, and for exposing timing marks on motion-picture films and other recording applications.

glycerin (glycerine) Common name for glycerol, a colorless, odorless, liquid alcohol with a syrupy consistency that absorbs and retains moisture. Commonly used to reduce brittleness of photographic emulsions and curling of emulsion-coated materials. Glycerin is also used in liquid-gate printing. See glycerin sandwich.

glycerin sandwich A glass negative carrier for a projection printer containing a negative with a layer of glycerin on each side that fills in scratches, making superficial scratches on the negative less apparent on the print. See liquid gate.

glycin A slow acting, stable developing agent for film and paper that produces warm-black images.

gm Gram. Also g. Not to be confused with gr (grain).

G-number The ratio of subject luminance to the corresponding illuminance in the principal focal plane. In practice, the G-number can be considered to be equal to four times the square of the f-number divided by the lens transmittance. Syn.: photometric aperture.

go A command, given by the director of a motion picture, to the actors to begin performing and to the camera operator to begin filming. Syn.: action.

gobo A small opaque panel usually mounted on a portable stand, used to shade selected areas of the subject to obtain a desired lighting effect or to protect the camera from light that could cause flare or fog. Also see flag; cutter.

Goldberg In animation photography, artwork that has a moving component, such as a part that slides or rotates. Since the part can be photographed in different positions, the number of drawings that must be made is reduced. Named after the cartoonist Rube Goldberg, who was noted for creating complicated devices to perform simple tasks.

goldenrod Identifying a type of paper that is opaque to actinic radiation, used to hold halftone and line negatives in position during exposure of photomechanical printing plates.

gold protective solution A bath containing gold chloride used for the treatment of microfilms and washed black-and-white photographic prints to obtain more than normal permanence.

gold reflector In color photography, a piece of cardboard, plywood, or other material with a shiny yellow (gold) surface used to reflect light. In outdoor scenes, the warm color of the reflected light tends to neutralize bluish shadows. Gold reflectors are also used for special effects, e.g., behind a glass of beer to produce a warm glow.

gold-tone (1) Applied to a photographic print that has been treated in a toning bath containing a gold compound, such as gold chloride, to alter the color of the image. (2) Loosely applied to any photographic print that has a brown image as a result of toning.

goniophotometer An apparatus for measuring the energy reflected from a surface at various angles. A simplified version of this apparatus measures gloss.

go-no-go In inspection, the grouping (of, for example, photographic prints) into two classes: go = acceptable and no-go = unacceptable.

GOST A film-speed rating based on a specified density (0.2) above base plus fog and an arithmetic scale of speed numbers, used in the Soviet Union and some other European countries. GOST = Gosudarstvenny Obshchesoyuzny Standart = Soviet Government All Union Standard.

gr Grain, an avoirdupois unit of weight. There are 7,000 grains in a pound. Not to be confused with g or gm, which stand for gram.

gradation A change in tone, texture, etc., between adjacent areas of an object or the corresponding image. Gradation provides the viewer with information concerning the form or depth of the subject, e.g., the facial features of a portrait subject as revealed by the lighting. Syn.: local contrast.

grade A nonstandardized approach to rating the inherent contrast of photographic printing papers, typically a number from 0 to 6, with 0 representing "low contrast." Numbers are assigned by the manufacturer on the basis of scale index, the useful range of log exposure.

gradient The rate of change in a dependent variable, such as the rate of change in density with log exposure. Specifically, the slope of a D-log H (D-log E) curve at any point. (See average gradient; edge gradient.) Gamma is the slope (gradient) of the straight line of the D-log H curve.

gradient speed Identifying a classification of meth-

ods for determining the speed of photosensitive materials, based on the slopes of specified parts of D-log H (D-log E) curves or of artificial lines constructed on the curves. The ASA speed was formerly so defined.

graduate (1) A calibrated cylindrical container used to measure liquids by volume. (2) In photographic education, a person who has received a degree or diploma upon completion of a program of study. (3) In photographic education, a person who has received a bachelor's degree and is studying for a higher degree. Usually identified as a graduate student.

graduated filter A layer of more or less transparent material that has a systematic change in absorption characteristics across its surface. The upper portion of a graduated camera filter, for example, may be yellow to darken blue sky on photographs while the lower portion is clear so that the reproduction of foreground objects will not be affected.

grain (1) A silver halide crystal in a photographic emulsion. (2) A silver particle resulting from the development of one or more silver halide crystals. (3) An attribute of photographic paper related to the orientation of the fibers. (4) The textured surface of a photomechanical printing plate, ground glass, etc. (5) To produce a textured surface on an object, such as a photomechanical printing plate. (6) A small unit of weight. There are 7,000 grains in the avoirdupois pound. Abbreviation: gr.

graininess Nonuniformity of density in a presumably uniformly exposed and processed area of a photographic image as perceived by a viewer. A measure of graininess is the magnification at which the nonuniformity just disappears. Graininess is a subjective property that corresponds with granularity, an objective property.

grainy Identifying an image in which areas of uniform tone on the subject appear spotty due to clumping of silver particles (or other material) that make up the image.

gram (g, gm) A unit of mass (roughly, weight) in the metric system.

granular Applied to dry chemicals or other material in the form of moderately small, irregularly shaped particles, as distinct from powdered and crystalline forms.

granularity An objective measure of nonuniformity of density in a uniformly exposed and processed area of photographic material. Specifically, the standard deviation of density values with respect to the average density, based on a microdensitometer trace at a fixed aperture.

graphical construction A drawing which illustrates image formation with a lens, typically containing lines representing the lens, the lens axis, the object, two or more rays of light, and the image.

graphic arts Hand and photomechanical processes for producing or reproducing images, generally applied to production aspects of the art and printing fields but excluding some operations such as typesetting.

graphics The specialization of producing diagrams, titles, charts, etc. A graphic designer is a person who is skilled in this area and has the responsibility for this part of a production, e.g., in television and motion pictures.

Grassman's laws In colorimetry, a group of rules concerning the application of algebraic operations to color matching.

grating A repetitive or systematically varied pattern of parallel lines or areas. Square-wave and sine-wave gratings containing alternating light and dark areas are used as targets for the purpose of studying image formation. Diffraction gratings are reflecting or transmitting optical elements, containing narrow parallel slits, used to produce spectra.

gravure A photomechanical reproduction process in which the image elements are recessed below the surface of an otherwise flat or cylindrical printing plate.

gray Any tone between white and black in lightness and without noticeable hue.

grayback Identifying negative film materials that have a neutral-color antihalation substance in the base. Since the substance is not removed in processing, the processed negatives have a relatively high base density.

gray card A neutral-color cardboard, typically having 18% reflectance, used as a standard artificial medium tone for luminance (reflection-type exposure meter) readings. In the zone system, an 18% reflectance gray card corresponds to zone V. In the Munsell system of color notation, middle value 5 has a reflectance of approximately 18%.

gray contact screen An array of dots of neutral dye on a flexible, transparent base, used in photomechanical reproduction processes to make halftone reproductions from continuous-tone images.

gray scale A series of neutral tones arranged in sequence from light to dark, usually in discrete calibrated steps, ideally with equal density differences between steps. Transmission (as distinct from reflection) gray scales are also known as step tablets and "step wedges." A gray scale is often included with a subject or added at an intermediate stage of a

gray scale

reproduction process as a standard for control purposes. In the zone system, a ten-step gray scale representing the print tones produced by a series of negatives, exposed at "one stop" or 2X increments and developed "normally," is used to define the ten steps from 0 (maximum black) to IX ("pure" white).

grazing Applied to a light beam or ray that falls on a surface nearly parallel to it.

grease pencil A marking device containing a waxy substance that adheres to most surfaces but can be removed by rubbing with a cloth or tissue, used by picture editors to indicate the desired cropping on prints, etc.

green (1) A color that corresponds to the 500-600 nm (middle) wavelength region of the visible spectrum, and that can be produced by removing the red and blue components from white light. (2) Identifying a filter having major absorptance for short and long wavelengths of light, i.e., from about 400-500 and 600-700 nm. (3) Applied to motion-picture film that has not been thoroughly dried, and therefore is more likely to stick during projection.

green blindness See deuteranopia.

Grenz rays X-rays with wavelengths near the ultraviolet region in the electromagnetic spectrum, having the advantage over shorter-wavelength x-rays of producing higher-contrast radiographic images of low-contrast objects.

grid (1) An array of crossed lines or other marks, commonly on a clear or translucent base to permit superimposition on a photograph or other object. Different designs are used to check parallelism of lines, to identify positions on photographs, to measure distances, and for various other purposes. (2) Identifying a tubular light source in which the tube has been bent to cover a circular, rectangular, or other area so as to provide diffuse light. Used as an enlarger light source, as a ring light to be placed around a camera lens for close-up photographs, etc. (3) In motion-picture photography, an overhead catwalk used by the persons responsible for rigging lights above a set.

grid diaphragm In radiography, a device containing thick strips of lead, equally spaced, that moves over the film during exposure to absorb scattered x-rays, which would degrade the image.

grid shutter A device containing two overlapping plates, each of which consists of an array of alternating opaque bars and spaces, When the bars in one plate cover the spaces in the other, no light is transmitted. A single movement of one plate produces a complete cycle from closed to open to closed. Such a device is capable of producing multiple exposures at controlled intervals, a useful technique for measuring the speed of moving objects.

grip A member of a motion-picture-camera crew who is responsible for transporting, setting up, operating, and removing support equipment for the camera (such as dolly tracks and dolly), and related activities.

Grotthus-Draper law Only those photons that are absorbed by a photosensitive material can cause a photochemical reaction. The law is important, for example, in the theory of dye sensitization.

ground (1) In the study of perception, the perceptual field in which a figure of stimulus of interest is located. In a photograph, the ground corresponds with the surround, i.e., the combined foreground and background, as distinct from the subject. (2) An electrical conductor that connects a circuit or a piece of equipment with the earth or other suitable conducting body. A ground carries off electricity that would otherwise be dangerous.

ground glass Sheet-glass having a granular textured surface, used for focusing panels in cameras, light diffusers in printers, viewers, etc. In illuminating systems, the function of the ground glass is to provide the equivalent of a uniform light source.

ground noise Random variations, associated with detection and reproduction systems, that limit the sensitivity of detectors and the fidelity of reproductions. Examples: graininess in a photographic image, hum produced by a sound amplifier, and neural firing in an optic nerve with the subject in darkness.

ground resolution The size (usually width) of the smallest object that is detectable in an aerial photograph.

guide (1) A bar on a trimmer, an easel, etc., used to assist the operator in positioning paper or other material. (2) A calibrated template used to assist an animator or a cameraman in positioning scenic elements in animation or stop-motion photography.

guide number A numerical value used to obtain a desired exposure effect when making photographs with a flash or electronic-flash light source. The guide number typically is divided by the distance in feet from the light source to the subject to obtain the recommended f-number.

guide track A synchronized sound record that is not itself used in the finished motion picture because of deficiencies in quality, but instead assists in synchronizing another sound record that is made at a different time under more favorable conditions, typically in a sound studio.

Guild colorimeter A device for mixing three colored lights, by presenting them repetitively in rapid se-

quence, so as to match a sample in appearance.

gum arabic A water-soluble substance obtained from an acacia tree. Used as an adhesive, or, when treated with a bichromate, (typically potassium bichromate), as a photosensitive material that becomes insoluble upon exposure to light.

gum bichromate Identifying a process that forms images through the hardening action of light on gum arabic that has been sensitized with a bichromate, typically potassium bichromate. On lithographic plates, the hardened gum is ink-receptive, whereas the metal plate in the areas where the unhardened gum has been removed by washing repels ink. Pigment is mixed with the gum arabic and bichromate for the contact printing paper process. The pigment remains in the hardened gum in the shadow areas but is removed with the unhardened gum in the highlight areas. The paper process is obsolescent, but has received some revival of interest in recent years.

gun camera A motion-picture camera used with a gun or in place of a gun to record the accuracy of actual or simulated gunnery.

gun mike A microphone that has a narrow angle of acceptance, and therefore is highly selective in recording sound only from the direction in which it is aimed.

gunpod A device shaped like a gunstock, used in the same manner to steady the camera against a shoulder, especially when a long-focal-length lens or a slow shutter speed is being used.

Gurney-Mott theory An explanation of the mechanism of latent image formation proposed by R. W. Gurney and N. F. Mott in 1938, whereby photolytic silver is formed at sensitivity centers in silver halide grains during exposure.

gutter The blank area down the inside edges of facing pages of magazines, books, etc., into which illustrations and type are not allowed to extend.

gyro stabilizer A camera-support device containing a wheel that spins rapidly during operation, causing the device and attached camera to resist sudden changes in orientation that would result in blurred or unsteady images.

gutter

gutter

HH

halation

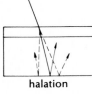

R. Mergler

halation

antihalation backing

half-frame

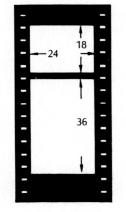

H The international standard symbol for photographic exposure. $H = E \times t$, where H is the exposure in lux-seconds (lumen-seconds per square meter; meter-candle-seconds), E is the illuminance in lux (lumens per square meter, meter-candles) and t is the time in seconds. The former symbols made the defining equation read $E = I \times t$.

hafnium A metal used as the combustible material in some flash lamps in place of zirconium. Advantages of hafnium include ease of ignition and large light output.

hair check In motion-picture photography, the procedure of inspecting the camera aperture for dust or other foreign material before exposing film.

hairline Identifying any of a variety of fine lines, such as a reticle marking in an optical system, a scratch on a negative, or a crack in a dark slide.

halation An effect, or defect depending on intention, consisting of an unsharp image around the desired image of a bright object, caused by image-forming light that penetrates the photosensitive layer, with some scattering, and is then reflected back from the base. Minimized on some photographic films by the addition of a light-absorbing anti-halation material to the back surface, between the emulsion and the base, or as an integral part of the base.

half frame An 18x24mm picture format on a 35mm still camera, as distinct from the more common 36x24mm format. The 18x24mm format is also referred to as single frame, since this is the conventional 35mm motion-picture-camera format.

half-life In radiography, the time period over which a source of radiation decreases to 50 percent of its original intensity. Cobalt-60, for example, has a half-life of 5.3 years. A change in intensity produces a corresponding change in exposure unless compensated for.

half-open Identifying that position of a leaf-type shutter at which it admits to the image 50% of the maximum light. The time interval between the two half-open positions is the standard measure of the effective exposure time. (See illustration, p. 93.)

half-peak That point in the operation of a flash lamp at which it emits 50% of the maximum possible light. The time interval between the two half-peak points on the time-light curve is the standard measure of the effective duration of the flash. (See illus., p. 93.)

half shutter An opening that is 50% of the maximum opening of a variable shutter in a motion-picture camera.

half-silvered mirror A sheet of glass or other transparent material carrying a coating of reflective material sufficiently thin that some of the incident light is transmitted. The proportions of light transmitted and reflected can be altered by varying the thickness of the coating. Half-silvered mirrors are used in rangefinders, front projectors, etc. A type of beam splitter. Syn.: semireflective mirror; semitransparent mirror. (See illustration, p. 93.)

halftone (1) A photomechanical reproduction process in which gradations of tone are represented on the image as dots of varying size and nearly uniform density. Under normal viewing conditions the eye does not resolve the individual dots and the viewer perceives progressively darker tones as the dots increase in size. See full-tone. (2) Applied to a glass or contact screen used to convert continuous-tone originals to dot images. (3) Applied to the intermediate and final dot images in a reproduction process, e.g., halftone negative; halftone plate.

halftone effect The difference between integrated density of a continuous-tone print when grains are reproduced and the density of a similar area at a scale of reproduction too small to resolve grains.

half track A band of magnetic sound-recording ma-

terial applied lengthwise to 16mm motion-picture film, covering one half of the optical sound track, thereby giving the projectionist a choice of sound systems.

halide A compound of bromine, chlorine, fluorine, or iodine, e.g., silver bromide.

hallucination A visual or other perception for which there is no corresponding external cause, e.g., an image seen while dreaming or an image induced by a drug.

halogen A group name for bromine, chlorine, iodine, and fluorine. Silver compounds of the first three elements are used as photosensitive components in photographic emulsions.

halogen acceptor A substance, such as gelatin, that can combine with the bromine or other halogen produced during formation of a latent image, thereby reducing the possibility that the halogen will destroy the latent image by recombining with the photolytic silver.

halogen lamp A tungsten lamp, the filament of which is surrounded by an active (rather than an inert) gas, which is effective in prolonging lamp life and permitting higher operating filament temperatures. (Note that the color of the emitted light is little affected by the presence of the active gas, since the light is emitted by the filament itself. Note also that the envelope is fused silica, rather than the mineral quartz.) Syn.: quartz-halogen (quartz-iodine, etc.) lamp.

H and D Hurter and Driffield, the originators of photographic sensitometry.

hand (hand-held) camera A camera designed to be operated while being held as distinct from a camera that must be attached to a tripod or other support, such as a view camera or a process camera.

H and D curve (Hurter and Driffield curve) (1) A graph obtained by plotting the logarithms of a series of exposures (quantity of light per unit area) received by a photographic material and the corresponding resulting densities. (2) A graph similar to that in (1), with the logarithm of the energy (quantity of radiation per unit area) as the input. Used for photographic materials normally responsive to radiation other than light, such as x-ray films. Such graphs are used to derive information such as base plus fog level, speed, contrast index, useful exposure range, and maximum density. Syn.: D-log H (D-log E) curve; characteristic curve; sensitometric curve.

H and D speed (Hurter and Driffield speed) A method of measuring film speed intended to indicate the minimum exposure for reproduction on the straight-line portion of the characteristic curve, specifically 34/i, where i is the inertia. This speed concept now has only limited application to situations where straight-line reproduction is desired, as in making color-separation negatives.

hand test The manual processing of a short length of motion-picture film for a quick check on possible malfunctions of the camera, etc. Syn.: slop test.

hang To display a photograph by attaching it to a wall or panel.

hanger A device, usually a rectangular frame, designed to hold exposed photographic material (typically sheet film) during processing.

hanger marks Uneven density near the edges of a negative or transparency processed in a film hanger, typically due to nonuniform movement of developer over the entire film surface.

hard (1) In lighting, involving a high (1:16, for example) ratio of illumination. (2) Identifying negatives with high contrast, i.e., a great difference between the extreme densities. (3) For printing papers, having a small scale index (useful range of log exposures). Such papers are graded 3 to 6. (4) As applied to water, having a considerable concentration of dissolved salts of calcium and magnesium. (5) Applied to materials that resist scratching. (6) In sound, identifying a surface that is highly reflective. (7) For x-rays, having relatively short wavelength, and thus great penetrating ability.

hard copy An enlarged print of a microfilm image, as distinct from a projection of the microfilm image onto a screen for visual inspection. Syn.: printout (2).

hardener A chemical (hardening agent) that limits softening of wet gelatin, or a formulated solution (hardening bath) containing such a chemical. Hardening agents are generally added to photographic emulsions and also to fixing baths during manufacture to reduce the danger of physical damage to the emulsion during processing. Potassium alum and formaldehyde are examples.

hardware Equipment, especially in audiovisual and computer contexts, as distinct from software (films, programs, punched tape, and other instructional material).

hard water Water that contains mineral salts. Since some such salts can cause undesirable reactions in photographic solutions, the danger can be eliminated or reduced by distilling or deionizing the water or by treating it with a chemical softener. Hard water is more effective than soft water in washing soluble materials out of processed photographic materials.

harmonic A wave having a length 1/2, 1/3, 1/4, etc., that of another (fundamental) wave. In sound, the number and intensity of harmonics determine the quality of the sound. Interference filters may

half-open

half-peak

half-silvered mirror

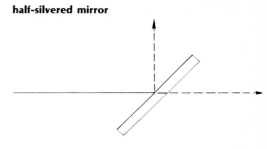

halogen lamp

H and D curve

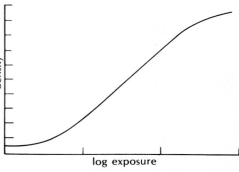

transmit, in addition to a desired wavelength, one or more harmonics that must be removed by a supplementary filter.

harmonic filter In television, a device for removing unwanted multiples of an output signal.

harmony A pleasing effect with respect to the choice and arrangement of the visual elements that make up a subject or photograph, sometimes limited to a single attribute (e.g., color harmony).

haze (1) An atmospheric condition in which small suspended particles scatter radiation from the sun and sky, and thereby reduce the contrast of images of distant objects. Since scattering is an inverse function of wavelength, scattered radiation reaching the observer or the camera under hazy conditions is rich in the ultraviolet and blue regions. (2) Light scatter in film base or other essentially transparent material.

haze filter Any of various absorbing devices used to reduce the effects of the bluish veil that results from the scattering of radiation by suspended particles in the atmosphere. Since short-wavelength radiation is scattered more than long-wavelength, haze filters for color films absorb ultraviolet radiation and usually a small portion of the blue light. For black-and-white photography, penetration increases with the additional absorption of progressively longer wavelengths through the blue and green regions. Maximum penetration is obtained by using infrared film and a filter that transmits only the relatively long-wavelength infrared radiation.

HE Head end.

head (1) That part of a sound-reproduction device which applies or detects a magnetic field. Sometimes further distinguished as recording head, reproducing head, or erasing head. (2) The upper or the main functioning part of any of various devices, such as a tripod head, the part that directly supports the camera and typically permits the camera to be tilted and panned.

head end (HE) That portion of a motion picture which is to be projected first.

head leader A strip of motion-picture film containing information for the projectionist. It is attached to that end of a reel of film which will be projected first, as distinct from a tail leader, which is attached to the other end.

headphones A device containing two telephone-type receivers, worn by certain motion-picture and television workers for the purposes of monitoring sound or receiving auditory instructions. Syn.: earphones.

headpiece In photomechanical reproduction, a photograph or other image used at the beginning of a chapter or other section to serve as a visual introduction to that section.

headscreen A small opaque or translucent panel, usually mounted on a portable boom stand, used to shade selected areas of the subject to obtain a desired lighting effect or to protect the camera from light that could cause flare or light fog. See gobo; cutter.

headset A device containing one or two telephone-type receivers and a microphone, worn by certain motion-picture and television workers to monitor sound and to communicate with others involved in the production.

heads up In motion-picture photography, film that is wound so that it is ready for projection.

head sync In motion-picture photography, synchronism marks at the leading end of a film.

heat-absorbing Identifying a filter that transmits light freely but is relatively opaque to infrared radiation, used in projection systems to protect the material being projected and parts of the projector from becoming excessively hot. Note that such a filter accumulates heat that must be removed by adequate ventilation.

heat development An image-forming method dependent upon the absorption of infrared radiation. The image may be produced by the melting of small capsules containing a dye or pigment. Syn.: thermography (1).

heat it up An instruction to an electrician to make the light from a spotlight more intense in a given area by concentrating the beam, or to increase the intensity by adding more lights.

heat-recording Identifying any of several systems for making a permanent visible image of temperature variations in a subject. At high temperatures, luminance and color differences of glowing objects can be photographed on color film. At lower temperatures, a variety of materials and techniques is used, including infrared-sensitive films and heat-sensitive phosphors.

heavy oil An opaque colorant (with an oil base) used in hand-coloring photographs, either to accent certain parts or to convert a photograph into an oil painting.

held cell In animation photography, an acetate kept in place for more than one or two frames to produce a motionless image of that element, or a blank acetate kept in place to prevent a change in background density.

held takes In motion pictures, sections of film which will be printed, and on which the decision about quality will be made in the cutting or screen-

headscreen

ing room. Distinguish from bad takes, which are known initially to be unsatisfactory.

helical Applied to a lens mount attached to a camera or other optical device with matching spiral threads, enabling the user to focus the image by rotating the lens.

Herschel effect The partial destruction of a latent image upon exposure to red or infrared radiation in an emulsion that has not been sensitized to these wavelength regions. The effect appears as a decrease in density and contrast of the developed image.

hertz (Hz) Cycles per second, used for sound and other wave motions. The preferred unit of frequency.

heterochromatic Of more than one color.

hicon (1) Short for high-contrast material. (2) A strip of high-contrast film used for mattes or titles, as distinct from the regular picture negative or fine-grain master.

high-angle shot A photograph made with the camera well above the important subject matter and aimed downward.

high-contrast Applied to a lighting, developer, printing paper, film, etc., used to increase differentiation of tones, either to achieve a desired contrasty effect or to compensate for a low-contrast influence elsewhere in the process.

high-front lighting A type of portrait lighting in which the main light is positioned in the direction the subject is facing and somewhat above the subject, thereby projecting the nose shadow straight down onto the upper lip. Syn.: butterfly lighting.

high hat A device designed to support a camera, used when a low angle is desired.

high key (1) Applied to a subject or image in which most of the tones are light. (2) Applied to a lighting having the characteristics of frontal direction, low contrast, and uniform distribution.

highlight (1) Any subject area illuminated by the main light source or a corresponding area on an image. A strong reflection from a shiny surface is differentiated as a specular highlight. (2) Loosely applied to any light-tone area on a subject or a positive image, or a corresponding dense area on a negative image.

highlight exposure (Not to be confused with highlighting exposure.) In photomechanical reproduction, a white-light camera exposure from the copy to the film through a halftone screen. The highlight exposure produces a dot image having a basic tonal range which can be altered with supplementary exposures (bump, flash) to increase or to lower the contrast. Syn.: main exposure; detail exposure.

highlighting exposure (Not to be confused with highlight exposure.) In halftone negative making, a supplementary exposure made with light from the copy without the halftone screen. By exaggerating differences in the areas of dots representing the lighter tones of the copy, the effect of an increase in image contrast is produced. The highlighting exposure is used especially with low contrast copy, high-key photographs, and drop-outs. Compare with flash exposure, which produces a decrease in image contrast. Syn.: bump exposure; no-screen exposure.

highlight mask A negative image that is typically produced from a color transparency and then bound with it in register during part of the reproduction process. Used to increase local contrast in the light-tone areas of the print or other reproduction.

high-low (1) An electrical circuit that enables pairs of incandescent lamps to be operated either in parallel or in series. The latter system, which reduces light intensity and extends lamp life, is sometimes used to reduce discomfort for the subject while the lighting is being arranged. (2) An electrical circuit that permits use of all or only part of the condensers in an electronic-flash power pack, thereby altering light output. Such control is desirable in electronic-flash photography, since the shutter cannot be used to control exposure because of the short duration of the flash.

high oblique An aerial photograph made with the camera inclined at an angle that places the horizon near the top of the photograph.

high-pressure Identifying an arc lamp, especially one

Herschel effect

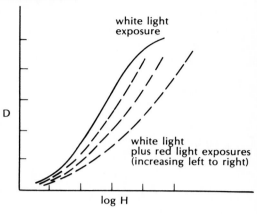

white light exposure

white light plus red light exposures (increasing left to right)

D

log H

high key (1)

B. Zavitz

high-contrast W. Billings

highlights R. Mergler

containing mercury, operated so as to produce (besides the usual vapor line spectrum) some energy throughout nearly the entire visible spectrum.

high-speed (1) Applied to that branch of cinematography involving exposure of a large number (up to about 10,000) of frames per second so that subject motion will appear slow when the film is projected at the normal speed. See very high-speed and ultra high-speed. (2) Identifying the still-photography specialization of making photographs at very short exposure times so that sharp images are obtained of rapidly moving objects. (3) In photographic data recording, a writing rate of 1/1,000mm to 1/10mm per microsecond (1/1,000,000 second).

hit In animation photography, a point on the soundtrack that must be synchronized with the completion of an action accent.

hit the marks In motion-picture photography, an instruction to performers to take their assigned positions.

Hogarth curve See S-curve.

holdback In motion-picture photography, a traveling matte.

hold back To reduce the exposure in selected areas of an image so as to alter the density. The converse of burning in. Syn.: dodge.

holdback sprocket A toothed wheel that prevents a motion-picture take-up mechanism from advancing the film too far.

holder A light-tight device designed to be loaded with film or other photographic material and attached to a camera, printer, etc., so that the material is correctly positioned for exposure after removal of a dark slide or other protective covering.

hold frame A single picture from an action sequence duplicated a number of times (in motion pictures) or retained electronically (in television) so as to stop all motion. Syn.: freeze frame; stop frame.

hole (positive hole) Absence of an electron (negatively-charged elementary particle) from its normal position in a crystal of silver halide.

hologram A three-dimensional picture made by holography.

holography Recording, on a photographic material, the interference pattern between a direct (reference) coherent light beam and one reflected or transmitted by the subject. The resulting hologram is usually viewed by coherent light, giving the appearance of three dimensions. Within limits, changing the viewpoint from which a hologram is observed shows the subject as seen from different angles.

home movie An amateur motion picture, generally involving members of the photographer's family.

hookup In animation photography, the last drawing of a series, where the image blends with that of the first drawing so that the series can be photographed repeatedly to produce continuing action of a cyclic nature.

horizon The apparent boundary between the earth and sky. The horizon is an important compositional element in outdoor photographs, and is used as an orientation reference on some aerial photographs.

horizontal Applied to the following: (1) An enlarger (projection printer) designed to project the image onto a wall or other vertical surface, as distinct from a vertical enlarger. (2) A movement on a view camera whereby the lens board or back can be rotated about an axis perpendicular to the camera bed. Syn.: swing; horizontal swing. (3) A photograph made with the camera axis parallel to the ground, or, to distinguish from a vertical photograph in aerial photography, a photograph made with the camera axis tilted at any angle from vertical. (4) A format with its long dimension parallel to the ground, as distinct from a vertical format.

horse A device consisting of a support with a spindle, used in motion-picture editing rooms to hold rolls of film.

horticultural photography The specialization of making photographs of gardens, garden plants, etc., for any of various uses, including advertising, editorial, and instructional.

hot Identifying an electrical wire or other part of an electrical circuit that is supplied with electricity, as distinct from the ground part.

hotbox A small, portable darkroom used for loading motion-picture magazines with raw stock and for transferring exposed stock from magazines to cans.

hot splicer A device used to join sections of motion-picture film that contains a heating element to reduce the drying time of the cement.

hot spot An area that appears appreciably lighter than the surrounding area, commonly the result of nonuniform distribution of light by a reflector or optical system. In copying, for example, hot spots are usually caused by placing the lights too close to the original.

house lights The lights ordinarily used for general illumination in a motion-picture set or theater, as opposed to the set lights or the stage lights.

house organ A periodical publication, produced by a business organization, that typically contains photographs and other material related to its operation and is distributed to its employees and other interested persons.

housing An enclosure, as for a lamp in a projector.

hold back

hot spot

how-to-do-it Identifying a type of continuity for a motion picture, filmstrip, picture series, etc., in which important steps in a process are presented in sequence for the purpose of instructing the viewer, e.g., how to ski.

hue An attribute of color that varies with the wavelength composition of the light and is associated with names such as red, green, blue, cyan, magenta, yellow, orange, and greenish yellow. The other two attributes of color are saturation (or chroma) and lightness (or brightness, or value).

hum (1) Noise of a constant pitch in a sound system. (2) In television images, a bar that is usually stationary but that sometimes moves up or down the picture, or a kink in vertical lines. Both defects are related to the electrical power frequency.

humectant A substance that absorbs a slight amount of water. Used in the manufacture of film, for example, to make it more flexible.

humidify To add moisture to the air, thereby reducing the accumulation of static electricity and extending the life of photographic materials that become brittle in excessively dry air.

humidity Dampness of the atmosphere. Specifically (relative humidity), the relation between the concentration of water vapor present in a gas (especially air) to the maximum that could be present at a given temperature. Of importance in photography because it is a factor in the keeping qualities of photographic materials and latent images, and because it affects physical properties such as brittleness, curl, and dimensions.

Hunter system A system of color notation based on the three attributes: hue, saturation, and darkness.

hunting head On a motion-picture-film editing machine, a scanning detector that moves back and forth within adjustable limits over a soundtrack to isolate syllables or musical beats. Used to make frame-by-frame notations to guide the animators.

hydrate A compound in which water is a chemically-combined component, e.g., the monohydrate form of sodium carbonate, as distinct from the anhydrous form.

hydrogen ion concentration A measure of the acidity or alkalinity of water solutions or other substances, commonly expressed in pH values, where pH is the negative logarithm of the concentration of hydrogen ions. pH affects the activity of developing agents, the effectiveness of hardening agents in fixing baths, etc. A pH of 7 is neutral; acids have pH values below 7, while alkalis have pH values greater than 7.

hydrological photography The specialization of making photographs of water on the land for any of a variety of uses, including scientific, engineering, and educational.

hydrolysis Chemical decomposition due to reaction with water. For example, some acetic acid is formed when sodium acetate is dissolved in water.

hydrometer An instrument designed to measure the specific gravity of liquids. Used, for example, as a rough check on the accuracy with which a processing solution has been compounded. Not to be confused with hygrometer.

hydrophilic (water-loving) Identifying the areas on a lithographic printing surface that accept water and reject ink, as distinct from the areas that reject water and accept ink. Syn.: oleophobic.

hydrophobic (water-fearing) Identifying the areas on a lithographic printing surface that reject water and accept ink, as distinct from the areas that accept water and reject ink. Syn.: oleophilic.

hydroquinone (p-dihydroxybenzene) A developing agent used alone in high-contrast developers and in combination with metol (p-methylaminophenol) in general-purpose developers.

hydroxide A chemical compound containing the hydroxyl (OH) radical. Example: sodium hydroxide, which is used as an alkali in some developing solutions.

hygrometer An instrument designed to measure relative humidity. Not to be confused with hydrometer.

hygroscopic Applied to a solid or liquid that attracts moisture from the atmosphere, e.g., glycerin.

hyperfocal Applied to: (a) The nearest object point that is imaged with acceptable sharpness when a lens is focused on infinity, or, the nearest object point that can be focused on while imaging objects approaching infinity with acceptable sharpness. (the two procedures produce the same result.) (b) The distance from the point defined in (a) to the front nodal plane of the lens.

hyperopia A condition in the human eye such that images tend to be formed behind the retina. Although accommodation may enable the person with hyperopia to see distant objects with satisfactory sharpness, the nearest distance at which objects can be seen clearly is greater than normal.

hypersensitization A process for increasing the speed of a photosensitive material between manufacture and image exposure by chemical or physical treatment such as uniform exposure to weak light, treatment with mercury vapor, or bathing in solutions of organic acids, hydrogen peroxide, etc. (Distinguish from latensification, which involves treatment following the image exposure.)

hue

400 500 600 700 nm

blue green red

hypersteroscopy A modification of stereoscopy whereby the distance separating the viewpoints for the two images is increased beyond that of the eyes for the purpose of increasing the appearance of depth.

hypo Common name for sodium thiosulfate, a fixing agent. Also loosely used for ammonium thiosulfate and, as a general term, for a fixing bath.

hypo-alum A toner containing sodium thiosulfate, potassium alum, and other ingredients, used to produce brown image tones.

hypo elimination The use of a bath (e.g., a mixture of hydrogen peroxide and ammonia) that converts residual hypo into substances that will not react with the silver image and can be easily removed by washing. In a broader sense, hypo elimination also includes the use of an alkaline or salt bath that increases washing effectiveness without reacting with the sodium thiosulfate or other fixing agent.

hypo test (1) A method of determining whether a fixing bath is exhausted or not. (2) A method of detecting or measuring sodium thiosulfate or other fixing agent, used for checking the completeness of washing of photographic material.

Hz Hertz. Unit of frequency. Preferred to cycles per second.

||

I

I (1) Internationally-accepted symbol for radiant intensity I_e or luminous intensity I_v. (2) Obsolescent symbol for illuminance (the preferred symbol is E.) (3) Instantaneous, marking on some old-style shutters.

ICI International Commission on Illumination.

iconoscope A television camera tube containing a mosaic of photoelectric elements that is scanned by an electron beam.

identification (ID) (1) Specifying a portrait used to permit others to recognize the subject, the purpose being to prevent misrepresentation. Also applied to related equipment, e.g., identification (ID) camera; ID card. (2) In motion pictures, data about film in magazines, such as film type, length, etc.

idler A non-driven roller, used to direct and stabilize the motion of film through a camera, printer, processor, etc.

ignition time (1) Number of seconds required for film to begin burning when tested under standard conditions. (2) For a flashbulb, the number of milliseconds (thousandths of a second) between the application of the electrical current and the beginning of light emission.

ikonograph In motion pictures, a film made up of still photographs and drawings, in which an impression of movement is dependent upon the action of the camera. Syn.: filmograph.

illuminance (E) The measure of the strength of the light received at a point on a receiving surface. Unit: usually foot-candle or meter-candle, derived from the obsolete unit light source (candle) and the inverse-square law. The modern unit is lux (lumens per square meter) or lumens per square foot, numerically equal to meter-candle or footcandle. Strictly, $E = d\phi/ds$, where E is illuminance, ϕ is flux, and s is area. (Note: Distinguish illuminance, which is the measure, from illumination, which is the process. Also note: Distinguish illuminance, which is the measure of *light*, from irradiance, which is the measure of radiant energy without regard to wavelength.)

illuminance meter A photoelectric light-measuring instrument that has an acceptance angle of 180 degrees or nearly so. An "incident" light meter, used to measure the light level on the subject. Distinguish from luminance meter, a reflected-light meter.

illuminant A light source, especially one that is specified by the CIE (International Standards Association). Standard tungsten (illuminant A) has a color temperature of 2,854 K; standard sunlight (illuminant B, 4,870 K; standard daylight (illuminant C), 6,740 K. Other illuminants are photographic daylight, 5,500 K, and another type of daylight (illuminant D), 6,500 K.

illuminant point On a graph of color-mixture data (chromaticity diagram), the position at which the assumed light source plots. Such a point also represents the position of visual neutrals, i.e., white, grays, black.

illumination The process by which a surface receives light. Distinguish from illuminance, which is the measure of the received light. Analogous to irradiation, which involves radiant energy regardless of wavelength.

illuminator A light box for viewing transparencies.

illusion A false perception, as of size, straightness, etc.

illustration (1) A photographic image that supplements text, as in books, magazines, and catalogs. (2) The profession of making photographs for such uses, especially emphasizing the representation of intangible concepts, as distinct from merely recording the appearance of objects.

illustrative photography The specialization of pro-

illuminance meters

angle of view

diffuser

photocell

illusion

identical shapes

ducing photographs that are intended to communicate some aspect of the subject beyond its physical appearance, typically an intangible concept with an affective connotation such as beauty, love, security, fun, fear, sorrow, etc. The term is most commonly associated with photographs made for advertising and editorial purposes.

illustrator A communicator who uses graphic means, such as photography, to present and interpret ideas, information, events, etc. The illustrator is concerned with persuasion, promotion, education, entertainment, etc.

image (1) In optics, the intersection or the apparent intersection of light rays. The first is the real image, the second, virtual. Real images typically fall on the photographic material or on the viewing screen of a camera. (2) The invisible change in a photographic material caused by the absorption of radiation (latent image). (3) Visible differentiation in silver or dye or other deposit in a photographic material, as in "negative image" or "positive image."

image amplification (1) Any process by which the initial effect of the absorption of radiation is increased. For example, the development of silver halide materials is sometimes said to be an image amplification of several orders of magnitude. (2) A process which increases the luminance of an image, especially by electronic means. Such an amplification process is often at the expense of image quality, such as sharpness and resolution.

image dissection Representation of a scene by discrete spots, often preparatory to transmission of information by electrical or other means. A halftone screen produces a dissected image for use in photomechanical reproduction. See dissection.

image distance The spatial separation between the position of the image in a camera, etc., and the rear nodal plane of the lens.

image enhancement Any process by which a photographic record is improved, as by increase in sharpness or contrast, or by reduction in noise.

image-motion compensation (IMC) A mechanical, optical, or electronic method of keeping the image of a moving object at nearly the same position on the photographic material, thus reducing image degradation.

image plane See focal plane.

image reconstruction The preparation of an easily interpreted image, as from a dissected or streak camera record, or from a hologram.

imagery General term for images, or group or type of images.

image spread Increase in size of a small photo-

graphic or optical image over that to be expected from geometrical considerations.

imbibition In a photographic printing process, the absorption of a dye by a coating containing an image (as in varying thickness of gelatin), after which the dye is usually transferred to a receiving sheet.

IMC Image-motion compensation.

immersion heater An electrical device used to raise the temperature of photographic solutions by inserting that part containing the heating element into the solution.

immiscible Nonmixable, as oil and water.

imperfection Especially in a silver halide crystal, a departure from complete regularity of the crystal structure. Such departures affect the sensitivity of the crystal to radiation.

impermeable Not penetrable, as by a processing bath. Film base is nearly impermeable to developing and other solutions.

imposition In photomechanical reproduction, the assemblage of printing plates, negatives, or positives into appropriate positions preparatory to printing.

impression In photomechanical reproduction, a single image produced by a single contact of the plate, etc., with the paper or other sheet of material.

impressionism In art, a style emphasizing light and color as interpreted subjectively by the artist, as distinct from a realistic style with emphasis on detail. By extension, any of a variety of styles used by photographers to produce nonrealistic images.

impulse In visual perception, a pulse of light that theoretically has no duration. In practice, a pulse sufficiently brief so that decreasing the duration would not significantly affect the results.

impulse response The luminance distribution in an optical image for a target which is an infinitely narrow slit. Syn.: delta function.

in-betweens In animation photography, drawings added to complete a sequence. They are less important in establishing the action than are the extreme drawings. An in-betweener is an artist who makes such drawings.

incandescence Emission of light (i.e., visible radiation) by objects that have been heated to a sufficiently high temperature, above about 1,000 K. Solids and liquids above this temperature produce a wide range of wavelengths; vapors produce relatively few wavelengths.

incident Identifying energy, especially light, falling on a surface, as contrasted with that reflected, transmitted, or emitted by a surface. An incident light

imperfection

perfect imperfect

crystals

meter estimates the illuminance on a surface of interest, such as a part of a scene or an exposure plane.

inclusion In optics, the presence within an optical element of unwanted material, such as a bubble or other inhomogeneity.

incoherence Randomness, especially of radiation. Ordinary light is incoherent; laser light is highly coherent.

incorporated Included within (an emulsion). The term is applied to substances which are added to the emulsion during manufacture of stabilization printing papers, color films, etc., but which otherwise are usually components of processing solutions. Examples are developing agents and color couplers.

increment A change, or an increase, in some value or factor. Syn.: step. In a sensitometric step tablet (wedge), the increment is a log H (log E) change, often 0.15 or 0.30. In animation, an increment is a specific change in the position of the camera, or of a drawing, etc.

incubation test An experiment in which a photographic material is held for a period of time at elevated temperature and humidity, to estimate the deterioration in behavior of the material. Incubation tests are used as rapid methods of estimating shelf life, latent-image keeping, etc.

in date Identifying photographic material that is used on or before the time of expiration marked on the package. Use of the material before the expiration date does not guarantee its quality, since storage conditions may have been adverse. Contrast with outdated.

indecatrix A three-dimensional array of vectors, as of light reflected from a surface or emitted by a light source.

index of refraction (Symbol: *n*) (1) The numerical measure of the effect of a material on the velocity of light, as compared with the velocity in vacuum (or air). (2) The ratio of the speed of light in vacuum (sometimes in air) to the speed of light in the material. (3) For a light ray passing from vacuum (or air) into a material, the ratio of the sine of the angle of incidence to that of the angle of refraction. The image of refraction is basic to lens design, since the value of the index determines, in part, the effect of a material in causing light rays to deviate.

indicator A substance that shows, usually by its color, the chemical condition of a processing bath. Most indicators change color with a change in pH, and thus respond to a change in the acid-base properties of the solution. Litmus, for example, is pink in acid and blue in alkaline solutions.

indirect In lighting, reflected light, as from walls, ceilings, flats, etc., near the subject. "Bounce" lighting usually implies indirect light from flash or other artificial illumination.

induced movement A visual effect whereby a small stationary object appears to move in the presence of a large moving object. The moon often appears to move past clouds at night.

induction period The time after immersion of a silver halide material into the developer before the first appearance of the image.

industrial photography Production of photographic images, ordinarily in an establishment associated with a factory or other similar enterprise. The objectives of such an establishment are to serve the needs of the factory operation.

inert As applied to gelatin, without any substance that would affect the sensitivity of a silver halide emulsion. The use of an inert gelatin makes possible the addition of controlled amounts of sensitizers without concern about those which may be initially present in the gelatin.

inertia The exposure near the beginning of the straight line of the D-log H (D-log E) curve, found at the intersection of the straight line with the base + fog level. The H and D speed is reciprocally related to the inertia, and thus is a useful measure of film sensitivity for straight-line reproduction.

infectious Identifying a type of development in which the rate of development of weakly exposed grains is greatly accelerated in the presence of adjacent fully exposed grains. The effect is most marked for the film-developer combinations used in lithography.

infinity (∞) (1) In optics, an object distance so great that the image is essentially at the principal focal plane of the lens or curved mirror. (2) In the phrase "gamma infinity," the maximum attainable, applied to the slope of the straight line of the D-log H (D-log E) curve.

infinity stop (1) The position on a focusing scale that indicates the lens position for focusing on far distant objects. (2) A position on a focusing mechanism for placing a lens so that the focusing scale or rangefinder will accurately indicate the distances at which objects are focused at the film plane.

influx Flowing in, as energy to a sample. In a microdensitometer, the influx optics involves the light source and the lens that focuses the light on the sample.

in focus Applied to an optical image that is sharply defined at the exposure or viewing plane.

informal Applied to an unposed portrait, or to one

indecatrix

vector

lamp

index of refraction

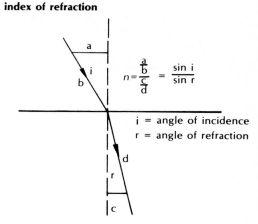

$$n = \frac{\frac{a}{b}}{\frac{c}{d}} = \frac{\sin i}{\sin r}$$

i = angle of incidence
r = angle of refraction

inertia

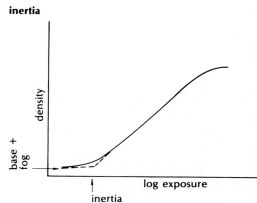

density

base + fog

log exposure

inertia

informal portrait

D. Krukowski

that has been posed so as to appear casual, usually made on location as distinct from a formal studio portrait.

infrared Electromagnetic radiation just greater in wavelength than red light, of wavelength from approximately 700 to 300,000 nanometers. Photography with infrared requires emulsions that are especially sensitized. (The phrase, "infrared light" is inappropriate since infrared radiation is invisible, and light is defined as visually effective radiation. Infrared radiation is sometimes, also inappropriately, called "heat" rays, as in "heat-absorbing" filters. Heat is the energy of molecular motion.)

infrared color film A three-layer photographic material sensitized to green, red, and infrared radiation. The material reproduces infrared-reflecting surfaces as red, green surfaces (other than foliage) as blue, and red surfaces as green. The film is used for aerial reconnaissance and agricultural surveys, as well as for unusual pictorial effects.

infrared film A photographic material especially sensitized to wavelengths longer than the extreme visible red. Since the material also has shortwave sensitivity, a shortwave-absorbing filter (yellow or red) must be used if only infrared radiation is to be recorded. The material is used for pictorial purposes as well as for recording information.

infrared mark On some lens mounts and focusing scales, an indication of the adjustment in lens-to-film distance required when infrared-sensitive film is being used. Because infrared has long wavelengths, the effective focal length of the lens may change from that with light.

infrared mirror A surface that has a high reflectance (low transmittance) for wavelengths longer than the extreme visible red, and the converse properties for light. Such a mirror may by used instead of an infrared-absorbing ("heat-absorbing") filter in projection, to reduce the infrared radiation falling on the image being projected.

ingenue In motion pictures and television, a young woman who plays a part characterized by innocence and näiveté.

inherent sensitivity The basic response of a photosensitive substance apart from that conferred by the addition of dyes or other sensitizers. Most photographic materials are inherently sensitive only to radiation of short wavelengths, such as ultraviolet radiation and blue light.

inhibitor Restrainer, a component of a developer that reduces the rate of fog development compared with the rate of image development. Example: potassium bromide.

in-house Carried out within the parent organiza-

tion's facilities, as opposed to being performed elsewhere.

ink (1) (noun) A pigment-vehicle mixture, used in photomechanical printing processes. (2) (verb) To transfer a mixture as in (1) to a printing plate. (3) (verb) In motion-picture animation, to transfer a drawing manually to another surface, especially to a transparent overlay (cell).

inker In motion-picture animation, a person who traces in ink, on acetate sheets, drawings prepared by animators and other artists.

ink-film thickness In photomechanical printing, a measure of the pigment deposit on a receiving surface (paper and the like) in terms of the reflection density of a patch.

inky (inkie) (slang) Incandescent light source.

inlay In television, the replacement of parts of a scene by corresponding parts of a different scene. An example is in the simulation of a landscape as seen through the windows of an automobile. The method involves rapid electronic switches and black-and-white shapes, the position and shape of which conform to those of the windows. See overlay.

in-phase (1) Identifying two or more wave forms that are matched, so that the crests coincide in time or space. (2) In motion pictures, coincidence of operation of the camera and projector shutters when making a process shot. (3) In motion-picture animation, an arrangement of the motor such that the shutter is closed when the camera stops.

in-plant Within the parent organization and facilities. An in-plant photographic facility, for example, may be part of an automotive, electronic, or military operation.

input (1) The energy, current, etc., delivered to a device such as a transformer, amplifier, photocell, as distinguished from output, that which emerges from the device. (2) In an experiment, that variable which can be directly changed by the experimenter, as contrasted with output, where the change can be controlled only indirectly.

insensitive As applied to a photographic material, not responsive to, or not affected by, a particular type of radiation. Orthochromatic materials are insensitive to radiation of long wavelengths, i.e., red light. Insensitivity is rarely absolute.

insert A close-up shot showing details of a scene, for the purpose of impact, artistic detail, or to clarify the situation to the audience.

inspection (1) In general, an examination of a product with the purpose of detecting flaws. (2) In motion pictures, running a print on a projector to find scratches, dirt, errors in cutting or exposure,

infrared mark

infrared mark - R

etc. Also, a check on film during rewinding for poor splices, broken perforations, etc. (3) In development by inspection, the use of the appearance of the image as a guide to the completion of development. Contrast with time-temperature development.

instantaneous Characterizing an exposure time of a second or less, i.e., other than "bulb" or "time."

instant-return Identifying a viewing mirror in a single-lens reflex camera that returns quickly to the viewing position after the exposure is made. Thus the photographer is only momentarily prevented from observing the scene. Syn.: quick-return.

instrumentation (photographic) Apparatus such as cameras, optical accessories, timing systems, etc., used to obtain photographic records of events of interest.

insurance shot A photograph made as a substitute for another, in case of loss of or damage to the first. Syn.: safety shot; protection shot.

in sync (1) In cinematography, a match of the sound with the picture. (2) In cinematography, the coincidence of operation of two pieces of equipment (cameras, projectors, etc.) by means of an interlock system. (3) In still photography, the correct timing relationship between opening of the shutter and firing of the flash to utilize the peak output of light.

intaglio In a photomechanical printing process, an image cut or etched into a plate, capable of producing continuous tones. Gravure is an example. Contrast with relief.

integral density A type of density measurement of a multilayer color image in which all the layers affect the measured value. Contrast with analytical density, a measurement by which the effect of each layer is treated separately from that of the other layers.

integral tripack Photographic material for color photography, consisting of three differently sensitized layers on the same support. Syn.: monopack.

integrated (1) Identifying a light-meter reading made so that the instrument receives light from many parts of the scene, as distinct from a spot or close-up reading. An integrating meter has a large angle of acceptance; it reads an average value that is determined by the luminance and area of each part of the subject. Also see camera-position. (2) As applied to a television program, including commercials as well as program material on a single reel. Also, the use of film with taped or live segments on a program.

integrated circuit A pattern of electrical parts and connectors, typically on a flat nonconductive support. Such circuits are often made by the use of photoresists and chemical etching.

integrating (1) Applied to a photoelectric meter that responds to energy from a broad area or over a wide angle. Contrast with spot meter. (2) Applied to a light meter for electronic flash. The meter responds to the total quantity of light in the pulse from the lamp. Light meters that integrate over longer time intervals are used with some process cameras to compensate for fluctuations in light output with arc sources.

integrating bar An optical element intended to produce a uniform light source, often consisting of a glass rod of square cross section, ground on both ends, illuminated by a source at one end.

integrating sphere A hollow ball with diffuse white interior, and with apertures for the entrance and emergence of light. Such an object provides a highly diffuse source of light, and also is used to collect diffuse light in density measurement.

integrity General term for quality, applied to a photoresist. It includes properties such as adherence to the substrate, edge characteristics and resistance to abrasion and chemicals.

intensification (1) A method of increasing image density by chemical means. The converse of reduction (2). (2) A method of increasing the luminance of fluorescent images by electrical means. (3) A method of reducing the required exposure time in radiography, by the use of a fluorescent or lead screen.

intensity (1) (I_v) A measure of the rate of emission of light from a source in a specified direction. Unit: candela (candle and candlepower are obsolescent); lumens per steradian. (2) (I_e) Similar to definition (1), but extended to radiation other than light. Unit; watts per steradian. (3) Loosely, the strength of light or radiation. (4) As applied to a color, vividness; saturation.

intensity-scale A type of sensitometer that exposes a sample to energy for the same time over the whole sample, but with different illuminances at different points on the sample. An intensity-scale sensitometer is provided with a step tablet or other light attenuator. Such a sensitometer exposes the material in a manner conforming to practice in most real-life situations, as in conventional cameras. Compare with time-scale.

interaction (1) The joint effect of two input variables, such as exposure and development. (2) In statistics, the nonadditive effect of two variables. A change in the level of one input variable has an effect that varies with different levels of another input variable. For example, a change in the hydroquinone concentration in a developer may have different effects on density, dependent on pH.

interaxial Between axes, as of two optical systems: for example, the eyes or the lenses of a stereo camera. In three-dimensional photography, the inter-

axial distance should be approximately two inches for correct perception of the stereo effect. Also see interocular.

interchangeable Applied to parts or devices, especially lenses, that are readily removed and replaced by others.

intercutting In editing motion pictures, the process of splicing different shots of the same sequence in appropriate time relation.

interface (1) A boundary between two different chemical substances. Especially, the boundary between silver and silver halide, the nature of which is important in the theory of development of silver halide photographic materials. (2) By extension from (1), a person, piece of equipment, etc., occupying a position between two other persons, etc. A photographic engineer often acts as an interface between research personnel on the one hand and production personnel on the other.

interference The variation in energy level caused by the superposition of two waves of nearly the same wavelength (frequency). Colors in soap bubbles and oil films are caused by interference between a direct and reflected wave. Lens coatings function on a similar principle. See Newton's rings.

interference filter A narrow-passband radiation attenuator. It consists of two reflecting surfaces separated by a thin transparent film, of thickness such as to cause constructive interference of only a small range of wavelengths.

interference photography See Lippman (color) process; holography.

interferometry Measurement of distances to a high degree of precision from the pattern observed when two beams of light (or similar radiation) superimpose. The difference in path length of the two beams can be accurately inferred from the interference pattern.

interimage effects In multilayer color photographic materials, a change in the image formed in one layer when there are differences in the images formed in adjacent layers. The cause is altered developer activity, similar to that which produces adjacency effects in single-layer materials.

interior A scene or photograph inside a building, as compared with exterior.

interior-exterior A simulated exterior setting built inside a studio and lit to appear as if it were outdoors.

interlock (1) The coupling of f-numbers and shutter speeds, so that they can be changed simultaneously by a single movement of a lever or other control. (2) A method of ensuring synchronism of picture and sound records where separate films or tapes are used, or where two or more cameras, projectors, etc., are involved. A special motion-picture projector can handle a work print along with a separate soundtrack, maintaining synchronism. When screened, the procedure is often called an interlock.

intermediate (1) A second-generation image used to make reproductions, as a negative made from a positive transparency. (2) In photofabrication, a somewhat reduced image requiring further reduction to obtain the final desired size.

intermittency effect The change in response of a photographic material associated with an exposure divided into portions, as compared with the response associated with a single continuous exposure of the same magnitude.

intermittent (1) In motion-picture cameras and projectors, the stop-and-go motion of the film, as well as the apparatus that produces such motion. Some high-speed motion-picture cameras have a continuous rather than an intermittent movement. (2) As applied to agitation, periodic rather than continuous. Often used in tank processing of roll and sheet film.

intermodulation The generation of wave forms (by an amplifier or photographic system) other than those which are fed into the system. If a reproducing system is nonlinear, it may produce harmonics that distort the record. Intermodulation is a problem in sound recording and also in ordinary photography.

internal (1) As applied to the effect on light of an optical element, independent of surface reflection. (2) For silver halide materials, applied to a latent image that is developable in a bath containing silver halide solvents, after removal of the surface image by a suitable oxidizing agent.

International Commission on Illumination (ICI) English for (French) Commission Internationale de l'Eclairage (abbreviated CIE), the preferred term. A standards organization dealing with definitions and methods in the field of light.

International Organization for Standardization (ISO) As association concerned with the development of measurement procedures in science and technology.

International Radio Consultative Committee English for Comite Consultatif International de Radio (CCIR), an international organization concerned with television film standards among other matters.

internegative An intermediate image obtained directly from a color reversal (positive) original or from a black-and-white positive original. Contrast with color duplicate negatives, which are from other originals.

interference filter

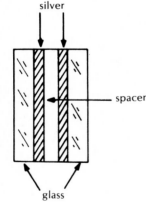

silver

spacer

glass

interocular ("between eyes") Interocular distance is the distance between the centers of the pupils of the eyes of a person; it is of importance in stereoscopy. Interocular adaptation involves the influence of the behavior of one eye on the function of the other eye. Syn.: interpupillary. See interaxial.

interpolate To estimate the value of a variable from information which brackets (lies on either side of) the desired value. If the correct processing times are known for two different temperatures, interpolation involves the estimation of the correct time for an intermediate temperature. (Interpolation usually assumes a straight-line relationship, which is rare in photographic processes.)

interpositive See diapositive.

interpreter (also **photointerpreter**) A person trained to make deductions concerning the subject on the basis of careful examination of photographs, commonly applied to those who seek military information from aerial photographs.

interpupillary distance The separation of the centers of the two eyes, approximately two inches. In stereophotography, for correct simulation of the scene, two images must be made with lateral separation of the viewpoints equal to the interpupillary distance. Syn.: interocular. Also see interaxial.

Intersociety Color Council (ISCC) An association of organizations concerned with various aspects of color. The initials also identify a system of naming colors developed with the National Bureau of Standards.

interstitial Applied to ions in a crystal that are displaced from their normal positions in the array and can move through the crystal. Such ions may participate in the formation of the latent image.

intervalometer A device for controlling the length of time between frames in, for example, time-lapse or aerial photography.

in the can In cinemaphotography, slang for finished with shooting.

intra-lens As applied to a shutter, between the lens elements.

intro Short for introduction, that part of a motion picture or television production which begins the presentation, often opening bars of music.

inverse (1) Reciprocal, i.e., the relationship of 1/2 to 2. (2) Specifying a relationship between two variables, by which as one increases, the other decreases proportionally. For a fixed exposure, the necessary exposure time is related inversely to the light level (illuminance) at the film. Mathematically, an inverse relation is shown by an equation of the form $y \bullet x = k$, where k is a constant and y and x are the variables.

inverse-square law At a point on a surface receiving radiation from a point source, the irradiance (or illuminance) diminishes as the square of the distance from the source is increased. $E = I/d^2$, where E is illuminance at the surface, I is the intensity of the source toward the surface in candelas, and d is the distance. For real (i.e., not point) sources, the law applies sufficiently for most purposes if the greatest dimension of the source is not more than one-tenth of the distance. The law fails for nearby nonpoint sources like fluorescent lamps, of broad sources such as banks of lights.

inversion (1) A technique for agitating film-processing solutions in a closed tank by turning the tank upside down at intervals. (2) A temperature change opposite to that usually encountered. In a deep processing tank, for example, if the circulation is inadequate, the temperature near the bottom may be warmer than that near the top.

inverted (1) Upside down, applied to images. (2) For an optical system, having the negative assembly of elements in front and the positive assembly in the rear. The distance from the rearmost lens surface is considerably greater than the system focal length. The design is sometimes called "inverted telephoto," "reversed telephoto," or "retrofocus" and is used in wide-angle lenses, especially those used in single-lens reflex cameras.

ion A charged particle, such as an atom that has lost (or gained) one or more electrons. Silver halide crystals consist of ordered arrays of silver and halide (bromide, chloride, iodide) ions.

ion exchange A method of water purification involving replacement of metallic ions by hydrogen ions, and of unwanted nonmetallic ions by hydroxyl ions.

ionic conductivity That property of a substance by which it allows ions to move through the material, as distinct from electronic conductivity. Ionic conductivity and electronic conductivity are important in latent-image formation in silver halide crystals.

IR (i.r.) Infrared radiation; that band of electromagnetic radiation just greater in wavelength than light, between 700 and 300,000 nanometers approximately.

IRE unit As seen on a television monitor, a division of a scale from 0 to 100, related to the voltage applied to the television tube. The scale is nonlinearly related to the image luminance.

iris The structure of the eye that adjusts the diameter of the pupil, over about a 1-4 ratio, in rough accordance with the illuminance on the eye.

iris diaphragm A variable diaphragm used on cameras and other equipment, consisting of a set of

overlapping thin blades whose position is adjustable by the motion of a ring or lever.

iris (in, out) In motion pictures, to open (or close) a diaphrgam gradually, thus fading the image in (or out).

iris wipe In motion pictures and television, the replacement of one scene by another in which the effect is that of an expanding or contracting circular boundary between the two scenes.

iron processes (1) Photographic materials making use of the conversion of ferric to ferrous ions by the absorption of radiation, as for blueprints. (2) Toning methods making use of compounds of iron.

irradiance The measure of the rate at which radiant energy is received per unit area of the receiving surface. Irradiance is to radiant energy as illuminance is to light. Unit: watts per unit area, etc.

irradiation (1) The process by which a surface receives radiant energy. Analogous to illumination for light. (2) The scattering of energy within a photosensitive layer, resulting in the diffusion of energy and an increase in image size.

ISCC Intersociety Color Council.

ISO International Organization for Standardization.

isodensitometry A method of graphical display of contours of equal density (absorption) in an image. The method permits detection of very small differences in the image, and is useful in information recovery from photographic records.

isoelectric point (1) The pH (measure of acidity or alkalinity) at which the electric charges on the gelatin molecule are balanced. The swelling of gelatin is at a minimum at this pH when it is surrounded by little or no dissolved salts. (2) The pAg (measure of silver ion activity) at which the net electrical charge on a silver halide crystal is zero.

isohelie (isohely) Line of equal luminance in an image, analogous to a contour line. Similar to isophote; isodensity.

isomer One of two or more colored samples that have identical spectral reflectance or transmittance distributions, so that they match under all conditions of viewing. Compare with metamer. Also see unconditional match.

isophote In an image, a line of equal light intensity, useful in data-extraction procedures. Similar to isohelie; isodensity.

isoradiant Having substantially uniform energy per unit cross-section area. Applied to a beam of energy, to an irradiated area, or to a source of radiation.

isotropic Having the same properties in any direction in space. As applied to photographic materials, having the same photographic characteristics lengthwise and widthwise.

JJ

J

jack A single-pin electrical socket into which a pin connector may be inserted.

jacket (1) A transparent envelope for storing microfilm strips. (2) With "water," a means of controlling the temperature of processing solutions, by which processing tanks or trays are surrounded by a water bath at the proper temperature.

jam A pile-up of film in a camera or processor caused by a mechanical failure, or by incorrect threading.

jelly A sheet of dyed gelatin, etc., used to change the color of the light on a set. Syn.: gel.

jet (1) Deep black, applied to an antihalation backing used on some films for motion pictures. (2) Applied to a type of agitation in which the processing bath is forced against the film through a nozzle in a forceful fine stream.

jig A device made to hold an object to be photographed. In microfilming, a jig holds cards or other documents. In motion pictures, a jig supports a prop in the correct position.

jitter The random motion of an image on a motion-picture screen, especially in animation.

JND Just noticeable difference.

judge A person who evaluates the quality of photographic images, especially in connection with the showing of prints and transparencies.

juicer In cinematography, slang for an electrician.

jump (1) In motion pictures, an obvious discontinuity between two consecutive scenes. (2) Marked unsteadiness of a projected motion picture.

junior Slang for a medium spotlight.

jury A group of persons who make judgments of photographic quality. The persons may be experts who choose prints for hanging in a salon, or may be selected as typical of a group of potential customers.

just noticeable difference (JND) The smallest change in a stimulus that an observer can detect. As applied to vision, the smallest visibly detectable change in luminance, spectral, etc., characteristics of light.

juvenile A young, usually handsome male actor.

KKK

K

Kerr cell

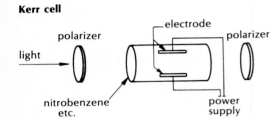

light → polarizer · electrode · polarizer · nitrobenzene etc. · power supply

K (formerly, k°) Kelvin. A temperature scale based on absolute zero, and used for the specification of the color of some light sources. See color temperature.

kaleidoscopic In motion pictures and television, applied to an effect obtained by combining several images, typically with rapid changes in images, sizes, angles, positions, etc.

keep In motion pictures, a scene record (take) good enough to retain, with the intent that it will be used in the finished film.

keeping characteristics (quality) Stability of photographic chemicals, baths, or materials with time.

keg Applied to a large focusing light source in a cylindrical housing, used for spot lighting.

kelvin (formerly **degree Kelvin**) A unit of temperature measurement on the Kelvin (absolute, thermodynamic) scale. For example, 100 kelvin means a temperature 100 degrees above absolute zero. See K.

Kelvin Identifying a thermodynamic temperature scale with degree intervals equal to those of the Celsius (formerly centigrade) scale, but with the zero at approximately −273 C. Thus, the Kelvin value is approximately 273 greater than the Celsius value. Sometimes called the "absolute" scale. One application is to light sources, as a 3200 K lamp. See color temperature. (Note the omission of the degree sign, a recently adopted convention.)

Kerr cell A container, usually cylindrical, of liquid such as nitrobenzene, between a pair of electrodes and crossed polarizers. When an electrostatic field is produced between the electrodes, the plane of polarization of light is rotated. The apparatus constitutes a shutter capable of controlling exposure times of the order of a billionth of a second.

key (1) That source which supplies the major lighting on a scene. (2) The prevailing tone of a photograph.

A high-key picture consists mainly of light tones, a low-key picture, of dark tones. (3) A slot in a film spool that is engaged by a rotatable element on the camera to permit changing of frames. (4) In photomechanical reproduction, the plate that has the most detail and is thus used to register the other plates. (5) In photomechanical reproduction, the black printer in a four-color process. (6) Applied to a master drawing in animation, i.e., one that is exceptionally important in the movement of the character, etc.

key numbers See edge numbers.

keystone effect (1) Change in the shape of a projected image from a rectangular form, caused by the inclination of the axis of projection to a perpendicular to the screen. (2) Unwanted convergence in the image of vertical parallels in the subject, as in architectural photographs.

kg Kilogram, a unit of mass (loosely, weight) in the metric system (now called Systeme International). One thousand grams, about 2.2 pounds.

kHz Kilohertz, 1000 cycles per second.

kick (slang) A brilliant specular reflection, as from a shiny metal surface, from water, etc.

kickback Light reflected into a camera lens, especially that reflected from the ports of a blimp covering a motion-picture sound camera.

kicker (slang) A light from the side or back, used to increase the visual separation of a subject from the background.

kill (slang) (1) An order not to publish (a photograph) or to discard a motion-picture take. (2) A command to turn off a specific light or lights on a set.

kilo- In the metric system, a prefix meaning "thousand."

kilowatt (kw, k.w.) A unit of electrical power. One thousand watts.

keystone effect

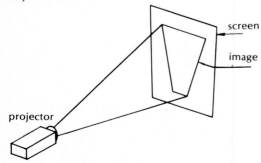

screen · image · projector

kinescope A type of television picture tube used in receivers.

kinescope recording A motion picture made from a receiver-type television tube.

kinetics In chemistry, the study and measurement of rates of reaction, as of developing agents with silver halides.

kink marks Defects in images on film, usually crescents, caused by sharp bending before processing. Whether the mark is light or dark depends on the film, whether the stress occurs before or after exposure, the extent of the stress, etc.

Kirchhoff's Law At any temperature, the energy emitted by a surface is proportional to the absorptance of the surface. An ideally black surface with an absorptance of 1 is, therefore, the most effective radiator of energy.

Köhler's illumination In making photographs with a microscope, a lighting technique that produces a uniformly bright field with a light source of almost any type. A lens is used to focus the source on the substage condenser, which focuses an image at the field (limiting) aperture on the specimen.

Kostinsky effect As development proceeds, the measured distance between the centers of two small adjacent dense image elements increases. The cause is greater developer exhaustion between the elements than at their outer edges. When the image elements are less dense than the area around them, the effect is reversed, and the elements appear to move closer together.

K radiation In radiography, applied to a discontinuous spectrum produced when chromium, copper, molybdenum, etc., targets are used, as distinct from a continuous spectrum. K radiation is preferred to continuous x-radiation for distinguishing between sample components that have similar atomic numbers.

kw; k.w. Kilowatt.

Kostinsky effect

exposure

image after brief development

image after long development

LL

L

l Liter or liters, preferably spelled out.

L (1) Internationally-accepted symbol for radiance L_e or luminance L_v. (2) Lightness. (3) Long, identifying films intended for exposures at relatively great exposure times.

lab Short for processing laboratory.

laboratory In still and motion pictures, a film-processing plant.

laboratory packing Applied to motion-picture film supplied on a spool not suitable for daylight loading because of the absence of light-protective flanges on the spool.

lacquer A transparent protective coating, applied to motion-picture films, slide films and transparencies, color prints, etc.

lag (1) In processing control, that time between the collection of data about the process and the correction of the error if one is found. For effective process control, the lag should be as short as possible. (2) In measuring instruments, the time between the actual change in the quantity to be measured and the response of the instrument. For example, a thermometer responds only slowly to an abrupt change in the real temperature of a processing bath. (3) A characteristic of phosphors of a continuing glow after the input energy stops. Fluorescent lamps produce light for a period after the current is turned off. In television receivers, this lag produces streaks behind the images of bright moving objects.

laid in (1) In motion pictures, identifying film matched to soundtrack, or original matched to workprint. Film is said to be laid in when it is being made up on the cutting table. (2) Identifying soundtrack not specifically edited to fit the picture, but simply added.

λ (Greek letter **lambda**) Wavelength.

lambert The unit of measure of luminous emittance into a hemisphere from one square centimeter of radiating or reflecting surface. For a reflecting surface, the number of lamberts is the product of the reflectance of the surface and the illuminance in lumens per square centimeter. For a perfectly diffusing surface, and *only* for such a surface, a luminance of one candela per square centimeter is equivalent to π lamberts.

Lambertain surface An emitting or reflecting surface that has the same luminance from any direction of observation. For such surfaces, the angle of incidence of illumination is irrelevant. No real Lambertian surfaces exist, but blotting paper is an approximation.

Lambert's law (1) For a perfectly diffusing surface, the luminance is independent of the direction from which the surface is viewed. A mat projection screen looks nearly equally bright from any position. A consequence is that the apparent candlepower varies with the cosine of the angle of observation. (2) The optical density of an absorbing substance is directly proportional to its thickness. Also known as Bouguer-Lambert law; Bouguer's law. The law holds for nonscattering, nonfluorescent materials and strictly only for monochromatic radiation. Furthermore, surface effects must be negligible.

laminar Applied to a thin layer, especially of a developing solution in contact with a photographic material being processed. The thickness of such a laminar layer affects the rate of penetration of developing chemicals into and out of the emulsion, and thus affects the rate of development. Laminar flow involves the movement of a thin sheet of a fluid, as distinct from turbulent motion.

laminate To bond two or more sheets of material by cement, heat, etc. ID photographs may be laminated in clear plastic.

lamp A source of artificial light, such as tungsten

lamp, carbon-arc lamp, fluorescent lamp.

lamphouse That part of a projection apparatus that contains the light source.

Land color system A method for the approximate simulation of colors by the additive synthesis of only two records of the scene. The images may be made with green and red light, and projected with white and red light. (Distinguish from the three-color diffusion transfer system, a subtractive process, also developed by Edwin H. Land's research group.)

lantern slide A transparency intended for projection. Usually shortened to "slide." Syn.: diapositive (2).

lap dissolve In motion pictures, a special effect involving the gradual replacement of the whole of one scene by another. Preferred term: dissolve. (Distinguish from fade-out, fade-in, in which one scene disappears and is succeeded by another scene.)

lap marks In motion pictures, longitudinal streaks, often caused by defective processing rollers.

lap splice A method of joining two lengths of film, by which one length slightly overlaps the other. Compare with butt splice.

large-format Applied to a still camera that uses film size of 4 x 5-inches or larger.

laser (Acronym for "Light Amplification by Stimulated Electromagnetic Radiation.") A source which produces light that is nearly monochromatic (of only one wavelength) and highly coherent (with waves closely aligned). Such sources can be used to produce uniquely high illuminances and to generate well-collimated beams. They are often used in holography.

latensification Chemical or physical treatment of the latent image (i.e., of the photosensitive material after exposure), intended to increase the image density and contrast. For silver halide materials, latensification increases the number of developable crystals. Methods of latensification include uniform exposure to very weak light, treatment with mercury vapor, or bathing in solutions of organic acids, hydrogen peroxide, etc. The increase in sensitivity is small or absent with modern fast materials. (Distinguish from hypersensitization, which involves treatment of the photographic material before exposure to the image.)

latent image (1) The image in a photosensitive material, after exposure but before it is made visible and usable by development. (2) That change in a photographic material, caused by the absorption of radiant energy (or by chemical action), which makes the material develop at a much higher rate than would otherwise be the case. In silver halide grains, the latent image is most probably a group of a small number of atoms of silver. Development is normally necessary for a study of its characteristics.

lateral adaptation A visual effect by which a surrounding area, or an adjacent color patch, affects the appearance of a given patch. A gray looks darker next to a white patch than next to a black patch. A yellow looks lighter and more saturated (vivid) next to a blue patch than next to a white patch.

lateral chromatic aberration (lateral color) A lens defect resulting in a variation in image size (magnification) with the wavelength of radiation. The defect causes image deterioration for off-axis areas, and thus determines in part the angular field of the lens. Distinguish from longitudinal chromatic aberration.

lateral coverage In aerial photography, the distance (measured on the ground) included in a photograph, perpendicular to the direction of flight.

lateral inhibition In visual perception, an effect whereby light from one subject area causes a reduction in response to light from an adjacent area. Although lateral inhibition reduces contrast between adjacent areas, the effect is perceived as an enhancement of contrast along the edge. For example, steps on a gray scale that are uniform in density do not appear to be uniform in lightness. A psychophysical phenomenon analogous to photographic edge effects.

lateral oblique In aerial photography, identifying a photograph made with the camera axis perpendicular to the line of flight, but not vertical.

lateral reversal A right to left change in image orientation. One's image as seen in a conventional mirror is laterally reversed.

lateral shift (1) On a view camera, a sidewise adjustment of the lens or film position. (2) On the D-log H (D-log E) curve of a photographic material, the simulation of an exposure change. A lateral shift of 0.3 on the log H axis is the equivalent of a one-stop change in camera settings.

latitude in exposure The permissible change in camera exposure, usually expressed in stops, without significant effect on image quality. Often, simply called latitude. Latitude is affected by: the definition of image quality, the usable extent of the characteristic curve, and the subject luminance range (contrast). For images of high quality of usual subjects, the latitude in exposure is small when conventional films are used. Extended-range films may permit a latitude in exposure of many stops for usual subjects. Syn.: exposure latitude.

lattice A structural arrangement, especially of atoms or ions in a crystal, e.g., a silver bromide crystal.

lateral adaptation
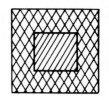

lateral chromatic aberration
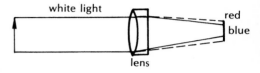

white light　　　　red
blue
lens

lateral oblique

line of flight

camera axis

perpendicular

latitude in exposure
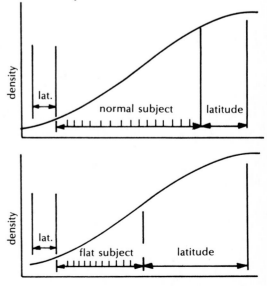

density
lat.
normal subject　　latitude

density
lat.
flat subject　　latitude

law enforcement photography Legal, crime or forensic photography.

law of reflection When a light ray is reflected from a surface, the angles of incidence and reflection are equal. Furthermore, the incident ray, the reflected ray, and the perpendicular to the surface at the intersection of the rays, all lie in the same plane.

layout (1) An arrangement of photographs, typographic material, etc., used as a guide for those engaged in preparing advertisements or other types of display such as books and magazines. (2) In animation, a careful plan of the action as a guide for the animator.

lb Pound; 16 ounces avoirdupois weight.

LCL Lower control limit.

lead The principal performer in a motion picture or television production.

leader A strip of film (sometimes paper) used for protection and threading of motion-picture film, etc. A leader can be clear, or in any of several colors to assist in identification of the film. Special cuing leaders are marked to indicate changeovers to a motion-picture projectionist. See Universal leader; Society leader; Academy leader.

leading line In pictorial composition, a linear element (such as a road) that is thought to direct the eye of the viewer in a specific direction. (Studies of the eye motion of observers suggest, however, that they actually look as different picture areas in a less predictable way.)

lead line (Pron. leed) A sign added to a photograph to direct the viewer's attention to a specific area, typically a line ending in an arrowhead, of a tone that contrasts with the background. Syn.: leader line.

lead screen (Pron. led) In radiography, a sheet containing lead or a lead salt placed in contact with the photosensitive material. With high-voltage x-rays, the screen reduces scattered radiation and improves image quality.

lead sheet (Pron. leed) In motion-picture animation, a compact frame-by-frame breakdown of the story indicating to the animator the music and dialog cues he must follow in his work.

leaf (1) Specifying a between-the-lens shutter made up of thin blades. (2) In the manual processing of sheet films, an agitation method that consists of repeatedly and continuously moving the bottom sheet of a stack of several sheets to the top of the stack. (3) In a motion-picture projector, that part of the shuttle through which the film passes.

legal (forensic) photography The production of photographic images intended for use as evidence in a court of law. See crime photography.

legend (1) Caption. A brief description appended to a photograph, especially beneath it. (2) In motion pictures, a subtitle.

lens (1) A piece of glass or other transparent material, curved so as to form an image by the refraction of light or other radiation. (2) A combination of several transparent curved pieces of glass, etc., capable by refraction of producing an image of quality better than is possible with a single piece. (3) In electron microscopy, a coil of wire (or other device) that focuses electrons to form an image.

lens board A detachable portion of a camera or enlarger front, into which a lens and a shutter may be inserted.

lens cap A protective cover kept on a lens when it is not in use.

lens coating A thin layer of transparent material, usually magnesium fluoride, applied to an optical surface that as used is in contact with air. The effect of the coating is to reduce light reflection, and thus to lessen stray (flare) light and to improve image contrast. An additional benefit is the increased transmittance of the lens, and therefore greater effective lens speed.

lens flare Light, reflected and re-reflected from air-glass surfaces, that finally falls on the image plane. The effect in the camera is a reduction in contrast of the dark (shadow) areas. In printing, a similar deterioration occurs in the highlight areas. Lens coating reduces lens flare and for this reason improves image quality.

lens hood Typically a conical, pyramidal or bellows-shaped device, intended to shield a lens from extraneous light. Syn.: lens shade.

lensmakers's formula The rule that $\frac{1}{f} = (n-1)\left[\frac{1}{R_1} - \frac{1}{R_2}\right]$

where f is the lens focal length, n is the index of refraction of the material of which the lens is made, and R_1 and R_2 are the radii of curvature of the two spherical surfaces of the lens. The formula applies to a thin lens in air, and with the convention that a radius has a positive sign if the surface is convex to the object, and conversely.

lens mount A device for holding a lens, typically built into a camera, projection printer, projector, or interchangeable lens board.

lens shade See lens hood.

lens speed A measure of the capacity of a lens to admit light to the image. Lens speed is usually expressed by the f-number (the ratio of the lens focal length to the diameter of the cylindrical bundle of light that can pass through the lens). Lens speed is

inversely proportional to the square of the *f*-number. Thus, an *f/2* lens is four times as fast as an *f/4* lens.

lens tissue Soft, nearly lintless paper used to clean optical surfaces.

lenticule A small optical element, especially one embossed on film or on a projection screen. Lenticular screens direct reflected light effectively to the audience. Cylindrical lenticular embossings have been used for color photographic systems and for stereophotography.

letterpress A photomechanical printing process by which ink is transferred from a raised surface, as distinct from gravure (where the image portions of the plate are depressed) and lithography (where the plate is essentially flat).

level (1) A device for determining when a surface such as a camera bed is in a horizontal position. (2) In sound, loudness. (3) Applied to a sound recording made without alteration in the loudness (volume). (4) In animation, the position of a cell with reference to the background. If there are three overlaid drawings on transparent sheets, the levels may be identified as B (bottom), M (middle) and T (top).

level-corrected In animation, applied to the color of paint used for a cell as it must be adjusted if the drawing is overlaid by a number of cells different from that used in another part of the film. The slight absorption of the different overlays requires a small change in the paints used for the given cell.

level sync (synchronization) The alignment of the sound and picture components of a motion picture so that the corresponding points coincide, as distinct from projection (printer) sync, in which the sound is ahead of the corresponding picture. Syn.: dead sync; editorial sync.

levorotary Identifying transparent materials that rotate the plane of plane-polarized light in a counterclockwise direction for an observer looking toward the light source. Compare with dextrorotary.

library A collection of books, still photographs, motion-picture sound or pictorial records, etc., arranged in an appropriate place for convenience in locating and using. When the collection is restricted to a single category, the library may be identified more specifically as a picture library, film library, etc.

lidar Acronym for Light Detection And Ranging. A measurement system similar in purpose to radar, but making use of visible wavelengths of radiation.

life (1) In the phrase "shelf life," that time during which little change can be expected in photographic or chemical properties. (2) As applied to equipment

(especially lamps), that time by which half of a large number of samples will have stopped functioning.

light (1) Radiant (electromagnetic) energy that can evoke a human visual response. Light differs from other radiation in wavelength, lying between about 380 and 780 nanometers. Since the standard luminosity curve is nearly zero near 400 and 700 nanometers, such a range is often taken as the limits of light. (Note: Terms such as "invisible light," "black light," "ultraviolet light," and "infrared light" are inappropriate. The term "visible light" is redundant.) (2) (adj.) Pale (color), the converse of dark.

light-activated Applied to a switch that causes a secondary (slave) lamp to function when light from a primary source is received, as distinct from a switch that requires an electrical connection. The application is generally to electronic-flash setups.

light adaptation A decrease in the sensitivity of the eye as the level of illumination is raised. Compare with dark adaptation.

light-balancing Applied to a type of filter intended to slightly change the color of a light source (especially incandescent) so that it will be correct for the color films being used. Such filters are bluish or yellowish, and are sometimes marked with the change in mireds they produce. Distinguish from conversion filters.

light bar A support for lamps, especially one to which the camera can also be fastened.

light box A translucent surface illuminated from the rear, on which a transparency (negative or positive) may be placed for examination or to be photographed. In medical photography, catalog photography, etc., objects may be placed on a light box so that the image will have a light surround.

light-change board In a motion-picture printer, the device that controls the light intensities to preset values, so as to obtain a properly timed (exposed) print.

lightfast Relatively unchanged when exposed to radiation. Said of dyes, etc. Syn.: fast.

light fog An image defect or degradation produced by accidental exposure of a photographic material to non-image forming light.

lighting (1) The arrangement of sources of illumination, as on a set. (2) The process of adjusting such sources so as to produce a desired effect. (3) The character or quality of the illumination as seen on a subject, a photograph or a motion picture.

lighting ratio Factor by which the illuminance changes on a subject, as from side to side of the face in portraiture. (Distinguish from the total luminance — often called "brightness" — ratio, which includes

lenticules (enlarged)

the variation in the subject reflectance as well as the variation in lighting.) (Note that the lighting ratio is not the ratio of the key to the fill light separately measured, but combined instead.)

lightline Designation for a style of glassware lighting in which the edges of the glass object appear lighter than the background.

light lock An arrangement of doors or offset passages to provide access to a dark area, such as a printing darkroom, without penetration of light.

light meter (Usually called exposure meter.) An instrument, usually photoelectric, used to measure luminance (intensity of light produced per unit area of a subject) or illuminance (light falling at a given point on an illuminated surface). The differences between the two types of measurements are in the angle of view of the devices (luminance meters having a narrow angle and illuminance meters having an angle approaching 180 degrees), and in calibration. Luminance meters are often called "reflectance" or "reflected-light" meters; illuminance meters are often called "incident-light" meters. (Note that photocells have a spectral response different from that of the eye, and therefore require special filters to measure light reliably.) (Note further that since photocells have a spectral response that is no doubt different from that of any film, they do not reliably predict correct camera settings except for a specific color of light.)

lightness (1) That aspect of color which applies to reflecting surfaces and which relates the appearance of such surface to a scale of grays. Whites are grays of high lightness; blacks are grays of low lightness. Highlights are tones of high lightness; shadows are tones of low lightness. Lightness corresponds roughly with luminance. In the Munsell system, the dimension of value is closely correlated with lightness. Brightness is simlar to lightness but differs in that brightness is applied to surfaces seen as sources of light, rather than as reflecting surfaces. (2) A number on a scale from 0 to 100 which is related to the visual appearance of a tone. Black has a lightness of 0; white has a lightness of 100. L (lightness) = $25\sqrt[3]{y} - 17$, where y is the reflectance (in visual terms) of the object patch in percent. Lightness is approximately 10X the Munsell value of the patch.

lightness constancy A psychophysical visual phenomenon whereby the lightness of a surface is perceived as remaining unchanged when viewed under different levels of illumination. A white object, for example, continues to be perceived as white rather than gray when a light source is moved away from the object, decreasing the illuminance. Commonly, but incorrectly, referred to as brightness constancy.

light pipe A small-diameter rod of glass, plastic, etc., constructed so that light entering one end is multiply reflected and, despite bends in the rod, emerges at the other end. See fiber optics.

light struck Said of photographic materials that have been accidentally exposed to non-image-forming radiation.

light table. A translucent surface, illuminated from below, and at a convenient working level for use in examination of transparencies, retouching, photographing small objects, etc. See light box.

light-tight Applied to film holders, magazines, etc., constructed so as to protect photosensitive material from fogging by radiation.

light trap (1) A passage admitting personnel or materials to a darkroom, but excluding light. See light lock. (2) On a film spool, a baffle or other means of protecting photosensitive materials from being exposed. (3) A cover for the eyepiece of some motion-picture cameras that prevents light from entering the eyepiece and reflecting off the reflex mirror onto the film.

light value A number relating shutter time and f-number, used in the determination of camera settings. The series of light-value numbers is based on the equation $2^{LV} = (N)^2 \cdot 1/t$, where LV is the light value, N is the f-number, and t is the time. Since the series is logarithmic, computations can be made by addition or subtraction. Light meters marked in the light-value system have scales marked 1, 2, 3, . , . , . , where a change of one digit represents one stop.

lightweight Characterizing photographic printing paper on a thinner support than singleweight.

limen (pron. li men) A threshold, as of perception. In vision, that light level which is barely detectable.

limited As applied to animation, the use of only a few drawings for the sake of economy. Camera movement, fades and dissolves, and other effects are used to produce a feeling of motion.

limits In process control, the boundaries between which a stable system usually fluctuates (control limits), or within which a process must operate in order to produce an acceptable product (specification limits). For effective processes, the control limits lie within the specification limits.

line (1) Specifying a type of lighting arrangement by which the subject is bordered with a light edge. (2) Identifying an image (negative, or positive, or printing plate) made so as to reproduce only two tones, as of a drawing, typescript, etc., as contrasted with continuous tone. (3) In graphic arts, a measure of halftone screen frequency. A 100-line screen is one that produces 100 dots per inch, as measured

limits

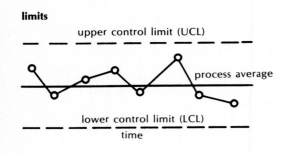

upper control limit (UCL)

process average

lower control limit (LCL)

time

along the diagonal of the screen. (4) As applied to spectra, containing only a few wavelengths. Discontinuous, as compared with continuous.

linear (1) As applied to magnification, the ratio of image width (or length) to object width (or length), as distinct from a similar ratio based on areas. (2) A relationship between variables which plots as a straight-line graph. Rectilinear, as distinct from curvilinear. (3) As applied to a system, one which produces an output that is directly proportional to input, and which also sums the effects of different input values arithmetically. Photographic systems are usually not linear in this sense, whereas optical systems are often linear. (4) A type of perspective in which the perception of depth results from the convergence of parallel subject lines or the decrease in image size with increasing object distance (5). Identifying a scale using plain numbers as distinct from logarithmic or geometric, etc. On a linear scale, such as on a thermometer, numbers in a series, such as 10, 20, 30, and so on, are equally spaced, whereas on other scales they are unequally spaced.

line-conversion In photomechanical processes, applied to any of a variety of methods of producing the effect of a drawing, etching, etc., from a photograph. Special screens are often used.

line cut See line (2).

lines per millimeter The usual measure of spatial resolution. In a target consisting of light and dark bars, a "line" consists of one of each, and thus corresponds to one square-wave cycle. To clarify this situation, the phrase "line-pair" is often used.

lining up The set of operations by which a motion-picture cameraman readies the camera and other equipment to record a scene.

Lippman (color) process A method of color photography based on the recording of interference patterns within the photographic layer. The exposure is made through the base, and light is reflected from a mirror in optical contact with the emulsion surface. After processing, silver lies in positions corresponding to the regions of constructive interference, and when the image is properly viewed, a simulation of the scene appears.

Lippman emulsion An extremely fine-grained silver halide photographic material, having little sensitivity but extremely high resolution and low graininess.

lip sync (synchronization) Slang for motion-picture sound recording such that the speech movements coincide with the uttered sounds.

liquid development In electrostatic photography, the transfer of toner from a fluid carrier.

liquid gate In printing negatives, the use of a sub-stance such as glycerin to fill the space between the negative and the glass holder, or in contact printing, between the negative and the print material. The presence of the liquid reduces the effects of reflection (Newton's rings) and of scratches and other defects. See glycerin sandwich.

listing camera A device for automatically photographing selected lines of text, used in the preparation of catalogs, indexes, etc.

liter In the metric system, a unit of volume measurement equal to 1,000 milliliters and, approximately, to 1.06 quarts.

lith (litho) Short for lithographic, lithograph, lithography.

lithographic film (also **litho, lith**) Photographic material of high gamma infinity (maximum contrast), especially intended for use in making images for photomechanical reproduction.

lithography Photomechanical printing process using a nonrelief surface having ink-receptive and ink-rejecting areas. Syn.: offset.

live (1) In television, a broadcast at the time the action occurs, as distinct from taped or filmed. (2) In acoustics, characterizing a room (studio) in which sound is recorded as brilliant, as opposed to dead, or muffled. (3) As applied to a motion-picture or still set, in use or about to be used. (4) Identifying an electrical device, e.g., microphone, that is supplied with electricity and is therefore operational.

LLL Low light level; for example, starlight.

lm Lumen

l/mm Lines per millimeter, a measure of spatial resolution.

lm-s Lumen-second, a unit of light energy emitted by a source.

ln Natural logarithm, i.e., logarithm to the base e (2.718...).

load (1) To insert film or paper into a piece of photographic equipment (camera, printer, processor) or into a holding device to be used with such equipment. (2) In connection with electricity, the number of amperes of current needed to operate a device.

loading room A darkened area used for transferring film from one container to another, such as sheet film into holders, or motion-picture film from magazines into cans.

local Involving only small areas of an image, as distinct from overall treatment. The term is applied to burning in, dodging, intensification, reduction, etc.

local contrast See gradation.

locale In motion pictures and television, a place in which the action occurs.

localization In visual perception, the ability of the

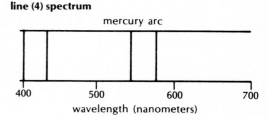

line (4) spectrum

subject to detect a small displacement of one part of a test object, such as a broken part of a straight line. Localization is one aspect of visual acuity. Also see detection; recognition; resolution (2).

location In motion-picture and television production, a scene outside the studio or lot, such as a street scene or countryside. The word is also used in still photography.

lofting The production of (typically full-size) mechanical drawings for engineering uses, often by photographic means.

log (1) In motion pictures, a detailed record of the circumstances under which a picture or sound recording is made. (2) Abbreviation for logarithm to the base 10.

logarithm An exponent (power) that when applied to some constant (called the base) produces a given number. To the base 10, the logarithm of 100 is 2, because $10^2 = 100$. Similarly, the logarithm of 1000 is 3, because $10^3 = 1000$. Logarithms are commonly used in photography, especially in the D-log H (D-log E) curve, where the values on both axes are logarithms.

logarithmic speed A measure of the sensitivity of a photographic material whereby equal changes in the logarithmic speed value represent equal arithmetic speed ratios. °DIN is an example: a change from 2° to 5° represents a speed change by a factor of 2, as does 20° to 23°. Compare with the arithmetic speed system commonly used in the United States.

log E Log H, the preferred term.

log exposure range (scale) The difference between the values of the minimum and maximum useful points on the D-log H (D-log E) curve. The range varies with material, with processing, and with the definition of "useful," which includes many variables. For photographic papers, the log exposure range is the scale index, and varies with paper grade.

log H (1) The logarithm to the base 10 of the exposure (quantity of light per unit area of sample) received by the photographic material. The characteristic (D-log H) curve is a plot of the response of the material against the log H. The use of a logarithmic scale derives from the only approximately correct belief that the human visual response is linear with the logarithm of the light level. (2) The logarithm of the energy received by the photographic material per unit area, for x-rays, ultraviolet, infrared, etc.

log-normal Identifying a type of frequency distribution that is similar in shape to the normal distribution when the measured values are scaled in proportion to their logarithms. The size distribution of silver

halide grains in an emulsion often resembles such a distribution.

logotype (logo) In advertising, editorial, and other photography, the name of the sponsor or producer (sometimes in the form of or incorporating a trademark or title) which typically appears as part of advertisement, publication, etc.

long-focus Characterizing a lens having a focal length considerably greater than normal for the negative size used. Although telephoto lenses have relatively long focal lengths for the recommended film sizes, the term "long-focus" does not imply telephoto construction.

longitudinal chromatic aberration A lens defect resulting in a shift of image distance with wavelength of radiation. For a simple lens, the focal length is less for blue light than for red light. Distinguish from lateral chromatic aberration.

long pitch (1) Applied to film intended for use in high-speed cameras. The perforation interval is slightly greater than in film intended for other applications. (2) In motion-picture films, a perforation interval such that 100 intervals cover a distance of 30.00 inches, slightly more than that for short pitch.

long shot (LS) In cinematography, a scene in which the important action appears to be at a considerable distance from the camera by use of a large subject distance or a short-focal-length lens. The term is usually interpreted in relation to a medium shot or closeup of the same scene rather than implying any minimum object distance.

loop (1) In a motion-picture camera, projector, processor, etc., slack film allowing for the action of an intermittent mechanism, or for permitting expansion or contraction of the film without damage. (2) In a printer or projector, a continuous film made by splicing the ends together, thus making rethreading unnecessary.

loose Applied to a motion-picture shot in which the subject matter is not close to the frame lines, as opposed to tight.

lot (1) In motion pictures, television, etc., an area (usually outside the studio) in which a set may be constructed. (2) In inspection procedures, a batch of material or a group of items from the same manufacturing process.

loupe Magnifying glass of high optical quality, used to examine fine image details.

louver A device for controlling light, consisting of a set of narrow opaque strips that move as does a venetian blind.

low-angle shot A photograph made with the camera

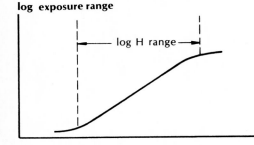

log exposure range

log H range

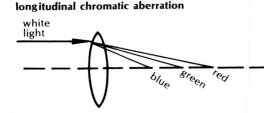

longitudinal chromatic aberration

white light

blue green red

well below the important subject matter and aimed upward.

low contrast (1) In a subject, little difference between tones; i.e., a small ratio of subject luminances. (2) In a negative, little density difference; soft; flat. (3) In a negative material, small slope of the characteristic curve; small gamma infinity. (4) In a print, with less than normal tonal difference, usually because of the absence of light highlights and dark shadows.

lower control limit (LCL) That line on a process control chart above which the process usually operates when it is stable. A value below the LCL indicates an abnormality that should be corrected.

low-key Identifying a subject or image in which most of the tones are dark.

low oblique An aerial photograph made with the camera axis inclined from the perpendicular, but not by so much that the horizon is included in the photograph.

low-pressure Applied to arc (especially mercury and sodium) lamps in which only a small quantity of vapor is contained within the bulb or globe. In low-pressure lamps, most of the light produced is found in isolated wavelengths. Contrast with high-pressure lamps, from which a significant light output is found throughout the spectrum.

LS Long shot.

lubricant (1) A substance, usually a wax, applied to a motion-picture film to reduce friction and consequent damage, especially during projection. (2) Oil, grease, graphite, etc., used to reduce friction between moving parts of cameras, etc.

lumen A fundamental light unit, applied to the concept of light flux ("flow"). A uniform source having an intensity of 1 candela emits a total of 4π lumens, 1 lumen per steradian (unit solid angle). One footcandle of illuminance is more rationally expressed as 1 lumen of flux per square foot of illuminated surface. Time-light curves for flashbulbs are plotted in terms of lumens versus time.

lumen-second A measure of light energy, the product of the flux in lumens and the time in seconds. For a flashbulb, the area under the curve of lumens versus time is measured in lumen-seconds.

luminaire Lamp plus housing, used for general illumination.

luminance The light produced (or reflected) by a unit area of a surface in a specific direction. Unit: candelas (or candles) per square foot, per square meter, etc. Luminance is measured with photoelectric meters having a restricted angle of view (often called reflected-light meters). Luminance has

these useful properties: (a) neglecting losses by reflection or absorption, it is unchanged by an optical system; (b) it is unchanged by distance so long as the surface has a definite area; (c) for a perfect diffuser, it is unchanged with the direction of observation. (Note: Distinguish luminance, which is psychophysical and measurable, from brightness, a subjective psychological response and unmeasurable.)

luminance gain For a projection screen, the ratio of its luminance from a given direction to that of a perfect diffuser similarly illuminated.

luminance meter A reflected-light meter. Distinguish from illuminance or incident-light meter.

luminance-range Identifying a method of using an exposure (light) meter in which two luminance (reflection-type) readings are taken: one from the lightest area in which detail is desired, and one from the darkest. A position halfway between the two readings is used in selecting the combination of f-number and shutter speed. Syn.: calculated midtone.

luminescence Emission of light at low temperatures. Various types are distinguished, dependent upon the source of energy. See chemiluminescence; triboluminescence; fluorescence; phosphorescence; electroluminescence.

luminosity factor The ratio of the energy required to produce a fixed brightness at the wavelength of maximum eye sensitivity (about 555 nm) to that at any other given wavelength. Also called spectral luminous efficacy. For example, at 510 nm the factor is about 0.5, meaning that it requires half as much energy at 555 nm as at 510 nm to produce the same sensation of brightness.

luminosity function (Formerly, visibility function.) A plot of the relative sensitivity of the human eye to different wavelengths of light. The sensitivity is the reciprocal of the energy (in physical units) needed to produce a fixed response. The eye is most sensitive to the middle (green) wavelengths under normal (photopic) lighting conditions.

luminous (1) Emitting light. (2) Specifying the evaluation of radiation according to its capacity to evoke a visual response, as luminous intensity; luminous flux.

luster (1) Gloss; shine. (2) Applied to surfaces of photographic papers intermediate between semi-mat and glossy.

lux (lx) The preferred unit of illuminance, equivalent to one lumen per square meter, and to one meter-candle.

lux-second (lx-sec) The preferred unit of exposure, equivalent to one lumen-second per square meter, and to one meter-candle-second.

low key

J. Barstow

lumen

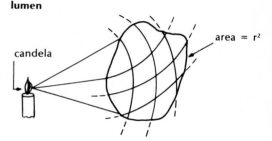

luminance meters

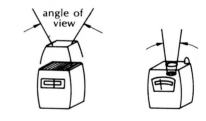

luminosity function

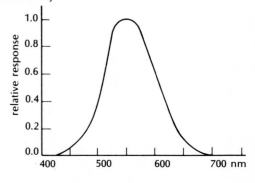

MM

M-class lamps

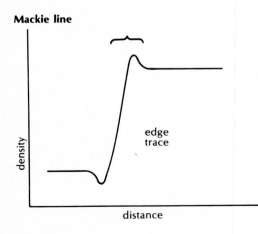

Mackie line

edge trace

density

distance

M (1) Medium. Designation of flashlamps that reach their maximum light output about 20ms (thousandths of a second) after ignition. (2) On internally synchronized shutters, a setting for use with M-class flashbulbs. (3) Internationally-accepted symbol for radiant emittance M_e or luminous emittance M_v.

m Meter, a unit of measurement of length in the metric system (Système International). One meter is 39.37 inches.

MacAdam ellipses Areas on a chromaticity diagram within which the points represent colors that are not easily distinguishable.

Mach band An optical illusion consisting of a visual effect produced when a subject area having a uniform tone gradually blends into an area having a lighter or darker uniform tone, whereby a dark border is seen near the edge of the darker area and a light border is seen near the edge of the lighter area. Also see lateral inhibition.

machine leader Heavy-duty blank film used for threading motion-picture processors.

Mackie line A processing effect associated with adjacent light and dark image areas. The phenomenon includes the border effect (density suppression within the high-density area), and the fringe effect (density suppression just within the low-density area). The Mackie line is one of the adjacency effects.

macro- (1) Prefix meaning "large." (2) In photo-fabrication, having no dimension smaller than 0.002 in.

macrograph A photograph or other image with a scale of reproduction of one-to-one or larger. The term "photomacrograph" is preferred when the image is produced photographically.

macrophotography Production in the camera of images at a scale of reproduction of one-to-one or greater. Distinguish from microphotography, which is the production of very small images, and from photomicrography, which employs a microscope to obtain great magnifications. Syn.: Photomacrography, which is the preferred term.

macroscopic Relatively large; ordinarily visible to the unaided eye. Distinguish from microscopic.

macula In the human retina, a yellowish area 1mm across, within which lies the fovea, the spot of best seeing under normal light levels.

mag Short for magnetic, as in mag soundtrack.

magazine (1) A bound periodical publication; with newspapers, a leading medium for photojournalism. (2) Light-tight holder for lengths of film or paper, or for sets of sheet films or plates. Such a holder is generally designed to be used with a specific camera, printer, or processor, and is usually detachable. See cassette; cartridge; film holder.

magenta (1) A green-absorbing colorant, having maximum density in the 500-600 nm wavelength region. One of the three fundamental colorants in subtractive color processes, the other two being yellow (blue-absorbing) and cyan (red-absorbing). (2) An additive mixture of red and blue light.

magenta contact screen In photomechanical reproduction processes, a device for producing halftone images. The screen consists of a regular pattern of magenta dye on a transparent support.

magnesium fluoride A transparent metallic salt, often used as a lens coating to reduce reflection from glass-air surfaces. Light that would otherwise be reflected is "cancelled" by interference, as in oil films, accounting for the various colors seen in lens coatings.

magnesium oxide A nearly-perfectly-diffusing white substance, often used as a standard for reflectance measurements.

magnetic Identifying a type of sound recording

making use of iron oxide particles in a support, as distinct from a photographic soundtrack.

magnification (1) The process of making larger, as image compared with object. (2) A scale of reproduction larger than unity. (3) In optics, scale of reproduction no matter what the value. Thus a scale of 1/10 is sometimes called "magnification" even though the image is only one-tenth the size of the object. (4) For a magnifying lens, the ratio 25/f, where f is measured in centimeters. (5) For binoculars and telescopes: a) the ratio of the focal lengths of the objective and eyepiece lenses; b) the ratio of the diameter of the objective to the diameter of the beam of light that emerges from the instrument.

magoptical Identifying a motion-picture release print that has both magnetic and photographic (optical) soundtracks.

main exposure In photomechanical reproduction (process camera work), a white-light exposure of the film to the copy through a halftone screen. A correct exposure produces proper dot formation in the negative for highlight tones, and establishes a basic halftone dot range that can be changed by supplementary exposures to increase or decrease the contrast of the halftone. Syn.: detail exposure; highlight exposure. Also see bump exposure; flash exposure.

main title Material that includes the name of the production introducing a motion-picture or television program.

makeup (noun) (1) A cosmetic material applied to the face or body of an actor. (2) The assembly of a complete integrated reel of films, as for television use. The reel will contain both program segments and commercials.

make up (verb) (1) To apply cosmetics to the face or body of a model or actor to change his appearance. (2) To prepare a solution for processing. (3) To adjust to the correct volume, as in make up to 1 liter.

male Applied to an electrical connector (jack) with one or more protruding pins. The male portion is inserted into the mating female portion of the device.

male matte One of a pair of complementary traveling mattes, the reverse of the female matte. The designation is usually arbitrary, but often the male matte blocks out the center area of the scene. Also see black-core; white-core.

Maltese cross A type of gear used to convert a continuous rotary motion into an intermittent one. Slots in the gear are successively engaged by a pin in a rotating part. A Maltese cross is part of the mechanism of some motion-picture projectors.

manipulated Applied to a photograph that is significantly altered by darkroom or other techniques, as opposed to straight or documentary, which is a record of "reality."

mantissa The decimal part of the logarithm of a number to the base 10. The mantissa is determined by the digits in the number, independent of the location of the decimal point in the number. For example, the mantissa of the logarithm is 0.301 for the set of numbers 0.02, 2.0, 2000, etc.

mapping camera Photographic apparatus in which the scale and orientation of the image are accurately known, usually equipped with special optics which are nearly distortion-free.

marginal Identifying rays of light that pass through an optical element near the edge of its aperture.

marked As applied to shutter speeds, lens apertures, etc., indicated as distinct from actual values. Syn.: nominal.

marking up Indicating, on a proof, necessary cropping, retouching, etc., preparatory to making plates for reproduction.

Martens photometer A visual instrument for comparing luminances. One beam of light passes through the sample; the other is variable by the use of rotating polarizers. Used for primary density measurement.

mask (1) A cutout in an opaque material, used for special effects in motion pictures or for photomontage, etc. (2) A device to protect specific areas of photosensitive material from exposure, as on easels, in contact printers, and in photofabrication. (3) A device to outline the scene in a viewfinder. (4) A silver or dye image, used in conjunction with other images, to improve contrast, sharpness, or color. (5) By extension from (4), an electronic correction, based on scanning an original image, used in plate making.

mass radiography Medical use of photography for testing large numbers of persons, for example, for chest diseases, by means of x-rays.

master (1) In still photography, a carefully prepared original or intermediate negative or positive, used for subsequent printing. (2) In motion pictures, a fully-edited positive, used to make negatives suitable for producing release prints. (3) In motion-picture photography, applied to a shot that covers the entire action. Other shots of the scene are usually intercut with the master.

Master Photo Dealers and Finishers Association (MPDFA) An organization of photographic dealers and persons involved in the business of mass processing of films, especially amateur films.

Maltese cross

pin

mat (1) A board with a cutout portion serving as a decorative frame for a photograph. (2) In photomechanical reproduction, a matrix consisting of a thick paper sheet which can be impressed with raised type and from which letterpress plates are cast in hot metal. (3) Short for matrix. (4) Dull-surfaced; not glossy. Syn.: matted.

mat back Identifying film with a rear (base-side) surface frosted so as to facilitate retouching.

mat board See mount board.

match dissolve In cinematography, a continuity link between two scenes of similar design. For example, a shot of a turning automobile wheel can dissolve to an image of a roulette wheel of similar size.

matching (1) The act of producing uniform quality (density, contrast, color balance, etc.) in a picture or slide series, or in a set of prints from the same negative. (2) In cinematography, the act of fitting one film to another, as negative to work print, picture to sound track, etc. (3) In cinematography, the process of meshing action in one scene with that in a following scene.

match line In animation, a straight mark on the background serving as a reference for the cell action drawings.

mat down (1) To reduce reflections from shiny surfaces by dabbing them with putty, or by the use of dulling sprays. (2) To adjust the variable outlines in a camera viewfinder to match the field of the lens being used.

matrix (1) A gelatin relief image used in a dye-imbibition photographic process. (2) In photomechanical reproduction, an impressed paper sheet from which letterpress plates are cast. (3) In mathematics, an array of numbers in square or rectangular form. The coefficients in color-matching, etc., equations are often expressed in such a form. Matrix algebra involves the study of such arrays. (4) An array of switches and other controls for use in programming a group of cameras, projectors, etc., so that they will operate in correct relationship.

matte (1) (adj) Dull, as contrasted with glossy, in reference to the surface of a printing paper; mat. (2) (noun) A thin opaque plate carrying an aperture, placed in front of a camera. Example: a double-linked circle, to indicate a scene as viewed through binoculars. (3) In motion pictures, a special effect by which part of a scene is masked out during exposure and the film is exposed a second time to another scene with a complementary mask. Also see traveling matte. (4) In a viewfinder, especially for a motion-picture camera, an outline of the field covered by the lens inside a larger viewing area.

matte box A device used in front of a camera lens for supporting a cutout or other mask for special effects. Such a device may also support filters, diffusers, etc., and may function as a lens hood.

matte rim A narrow, undesirable halo, caused by the improper fit of a still or traveling mask (matte).

matte roll In motion-picture printing, a film used to control the exposure level. One such film, made on high-contrast stock, produces the equivalent of a varying slit width in the printer, and is keyed to the negative.

maximum density (Dmax) (1) The greatest response a given photographic material can produce; its darkest possible tone. (2) The darkest tone in a given negative, print, test strip, etc. Unless the exposure is very great and the processing extended, the maximum density of a given film sample will typically be less than the greatest possible density.

Maxwell disk A circular array of different color patches, which join additively when rotated rapidly. Used for the demonstration and study of additive color mixture.

Maxwellian view In visual perception, the presentation of a stimulus by means of an optical system. By this means, luminance can be made very great, exposure time can be well-controlled, and the Stiles-Crawford effect can be eliminated.

Maxwell triangle A display of data from color-mixing experiments, with red, green, and blue at the vertexes of an equilateral plane figure.

mc Meter-candle, unit of illuminance in the metric system. Meter-candles are equivalent to lumens per square meter (lux, the preferred term).

mcs Meter-candle-second, metric unit of exposure (quantity of light per unit area). Equivalent to the preferred unit — lux-second.

M & E In motion-picture photography, a sound track containing music and effects as distinct from narration, for example.

mean (1) Arithmetic average, found by adding a set of values and dividing by the number of items in the set. A common measure of the level about which a process fluctuates. (2) Geometric average, the square root of the product of two numbers. A geometric average is used for subject luminances. If the shadow reads 2 candles per square foot and the highlight 50, the geometric average is $\sqrt{2 \times 50}$ or 10 candles per square foot.

measles effect Slang for a fault in photographic materials, especially prints, involving a spotty appearance that is especially noticeable when the image is wet. The fault is sometimes associated with nonuniformity in coating.

mechanical In photomechanical printing processes,

Maxwell triangle

a complete piece of copy, ready for reproduction; an accurate assembly of text and illustrations.

mechanicomorphic Applied to a human subject or corresponding image that is perceived as having nonhuman attributes. A silhouette photograph of a reclining nude may be perceived as a landscape. Compare with anthropomorphic.

medium (plural, **media**) (1) In optics, that which is capable of carrying radiation, such as air, glass, water, even a vacuum. (2) In retouching, a solvent for inks or a carrier for pigments. (3) Generally, any method or process by which an artist expresses his concepts or ideas, as sculpture, painting, photography, etc. (4) In photographic emulsions, the material (usually gelatin) in which silver halide crystals are embedded.

medium contrast In photographic emulsions, having average or normal contrast characteristics.

medium shot (MS) In cinematography, a scene in which the important action appears to be at an intermediate distance from the camera, between a long shot and a closeup of the same scene — commonly used as a transitional device.

meg(a)- In the metric system, a prefix meaning "million" as in megahertz (million cycles per second), and megohm (million ohms.)

megilp (sometimes **magilp**) Medium for oil colors, composed of linseed oil and a natural gum (mastic). Also used in retouching.

memory The tendency of photoelectric light (exposure) meters, especially those with cadmium sulfide cells, to give false high readings for a short time after they have received intense light. The converse of fatigue.

memory color A recalled visual perception, usually different from the original perception. Light colors are usually remembered as lighter than they are, dark colors as darker, hues as more saturated. In addition, the hues of memory colors differ from the original ones.

meniscus Identifying a lens having the centers of curvature of the two surfaces on the same side of the lens: concave-convex or convex-concave. Often used in inexpensive cameras.

Mercer clip In motion pictures, a metal or cardboard device for holding shots together before splicing.

mercury arc A type of lamp involving an electrical discharge through a space filled with mercury vapor. The emission is greenish, and high in ultraviolet. Such lamps are used in some photographic printers.

meridian In optics, specifying a plane containing the axis of a lens or lens system. Meridian light rays lie in such a plane and intersect the lens axis at some point. Compare with skew.

mesopic Specifying an intermediate light level, at which both retinal rods and cones function to some degree. Distinguish from photoptic and scotopic, which see.

metallography The study of surfaces of metals by means of photography.

metamer (1) One of a pair of physically different spectral-energy distributions that nevertheless produce the same visual sensation. (2) One of a pair of colored surfaces that look alike under some specific conditions of observation but not under other conditions (3) Specifically, one of two surfaces of different spectrophotometric characteristics that look alike under some quality (color) of illumination but not under other qualities.

metamerism The visual equality of physically different stimuli, i.e., the similar appearance of two surfaces that differ in spectral absorptance. Such a visual match will be obtained only under specific conditions of examination. Metamerism makes color photography possible, since even though the physical properties of a color image differ from those of the subject, a sufficient perceptual similarity is possible.

meter (1) A general term for a measuring instrument, as light meter, voltmeter, "exposure" meter, etc. (2) A unit of length in the Système International (metric system) equal to 100 centimeters, or 39.37 inches.

meter-candle (mc) Metric unit of illuminance, the light received at an illuminated surface. One meter-candle is the light received at a point 1 meter away from a point source having an intensity of 1 candela (formerly candle). 1 meter-candle is equivalent to 1 lumen per square meter (lux), which is the preferred unit.

meter-candle-second (mcs) The unit of sensitometric exposure, the quantity of light received by a unit area of a photographic material during one second of time. Equivalent to lumen-seconds per square meter, the preferred unit.

metol (p-methylaminophenol) A developing agent typically used with hydroquinone for general-purpose development.

metol poisoning A skin ailment of darkroom workers, involving a sometimes disabling irritation associated with sensitivity to the developing agent, metol. Avoiding contact with developers containing the chemical is the only available remedy. The cause is, in fact, impurities in the chemical rather than the metol itself.

metric system A set of measuring units, almost

meniscus

mercury arc

mercury arc

wavelength (nanometers)

universally employed except in the United States, based on a decimal mathematical relationship. It is being replaced by the Système International d'Unites (SI).

mg Milligram, one thousandth of a gram. Used as a measure of small quantities of substances.

MHertz (MHz) Megahertz, one million cycles per second. Used as a measure of wave frequency.

micro- (1) In the metric system, prefix meaning one millionth, as in micrometer (one millionth of a meter). (2) Generally, a prefix meaning "small," as in microphotography (production of small images). (3) In photofabrication, involving at least one dimension less than 0.002 inch.

microcard A photographic image-storage record that is a very small reproduction on a reflective base. Distinguish from microfilm, on a transparent base.

microcharacteristic curve Graph of density versus log exposure (D-log H curve) for small image areas, usually having different slopes from a similar graph based on large image areas.

microdensitometer An apparatus for measuring the density of very small sample areas, leading to the estimation of acutance, granularity, and modulation transfer functions.

microelectronics The technology of constructing useful electrical circuits in a small space, usually employing photographic methods.

microfiche A photographic image-storing device, consisting of several images of documents, drawings, and the like on a small sheet, or strips of film assembled in a jacket. A type of microfilm record.

microfilm (1) Photographic transparency material, in 35mm width or smaller, used for recording images at small scales of reproduction. (2) A small image or images so made.

microflash A light source used in ultra high-speed photography, involving an effective time of the order of a millionth of a second (a microsecond).

microform A general term for any very small recorded photographic image, as of a document or drawing, for the purpose of storage in little space. The term includes microfilm, microfiche, micro-opaque, etc.

micrographics The production and reproduction of microfilms.

micrometer (1) (mi'-cro) (μm). One millionth of a meter, a measure of length used especially for infrared and longer waves. Equivalent to the obsolescent micron (μ). (2) (mi-crom'-e-ter) A measuring instrument for determining length to high precision, such as to thousandths of an inch.

microminiaturization Production of exceptionally small parts, electrical circuits, etc., often at least in part by photographic means.

micron (μm) One millionth of a meter, a term now obsolescent and being replaced by micrometer.

micro-opaque A very small image, as of a document, drawing, etc., on a reflective as opposed to transparent base. See microcard.

microphone A device for producing a varying electrical current or voltage from a sound wave, used in the recording of sound by photographic and other means.

microphotography The production of photographic images at very small scales of reproduction (great reductions). The opposite of photomicrography, which is the production of greatly enlarged images.

microphotometer An instrument for measuring light in very small sample areas. A microdensitometer is a type of microphotometer.

microprint A microcard image produced by photomechanical reproduction processes.

microprism A focusing aid consisting of an area of very small glass prisms forming a screen, or a portion of it, especially in single-lens reflex cameras. The image shows an obvious discontinuity unless it is in accurate focus.

micropublication (-publishing) The dissemination of texts, articles, etc., in small format, e.g., on microfilm.

micro-reciprocal-degree Expanded form of mired.

midtones In a scene or photographic image, areas intermediate in lightness or brightness between highlights and shadows. Grays, as distinguished from whites and blacks.

migration imaging An electrostatic photographic process based on the relationship between the radiation absorbed by a film and the penetration of the film by photosensitive particles. Three steps are involved: charging electrically, exposing, and temporarily softening the film.

mike Short for microphone.

mil 0.001 inch, often used as a measure of thickness of film base, emulsion coatings, magnetic tape, etc.

mileage In pricing photographs, a fee to be paid by the client based on the distance traveled to and from the location.

milky Cloudy; not clear. Characterizing the appearance of insufficiently fixed films, or of nearly exhausted (or improperly compounded) fixing baths or other solutions.

milli- Prefix meaning "thousandth," as in milligram, millimeter.

milliliter (ml) One thousandth of a liter. Preferred to cubic centimeter, to which milliliter is nearly but not exactly equivalent.

millimeter (mm) One thousandth of a meter, or 0.03937 inch. Lens focal lengths, especially those used in small-format cameras, are often given in this unit, as 50mm lens.

millimicron (mμ) Obsolescent term for a unit of length equal to one millionth of a millimeter, or a billionth of a meter. See nanometer; angstrom.

miniature (1) Applied to a hand-held still camera that uses 35mm or smaller film. (2) A small set or prop photographed so as to appear of normal size. (3) A very small image, typically made for direct viewing, as a miniature portrait.

miniaturization Extreme reduction in image size by optical means.

minimum density (Dmin) (1) The lightest possible tone that a photographic material can produce. For a transparency (negative or positive), the Dmin is base + fog; for a color print, the Dmin is base + stain. (2) The lightest tone in a given negative, print, test, strip, etc. Unless the exposure is very small and the processing restrained, the minimum density of a given sample will typically be greater than the least possible density.

minus (1) For filters, etc., applied to that color of light mainly absorbed. For example, a yellow filter may be called "minus blue" because a yellow filter mainly absorbs light in the blue spectral region. Similarly, a magenta filter may be called "minus green," and a cyan filter "minus red." (2) In optics, negative, divergent (lens).

minus-density A less-than-normal amount of silver, dye, etc., in an image, usually associated with a defect caused by handling or processing. A kink mark may be a minus-density, i.e., a light area on a film. The converse of plus density.

mired Shortened form of micro-reciprocal-degree. A designation of a light source, derived from color temperature by multiplying its reciprocal by one million. For sources similar to a blackbody (e.g., tungsten), a significant change in micro-reciprocal-degrees has the same value over the entire range, whereas for color temperature, the significance of a given change varies with the level. For a light-balancing filter, the change it produces in mireds is constant for blackbody radiation; some filters are so marked. Decamireds are the value of mireds divided by 10.

mirror A polished reflector, usually metallic. Plane (flat) mirrors are used in optical systems to alter image orientation, as in reflex cameras. Concave mirrors are substituted for lenses in, for example, astronomical photography. Mirrors are free of the color defects associated with lenses. Also see front-surface mirror.

mirror cutoff In single-lens reflex cameras used with long lenses or great bellows extensions, interference with the image due to the insufficient size of the reflecting surface. Typically, one part of the image does not appear on the ground glass.

mirror galvanometer A device, actuated by an electrical signal as modulated by sound, which reflects a varying light to photosensitive film. The device is used in making optical (variable-area) soundtracks.

mirror image Characterizing a reversal of orientation, as the image of an object formed by a planar reflecting surface. Right-to-left change, as seen in a flat mirror.

mirror lens An image-forming optical system including at least one reflecting element. Such systems are especially useful for obtaining great focal lengths with relatively simple design, because the use of mirrors reduces color errors (chromatic aberrations). See catoptric and catadioptric.

mirror lockup On single-lens reflex cameras, a device that holds the reflector in the "up" position to prevent it from coming into contact with the back of a lens that intrudes into the camera body, or to reduce the likelihood of camera movement when the shutter is actuated. In general, only extreme wide-angle lenses require the use of mirror lockup.

mirror shutter In some reflex motion-picture cameras, a surface on a shutter blade that reflects light to the viewing and metering systems during the closed part of the shutter cycle.

miscible Capable of mixing in all proportions. Said of liquids such as water and alcohol.

mislight In motion pictures, an error in exposing the print.

mismatch The failure of the three D-log H (D-log E) curves for a color material to superimpose. (Note: Superposition of the three curves indicates appropriate color rendition only of neutrals, and only when equivalent neutral density is used as the measure of the image.)

misregister Failure of successive images applied to the same support to superimpose. Misregistration is usually a fault (as in photomechanical processes) but is used for an esthetic effect in bas-relief printing.

Mitchell mechanism A modification of the Gurney-Mott theory of latent-image formation, differing slightly in the explanation of the process of recombination of the separate positive and negative

mirror lens

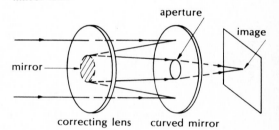

charges produced when radiation is absorbed by the silver halide crystal.

mix (1) To prepare processing or other solutions, such as developers or fixers. (2) To adjust the recording level of two or more sound records to produce a desired effect.

mixed-grain emulsion A photosensitive material prepared by the blending of two materials of different characteristics, especially grain-size frequency distribution.

mixer (1) Apparatus for stirring mixtures of chemicals and water or other liquids to make solutions. (2) In sound recording, a device permitting the combination of music and speech, or other separate sequences of sound, into a single record. (3) A person who supervises and regulates sound equipment, especially in the combining of separate sound records.

ml Milliliter, one thousandth of a liter. Used for measurements of volume. Preferred to cc, cubic centimeter, a similar, but not identical, unit of volume.

MLS In cinematography, medium long shot.

mm Millimeter, one thousandth of a meter.

mμ Millimicron.

mock up See process body.

mode (1) In applied statistics, the most-frequently-occurring member of a set of data. In the data set 2, 3, 3, 3, 4, 4, 5, 6, the mode is 3. (2) As related to perception, the manner in which a surface is identified as belonging to an object (object mode) or to a source of light (illumination mode) or to an illuminated opening (aperture mode).

model (1) A person who is the subject of a photograph, especially in portrait and fashion photography. (2) A small-scale simulation of a real scene, as in tabletop photography. (3) In animation, a drawing that serves as a guide to the animator or inker. (4) To pose for a photograph.

modeling (1) A three-dimensional lighting effect on objects being photographed or on the resulting photographs. (2) The act or profession of posing for photographs, especially in fashion photography.

model release A document, signed by the subject of a photograph, giving permission for its commercial or editorial use. When a child is the subject, the release is signed by a parent or guardian; in the case of a domestic animal, the owner signs.

modular Specifying a design such that parts may be readily added or removed. Applied to a camera designed so that units may be added to the camera bed, body, or bellows in order to change lens-to-film distance, film size, etc. A modular camera designed

for use with a number of systematically varied lenses and/or accessories is known as a system camera. Processing systems are sometimes constructed on a modular basis for changing the number of tanks as needed for different systems.

modulation (1) Generally, alteration of energy, especially light or sound. A filter is said to modulate light. (2) For a sine wave, the ratio of the ac to the dc component, i.e., the ratio of the amplitude of the varying signal to the signal level. (3) In radio and television, the application of the signal to the carrier wave or waves. Modulation converts the blank television receiver screen into the picture. (4) Generally, any detectable change in light or radiation caused by an object. Thus, in this sense, modulation includes refraction, reflection, fluorescence, polarization, etc., as well as absorption.

modulation transfer factor For a specific spatial frequency, the ratio of the output modulation to the input modulation. A measure of the fidelity with which a system reproduces a given input. A modulation transfer factor of 1.0 means correct reproduction; one of 0.0 means complete failure of the recording system or transmitting system.

modulation transfer function (MTF) A mathematical description of the way in which an optical (or photographic) system transmits signals of varying frequency, i.e., element size. A perfect system would reproduce small as well as large subject patches with equal fidelity, and would thus have a flat modulation transfer function, analogous to a high-fidelity sound system. In fact, no optical or photographic system can produce a perfect image in this sense.

modulator (1) Generally, that element of a recording (sound or light) system that alters the record in accordance with a received signal. (2) In sensitometry, a step tablet (wedge) or other device used to generate an exposure series.

module (1) In microelectronics, a part of a microcircuit. (2) In modular camera (or other) systems, one component.

mogul A lamp base for tungsten lamps larger than that used for conventional lamps.

moiré (pronounced mo-ray') A coarse repetitive pattern produced when two or more small-scale regular patterns are superimposed. Especially, such a pattern formed in printing screened halftone images in photomechanical reproduction.

monaural With a single ear. As applied to sound recording, the reproduced sound seems to have a single source, as contrasted with stereo (phonic). Syn.: monophonic.

Mondrian layout An arrangement of photographs, typographic material, etc., that emphasizes vertical

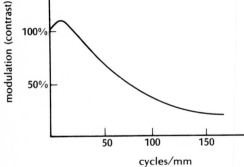

and horizontal lines suggestive of the design of a Piet Mondrian painting, commonly used for advertisements in periodicals.

monitor (1) (verb) To observe a possible changing process with the intent of controlling it by making adjustments as needed. (2) Specifically, to listen to sound during recording, or to watch a TV image during transmission and make appropriate changes in the apparatus. (3) (noun) Apparatus especially intended to permit observations of a process. Particularly, a television receiver at the studio or sending station.

monobath For silver halide materials, a single processing solution that both develops and fixes the image. The process involves different rates of development and fixation.

monochromatic ("single-color") As applied to light, consisting ideally of only a single wavelength; in practice, containing a narrow band of wavelengths. Laser sources generate nearly monochromatic radiation. Vapor light sources, which produce "line" spectra, are used to produce monochromatic light. Mercury arcs, for example, produce four wavelengths of light. The term "monochromatic" is sometimes extended to apply to radiation other than light.

monochromatism A rare type of "color blindness" in which hue discrimination is totally absent. A person with such a defect sees only tones of gray.

monochromator A device for producing nearly single-wavelength radiation. The device usually employs a prism or diffraction grating to yield a spectrum, and a slit aperture to isolate the desired narrow-wavelength band.

monochrome Identifying a photographic process in which the image consists of a range of tones of a single hue, or of no hue (black-and-white).

monocular (1) Observed with a single eye or lens, i.e., lacking ordinary stereoscopic clues to depth. (2) An optical instrument for telescopic observation for use with a single eye, as distinct from binoculars.

monolayer Thin film, a single molecule thick. Sensitizing dyes are applied to silver halide crystals in such thicknesses.

monomer A relatively simple molecule capable of linking with similar molecules to form large aggregates called polymers. Some polymers are photosensitive.

mononumerosis The tendency, sometimes pathological, to describe a complicated concept or situation by the use of a single number. An example is the use of ASA speed in inappropriate contexts.

monopack Integral tripack. Color material consisting of three differently color-sensitized emulsions on a single support.

monopaste A viscous (thickened) monobath, i.e., a combined developer and fixer. Processing by the use of this material requires no agitation and little water.

monophonic See monaural.

monopod A one-legged camera support.

monorail A single bar or track for supporting a camera, studio light, etc.

monotonic Identifying a relationship between two variables by which as one increases in value, the other continually increases or decreases, without discontinuities or local maximum or minimum values. The D-log H (D-log E) curve is monotonic between D-min and D-max values.

montage (1) In still photography, the process (or result) of assembling separate prints or other images on a common support, as by adhesive or successive printing from several negatives. (2) In motion pictures, a blending of images simultaneously or in rapid time sequence.

mood General feeling associated with a photograph, as of sadness, excitement, etc. In motion pictures, mood music is intended to enhance the emotional quality of a scene.

mordant A substance that increases the extent to which a dye is bound to the material dyed. Mordants are often used in dye-imbibition color processes.

MOS Mit Out Sound, a code used on motion-picture sync slates to identify silent takes.

mosaic An assemblage of separate photographs to make a large continuous image, as of a panorama or in aerial mapping.

montage Martin Cohen

mother emulsion In the manufacture of photosensitive materials, a large batch of emulsion that may be subdivided into smaller batches which are differently treated so as to obtain emulsions with different properties.

motif A dominant figure in a photograph or other work of art.

motion picture A sequence of photographs taken with a short (usually fixed) time interval between successive exposures. When the sequence is projected (or otherwise viewed in rapid succession) the result to an observer is the impression of movement. The rate at which the exposures are made varies, but is typically 24 frames per second for ordinary photography. A similar effect is produced in animated films by a series of drawings progressively changing the pose or position of the character, etc. Motion picture is preferred to: moving picture; movie; film; flick.

mottle A defect in an image appearing as nonuniformity of density, seen especially in prints which have been underdeveloped. Mottle can be avoided by proper agitation during processing, and by full development. Mottle is also associated with the structure of the paper base, and with coating nonuniformities.

mount board A stiff support of paper, cardboard, etc., on which prints are fastened. Syn.: mat board; mounting board.

mounting press A device for applying heat and pressure in the process of fastening a print to a support by the use of a heat-softening tissue. A similar device is used for sealing transparencies in slide mounts. Syn.: dry mounting press.

mounting tissue Thin paper, impregnated with a heat-softenable adhesive, used for permanent fastening of prints to a support. Syn.: dry mounting tissue.

movement (1) See camera movement. (2) In the composition of a photograph, an effect that suggests a change in position of the subject (e.g., blurring of the image), or that is intended to guide the viewers attention from one part of the image to another. See rhythm.

movement adaptation A process by which a person's visual perceptual system adjusts to steady movement of a stimulus so that reverse movement is perceived when movement of the stimulus is stopped. For example, a spinning spiral that appears to be expanding is perceived as shrinking when it is stopped. Syn.: waterfall effect.

movie; moving picture Motion picture, the preferred term.

MPCD Minimum perceptible color difference.

movement (1)

tilt

tilt

focusing movements

MPDFA Master Photo Dealers and Finishers Association.

ms Millisecond, one thousandth of a second. Unit of time used for shutters and flash lamps.

MS In cinematography, medium shot.

MTF Modulation transfer function.

μ Greek letter mu. Used to symbolize the micron, one millionth of a meter, for which the preferred symbol is μm, micrometer.

muddy Characterizing a print that appears gray, flat, or fogged. Opposite of brilliant, snappy.

mug (slang) To overact; to chew the scenery.

mug shot (slang) Portrait, especially one made on a mass-production basis.

Mullen tester Apparatus for measuring the resistance of a sheet (e.g., paper) to bursting.

Muller-Lyer illusion See arrow illusion.

multifilter As applied to information recording by photography, the use of several regions of the electromagnetic spectrum, each region being used to produce a separate image. Ordinary color photography uses three bands of the visible spectrum. Other methods, usually involving several cameras, may use five or more bands (some outside the visible spectrum) to record more data about the spectral reflectances, etc., of the subject. Syn.: spectrozonal (the preferred term, which see); multispectral.

multihead (1) Applied to a motion-picture printer in which several copies can be made during one pass of the negative or positive film. The printer has several printing stations. (2) Applied to a motion-picture printer capable of combining images from two or more separate films on a single one, with one pass of the raw stock.

multilayer As applied to photographic materials, consisting of two or more superimposed sensitive layers. In color photography, the layers have different spectral responses, and at the end of processing contain different dyes. In black-and-white photography, the layers may serve to extend the range of response of the material.

multimedia Many forms of communication (sound, changing lights, slides, motion pictures, live actors, etc.) used simultaneously to produce a complex, often nearly overwhelming effect.

multiplane In animation motion-picture photography, a means of indicating depth by using different levels for background, middle ground, and foreground drawings.

multiple exposure The act of recording two or more images, usually superimposed on the same sheet or frame of photographic material. Sometimes acci-

dental, as when the photographer fails to change the film, but often deliberate, to serve an esthetic purpose.

multiple lens An optical device for cameras or printers, used to produce several small images on a single sheet of large-format film or paper.

multiplex (1) Identifying a type of image-projection printing system capable of rectifying images for plotting or mapping purposes. (2) In film and slide viewing, the interlacing of two film projectors, or of slides and motion pictures, etc., for esthetic purposes.

multiscreen A development of split-screen projection. Several images may be projected simultaneously or in sequence in different positions.

multispectral See multifilter; spectrozonal.

Munsell System An atlas of standard color patches, arranged in systematic order, each of which is designated by three numerical values. Such a designation may be, for example, 5B 8/4, identifying in order, the hue (a specific blue), the value (lightness), and the chroma (saturation). A sample may be compared visually with the set of patches, and thus the color of the sample may be identified and in a sense measured.

mural A large decorative photograph, usually scenic, typically consisting of two or more joined sections. Since the widest available photographic paper is 4 to 5 feet across, any larger print requires such a joining process. Syn.: photomural.

music over (under) An increase (or decrease) in the loudness of a musical soundtrack, intended to cover (or reveal) accompanying dialog, etc.

MUTE Code word used in the international exchange of television programs to identify a silent film. One of a group of such words recommended by CCIR (International Radio Consultative Committee).

mute copy A motion-picture film containing only pictures, no sound.

mutilator A device for deliberately punching holes in old release prints, so that they cannot be used or resold by unauthorized persons.

myopia Nearsightedness; a defect in the eye causing only close objects to be seen distinctly.

NN

n Index of refraction.

NA Numerical aperture.

nadir In aerial photography, the point directly beneath the camera position, and opposite in direction to the zenith.

nano- Prefix in the metric system meaning "billionth," as in nanosecond (billionth of a second).

nanometer (nm) One billionth of a meter, the preferred unit of wavelength for light. Equivalent to, and replacing, millimicron. One angstrom equals 0.1 nanometer; in photographic contexts, the nanometer has replaced the angstrom.

narration In motion pictures, words spoken by a person who is normally not seen, as distinct from the dialog of actors. Syn.: commentary.

narration script In motion pictures, text prepared for a commentator, usually added to the pictorial record.

narrator In motion pictures, an unseen speaker who comments on the events depicted on the screen.

narrow-angle Applied to a lens of greater-than-usual focal length for the film size being used. Normal lenses have focal lengths about equal to the film diagonal, and an angle of view of about 53°, from corner to corner.

narrow-band Involving only a small range of wavelengths in the spectrum, as a narrow-band filter. Also see monochromatic.

narrow-gauge Applied to motion-picture film not as wide as 35mm, including 8mm, super 8, and 16mm. The older term is "substandard."

National Bureau of Standards (NBS) A branch of the federal government devoted to the improvement of the quality of measurement in many fields. The photographic section deals with the measurement of resolution, light intensity, edge sharpness, etc.

National Free Lance Photographers Association (NFLPA) An organization of amateur and professional photographers interested in making photographs for sale on a part-time basis.

National Microfilm Association (NMA) An organization concerned with standards and procedures in the field of document recording, preservation and retrieval by photographic means.

natural (1) As applied to light sources, daylight. (2) As applied to color photography, simulating object colors with reasonable fidelity, as distinct from false-color materials (e.g., infrared color film).

nature photography The specialization of making photographs of flowers, plants, animals, etc., especially in their unaltered wild state.

NBS National Bureau of Standards.

NC Noncurl (coating).

ND Neutral density, applied to a filter with nearly equal absorption throughout the visible spectrum.

near distance In depth-of-field calculations, the distance to the closest object imaged with sufficient sharpness.

near point (1) The object closest to the camera lens that is sufficiently sharp when the lens is focused for a given (different) distance. (2) In aerial photagraphy, the intersection with the film plane of a vertical line through the rear nodal point of the lens.

needle-sharp Applied to an image having unusually good definition; crisp.

negative (1) A photographic image in which light subject tones are reproduced as dark (dense) and dark tones as light (thin). (2) In optics, divergent, applied to a lens that causes parallel light rays to spread. A negative lens has the focal point on the same side of the lens as an object at infinity. (3) Specifying a photoresist that after exposure adheres to the support. (4) Specifying a visual afterimage com-

negative

D. Krukowski

plementary to the original stimulus. (5) In colorimetry, identifying that primary which must be added to the sample stimulus in order that it can be matched with a mixture of the other two primaries. (6) A type of optical distortion in which image points are displaced inward toward the image center; barrel distortion. (7) In photographic materials, a type of curl in which the emulsion side is convex. (8) In photomechanical reproduction, a type of contact screen used especially for making halftones from positive originals; it produces higher contrast, especially in highlight areas, as compared with a positive screen.

negative carrier See carrier.

negative perforation In 35mm motion-picture film, a specially designed hole in the margin of the film intended to precisely fit camera and optical-printer registration pins.

negative-positive process A photographic system using separate materials for the camera image (negative) and the final image (positive), as contrasted with reversal materials. Especially applied to color processes.

negative-working In photomechanical reproduction processes, applied to a plate (made from a negative) in which the areas receiving the most exposure are rendered receptive to ink.

neococcine A red dye used in solution form in negative retouching to absorb actinic light in printing, producing effects similar to those obtained by dodging. The amount of dye deposited on the negative can be controlled by varying the concentration of the solution or the number of applications. Syn.: crocein scarlet; new coccine.

neon An inactive gas, used in arc lamps and some stroboscopic light sources, as well as in signal lamps (e.g., "ready lights"—indicators that an electronic-flash electrical system is in operating condition).

NEP Noise-equivalent power.

neper A unit in the system of natural logarithms. 1 neper represents a change by a factor of 2.718 . . ., which is the base of natural logarithms.

net (1) As applied to density, after subtracting the density of an unexposed processed area of the film (base + fog density). Several speed-computing methods are based on the exposure needed to produce a specified net density, e.g., ASA. (2) A piece of fabric or other translucent material used to diffuse light. Syn.: silk; diffuser.

neutral (1) Without noticeable hue; white, gray, or black; achromatic. (2) Ideally, absorbing the same fraction of any wavelength of light; nonselective. (3) In chemistry, neither acidic nor basic, such as pure water. Having a pH of 7.

neutral density filter A partially transparent sheet of glass, gelatin, plastic, etc., that absorbs approximately the same fraction of any wavelength of light.

neutral test card A panel, usually with an 18%-reflectance gray surface on one side and a 90%-reflectance white surface on the other. Such a card is useful as a standard object for light measurement in estimating the required camera settings, and also for checking color balance in color images. Syn.: gray card.

new coccine See neococcine.

news photography The specialization of producing photographs with emphasis on current events, for use in periodicals such as newspapers and weekly news magazines or in television. Advertising photographs are usually excluded from this specialization.

Newton's rings Faintly colored fringes caused by interference of light between two closely spaced reflecting surfaces. Such fringes may be seen when bound-in-glass transparencies are projected, or when a negative is placed in a glass carrier for projection printing. Attempts to reduce the effect of the fringes by reducing the space (as by increased pressure) make them worse. The remedy is to fill the space with a liquid, to use fine powder or "anti-Newton ring" (i.e., slightly roughened) glass to break up the fringes, or to use a glassless carrier.

NFLPA National Free Lance Photographers Association.

NFS Not for sale, sometimes posted by a photograph in an exhibition to notify viewers that the owner will not entertain offers to purchase the item.

NG No good, a marking on a camera slate at the end of an unsatisfactory motion-picture take, or on a camera report of a similar take.

nicad Nickel cadmium cell or battery.

nickel-cadmium cell A device for producing an electrical current. It is rechargeable and sealable, and produces great energy per unit weight. Such cells are often used in portable electronic-flash devices.

night blindness A visual defect resulting in the inability of the afflicted person to see well in dim light.

night filter A deep red or other absorbing glass used in daylight to simulate shots made in near darkness.

nit A unit of luminance, equal to 1 candela per square meter of radiating or reflecting surface.

nitrogen-burst Applied to a method of agitation during processing using an array of perforated pipes at the bottom of a tank. Admission of nitrogen to the pipes at appropriate intervals causes mixing of the processing bath, and the rising bubbles agitate the solution near the material being processed. Gas-

nodal plane (points)

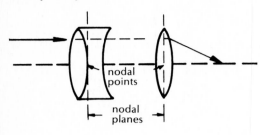

nomogram

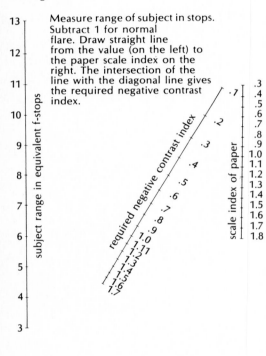

Measure range of subject in stops. Subtract 1 for normal flare. Draw straight line from the value (on the left) to the paper scale index on the right. The intersection of the line with the diagonal line gives the required negative contrast index.

normal curve

eous-burst is a more general term, including agitation by bubbles of air, etc., as well as nitrogen.

nm Nanometer(s).

NMA National Microfilm Association.

nodal planes In optics, surfaces intersecting the axis at points of intersection of the axis and parallel rays entering and leaving a lens or lens system. (Note: For lenses that contact the same medium on both sides, nodal planes and principal planes coincide in position.) See principal planes.

nodal points For a lens or lens system, two points on the lens axis such that a ray of light directed toward one of them appears to leave from the other. The thin-lens formula (which see) applies to a system if the object distance is measured to the front nodal point, and the image distance and focal length to the rear nodal point.

nodal slide An apparatus used to find the location of nodal points for a lens or lens assembly. It is based on the rule that if a lens is rotated about an axis through the rear nodal point, the image remains at rest.

noise Unwanted output, the converse of desired output (signal). (1) In sound, a perception without distinct pitch, associated with a random waveform, as distinct from a musical tone. (2) In photography, a random unwanted small-scale variation in the image, such as graininess. (3) Technically, often granularity, i.e., the variation in density in a supposedly uniformly exposed and processed area, as determined from a trace made with a microdensitometer. See Selwyn granularity.

noise-equivalent power (NEP) For a radiation detector (film, photocell, etc.), that power input which produces a response just equal to the response when no signal is received. NEP is the power just detectable with a signal-to-noise ratio of 1; it is dependent upon the frequency of the signal.

nominal Indicated or marked, such as shutter settings. The actual or effective shutter time may differ from the nominal value.

nomogram A graphical method for solving complex mathematical equations or performing difficult computations rapidly. The answer is found by drawing straight lines between appropriately constructed scales. Such a method may be used to determine the correct filter for any color film and tungsten light source.

nonactinic Identifying radiation to which a given photographic material is insensitive.

nonconformable Rigid; applied to supports for photosensitive materials or to backing materials such as glass used in contact printing.

noncurl (NC) A gelatin coating applied to the base side of some photographic films to reduce the buckling influence of the emulsion layer with changes in moisture content and temperature. Syn.: anticurl.

nondestructive Identifying a testing procedure by which the material being tested is not altered, as in testing lenses for image quality. Nondestructive testing permits the testing of all items produced, whereas destructive testing (e.g., exposing and processing photographic film to determine the film speed) must be performed on a sampling basis.

nondiffusing Applied to dyes, color formers, etc., in color materials that remain relatively in place in the emulsion during processing, thus retaining image quality.

nonintermittent Characterizing a motion-picture camera in which the film moves continuously through the camera, rather than in a go-and-stop manner. In many such cameras, a rotating mirror or prism is used to arrest the image momentarily. Some projectors and viewers are nonintermittent.

nonreversal A type of film or film processing by which negative images are produced from positive originals and positive images are produced from negative originals. Used to differentiate from reversal films or processes when the more specific adjectives "positive" or "negative" are not appropriate.

nonselective Identifying an absorber having equal absorptance for all wavelengths within a given range. Syn.: neutral.

nonsilver Applied to photographic processes that make use of the sensitivity to radiation of plastics, iron salts, silicon, etc.; any process that does not employ compounds of silver.

nontheatrical In motion pictures, applied to films intended for showing in other than ordinary theaters, such as for educational use, television, etc. Such films are often in 16mm; theatrical films are usually 35mm or wider.

noodles Shreds of silver halide emulsion, made in such a form to permit rapid washing away of unwanted soluble salts during manufacture.

normal (1) As applied to exposure and development, according to usual practice or to the manufacturer's recommendations. (2) In statistics, a pattern of variation, often called "bell curve," that is a result of chance causes. Experimental error often follows such a pattern. See Gaussian. (3) In optics, perpendicular to a surface. Applied to a light ray.

normalize To adjust a set of values so that they are relative to a base value arbitrarily made equal to unity. Relative spectral-energy curves are often

normalized relative to the value at 555 nm. Spectral-response curves are often normalized so that the value of unity is assigned to the maximum response.

Norman's rule An elastic measuring device for laying out drawings and photographs to scale. It can be expanded to ease the computations needed when the magnification is to be changed.

north-south In animation, a camera motion that results in a vertical displacement of the image on the screen.

no-screen exposure In photomechanical reproduction (process camera work), a supplementary exposure of the film to the copy, without the halftone screen in place. The effect is an increase in image contrast, caused by exaggerating the differences in dot area in the highlights. A no-screen exposure is used especially with low-contrast copy, with high-key photographs, and for dropouts. Contrast with flash exposure, which decreases the image contrast. Syn.: bump exposure.

notch (1) A coded edge-punch used in sheet film for the identification of emulsion type and emulsion side. (2) In cinematography, an edge-punch for coding negatives to indicate needed printer adjustments so as to assure appropriate exposure of the print material.

ns Nanosecond, i.e., billionth of a second.

nu- (Greek letter ν) **number** A measure of the extent to which a transparent optical material such as glass, plastic, etc., disperses light, i.e., refracts different wavelengths differently. The ν-number is of importance in the design of color-corrected lenses. Syn.: v-number.

nuclear Identifying a class of emulsions useful for recording the tracks of high-velocity subatomic particles. Such emulsions are exceptionally thick and contain a high concentration of silver halide grains.

nucleus In latent-image theory, an early stage in the formation of a development center (sensitivity speck). The nucleus may contain only two silver atoms but is sufficiently stable to serve as a site for further growth of the latent image.

nude A photograph, typically a posed one, of a person nearly or completely unclothed.

nudie Slang for a motion picture emphasizing partially or completely unclothed actors.

null (1) In measuring instruments, based on establishing a balance between a known and an unknown quantity, and the restoration of the device always to the same state; the converse of direct recording. Some densitometers are null instruments, a calibrated wedge being used to bring the light level to a fixed value. (2) As applied to a test lens, having optical curvature equal and opposite to that of another lens being tested. A null lens is often used to inspect lenses having nonspherical surfaces, which are otherwise difficult to examine.

numerical aperture (NA) A measure of the light-transmitting ability of a lens system, especially microscope objectives. The numerical aperture, with other factors being constant, is also related to the highest useful magnification of a microscope. Mathematically, the numerical aperture is the sine of the angle from the normal ray to the extreme marginal ray, multiplied by the index of refraction of the medium in contact with the first lens surface. The numerical aperture is equal to $1/(2 \cdot f\text{-number})$.

nuts and bolts (1) Slang for an industrial film, usually unimaginative in treatment, made in a factory and showing a manufacturing process or product. (2) Technical information about photographic equipment, processes and materials.

nystagmus The involuntary rapid tremor of the eye, of importance in that it probably is the basis of the scanning process essential to vision. Distinguish from saccadic motion, which involves relatively large-scale eye motions when a scene is scanned.

notch

sheet film

OO

O

object distance

object distance

front nodal plane

object attributes The characteristics of objects as perceived visually, including: size, shape and location; hue, saturation and brightness or lightness; glossiness, luster, transparency, sparkle, flicker. The first three attributes have to do with properties in space; the second three with color; and the others with other properties of objects.

object distance In optics, the linear separation of the subject from the front nodal plane of a lens.

objective (1) (noun) In an optical system, that lens (or set of lenses) which is nearest the subject. In photomicrography, the objective is the microscope lens assembly nearest the slide. (2) In an experiment, the specific aim of the work. (3) (adj) As applied to measurements, obtained primarily through the use of instruments. Opposed to subjective, which implies primarily human judgment. For example, acutance is an objective number obtained from a trace of an edge with a microdensitometer; sharpness is subjective, based on the visual appearance of an edge.

oblique (1) In aerial photography, a photograph made in a direction not perpendicular or parallel to the earth's surface. (2) In optics, off-axis. Applied to lens defects such as astigmatism, coma, distortion, and lateral chromatic aberration, all of which affect the marginal portions of the image.

ocular In an optical system used for visual examination, that lens (or group of lens elements) nearest the eye, as distinguished from the objective (the lens nearest the object being examined).

oculometer A device for producing a record of the movement of the eye while viewing a photograph, etc. The device is used in the study of visual perception, of the influence of picture composition, etc. One method involves a trace of a beam of infrared radiation reflected from the retina.

off-axis Specifying a position away from the inter-section of a line through the centers of curvature of the lens elements and the exposure plane. Off-axis lens aberrations afflict the outer portions of the image.

off-camera (1) Applied to flash photography in which the lamp is placed away from the camera, usually above and to one side. (2) In television and motion pictures, applied to a speaker not seen on the screen. Equivalent to off-stage in the theater.

office-copier A photographic apparatus for making duplicates of letters and the like.

off-line In process control, the separation of the data-analysis from the data-collection stage, so that correction of a fault may involve an appreciable time lag. Converse of on-line.

off-mike Applied to sound that is not properly directed to the microphone, and thus not correctly reproduced.

off-screen In motion pictures, applied to spoken commentary by an unseen narrator.

offset (1) The transfer of image-forming ink, dye, etc., from one sheet of material to another. Especially, a) a lithographic printing process in which a blanket (of rubber or plastic in sheet form) transfers the image from the printing plate to the printing paper; b) in printing, the unwanted transfer of ink from one printed surface to another, caused by the imperfect drying of the ink. Syn.: setoff. (2) Applied to a camera viewfinder made so that the position of the eye of the observer is laterally displaced from the center of the objective of the viewing system. The result is more comfortable viewing, without serious parallax.

off-stage (voice) Narration in which the speaker is heard but not seen.

ohm (Ω) The unit of electrical resistance. If the resistance of a wire is 1 ohm, an applied voltage of 1

volt will cause a flow of 1 ampere of current through the wire. See omega.

oil coloring The process of applying, by hand, pigments to a black-and-white or toned photograph, often a portrait print.

oleophilic ("oil-loving") Applied to those areas on a photolithographic printing plate that accept ink and reject water, as distinct from the hydrophilic areas that have opposite properties. Syn.: hydrophobic.

oleophobic ("oil-fearing") Applied to those areas of a photolithographic printing plate that reject the oily ink and accept water. Syn.: hydrophilic.

omega (symbol Ω) Greek letter, the symbol for ohm, the unit of electrical resistance.

ON Original negative. The primary record of a scene or event, usually made in a camera.

on-camera (1) In flash photography, applied to a lamp position near the camera axis, producing relatively flat lighting on the subject. (2) In motion pictures and television, applied to a person being seen as well as heard.

one-half up (1/2 up) To make a photograph, layout, or other copy one and one-half times the size of the final reproduction. The purpose is to render minor imperfections less noticeable when the image is reduced.

one-light print In motion pictures, a positive print that has been made without any adjustment of the printer for the exposure of different scenes. It is a work print good enough for editing and as a guide to exposure adjustment (timing) for future printing.

ones In animation, the photography of a single frame for each drawing as opposed to twos or threes, where the corresponding number of frames is shot for each drawing. Shooting on ones makes for smooth action but is costly.

one-shot (1) Identifying a camera having a single lens and beam splitters, used for making three color-separation negatives simultaneously. (2) A type of developer to be discarded after use rather than replenished. (3) A motion-picture scene involving only a single performer.

one-time use The sale of a photograph for a specific purpose only, as distinct from further or unrestricted use, for which a higher price is normally charged.

one-to-one (1-1) At unit scale of reproduction, i.e., yielding an image the same size as the subject.

on-line In process control, the linking of the data analysis (usually by computer) to the data collection from the process, so that almost immediate correction of a fault is possible. Converse of off-line.

on-mike Applied to sound that is properly picked up by the microphone.

on the set A directive indicating to actors and technicians that they are needed in the shooting area, as in motion-picture photography.

on twos (threes) An instruction to an animation cameraman to make two (three) successive exposures of identical drawings before making a change. The technique reduces the cost of animation.

opacity (1) The ratio of the light level (illuminance) on a sample of film, etc., to the light transmitted by the sample. Also, the reciprocal of the transmittance. Also, the antilogarithm of the (optical) density. If the two illuminances are 1000 and 50, the opacity is 20, the transmittance is 1/20, or 0.05, and the density is 1.30. (2) In graphic arts, that characteristic of paper by which an image on one side is not noticeable from the other side. (3) In photomechanical reproduction, that property of inks, etc., by which they hide what lies underneath. Syn.: covering power.

opalescence A hazy, milky-white appearance, sometimes faintly colored. Such an appearance is seen in some color films when wet, on lenses coated with condensed moisture, in images containing dichroic (two-colored) fog, and in fine-textured diffusing (opal) glass.

opal glass A translucent diffusing material containing scattering particles, used in illuminators and enlargers, and for some lamp bulbs. Used instead of ground glass where minimum graininess of the diffuser is desired.

opaque (1) (adj) Having zero, or nearly zero, transmittance. (2) (verb) In retouching, to cover unwanted areas of a negative (background, defects) with pigment so that they will not appear in the print. (3) (noun) A coating or covering paint used to prevent transmission of actinic light through a negative or other transparency. (4) (adj) As applied to a projector, using light reflected from the print or other object, as contrasted with a transparency projector.

opaquer In animation, a person who uses paint to color inked drawings. Syn.: colorist; painter.

op art (from optical) The use of design elements, usually repetitive with small variations in shape or color, and the principles of visual illusion, to cause the observer to experience a sensation of movement, scintillation, etc.

open end In motion pictures, the last part of a film made so as to have several possible conclusions. A commercial may have an open end to permit a local advertiser space for his own message.

open flash Using the entire light output of the bulb,

opening time

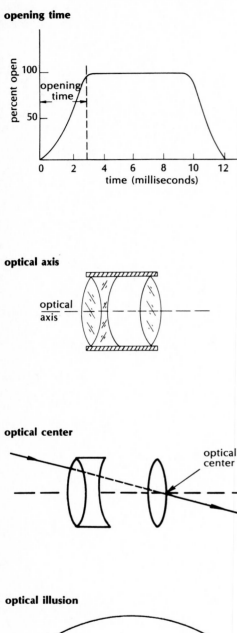

optical axis

optical center

optical illusion

identical shapes

as contrasted with synchronized flash. The shutter is opened, the bulb operated, and the shutter is then closed.

opening time As applied to a leaf-type shutter, the number of milliseconds needed for the shutter blades to clear the aperture completely. The opening time is part of the total operating time of the shutter. It is greater as the aperture is larger.

open shade In outdoor photography, lighting conditions on a subject under trees, etc., with no direct sunlight, but where the light is diffused into the shadows from the sky and from surrounding objects.

open up (1) To increase the size of the aperture in a camera, projection printer, etc. The converse of stop down. (2) In making a negative or print, to increase the detail in the shadows. In making the exposure in the camera, supplementary lighting may be used to open up the shadows. In making the print, dodging may be used to reduce the exposure in the dark areas of the print.

operator (1) In photographic studios, the person who actually exposes the film. (2) A motion-picture projectionist.

OPT FX (optical effects) In motion pictures, special treatments such as fades, wipes, and dissolves. The shortened form is commonly used as a label on cans containing film so treated.

optical (1) Containing lenses, mirrors, etc., as in optical viewfinder and optical printer. (2) In general, having to do with light and its behavior and control, as in optical properties, optical rotation. (3) In motion pictures, an effect made on a printer, such as a fade, dissolve, wipe, etc.

optical axis A straight line joining the centers of curvature of a lens or a set of lens elements.

optical bench (1) A support on which light sources, lenses, and other optical devices may be supported with rigidity and with precise placement. Optical benches are used for lens testing, etc. (2) In motion pictures, an optical printer. Optical printing is often called bench work.

optical brightener A fluorescent substance added to a photographic printing paper during manufacture, to make the highlights lighter, and thus to increase the maximum tonal range of the image.

optical center In a lens or lens system, that point on the optical axis at which undeviated rays intersect.

optical contact Juxtaposition of two surfaces so close that no air lies between them. Optical contact of lenses is secured by the use of an adhesive of nearly the same index of refraction as that of the lenses.

optical data processing Any method of obtaining information from an image by placing it in an apparatus comprising a light source and lenses, usually including spatial filters. One application is to the recognition of characters (letters and numbers) by machine.

optical density (Usually, simply density) (1) For transmitting materials (films, filters, etc.), the logarithm (to the base 10) of the ratio of the incident illuminance to the transmitted illuminance (light level). The same value can be found from the negative logarithm of the transmittance, which is the reciprocal ratio. (2) For reflecting materials, the logarithm (to the base 10) of the reciprocal of the reflectance, which is the ratio of the reflected to the incident light. For photographic prints and the like, the reflectance of the base is often adjusted (normalized) to unity, and thus reflection densities are made relative to a base density of zero.

optical distance The length of a path of a light ray multiplied by the index of refraction of the material in which the ray travels. A thickness of 12 cm of water (of index 1.33) is optically equivalent to 16 cm of air (index 1.00).

optical effects (OPT FX) In motion pictures, special processes such as fades, wipes, and dissolves.

optical flat A surface that departs from a true plane to the extent of only a few wavelengths of light or less.

optical glass A transparent material used for the manufacture of lenses and prisms, specially made to be clear, colorless, free of defects, and correct in refractive properties. Two or more optical glasses with different indexes of refraction are typically used together in the component elements of photographic lenses.

optical head In motion-picture sound reproduction, a sound reproducer that will work with a photographic (optical) soundtrack.

optical illusion Failure of a visual perception to correspond with objective reality in dimension, shape, etc.

optical lever A beam of light reflected from a movable mirror. The motion of the spot of light magnifies the movement of the mirror. Optical levers are used in making soundtracks, traces on photographic material such as electrocardiograms, etc.

optical negative In motion pictures, a negative made by other than contact printing (i.e., with an optical printer) usually from master positives. The optical negative will include effects such as dissolves, wipes, and fades.

optical printer An apparatus using lenses to reproduce images, as contrasted with a contact printer. In motion-picture photography, the use of optical

printers permits changes in format or size, and facilitates the production of special effects.

optical sensitization An increase in response of an emulsion to radiation of wavelengths longer than those absorbed by the silver halide, usually by the addition of a dye that absorbs such radiation. The preferred term is spectral sensitization. Contrast with chemical sensitization.

optical sensitizer Dye added to a photographic emulsion to increase its response to long wavelengths.

optical sound system A recording method using a light-modulation technique, and especially, photographic materials, as compared with magnetic tape or other techniques.

optical thickness For a lens, etc., the physical distance between surfaces multiplied by the index of refraction of the material. Similar to optical distance.

optical transfer function (OTF) A mathematical description of the manner in which a lens (or similar image-forming device) transmits information. The OTF includes the modulation transfer function and also any shift in the position of the maxima of the spatial waves, i.e., any shift in phase.

optical wedge A device for reducing illuminance, such as a step tablet or continuously graded filter, used in sensitometers (exposure test instruments) and in some visual densitometers (measuring instruments).

optics The study of the properties and behavior of light, especially the effects on light of lenses, mirrors, etc. Geometrical optics treats problems by the use of rays; physical optics involves the wave theory of light; quantum optics involves the interaction of light and the atomic and subatomic particles of matter. (The term "optics" is often extended to include radiations other than light, such as x-rays, infrared, etc.) Also see physical optics.

optimization The use of statistical methods of experimentation to determine the conditions under which a process operates best. One method is evolutionary operations (EVOP), which involves a systematic series of small changes (as of developer ingredients) centered around the usual levels, and continual adjustment of these levels, depending on the results of the experiment.

optimum aperture For a lens, that diaphragm opening that yields the best sharpness at the plane of correct focus. For most good camera lenses, the optimum aperture is about a stop under the maximum aperture.

orange (1) A hue intermediate between yellow and red. (2) Applied to a filter that has its major absorption in the blue (short-wave) region of the spectrum, and also partial absorption in the green (medium-wave) region. Example: 85 and 85B conversion filters used for tungsten color films in daylight.

ordinary ray In doubly refracting crystals (notably calcite), that part of an incident ray which obeys Snell's law of refraction. Such a ray is plane-polarized in a direction perpendicular to that of the extraordinary ray.

ordinate In graphs plotted on rectangular coordinates, a value plotted vertically, i.e., on the Y axis. Output data are so plotted, as density values on a D-log H (D-log E) curve.

organic Identifying chemical substances containing carbon, usually in relatively complex arrangements with other elements. Most developing agents, dyes, film bases, etc., are organic compounds. Organic chemistry is the science and technology of the study of such compounds.

original (1) The initial photographic record, usually made in a camera. Often, original negative. (2) A master from which reproductions are to be made. (3) In copying, the material to be reproduced. (4) Initial sound record.

orthicon A type of image-recording tube used in television, characterized by large size and relatively low sensitivity. Such a tube contains a photoemissive surface and an electron scanning beam.

ortho Orthochromatic.

orthochromatic (1) For emulsions, sensitive to blue (and ultraviolet) and green light, but not to red. The green-light sensitivity is obtained by adding a dye to a "color-blind" emulsion. (2) Correct in color rendering (now rare). Distinguish from panchromatic and color-blind.

orthogonal In mapping, applied to an image having correct scale and orientation.

orthoscopic Rectilinear, applied to an optical system that reproduces straight lines in the object as nearly straight in the image.

oscillography A method of recording data in the form of a trace on photosensitive material, usually paper. Energy from a small lamp is focused on the paper by a lens. The location of the spot of light is determined by a mirror or other optical device, whose position is in turn affected by changes in an electrical input.

oscilloscope A device much like a television screen that displays a trace showing the performance of, for example, a shutter.

oscilloscope camera A device for photographing the face of a cathode-ray tube for data recording.

Ostwald ripening In the manufacture of silver halide emulsions, that part of the process in which the

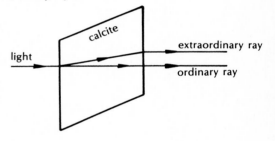

ordinary ray

light

calcite

extraordinary ray

ordinary ray

precipitated silver halide crystals are allowed to grow to a suitable size. Physical ripening is the preferred term.

Ostwald system A method of color classification and specification, used especially in Europe, and similar in intent to the Munsell system.

OTF Optical transfer function.

ounce (1) In the English system of weights and measures, 1/16 pound in weight. (2) In the English system of weights and measures, 1/32 quart, or 1 fluid ounce in volume. (Note: these units are obsolescent, being replaced—even in England—by the more rational units of the metric system.)

outdated Applied to photographic materials for which the expiration date marked on the package has passed. Such materials may have a lowered sensitivity and a higher fog level than materials still in date, but storage conditions markedly affect the deterioration of such materials with time. Contrast with in date.

outline In motion pictures, a synopsis of a film plot.

out-of-date See outdated.

out-of-focus Applied to an image that is not sharp because the lens and film planes are not in the correct relative positions. The effect may be produced by accident, or deliberately for pictorial purposes. For example, the background may be thrown out of focus by using a large aperture and focusing on the foreground.

out-of-sync (1) In sound motion pictures, a failure of the lip motions of the performer to coincide with the reproduced sound. (2) In still photography, a failure of the flashbulb and shutter operations to coincide.

output (1) Whatever is delivered by a device, as electrical current from a microphone or photocell, prints from an automatic processor, etc. Contrast with input, which is whatever is supplied to the device. (2) In experimentation, the data that result from the experiment.

output jack An electrical connection, as on a densitometer, into which other equipment, such as a plotter, can be plugged.

outtake In motion pictures, a record of a scene initially intended for use in the final version of the film but for some reason not included.

overcoat A thin protective layer (sometimes incorporating a filter) placed on top of a photosensitive layer. Syn.: supercoat.

overcorrect (1) To overcompensate, in lens design, for a specific defect (such as spherical aberration) in order to improve the lens with respect to other defects. (2) To use a very dense or strongly-colored filter, as a red filter for sky or night effects.

overcranking Operating a motion-picture camera at a larger number of frames per second than will be used in projection, thus causing the impression of slower-than-normal movement on the screen. The term originated with early hand-cranked cameras and is still commonly used.

overdevelopment Processing in the developer for too long a time, in an excessively active bath, or at too high a temperature or agitation rate. The result may be excessive image density (especially in highlight areas of the negatives) excessive image contrast, high graininess, and fog.

overexposure An excessive quantity of light on a photographic material. For negative materials, the effects may be too high densities, loss in highlight detail and contrast, and even reversal (solarization). In prints, overexposure may produce gray highlights and blocked-up shadows. In reversal materials, the result may be an image that is too light and has blank highlights.

overhead Applied to a projector that accepts large transparencies on a horizontal stage and may be used with the operator facing the audience. Overhead projectors are used widely in classrooms.

overlap (1) In aerial photography, the amount by which adjacent frames duplicate the areas being photographed, often expressed as a percentage. (2) In motion pictures, duplication of action at the end of one scene and the beginning of another, to increase flexibility in cutting.

overlay (1) A transparency superimposed on another image, used, for example, to build up a sequence of concepts on an overhead projector, or to facilitate the making of animated motion pictures. (2) In television, combining of two scenes electronically, as of live action against background from a film or other source. The live action may be performed against a white or black background, with electronic switching used to control what is seen at a given point on the screen. A pulsed light source may be used for one of the two images to facilitate the switching process.

overload To supply a device with more energy than normal. As applied to tungsten lamps, a voltage overload increases the light output and raises the color temperature, at the expense of greatly decreased operating life.

overmat A cut-out mount placed over a mounted print, typically to keep the surface of the photograph from touching the glass in a frame. See cut-out mount. The act of placing a cut-out mount on a print.

override A control that cuts out automatic operation of a device. On electric-eye cameras, the override

permits the photographer to expose without the automatic compensation (a feature of such cameras).

overvoltage For electrical devices, an electromotive force (voltage) above that at which the device would operate normally. When overvoltage is applied to tungsten lamps, they produce much more light, especially in short wavelengths (blue), but their life is greatly reduced.

oxidation (1) In chemistry, the chemical combination of oxygen with another substance. By extension, the combination of chemically similar elements (nonmetals) with other substances. (2) Technically, the loss of electrons from an atom or ion. Silver is oxidized when it is removed in a potassium dichromate bleach. The developing agent undergoes oxidation when it acts on silver halides. (3) In photography, loss of activity of a photographic developer caused by chemical action, especially associated with exposure to aerial oxygen.

oxygen sensitivity Loss in effective speed of photoresists when exposed in air as compared with vacuum or an inert atmosphere.

oyster shell A defect in a ferrotyped print appearing as concentric marks, caused by stepwise release of the print from the ferrotyping surface.

oz Ounce; ounces.

PP

P

package (1) (adj) Applied to a type of projection printer that exposes several images, of various sizes, simultaneously from a negative, usually on roll paper. (2) (noun) In microelectronics, an assembly of several parts into a unit.

packaging In microelectronics, the technology of assembling parts into a suitable arrangement, especially into as small a space as possible.

packet emulsions Photosensitive materials consisting of discrete small globules of different emulsions separated by nonmiscible binders. Such emulsions are used, for example, in variable-contrast papers.

packing density In microelectronics, number of components per cubic centimeter.

paddle A flat piece of hard rubber or plastic, used to agitate prints during processing without wetting the hands.

pAg A measure of the concentration of silver ions in a solution or emulsion, etc.; analogous to pH. It is the negative logarithm of the silver ion concentration. The pAg of an emulsion affects its response to sensitizers and also its reciprocity-law failure characteristics; thus it is important in silver halide emulsion manufacture.

page rate A pricing arrangement by which a publication agrees to pay a photographer a fixed rate for photographs, on the basis of the space they occupy when they are reproduced.

painter In animation photography, a person who applies dyes, paints, or other colorants to existing images. Syn.: colorist; opaquer.

painting with light The practice of moving a light source over a scene while the camera shutter is open. The method produces the effect of a diffuse source or of a group of sources without the necessity of a complicated lighting setup.

paired comparison A statistical technique for detecting differences in data that are not independent of other factors. Often used in tests of photographic quality to compare films, processes, etc.

pan (1) Short for panchromatic, having sensitivity to red as well as to green and blue light and ultraviolet radiation. (2) (verb) In making motion pictures, to move the camera about a vertical axis to record a scene over a wide angle. (3) In still and motion-picture photography, to move the camera in any direction during exposure, typically to follow action. (4) (adj) Identifying equipment useful in moving a camera smoothly about a vertical axis, as in pan head, pan tripod. (5) In animation, applied to a background larger than the camera field, used to present a moving background to the camera.

pancake (1) A type of makeup used to change the general color of a model's skin. (2) A platform a few inches high, on which a short actor stands to make him seem closer in height to another actor.

panchromatic Describing black-and-white photographic emulsions having sensitivity to red, as well as to green and blue light and ultraviolet radiation. Compare with orthochromatic and blue-sensitive (color blind).

panel A group of persons who make evaluations of image quality or discuss other issues, typically in public or for publication.

pan marking strip In animation, a calibrated guide for the necessary camera, etc., movement, in order to produce an effect of panning.

panorama A pictorial representation of a wide horizontal field of view, made by use of a special camera or by assembling images made in different directions.

panoramic camera An apparatus for producing an image that covers a wide horizontal field of view.

A lens may be rotated about an axis through the rear nodal point, with a slit aperture being used and the film moved past the slit in synchronism with the lens movement.

pantograph On an animation table, a pointer affixed to a rod, used in plotting the necessary successive positions of the movable table in order to accomplish a desired animation effect.

paper (1) A base for photographic prints, made of wood or other fibers formed into a sheet. (2) Photographic printing material on such a base, as in glossy paper, paper grades, etc. (3) (verb) In motion-picture film editing, to place markers (often cigarette papers) into film perforations to mark the beginning and end of a length of film to be printed. Strings are also used for this purpose. See cord off.

paper grade Numerical designation of photographic printing papers from 0 (very low contrast) to 6 (very high contrast). Many papers are supplied only in grades from 1 to 4. The grade numbers are roughly inversely related to the scale index (range of log exposure values over which the paper responds), and thus to the contrast (extreme difference in density) of the negative that will print well on a given paper. A paper with a grade of 0 or 1 will be useful in printing a hard (contrasty) negative; one with a higher grade will be useful in printing a softer (less contrasty) negative. Grade 2 is usually considered normal.

papier-maché (pronounced pap'-yay ma-shay') A mixture of paper pulp and glue, used for making three-dimensional models, puppets, etc., used in animated motion pictures.

parabolic (paraboloidal) mirror A reflecting optical device used in cameras of great focal length, especially for astronomical photography, and for illuminating systems. Rays of light parallel to the axis are reflected to the focal point, and conversely.

paraformaldehyde See formaldehyde.

parallax (1) The apparent shift in relative position (or shape) of an object when it is viewed from different positions. Since a viewfinder is often in a different position than the camera lens, because of parallax the image as seen through the viewfinder is different from the image recorded by the camera lens. (2) By extension from (1), a shift in position of an object with time. Time parallax is involved in a single-lens reflex camera, since the actual exposure occurs a short time after the last opportunity for the photographer to view the image.

parallax-corrected Identifying a viewfinder designed to reduce defects that result when the viewfinder axis and the camera lens axis do not coincide. Even though such viewfinders may prevent the top of close subjects from being cut off on the image, it should be noted that they do not eliminate parallax. The relative positions of near and far objects will still be different as seen through the viewfinder and as recorded on the film.

parallax stereography An image simulating three dimensions on a flat surface by the use of fine grids or lenticular (cylindrical) lenses embossed on the surface. The image consists of narrow strips, alternately comprising the right-and-left-eye image.

parallel (1) (noun) In motion-picture photography, etc.; a structure of wood or pipes that holds a horizontal platform for the use of the crew at varying heights. (2) (adj) Applied to a type of continuity for a motion picture, filmstrip, picture series, etc., in which comparisons are made between two different subjects or the same subjects at different times; e.g., a house before and after being remodeled. Syn.: contrast.

parallel action In motion pictures, a method of suggesting simultaneous occurrence of two or more events by showing them alternately. Often used to build emotional suspense. Syn.: crosscut, cross cutting.

parallel processing (recording) The simultaneous use of multiple channels, as distinct from sequential processing. For example, in ordinary photography each ray of light acts in parallel, i.e., simultaneously and nearly independently as a carrier of information. Scanning processes, on the other hand, are sequential.

parameter (1) In statistics, one of several numbers applicable to a population, such as mean and standard deviation. (2) Loosely, a factor that affects a result, such as temperature, duration, pressure, or rate of agitation.

paraxial Near the axis. Designating rays of light close to the optical axis of a lens.

parfocal Describing lenses, especially turret-mounted, having a common working distance, i.e., the distance from the object plane to the first principal point. The intent is to reduce the shift in focal position when lenses are changed, as in photomicroscopy.

partial color blindness Anomalous color vision, in the presence of which some hues are not perceived normally. Red blindness and red-green blindness are most common.

pass One run of a motion-picture film through a camera, printer, etc. For a double exposure made in a camera, the film makes three passes: first exposure; rewind; second exposure.

passband That region of the spectrum in which a

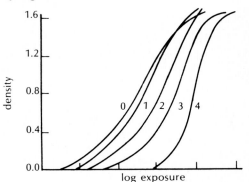

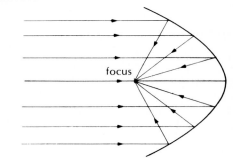

focus

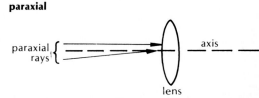

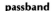

paraxial rays

axis

lens

filter curve

passband

pattern

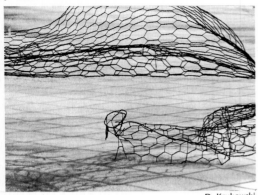

D. Krukowski

pentaprism

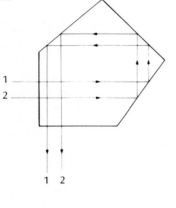

perforation streak

given filter has little absorption and, therefore, "passes" radiant energy or light within a specific range of wavelengths or colors.

passe-partout (pronounced pass-par-too') (1) Paper or cloth tape, gummed on one side, used for making masks and silhouettes and for binding mounts to glass. (2) A picture frame consisting of a piece of glass, under which a picture is placed, attached to a backing by means of adhesive strips of paper or other flexible material.

pastel Any light color of low saturation (chroma). Examples: pink; lavender.

paste-up A combination of two or more images, usually prints, on a single support, usually by the use of adhesives. Typically used to prepare material for publication in print. Distinguish from collage, which involves different media, and from mosaic, which involves the assembly of different parts of an image into a continuous whole.

patch (1) In motion pictures, a piece of film added to damaged film to permit it to be projected. (2) In motion pictures, a clip for temporarily joining two pieces of film in the editing process. (3) Misnomer for film splice.

pattern An organized arrangement of the visual elements of a subject or image, typically repetitive and rhythmical. Loosely, a general scheme; the configuration of a process or a complex arrangement.

pattern recognition Automatic detection and identification of specific shapes in a photographic (or other) image. The phrase includes character recognition, the application of the method to symbols such as numbers and letters. Pattern recognition is used in photointerpretation and in entering data from bank checks and the like, and offers promise in reading text and sorting mail.

PCB Printed circuit board, an assemblage of electrical devices on a flat support, usually produced in part by photographic methods.

PC connector A pair of electrical terminals, comprising a central pin and a surrounding cylinder. Typically used to link flash and electronic-flash units to synchronized camera shutters. The "flash cord" or "tripcord" has the male connection, the camera or shutter, the female.

PCM Pulse code modulation.

PE Photoelectric, as in PE cell.

peak Maximum light output for a flashlamp. Peak delay is the time after the lamp is fired until it reaches its greatest intensity.

peanut As applied to a lamp, very small.

peel paste An adhesive used for applying decorative

paper to a flat. After use, the paper can be easily removed.

peg bar In animation, a rectangular metal rod in which pins are placed, over which properly punched paper, cells, etc., are placed for correct registration.

peg board In motion-picture editing, a means of holding and arranging short lengths of film. The pieces of film are placed on pins that project from a vertical support.

pellicle A thin film or membrane. Pellicle mirrors are used as beam splitters in one-shot color cameras, to avoid the image deterioration associated with the use of thick mirrors.

pelloid A coating, placed on the back of some roll films, containing finely-divided particles. The purpose is to prevent adhesion of adjacent coils of film, and also to prevent "ferrotyping," which produces a variable gloss on the emulsion surface unless the film is well hardened.

pencil In optics, a narrow beam of light.

pencil test In animation, the photography on high-contrast material of preliminary (pencil) drawings to permit an examination of the motion before finished drawings are made.

pentrameter A test object used for industrial x-rays, analogous to a resolving-power test chart. It usually consists of a metal sheet with a series of small apertures of varying diameter.

pentaprism A five-sided optical device, used in rangefinders and in eye-level viewfinders for single-lens reflex cameras. By multiple reflections, such a prism provides an upright, laterally-correct image.

PEP Photoelectrophoresis.

perambulator A small movable support for a camera; a type of dolly.

percent solution An ingredient concentration specified in terms of parts per hundred. Three different methods are used: a) Number of grams of dissolved material in 100 milliliters of solution. Most photographic solutions are so compounded. b) Number of grams of dissolved material in 100 grams of solution, sometimes used in chemistry contexts. c) Rarely, number of grams of dissolved material added to 100 milliliters of solvent. Definition (a) is preferred since its use allows one to add a specific volume of solution in order to add a specific mass (weight) of the active chemical.

perception A psychological process that includes sensation, memory, and thought, and results in recognition, understanding, etc.

perforation One of a set of precisely-spaced holes in the edge of film, used for film transport in cameras,

printers, processors, and viewers. The shapes and positions of such holes are specified in various ANSI standards.

perforation streak Uneven density associated with the holes in the margin of film, a sign of inadequate agitation during development.

peripheral (1) Away from the center of a field, as of a camera image. (2) As applied to vision, more than 5 degrees from the fovea (retinal area of best vision in good light). Peripheral vision varies in acuity and hue discrimination in different parts of the retina.

periscope viewfinder An optical system, used especially on motion-picture cameras, that permits the placement of the camera in various positions for special or trick shots, while allowing the photographer to view the scene. The unit contains mirrors to produce a bent light path, and usually may be adjusted in attitude.

permeable Capable of being penetrated, as a gelatin emulsion by processing solutions.

persistence of vision The continuance of a visual image after the stimulus is removed. The duration of the image is usually about 1/25 second, but the time varies with luminance and other factors. The phenomenon permits the fusion of successive images, as in motion pictures and television, into an apparently smooth and continuous change.

persistent internal polarization (PIP) In electrophotography, the formation of a charge within, rather than on the surface of, the image-receiving material. An advantage of PIP is that the charge is little affected by atmospheric conditions.

perspective (1) Generally, the impression of depth when a three-dimensional scene is represented in a two-dimensional photograph or drawing. Many factors, such as change in size of similar objects, converging lines, atmospheric effects, etc., contribute to perspective in this sense. (2) (adj) Applied to an image made in principle from a fixed viewpoint, through which straight lines from object points are drawn to generate image points by intersecting the image surface. In this sense, a photographic image made with a pinhole or with a lens free of optical distortion is a perspective image. It will display shapes and sizes correctly when examined from the correct viewpoint, which is at a distance from the image equal to the taking lens-to-film distance for a contact print (multiplied by the magnification for an enlargement). See strong perspective; weak perspective.

Persson process A method of manipulating image tones by making several masks, each affecting only some of the image tones, such as shadows or midtones or highlights. Since the masks are sharp, registration difficulties are encountered.

Petzval A type of lens characterized by small useful field and relatively large aperture. Used formerly for portrait lenses, now for some microscope objectives and for slide projectors.

pH A measure of the acidity or alkalinity of a substance, especially of water solutions. A pH of 7 indicates neutrality, e.g., pure water. Acids have pH values of less than 7; bases (alkalis) have pH values of more than 7. pH affects the activity of developing agents, most of which require pH values greater than 7 in order to function. pH is the negative logarithm of the concentration of hydrogen ions. If the concentration is 0.001 moles/liter (10^{-3}), the pH is 3.

phantom (1) In an illustration, a subdued, ghostlike image, as of a background, to provide emphasis to other portions of the image. (2) An image through which the background or other image can be seen. This effect can be produced deliberately or inadvertently, as by a double exposure.

phase In a waveform, especially a sine wave, the distance from a given point on the wave to the assumed origin of the wave. For two waves of the same length, a shift of one relative to the other is a phase difference, or phase shift. Some techniques in photomicrography depend on phase contrast. Holography involves the recording of phase differences.

phase contrast In microscopy, a method of viewing and photographing unstained specimens, by which image contrast is enhanced. The central beam of light at the back focal plane of the objective lens is retarded by a quarter-wavelength plate; an annular (ring) stop is used at the substage condenser. Distinguish from dark-field illumination and from the use of polarizing filters.

φ (phi) Internationally-accepted symbol for radiant flux ϕ_e or luminous flux ϕ_v.

phi phenomenon The appearance of motion when two similar objects or images, somewhat separated in space, are observed briefly with a short time interval (about 1/16 second) between them. This phenomenon and the persistence of vision are the psychological bases for motion pictures and television.

phon A measure of perceived loudness, as distinct from decibel, which is a physical measure of the power in a sound wave, etc.

phosphor (1) A solid, usually powder, that radiates light when supplied with short-wavelength radiation (e.g., ultraviolet, as in fluorescent lamps), or when struck by an electron beam (as in a television receiving tube or cathode-ray tube). (2) Loosely, any substance which has luminescent properties.

phosphorescence A type of luminescence that lasts

phase

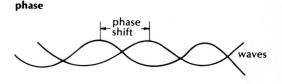
phase shift

waves

phase contrast

P. Groulx

an appreciable time after the source of external energy ceases.

phot A unit of illuminance, equivalent to 1 lumen per square centimeter, i.e., 10,000 lumens per square meter or 10,000 meter-candles.

photo Short for photograph, the preferred term.

photo- (prefix) (1) Associated with light, as in photometer, photochemistry, etc. (2) By extension from (1), associated with electromagnetic radiation of wavelength near that of light. Thus some photographic materials respond to ultraviolet radiation exclusively. (3) Abbreviation of photographic, as in photomechanical, photodrafting, photogrammetry, etc.

photocell Short for photoelectric cell. See photoelectricity.

photochemistry The study of chemical reactions initiated by or altered by the absorption of radiation, especially light. (Distinguish from photographic chemistry, which is the science of the chemical formulation and behavior of photographic materials, especially the chemistry of processing.)

photochromatic interval In visual perception, the difference between the minimum intensity of a light stimulus at which hue becomes apparent (chromatic threshold) and the minimum intensity that can be detected (absolute threshold). Syn.: colorless interval.

photochromism A property, possessed by some materials, of changing color when acted upon by short-wavelength radiation. The color change is usually reversible when the stimulating radiation stops, or when radiation of longer wavelength is absorbed by the material. Photochromism is a characteristic of some glasses containing finely divided silver or other metals, of specially treated plastics, etc. Such materials are used in some sunglasses.

photocomposition Typesetting by exposure on a sensitive material from a negative of type characters or other symbols. The device employed in the process is known as a filmsetter, photographic typesetter, or photocomposing machine.

photoconductivity A change in electrical resistance associated with the absorption of radiant energy. A characteristic of some photocells, of silver halide crystals, and of some polymers.

photocopier General term for any device using photography to make reproductions, especially office equipment.

photocopy A photographic reproduction of graphic material. Syn.: photoduplicate.

photodetector A device that shows the presence of light and similar radiation. A general term that includes photoelectric devices and phototransistors as well as photographic materials.

photodevelopment In materials for recording traces, the production of a visible image from a latent image by the use of radiation such as ultraviolet, as distinct from chemical processing.

photodiode A type of semiconductor, having two terminals, that is sensitive to radiant energy.

photodrafting By the use of photography, the process of assembling drawings into a finished piece of artwork.

photoduplicate See photocopy.

photoelastic Specifying a material that when stressed affects polarized light. Many glasses and plastic materials are photoelastic, and are useful in the study of strains in machine parts, etc.

photoelectret A material, such as some waxes and ceramics, which is uncharged electrically but which becomes locally charged when radiation is absorbed. Such materials offer some promise for use in image-forming systems.

photoelectricity General term for a change in electrical properties of a substance when it absorbs radiant energy. The change may be in electrical resistance or in rate of electron release. The phenomena are used in various types of measuring instruments, such as "exposure" meters, densitometers, etc.

photoelectrolysis In the presence of an electrical voltage, an increase in current flow when radiation is absorbed in a photoconductive layer. The current produces free radicals in an image-recording layer; the radicals initiate polymerization. The method has been proposed as a compensation for the low sensitivity of most photopolymers.

photoelectron An elementary particle bearing a negative charge, i.e. an electron, freed from its normal position in a crystal (e.g., silver halide) by the absorption of radiant energy. Such electrons participate in the formation of the latent image.

photoelectrophoresis (PEP) An image-forming process involving the use of charged photoactive pigments in an insulating liquid. In an electrical field, the pigment particles become more conductive when they absorb radiation, and can be made to move to a receiving sheet.

photoemissive Having the property of releasing electrons when radiation is absorbed; one kind of photoelectric effect. The application is to some types of vacuum phototubes characterized by fast response but relatively low sensitivity.

photoengraving The process of producing letterpress (raised-image) printing plates by photography

followed by etching. Used in halftone engraving.

photo essay See picture essay.

photoetching The process of making patterns in thin metal by photographically reproducing the desired shape on a resist, followed by removal of the unwanted resist and chemical treatment of the metal. A type of photofabrication. Photomilling is a similar process but involves larger amounts of material.

photofabrication General term for production of parts, usually in metal, by photographing artwork on a resist, removing the unwanted resist areas by solvents, and then chemically removing the unprotected metal. Photofabrication includes photoetching and photomilling.

photo finish In racing, a result so close that it must be judged by a photograph of the racers at the conclusion of the race.

photofinishing Mass processing and printing, usually of amateur roll films.

photoflash lamp A flashbulb; a light source producing a single short pulse. The bulb contains an atmosphere of oxygen, plus metallic foil or wire or other combustible substance which is ignited by an electrical current. Distinguish from electronic flash (speedflash, or "strobe"), which involves a high-voltage electrical discharge through an inert gas and which may produce several thousand pulses of light.

photoflood lamps Tungsten-filament lamps operated at near the melting point of the filament, at a temperature near 3450 K. The emitted light is more intense than that from conventional tungsten lamps of the same wattage, but the life of the lamp is short, only a few hours. Distinguish from 3200 K lamps. Syn.: flood bulbs.

photogelatin A photomechanical reproduction process that uses reticulated dichromated gelatin as the printing surface. A halftone screen is not needed, and the process is capable of reproducing fine detail. Syn.: collotype.

photogenic (1) As applied to a model, attractive, photographing well. (2) Producing light, applied to biological sources such as fireflies, luminescent bacteria, and fungi.

photogram (1) An image produced without optics or camera, by interposing a transparent, translucent, or opaque object in a beam of light falling on the sensitive material (usually paper). (2) A photographic image prepared for use in aerial surveying, i.e., in photogrammetry.

photogrammetry The technology of using photographic methods to make accurate measurements. The term, initially applied to aerial surveying and cartography, etc., has been extended to include other types of mensuration, even to photographic methods of fitting garments to a person. Also see photometrology.

photograph (1) A relatively permanent image produced by the action of light on a sensitive material, commonly restricted to images of objects formed by means of optical devices, such as lenses or mirrors, as distinct from sound recording, etc. (2) By extension, any image formed by the action of radiation, including light, infrared, ultraviolet, and gamma rays.

photographic chemistry The science and technology of the chemical formulation and behavior of photographic materials, especially the chemistry of processing. Distinguish from photochemistry.

photographic club See camera club.

photographic daylight A light source used for testing (especially color) films that matches in color the light encountered in typical good weather conditions outdoors. The color temperature is 5500 K.

photographic definition The clarity of detail of a print or other photographic image as perceived by the viewer. Also see definition.

photographic engineering (1) The design and evaluation of equipment and systems used for the production of images by the interaction of radiation and matter. (2) The design and evaluation of methods employing photographic techniques, used in connection with the solution of problems in engineering and science.

photographic science The application of physics, chemistry, and mathematics to the study of image formation by the interaction of radiant energy and matter.

Photographic Society of America (PSA) An association of professional and amateur photographers.

photographic technology The application of known principles and practices of engineering to the use of photographic materials, equipment, and processes.

photographic typesetter In photomechanical reproduction, a device that sets type by exposure on a sensitive material from a negative of type characters or other symbols. Syn.: filmsetter; photocomposing machine.

photography (1) Broadly, the science, engineering, art, and craft of producing relatively permanent images by the action of light (and similar electromagnetic radiation) on sensitive materials. (2) Narrowly, the use of a camera to make images by the action of radiation on sensitive films or papers.

photogravure A photomechanical printing process based on the production by photography of a plate (usually cylindrical) containing small ink-receptive

pits. Commonly used in newspaper and art reproduction, in which the high quality and long-run characteristics of the process are useful.

photointelligence Information obtained by examining photographs. Initially used in military contexts but recently extended to nonmilitary ones, such as surveying and the like.

photointerpretation The process (usually visual) of obtaining qualitative or quantitative information from a photograph. The term initially had a military connotation but has been extended to other areas, such as geodetic, agricultural, climatic, and population studies.

photojournalism Photographic reporting. The occupation of making photographs, typically of news events and personalities, intended primarily for reproduction in newspapers and for editorial (as distinct from advertising) use in magazines and the like. Syn.: photo reporting; photo-reportage.

photokeratoscope A device used to study the form of the cornea of the eye by photographing reflections formed on the corneal surface of, for example, a series of concentric circles.

photolithography A method of photomechanical printing involving a metallic or other essentially flat plate, portions of which are ink-receptive and portions of which are ink-repellent.

photolysis The decomposition of substances by the absorption of radiation, especially of light.

photolytic silver Silver metal generated from silver halide as a direct result of the action of radiation. The latent image consists at least in part of a speck of such silver metal. See photodevelopment and printing-out paper.

photomacrography The production in the camera of images at a scale of reproduction of 1-to-1 or larger. Distinguish from microphotography, which is the production of very small images, and from photomicrography, which employs a microscope to obtain high magnifications. Syn.: macrophotography, to which photomacrography is preferred.

photomask (1) A pattern on photographic material, usually of small scale, used for the production of printed circuits, etc. (2) A supplementary transparency used to modify the tonal or color characteristics of a negative or transparency. Typically the mask is derived from the image it is used with.

photomechanical The combining of photography and mechanical printing processes to make multiple copies in ink of an original, as in photoengraving, photolithography, photogravure, collotype, etc.

photometer An instrument for measuring or comparing light levels. Different types are: (a) Visual

photometers, which use the eye to determine when equality exists in the illuminance on a surface produced by a standard and a sample source. The inverse-square law (which see) may then be used to compute the intensity of the sample with respect to the standard. Syn.: comparison meters. (b) Photoelectric photometers which may estimate illuminance directly if they are filtered to duplicate the spectral response of the eye. Such meters accept light over a hemisphere. Syn.: incident-light meter. (c) Photoelectric meters with a restricted angle of acceptance estimate luminance, i.e., intensity of a source or reflecting surface per unit area. Syn.: reflected-light meter; when the acceptance angle is only a few degrees or less, the term is spot meter.

photometric aperture The ratio of subject luminance to the corresponding illuminance in the principal focal plane. In practice, the photometric aperture can be considered to be equal to four times the square of the f-number divided by the lens transmittance. Syn.: G-number.

photometric brightness Luminance, the preferred term.

photometric equivalent The ratio of the mass of silver (or dye, etc.) per unit area of a processed image to the optical density of that image area. The reciprocal of the covering power.

photometric filter In visual light comparators (photometers) in which the two parts of the field differ in color (hue), an absorber used in one light beam to reduce the color difference and facilitate the judgment of equality of luminance.

photometrology The technique of making measurements of objects, terrain features, etc., through the use of photographic images.

photometry The branch of physics concerned with the measurement of light. The term is often extended to include the measurement of ultraviolet and infrared radiation. Compare with radiometry.

photomicrography The photography of objects at a large scale of reproduction (i.e., at high magnification) with a microscope. Not to be confused with photomacrography. In terms of the scale of reproduction, photomicrography is the opposite of microphotography, since the latter is the production of very small images.

photomicrometrology The combination of photomicrography and measurement techniques, used to find the dimensions of very small objects.

photomilling The process of manufacturing (usually metal) parts by exposing an appropriate pattern on a resist-covered metal, removing the unwanted resist areas, and chemically removing the exposed metal. Photomilling is one type of photofabrication,

photomacrograph

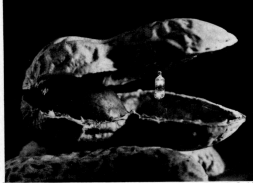

D. Smith

distinguished from photoetching in that it involves less precision and the removal of more material.

photomontage (1) A composite image, made by cutting and pasting, or by projecting several images in sequence on different parts of the receiving photographic material, such as photographic paper. (2) Any technique of making composite or multiple photographic images.

photomultiplier A type of photoelectric cell that contains a means of internal amplification of the initially released electrons, usually through several stages. Such cells are used in some densitometers and other light-measuring apparatus.

photomural A large decorative photograph, usually scenic, typically consisting of two or more joined sections. Since the widest available photographic paper is 4 to 5 feet across, any larger print requires such a joining process. Syn.: mural.

photon (1) An elementary particle of light. (2) By extension, a particle of any electromagnetic radiation of wavelength small enough that particle-like behavior can be observed, as near infrared, ultraviolet, etc.

photopic At normal levels of illumination. The term is applied to the visual process when the light level is sufficient to permit full activity of the retinal cones, so that perception of chromatic colors is possible. Compare with mesopic and scotopic (vision at moderate and very low light levels).

photopigment A light-sensitive substance in the receptors of the retina of the eye. Rhodopsin (visual purple) is found in the rods; red-sensitive erythrolabe, green-sensitive chlorolabe, and blue-sensitive cyanolabe are found in the cones.

photoplay A drama presented in motion pictures.

photopolymerization The formation of polymers (high-molecular-weight materials) from those of lower molecular weight facilitated by the absorption of radiant energy.

photorecording General term for any method of data collection by the use of photographic material. Oscillography is an example.

photo-reportage, photo reporting See photojournalism.

photoresist Nonsilver photographic material, coated on a suitable support (substrate), that changes in physical or chemical properties (solubility, water receptivity, etc.) after absorption of radiation. Examples are bichromated gelatin, various gums, and some polymers. Photoresists are used to make plates for photomechanical reproduction and in chemical etching and milling processes. In these techniques, the resist is used to make a mask by photographic

means. Where it covers the support, the mask prevents etching by a chemical bath. Complex shapes in metal, etc., can be made economically by such a method.

photoresistor A type of photoelectric cell that undergoes a change in electrical conductivity when irradiated.

photosensitive Capable of undergoing a physical or chemical change as a result of the absorption of radiation, especially light. The term is applied to photographic materials and also to photocells. Thus photosensitivity includes: latent-image formation; bleaching of dyes; change in solubility (as in photoresists); change in electrical properties.

photoserigraphy See silk screen.

phototheodolite An apparatus for mapping purposes that records data (such as the time) along with the subject (such as a star field).

phototherapy The use of light in the treatment of disease, e.g., in the treatment of jaundice of the newborn.

photothermographic Involving image formation by the use of infrared radiation. Applications are to the detection of temperature differences, as in medical photography.

phototopography The application of photographic methods to surveying and mapping. See photogrammetry; photometrology.

phototropism A reversible change in the color of a material caused by the absorption of radiation.

phototube A vacuum-tube photoelectric cell, the sensitive surface of which releases electrons when it absorbs radiation.

phototypesetting Text composition on photographic material from a negative of a typeface. Syn.: photocomposition; filmsetting.

phototypography General term for any technique using photosensitive materials for making plates used in printing text.

photovoltaic Capable of producing electromotive force (voltage) by the absorption of radiation, especially light. A class of photoelectric cell. Used in some light meters.

photozincography Using photographically prepared plates in zincography, which see.

physical densitometer Instrument other than visual for measuring the density of a photographic image. Modern physical densitometers use photoelectric cells as the response devices.

physical development In silver halide emulsions, deposition of silver from solution on the latent image. Dissolved silver salts may be placed in the

developer, or (in solution-physical development) a silver halide solvent in the developer may be used to dissolve silver halide from the film itself, after which the deposition occurs. Images formed by physical development are usually of very fine grain, but the effective sensitivity of the material to light is usually greatly reduced. See postfixation development.

physical optics That branch of the study of the physics of light which deals especially with the wave properties of radiation.

physical properties Those characteristics of photographic materials other than chemical and sensitometric. Physical properties include: dimensional changes with temperature and humidity; curl; abrasion resistance; surface characteristics such as sheen; etc.

physical ripening In the manufacture of silver halide photographic emulsions, holding the emulsion for a time at a relatively high temperature in the presence of a solvent for silver halide. During this holding period, the silver halide crystals grow to a suitable size. Physical ripening is usually applied to the first of two such periods that take place before washing of the emulsion. The second such period may be called digestion or afterripening. Ripening tends to increase the sensitivity and the exposure latitude of the emulsion.

picking In mechanical printing, adherence of paper fibers, etc., to the ink film on the plate (or blanket, in offset lithography), resulting in poor image quality.

pickup In sound reproduction, that part of the reproducing system which converts the motion of a phonograph needle in a record groove into electrical impulses.

pickup head In a tape recorder, that part of the equipment which detects the magnetic record.

pico- Prefix in the metric system meaning "millionth of a millionth," i.e., 10^{-12}, as in picosecond.

pictoral Applied to photographs intended to represent a subject, as distinct from those intended for data collection, or (on the other hand) for purely esthetic purposes.

pictorialism A type of photography that aims at a flattering representation of the subject, or at presenting a pleasing image. Contrasted with realism, which purports to present truth.

picture (1) A still photograph. (2) A completed "movie." (3) In television, two successive fields (scans) interlaced to form a single frame. (4) A roll of motion-picture film containing a pictorial record, as distinct from the soundtrack.

picture editor In photojournalism, the person who is responsible for selecting pictures to be used, for decision about layout, and, often, for the assignment of work to photographers.

picture element (pixel) A single discrete spot, one of many resulting from the dissection of an image by a scanning or other method. In transmitting photographic information as from space vehicles, such dissection is preliminary to sending the necessary data by radio or other means.

picture essay In photojournalism, a picture story that typically presents editorial opinion on a subject, as distinguished from purely factual reporting. Syn.: photo essay.

picture flutter An erratic variation in brightness of a projected motion-picture image, typically due to exposure variations in the camera or printer.

picture head The main mechanism of a motion-picture machine (camera, projector, printer) as differentiated from the sound head.

picture sequence (1) In layout, the order in which photographs are presented. (2) A picture series.

picture series A group of photographs dealing with a single concept or with a set of related concepts, but without the progression characteristic of the picture story.

picture story In photojournalism, a series of photographs related to a single theme, usually implying a progression of images analogous to a plot in literature; typically accompanied by a text and captions.

pigment (1) A colored substance used in inks, paints, etc., consisting of finely divided and relatively opaque particles. Compare with dye, which is a relatively transparent colored substance. (2) (adj) Identifying a photographic process based on the change in physical characteristics (solubility or tackiness) of a colloid when exposed to radiation. Examples: bromoil; carbon; gum dichromate. Modern variants involve photosensitive plastics, some of which change in surface stickiness and, after exposure, can produce a visible image merely by being dusted with a colored powder.

pigtail A flexible electrical cable used for making connections from photographic apparatus to outlets or junction boxes.

pilot (1) With "plant," a small-scale manufacturing operation, intermediate between a laboratory process and full commercial production. (2) With "lamp," a light providing a signal that an apparatus is ready for use. Often used in connection with battery-operated electronic flash. (3) On some projectors, a small lamp facilitating the change of motion-picture reels, slide carriers, etc., without the

need for turning on room lights. (4) With "pin," a protruding part on a motion-picture camera or printer that aids in proper film placement. Syn.: register pin. (5) Specifying a film or tape of a sample television program, made as an example of a series with the intent or hope of selling the series.

pin A projection on a device used to position materials in fixed locations, as in registering overlays or other sheet materials via punched holes.

pin base Supports and electrical contacts for lamps, in the form of short projecting rods, as contrasted with a screw base. Pin bases facilitate the precise positioning of lamps in optical systems.

pincushion Identifying a type of optical distortion in which image points are displaced outward from the correct position. The amount of displacement increases as the image point is farther from the lens axis. The result is that straight lines in the object are bowed in the image. Syn.: pillow; positive. The converse of barrel distortion.

pin down To narrow the beam of a variable spotlight from a flood to a spot mode.

pinhole (1) A tiny aperture that forms an image without the use of a lens, as in the pinhole camera. (2) A small clear defect in processed negatives producing small black spots in prints. Such defects may be caused by specks of dirt on the film during exposure or by solid particles or air bubbles sticking to the film during development. Cleanliness and effective agitation reduce the formation of such defects. Small gas bubbles may cause breaks in the emulsion if the film is transferred from the alkaline developer to an excessively acid bath (stop bath or acid fixer.) A water rinse or a sufficiently weak acid stop bath after development will reduce such defects.

pinion A small gear that engages a larger gear or a toothed bar (rack). Many view cameras are focused by the use of a rack-and-pinion assembly.

pint (pt.) A unit of volume in the English system of measurements. Equal to 16 fluid ounces, to 1/2 quart, and, in metric volume, to about 516 milliliters.

pinup A photograph of a scantily clothed female model emphasizing "glamor."

PIP Persistent internal polarization.

pipet(te) A narrow cylindrical volume-measuring device for liquids, often with an enlarged portion. The liquid is forced into the cylinder by air pressure to a mark. Pipets are used for accurate measurements, as of a stock solution to be diluted for use.

pit In motion pictures, taken from below ground level, as in pit shot. Dramatic effects may be obtained as vehicles, animals, etc., approach and then overrun the camera position.

pitch (1) In motion-picture films and apparatus, the distance from a point on one sprocket tooth or hole to the corresponding point on the next. (2) In photofabrication, the distance between a point on one image and the corresponding point on a similar nearby image. (3) In aerial photography, a tipping of the camera axis up or down; tilt. (4) In sound, that characteristic associated with frequency, i.e., rate of vibration. High pitch is associated with rapid vibration, and low pitch with slow vibration.

pix In journalistic slang, photographs.

pixel Picture element.

pixillation (1) In motion pictures and television, a special effect involving jerky movement. The effect may be produced by a combination of skip-frame and multiple-frame printing, i.e., omitting some frames and repeating others during the printing process. (2) In motion-picture photography of live actors, the result of operating the camera on a single-frame basis and posing the actors in progressive positions.

Planckian radiator A blackbody; one that obeys Planck's law of radiation, which relates the energy emitted at any wavelength to the temperature of the object. Tungsten lamps approximate blackbody sources. Syn.: complete radiator.

plane (1) (noun) A surface of interest, as film plane, image plane, exposure plane, nodal plane. (2) (adj) Flat, as opposed to curved.

plane-parallel Identifying sheets of glass, etc., especially filters, the two sides of which are nearly flat and everywhere equidistant from each other.

planetary (1) Applied to a camera used in microfilming in which the document being copied is not in motion during the exposure, as contrasted with rotary camera. (2) Identifying a gear train, used with a motion-picture shutter, designed to be adjusted so as to produce a dissolve, a gradual replacement of one scene by another.

plano- Prefix meaning "flat," in combinations such as planoconcave, planographic, etc.

planoconcave For a lens, having one flat surface and the other centrally curved inward toward the flat surface.

planoconvex For a lens, having one flat surface and the other centrally bowed away from the flat surface.

planography A mechanical reproduction method using a level printing plate, as distinct from those using plates with elevated or recessed image-bearing areas. Planographic methods are based on ink-receptive and ink-rejecting portions of the plate. See photolithography.

plastic (1) (adj) Capable of being changed in form, as

pincushion distortion

actual image

ideal image

pipet

25 ml

planoconcave

planoconvex

point spread function

polar diagram

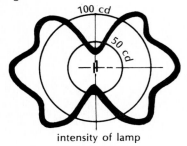

by heat, pressure, etc. (2) (noun) General term for a wide variety of substances that can be molded or cast into various forms. Film bases and many camera parts are made of plastics. Some plastics change in physical or chemical properties when they absorb radiation. Examples are photoresists. (3) (adj) Specifying a type of lighting by which the form of the subject is emphasized in the photograph.

plastic deformation An image-forming method based on the local, small-scale flow of a thin transparent layer when it is heated and subjected to an electrostatic field. By cooling, the plastic is fixed in position. The image consists of fine ripples which scatter light, and is visible with an appropriate (specular) illumination system.

plasticizer A substance added to a film base or other plastic material during manufacture to increase its flexibility and resistance to cracking when bent.

plastic matte An aperture cut in a semitransparent sheet that is placed in a viewfinder, especially of a motion-picture camera. Through the aperture the cameraman can see the part of the scene being photographed, and around it, adjacent parts of the scene.

plate (1) A relatively thick, stiff support, such as glass, metal, etc., on which a photosensitive material is coated. The coating may be done in manufacture, or in some situations (as in photomechanical reproduction) by the user. (2) In photomechanical reproduction, an image-bearing sheet of plastic, paper, or metal. (3) A locating device for film, to hold it in the image plane. Often called pressure plate.

platen The surface against which photographic material is pressed so that it will be in the image plane.

platinum process (platinotype) A photographic process dependent upon a photosensitive iron compound (ferric oxalate), which after the absorption of radiation is converted to a form (ferrous oxalate) capable of reducing a platinum salt to metallic platinum. Photographic materials based on this process are no longer manufactured, but some photographers produce their own. Platinum printing processes include both printing-out and developing-out techniques and materials.

playback (1) (noun) An apparatus for reproducing sound recordings or television recordings. (2) The act of listening to a sound record or of watching a television record, shortly after the record is made, for the purpose of assessing the quality of the record. (3) In motion pictures and television, the technique of fitting the pictorial record to a prerecorded soundtrack.

plot (1) A story for a photoplay. (2) A plan of camera

movements in animation, or in panning or zooming, etc.

plumming A change to a reddish or purplish color in prints, especially toned ones, when they are dried at a high temperature. Also see bronzing.

plus-density The presence of an abnormally large deposit of silver, dye, etc., in an image, usually because of a defect in handling or processing. A kink may produce a plus-density. The converse of minus density.

plus-or-minus (\pm) Indicating tolerances allowing for greater or lesser processing time, temperature, etc., without significant loss of quality.

pneumatic Operated by air pressure. Pneumatic shutters are operated by pressing a rubber bulb filled with air.

point (1) A theoretical object with location but no dimensions; infinitely small. (2) Point source; a source of radiation small enough and far enough away that its physical size may be neglected. Such a source obeys the inverse-square law with insignificant error. (3) A measure of printer's type size, equal to 1/72 inch.

pointer A device for calling attention to a specific position. A pointer may be a part of a densitometer to indicate a scale position. In projection, a pointer may be a device that produces an arrowlike spot of light on a screen, or it may be built into the projector and by a shadow accomplish a similar purpose.

point gamma Slope of a curved line at a given place on the curve. Preferred term; slope, gradient. (Gamma is properly the slope of the straight line of the D-log H (D-log E) curve.)

point spread function The distribution of light energy within the image from an ideally small object. The point spread function is fundamental to the study of optical and photographic images. The optical point spread function is related to lens performance, etc. The photographic point spread function is mainly determined by the scatter of light within the emulsion. Also see chemical spread function.

polar (1) Identifying a type of graph with a grid resembling a map of the earth as seen from one of the poles; used in displaying data involving angular measurement, such as angle of acceptance of light meters, light emitted by lamps in reflectors, etc. (2) Angular. Especially applied to the orientation of artwork or other images in microelectronics.

polarity (1) In photomasks, etc., the negative or positive character of the image. (2) In direct-current electricty, the direction of current flow.

polarization The production of orderly vibrations from the random vibrations of ordinary radiation,

especially light. Polarization may be: (a) plane, in which the waves vibrate in essentially a single direction; (b) circular or elliptical, in which the direction of vibration changes with time or distance. Plane polarization is obtained with special filters, by reflection from nonmetallic glossy surfaces at a specific angle, or by scattering from small particles, as in the atmosphere.

polarizer A filter that transmits light waves which vibrate essentially only in a single direction (plane). Such a filter is useful for modifying glossy (specular) reflection from nonmetallic surfaces such as water or glass, and in changing the photographic reproduction of sky tone, etc. A pair of polarizing filters can be used in combination as a variable neutral density filter, by turning one with respect to the other.

polarizing angle (Brewster angle) For light reflected from a nonmetallic glossy surface, that direction for which the reflected light most nearly consists of waves vibrating in a single plane. The angle of incidence is that for which the tangent is equal to the index of refraction of the material. For a material of index 1.5, the polarizing angle is about 55°.

polarizing screen A large filter, placed over a light source, used to reduce undesirable reflections in, for example, photographing an oil painting. When a polarizer is used on the camera as well, unwanted reflections can be reduced, regardless of the angle of reflection and the type of reflecting surface.

police photography The production of photographs to assist law-enforcement agents in their work. Syn.: crime photography; forensic photography; law-enforcement photography.

polish A surface characteristic that causes light to be reflected in a specular rather than a diffuse manner. Syn.: gloss. Also see sheen.

poly- Prefix meaning "many." Applied to plastics, which consist of molecules composed of many small molecules joined together. Examples: polyethylene; polyesters; polypropylene.

polyester As applied to film base, specifying a material containing more than one acetate or other organic group for each molecule. As compared with bases containing fewer such acid groups, polyester bases are more moisture-resistant and dimensionally stable.

polymer A substance consisting of linked similar small molecules, formed into chains or networks. Some polymer formation is facilitated by the absorption of radiation, and is thus the basis for some photographic processes. See photoresist.

pool An agreement, as among a group of newspaper photographers, to exchange prints, thus ensuring complete coverage of an event.

pop An annoying sound associated with the splice in a motion-picture soundtrack.

POP Printing-out paper.

pop-in (-on) In animated motion pictures, the sudden appearance on the screen of a symbol or figure.

pop-off The sudden disappearance of an animation image. The opposite of pop-in (pop-on).

popping In projection printing and the projection of small transparencies for viewing, a sudden change in focus. The cause is a change in buckle of the negative or transparency as it warms up in the projector. Some projectors have automatic methods of correcting the focus shift. In projection printing, popping can be prevented by using a glass negative carrier, or avoided by warming the negative before focusing the image and again before exposing the print.

population In statistics, all the members of a specific set, extended from the concept of the census. In photographic applications, examples of populations would be: temperature of a processing bath (implying all possible temperature measurements); film speed of a given emulsion number of a given film; resolution of an optical system. Distinguish from sample, specifying the data actually collected.

pop-up The sudden appearance of an image, as of a trace on photorecording paper when it is processed.

pornography (1) Applied to photographs intended to arouse the viewer sexually, often by portraying sexual activity. (2) In law, obscenity. According to the Supreme Court, that which appeals to prurient interest and is obviously offensive. The test of obscenity is applied to a (literary) work as a whole, and is based on contemporary community standards and the response of the average person. Since such standards change from place to place and with time, what is considered obscene (pornographic) changes similarly.

Porro A type of reflecting prism used in binoculars and viewfinders to produce an image with the correct orientation. A Porro prism has two angles of 45°, and one of 90°.

port A window, as in a projection booth, underwater camera housing, wind tunnel, etc., used for observation, projection or photography.

portfolio (1) A group of photographs assembled to demonstrate a photographer's competence. (2) A selected group of photographs, usually in a folder, and typically printed in a limited edition and offered for sale to collectors, museums, etc.

portrait (1) (noun) A photograph of a person and, by extension, of an animal, flower, etc. (2) (adj) Charac-

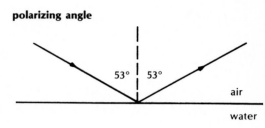

polarizing angle

53° | 53°

air

water

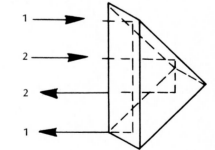

Porro prism

1

2

2

1

terizing cameras, lenses, etc., especially designed and used for photographing persons.

portrait attachment A positive supplementary lens used to reduce the effective focal length of a camera lens, enabling the camera to be brought closer than normal to the subject and thus to increase the image size. The preferred term is "closeup attachment."

pose (1) To place a model in a position suitable for being photographed. (2) On the part of the model, to assume a suitable position. (3) (noun) The position taken by a model for a photograph. (4) In animation, a single (usually principal) drawing.

positive (1) (noun) A photographic image in which the tones are in approximately the same relationship as in the original; light tones are reproduced as light, and dark tones as dark. (Compare with negative, in which the original tones are reversed.) (2) (adj) Convergent, as a lens or mirror. Causing rays of light from a distant point to come to a real focus. (Compare with negative lens or mirror.) (3) (adj) As applied to a photoresist, easily removed by a solvent developer after exposure. (Compare with a negative photoresist, which adheres to the support after exposure.) (4) A type of optical distortion in which image points are displaced outward from the image center; pincushion distortion. (5) A type of photographic material intended for printing from negatives, as distinct from negative and reversal materials. (6) In electricity, having a deficiency of electrons (negative charges). (7) A type of curl in film in which the emulsion side is concave. (8) Identifying a type of contact screen used to make halftones from continuous-tone negatives, as distinct from a negative screen used to work with continuous-tone positives. The positive screen accommodates a greater input range, but does not increase highlight contrast.

positive hole See hole.

positive splice In motion pictures, a joint between two pieces of film with greater overlap than in a negative splice, thus giving the greater strength needed for frequent projection of the film.

positive-working In photomechanical reproduction processes, applied to a plate made from a positive, in which the areas receiving most exposure are rendered least receptive to ink, so that the resulting print corresponds to the positive original.

postbaking Heating of a photoresist after exposure to remove solvent and to improve the adhesion of the resist to the substrate (support).

posterization A photographic printing method by which details of the image are suppressed and tonal separation of large areas is exaggerated. The final image consists of a limited number of discrete tones,

usually three to five. Separation negatives are made on high-contrast material, each negative recording a different narrow range of tones, and are successively printed on the same sheet of positive material.

postexposure In making a screened negative for use in photomechanical reproduction, additional light after the image-forming light. See bump and flash.

postfixation development The production of a visible image after the silver halide that is unaffected by exposure is removed in a fixing bath. The image is extremely fine-grained, but the effective speed of the material is lowered to a great extent. Also see physical development.

postrecording In sound motion pictures, making the soundtrack after the pictorial images have been photographed.

postscoring In sound motion pictures, recording appropriate music after the pictorial images have been photographed.

postvisualization An approach to photographic printing, especially of combination photographs and montages, in which the main picture decisions are made in the darkroom during the printing process. Also see previsualization.

POTA Acronym for Photo Optics Technical Area (of the US Army Electronics Command). Identifying a developer especially formulated to extend the useful exposure range of a silver halide photographic negative film.

pound (lb.) Avoirdupois unit of weight; 16 ounces, 1000 grains, or in metric weight, 453.6 grams or 0.4536 kilograms.

powder process An image-forming method involving a plastic or similar surface, portions of which are tacky and to which a powdered pigment adheres. The tackiness of such surfaces may be changed when they absorb radiation, and this change is the basis of some photographic processes.

power (1) The rate of energy production or consumption. Units: for electricity, watts or kilowatts; for light, lumens of flux; for radiation other than light (infrared, ultraviolet, etc.), usually watts. (2) A measure of the ability of a lens or mirror to converge or diverge light rays. Here power is the reciprocal of the focal length; i.e., the power increases as the focal length decreases. If the focal length is measured in meters, the power is measured in diopters. For thin lenses in contact, the powers of the elements are additive. (3) For visual instruments (magnifiers, telescopes, etc.) the magnification, e.g., 10X. (4) For telephoto lenses, the ratio of the focal length to the back (preferably flange) focal distance.

power pack Portable electrical apparatus, usually including batteries and condensers, used to supply

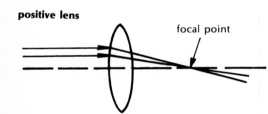

positive lens

focal point

electricity to light sources or to the film transport mechanism in motorized still and motion-picture cameras.

PPM Pulses per minute, applied to a rapidly flashing light source.

PPS Pictures per second.

practical As applied to a prop used in motion pictures, capable of operating. A practical kitchen sink is supplied with water, as distinct from one not so supplied.

Prägnanz's law A figure tends to be perceived in its simplest form. In a photograph, an angle that deviates somewhat from 90° is usually seen as a right angle seen in perspective. Also see shape constancy.

prebaking Heating of a photoresist before exposure, to remove solvent and to improve response to exposure.

precipitation Separation of a substance in solid form from solution. In the preparation of a silver halide emulsion, the mixture of soluble halide and silver nitrate solutions causes precipitation of insoluble silver halide crystals.

precision (1) For a measurement method, ability to reproduce closely; ability to detect very small differences. A thermometer capable of estimating differences of a hundredth of a degree is a relatively precise instrument. (Distinguish from accuracy, which means close approximation to the "correct" value.) (2) Loosely, as applied to a camera, a processing method, etc., consistently capable of producing excellent results. Preferably, a camera, etc., manufactured to close tolerances and conforming to high standards of quality.

pre-exposure The act of supplying radiation, especially light, to a photographic material before the image-forming exposure. A flash pre-exposure may be used as one method of hypersensitization. Also see preflashing; Clayden effect.

preflashing In making duplicates or prints, giving the photosensitive material a first uniform exposure before the image-forming exposure. The effect is a reduction in contrast of the image. A form of pre-exposure.

prefocus Characterizing a lamp mounted in a base in such a way that the filament is correctly oriented to the optical system. Especially applied to lamps used in projectors and spotlights.

pre-press proof In photomechanical processes, a sample made for inspection before the plate is put into production. One method is through the use of color scanners.

preprint In motion pictures, identifying all materials, films, etc., used in the process before the printing stage. Preprint films include: camera original, master positive, dupe negative, sound track, title negative, matte, optical negative, etc.

prerecording Making a soundtrack to which the pictorial image is later synchronized.

prerelease Exhibition of a motion picture prior to its general showing.

presbyopia The decrease with advancing age in the ability of a person's eyes to focus on different distances.

prescoring In motion pictures, recording of music before photographing the image.

presensitized Identifying plates to be used for photomechanical reproduction that have been coated by the plate manufacturer, as distinct from plates that are to be coated by the user.

preservative (1) Generally, any substance intended to prevent or reduce deterioration of another substance. In developing baths, sodium sulfite is a preservative in that it reduces the rate of oxidation of the developing agents. In fixing baths, the same chemical acts to reduce the rate of formation of free sulfur. (2) In motion pictures, lacquer, wax, etc., intended to reduce damage to film during handling or projection.

preset (1) Identifying a shutter that requires one movement to place tension on the spring and another to release the shutter. Less pressure is needed to release the shutter than with an automatic shutter in which the two operations are combined. (2) Identifying a lens diaphragm designed to remain wide open (regardless of the f-number at which it is set) until just before the exposure is made. It then either stops down automatically or can be stopped down manually without visual inspection. A bright image is provided for composing and focusing the image, without introducing a delay in making the exposure.

press (1) Equipment for making multiple copies from plates often prepared by photographic means. (2) A device for ensuring contact of print and support accompanying the use of adhesives, as in dry-mounting press, or to flatten prints. (3) (adj) As applied to cameras, especially used for photojournalistic applications, as in newspaper photography. Press cameras use relatively large film sizes in sheet or roll form, and often are equipped with focal-plane shutters, rangefinders, and flash synchronization equipment.

press-focus Identifying a mechanism on some shutters that enables the photographer to open the shutter blades to examine the ground-glass image with the shutter set for any of the instantaneous speeds (as distinct from the time and bulb settings).

pressure plate A flat or curved surface that holds photographic material in the correct plane for exposure, projection, printing, etc.

preview (1) Showing of a motion picture before release. (2) On single-lens reflex cameras, applied to a button, etc., that permits the photographer to stop his lens down to check the depth of field and then open up the aperture to view the subject without having to change the *f*-stop setting. Often used to decide what aperture to use for the picture.

previsualization In the zone system, the mental process of the photographer by which he anticipates the ways in which a given scene may be rendered in the final print and then controls the photographic exposure and development to produce the desired result. Also see postvisualization.

pricing Establishing the amount of money for which a photographic product or service is to be offered for sale.

primary (1) Fundamental; applied to a standard. The primary light standard is a blackbody at a temperature of 2048 K. Contrast with secondary. (2) In the additive formation of various colors, one of three variable lights, usually blue, green, and red. Different amounts of these can duplicate any hue. (3) In the subtractive formation of colors, one of three colorants (inks, dyes, etc.), usually yellow, magenta, and cyan. Superposition of different amounts of these can produce any hue. (4) In psychology, simple, in the sense that a given color does not look like any other. Psychological primary hues are red, green, blue, and yellow. Black and white (though not hues) are sometimes added.

primary focus For a lens or mirror, that point toward which rays from infinity converge (for a positive element) or from which rays from infinity appear to diverge (for a negative element).

prime (1) As applied to a lens, one that fits a camera directly, and can function alone. Compare with accessory or auxiliary lens. (2) As applied to a component of a zoom-lens system, that assembly which provides most of the optical power. The prime lens is often mounted separately from the variable-converter lens system, i.e., that which varies the focal length.

primer In a flashbulb, an easily ignitable substance which first starts to burn when the filament is heated electrically, and which then causes the metal wire or foil to start to burn. In some flashbulbs, a relatively large amount of primer is the sole source of light; such bulbs are often called "gas-filled."

principal In optics, surfaces defined by intersection of incident rays parallel to the axis and emergent focused rays. The principal planes are those of unit lateral magnification, inasmuch as the surfaces are intersected by the rays at equal distances from the axis. In photographic applications, object distances are measured to the first principal plane, and image distances and focal lengths to the second principal plane. (Note: When the medium surrounding the lens is the same on the front as on the rearmost surface, principal planes coincide with nodal planes.)

principal focal point Primary focus.

print (1) (noun) A photographic image, usually made from a negative or positive image, rather than directly from an original scene. A print is made to be viewed or reproduced, and is typically a positive image on a paper base for still photography, and a positive image on a transparent base for motion-picture photography. (2) (verb) The act of preparing images as defined in (1) above. Especially, in photomechanical reproduction, to make multiple copies by means of a printing press. (3) In motion pictures, the word from the director that he is satisfied, as in the command, "Print it."

printed circuit A pattern of electrical connections, usually in copper, on a nonconductive support, usually plastic, made by a photoetching process.

printer (1) An exposing apparatus used to make images from negatives or positive transparencies, as in automatic printer, projection printer, contact printer. (2) An image-bearing film or plate, as in magenta printer or black printer, used in a diffusion-transfer photographic process or in a photomechanical reproduction process. (3) A person whose function is (a) to produce positive photographic images or (b) to make multiple copies by mechanical reproduction methods.

printer point An increment of light intensity in a motion-picture print exposure machine. The usual increment is about 10%.

printer sync Projection synchronism

print flattener See straightener.

printing density A measure of the absorption of energy by a negative or transparency, evaluated in terms of the response of the printing material. For example, a negative with a yellowish stain will have a high printing density if it is to be printed onto a blue-sensitive material, although the same negative may have a small visual density.

printing frame An apparatus for making prints the same size as the negative or transparency. It consists of a sheet of glass and a means (spring or vacuum) of holding the negative or transparency close to the print material.

printing in (1) A method of local printing control by which additional exposure is given to print areas that would otherwise be too light. (2) Combining of

two or more negatives in a single positive, as the foreground from one negative and clouds from another.

printing index See printing speed (1).

printing light In motion pictures, a numerical indication of the illumination level needed for correctly exposing a given scene negative.

printing-out paper (POP) A photosensitive material that gives a visible image on exposure to radiation without development, typically used for making proofs of negatives. The image is unstable unless toned. Portrait photographers often use POP to let the customer choose the poses he prefers.

printing speed (1) A measure of the response of a positive material to light, analogous to film speed. Shadow speed (based on the exposure needed to produce nearly maximum black) and printing index (based on midtone exposure) are modern measures. (2) The rate at which a continuous-exposing printing apparatus functions, in feet per minute of material moving through the apparatus.

printout (1) The production of a visible image solely by exposure of the photographic material to a large amount of radiation, as in printing-out paper. (2) An enlarged reproduction of a microfilm image. (3) A computer-produced image on paper or film, etc.

print-through (1) In motion pictures, an unwanted image produced when a traveling matte has insufficient density. (2) In sound recording on magnetic tape, a transfer of the record from one turn of the tape to the next, resulting in a faint unwanted sound like an echo. (3) In a photomechanical reproduction, unwanted visibility of a picture as seen from the other side of the paper.

print-through gamma The slope of the straight line of a graph that shows the relationship between print density and negative density. Such a graph includes the effects of the printer (flare, etc.), as well as the effects of processing.

prism A transparent optical element having only flat surfaces, used to refract, reflect, or disperse radiation. Prisms are used instead of mirrors to reflect light and to form spectra. They are also used, as in rangefinders and reflex viewing systems, to change the direction of light rays, and in high-speed cameras, etc., to arrest the image briefly.

pro Short for professional (photographer).

probe A small-aperture attachment to a photometer, for example, to permit its use for the measurement of small areas, as of an image on a ground-glass viewing screen.

process (1) General term for a sequence of operations, as in photographic process, printing process, etc. (2) Implying a photomechanical reproduction method, as in process camera, process lens, etc. (3) In motion pictures, applied to the production of special effects, such as double printing, the addition of backgrounds, masking, etc.

process body A mock-up (simulation) of the interior of an automobile, etc., which is used in conjunction with an exterior shot of scenery, etc.

process camera (1) A copying apparatus used to make images for photomechanical reproduction. Such cameras include rigid mounts, lenses of high precision and great focal length, special lighting arrangements, and supports for the material to be copied. Some process cameras include remote controls and a darkroom at the image-recording end. (2) In motion-picture photography, a camera intended for animation purposes. (3) In motion pictures, a camera especially used to synchronize projected scenes with live action.

process colors Inks used in mechanical reproduction. "Process red" is magenta, "process blue" is cyan, and the third ink is yellow.

process film A photographic material on a transparent base, especially used to make line and half-tone negatives for photomechanical reproduction purposes.

processing (1) Any procedure that follows exposure of a photographic material. In conventional silver halide photography, processing involves developing, stopping, fixing, washing, and drying. (2) A general term for a sequence of operations on a photograph necessary to extract information from it. Processing may involve interpretation, preceded by coding, image enhancement, and other efforts to increase the information output.

processing effect Any evidence in an image of non-uniformity in development. Among processing effects are adjacency effect, border effect, Eberhard effect, edge effect, fringe effect, interimage effect, Kostinsky effect.

process lens An optical image-forming device of relatively great focal length, capable of producing excellent image quality; especially used for photomechanical reproduction purposes. Characteristically apochromatic.

processor (1) An apparatus, usually automatic or semiautomatic, for developing, fixing, washing, drying, etc., exposed photographic materials. (2) An operator of such an apparatus. (3) An establishment specializing in photographic processing. See lab and custom lab.

process shot In motion pictures and television, the combination of a projected background with live action.

producer In motion pictures, the person having the primary responsibility for all phases of the making of a finished film, including selecting the cast, writers, and technicians, and of administrative activities, including finances.

production designer A person who plans the settings to be used in a motion picture, etc.

professional Applied to photography done for profit, usually on instructions from a client. Some specialized branches of professional photography are commercial, industrial, portrait, advertising, photojournalism, and medical photography.

profile (1) Lighting in which the edge of the subject is outlined against a dark background. (2) In portraiture, a side view. Occasionally applied to other subjects.

program (1) (verb) To specify in detail a sequence of operations needed to produce a desired result. Programming often involves computer operation, as for example in automatic processing. (2) (verb) In education, to break up a complex learning process into small progressive steps, often with the aid of photographic images. (3) (noun) The sequence of operations or learning steps, etc., in the above: the process in detail.

projected background A scene imaged on a screen, in front of which actors perform, and thus appear to be on location. The technique is used in motion pictures and television, and also in still photography, especially for advertising purposes. (See front projection; rear projection; process shot.)

projection (1) The process of causing an optical image to fall on a screen or other surface for viewing, as in motion-picture projection. (2) As applied to printing, the use of optics to focus an image onto the print material. Compare with contact printing. (3) (adj) Identifying equipment or material intended for use as in the definitions above, such as projection lens, projection printer, etc.

projection angle The number of degrees between the axis of a projector and a horizontal.

projectionist The operator of a motion-picture or slide projector.

projection printer An optical device containing a light source used to project images of negatives or transparencies onto sensitized material, as distinct from a contact printer where the sensitized material touches the negative or transparency. Although commonly called an enlarger, projection printer is the preferred term since most such devices are used to produce reduced as well as enlarged images.

projection synchronism The appropriate relationship between sound and pictorial image in motion-picture projection. Inasmuch as the sound-reproduction head and the projection lens are not in the same place, the soundtrack must be displaced properly from the image. Syn.: printer sync.

projector An apparatus, including a light source and a lens, for producing an image of a transparency (still or motion picture), or of a reflecting object, on a screen. Examples: motion-picture projector; slide projector; opaque projector; overhead projector.

projectual A large transparency intended for use with an overhead projector.

promo (promotional) A short film made to publicize a specific event.

proof (1) (noun) A test print, made to check lighting, subject arrangement, expression of a model, cropping, etc., or photographic characteristics such as contrast and density level. (2) (adj) Applied to photographic paper especially intended for test purposes. (3) A print of one or more negatives, typically one roll of them, to serve as a file copy of the pictures and to facilitate selections for final printing. (4) (verb) To make a test print. Processing shortcuts are often used, inasmuch as print permanence is not required. (5) In photomechanical reproduction, a test sample made for inspection and approval before beginning the production press run.

prop Short for property. An object used as an incidental part of a subject for a photograph, a motion picture, etc. Properties are accessories used to establish the role of a person or the mood of a picture, etc., on a smaller scale than scenery.

propagance General term for any value which is a measure of the transfer or alteration in radiant energy, especially light. Propagance includes: reflectance, absorptance, transmittance, fluorescence.

property sheet A list of objects needed for a motion-picture or television production.

proportional (1) As applied to image intensification or reduction, dependent upon the amount of silver originally present. The effect of a proportional change is approximately equivalent to the effect of changed development time in the original processing, and thus such intensification or reduction can compensate for a development error. Also see subtractive, subproportional, superproportional. (2) Mathematically, a relationship between input and output variables that would plot as a straight line through the 0.0 point. Distinguish from linear, which implies only a straight-line relationship.

proscenium The area around a motion-picture screen, often lit by hidden lamps.

protanomaly One of three basic types of defective color vision in the anomalous trichromatism category; the other two are deuteranomaly and tri-

tanomaly. A person with this defect (i.e., a protan) requires more red in a red-green mixture to match a given yellow than a person with normal color vision requires.

protanopia One of four basic types of defective color vision (color blindness) in the dichromatism category; the other three are deuteranopia, tritanopia, and tetartanopia. A person with this defect (i.e., a protanope) sees red and cyan as gray.

protected As applied to a coupler (a chemical that takes part in a color-forming reaction in color photography) dispersed in a colloid, either as such or as droplets of its solution in a water-immiscible liquid, or as an insoluble salt. The purpose is to improve the image by preventing the material from diffusing away.

protection Applied to a negative, dupe, copy, print, etc., made and stored separately from an original for safety, lest the original be damaged or lost.

protective As applied to a colloid used in making photosensitive materials, having the property of keeping silver halide crystals separate, thus reducing the rate of development of unexposed crystals. Gelatin possesses this property to a high degree.

ps Picosecond, i.e., millionth of a millionth of a second.

PSA Photographic Society of America.

pseudoisochromatic As applied to a test of color vision, a display of colored dots against a background similarly constructed. The dots form a pattern only for persons with a specific type of color response.

pseudostereoscopy (1) Reversed stereo, produced by interchanging the right and left members of a stereo pair; e.g., hills become valleys. (2) In motion pictures, a method of enhancing the appearance of depth in an image, without being truly stereoscopic. The use of extremely wide screen projection is an example.

psychic photography The process of making pictures of alleged ghosts and other manifestations of the spirit world. The practice flourished in the 19th century and has recently been revived.

psychophysical Identifying measurement methods, etc., that relate human response and physical stimuli. Light is a psychophysical concept, as compared with radiation, which is a physical concept.

public domain The right of any person to reproduce a photograph, etc., because of the lapse of time or because the photographer has failed to protect his exclusive rights under the law.

public service Applied to a television spot, an advertising page, etc., used to promote a noncommercial cause or organization, such as antismoking, highway safety, etc.

pull (1) To remove a print, typically an overexposed one, from the developer before the normal time of development, in an (often unsuccessful) effort to obtain a good image. (2) In the graphic arts, to produce, as to pull a proof.

pullaway (1) In motion pictures, a shot in which the camera moves back from the subject. Syn.: pullback. (2) A translighted chart, projectual, etc., of which different portions are revealed by removing opaque masks.

pullback (1) In motion-picture printing, when an error occurs, to rewind the original to a position before the error, and to proceed with a corrected printing exposure from that point. (2) In motion pictures, a dolly shot in which the camera is made to move away from the subject. Syn.: pullaway.

pulldown (1) A claw or sprocket device for moving successive frames of film into position for viewing or printing, as in a motion-picture projector. (2) The length of film advanced by a single operation of the mechanism in (1).

pull focus In motion-picture photography, to change the focus during a take, typically done by an assistant to the cameraman.

pulse camera A photographic apparatus that operates in response to a brief electrical signal, exposing one frame and preparing for the next exposure.

pulse code modulation (PCM) Transformation of a continuously varying signal into a sequence of discrete levels. Such a method may be used in transmitting photographic information from space vehicles to a receiving station, where the photograph is reconstructed.

pulsed As applied to lamps, intermittent as opposed to continuous. Pulsed lamps are used in stroboscopic photography and some projectors and printers.

pumice A fine, chalky mineral powder, used for cleaning. Especially used for cleaning metals in preparation for coating with a photoresist in photofabrication processes.

pumpkin In the viewfinder of a motion-picture camera, an outline indicating the part of the scene that will be reproduced on most television screens. Contrast with TV cutoff, the part of the picture that falls outside the TV screen. Syn.: TV scribe.

punch (1) In motion pictures, an apparatus for making a hole in a leader to serve as a starting point for synchronization. (2) A device for making holes to ensure registration of drawings or other images as in animation or color diffusion transfer. (3) A device for reducing the unwanted sound associated with

splices in motion-picture films. (4) Slang for impact, as a picture has punch.

punch marks Perforations made in motion-picture leaders and films as start marks for editorial and printer use in the laboratory. Such punched holes are also used for cuing a work print for sound recording sessions.

punch-through (1) In lighting a set, the effect of a strong light as compared with weaker lights. (2) In printing, the use of a strong printing light for a very dense original.

pupil An aperture, especially of the eye and of lens systems. See effective aperture (entrance pupil), and exit pupil.

purchase order (PO) A document that includes information concerning an anticipated transaction and that, when found acceptable by both parties, authorizes the transaction to take place. A purchase order for photographs, for example, may identify the subject, indicate whether the photographs are to be black-and-white or color, the end use, anticipated price, expenses, etc.

purism (1) In art, a style exemplified by the work of Leger, characterized by two-dimensional treatment of three-dimensional forms. (2) Loosely, a style in photographic art free of "contaminating" influences.

purity (1) A quality of color expressing the nearness of the color to the same hue of the spectrum, as opposed to white. (2) Without admixture of other colors. A "pure" red is one without bluish or yel-lowish appearance. (3) Loosely, vividness (saturation) of a color. (4) As applied to chemicals, relative freedom from unwanted substances. "Purity" is relative to use; processing chemicals need not be as "pure" as those required for emulsion manufacture.

Purkinje phenomenon (also spelled Purkyne) (pronounced Pur'-kin-ye) At low energy levels, the sensitivity of the eye shifts from a peak at about 555 nanometers toward shorter wavelengths. In dim light, for example, blue objects look relatively lighter than they do in strong light, and red objects relatively darker.

pushing The process of attempting to increase effective film speed by increasing the degree of development (time, temperature, developer activity). The effect is not ordinarily equivalent to that produced by an increased exposure level. Pushed negative images usually have exaggerated contrast in the highlights, insufficient detail in the shadows, and increased graininess. With color films, a shift in color balance may also result.

pushoff (pushover wipe) A special effect in motion pictures and television, by which one scene appears to displace another by forcing it off the screen.

push-pull Applied to the technique of recording two signals (especially sound) opposite in phase in order to reduce faults in reproduction.

pyrometry Estimation of the temperature of an object by measurement of the radiation it emits, sometimes by the use of photography.

QQ

Q (1) Internationally-accepted symbol for quantity of energy Q_e or of light Q_v. (2) Callier coefficient. The ratio of specular to diffuse density for a given sample. As the scattering properties of a sample increase, the ratio of the two types of density also increases. The value of Q varies with the type of material, being only slightly greater than 1 for dye samples and considerably more for silver materials, and furthermore varies with density level and structure of the image. (3) A measure of the selectivity of a resonant device with respect to different wave frequencies. A device with high Q will pass frequencies in only a narrow range. Q is proportional to the energy stored in a device to that lost per cycle. Interference filters have high Q-values.

Q switch A device for shortening the pulse duration of a laser source.

quad A motion-picture printer in which the original is threaded through four successive gates, allowing four prints to be made in one pass of the original.

quadruplet Specifying a lens containing four elements, some of which may be cemented doublets, etc.

quality (1) General term for desirable characteristics, especially of an image. Image quality may be objective (acutance, resolution, modulation transfer factor, etc.) or subjective (sharpness, definition, legibility, etc.) (2) As applied to light sources, implying color, as in the phrase "daylight quality."

quality control (1) Broadly, any method of operating or inspecting a manufacturing or other process so as to assure the desired output. (2) In statistics, methods of sampling, measurement and data analysis used to detect the departure of a process from the usual (or desired) performance. Control charts are often used for this purpose.

quantum (plural **quanta**) The elemental quantity of energy which, according to modern theory, exists in discrete amounts. In light, the quantum is associated with the photon, the elementary particle of light.

quantum efficiency (1) Broadly, the measure of the effectiveness with which radiation causes detectable changes in a photosensitive material. (2) The number of electrons released per absorbed elemental particle of radiation (quantum), as in a photocell. (3) Similar to (2), except that the incident, rather than the absorbed, radiation is considered. (4) In photography, the number of silver halide grains made "developable" per incident (or absorbed) quantum. (5) In photography, the number of silver atoms finally generated per absorbed quantum.

quantum yield Number of affected particles (molecules, atoms, electrons) per absorbed elementary unit of energy, especially radiation. (The extension of this concept to include incident energy is to be avoided.)

quarter shutter In a motion-picture camera with variable shutter-blade setting, a position that gives an exposure time 25% that of the fully-open setting.

quarter-wave plate A slice of doubly-refracting material of thickness such that the two polarized rays are displaced in phase by 90°. Such plates convert plane-polarized light to circularly polarized light if they are at 45° to the entering beam.

quartz A transparent crystalline mineral used for some optical elements. Lenses, cells, etc., are usually, however, made of fused silica. Both quartz and fused silica, unlike glass, are valued for their transparency to ultraviolet radiation.

quartz-halogen (quartz-iodine, etc.**) lamp** A tungsten lamp, the filament of which is surrounded by an active (rather than an inert) gas, which is effective in prolonging lamp life and permitting higher operating filament temperatures. (Note that the color of the emitted light is little affected by the presence of the active gas, since the light is in fact emitted by the

quartz-halogen lamp

filament itself. Note also that the envelope is fused silica, rather than the mineral, quartz.)

quenching Reduction of phosphorescence or fluorescence. As an example, if infrared energy falls on a phosphorescing material, the intensity of the light may be reduced. The process has been used in some masking methods.

quenching tube A part of an electronic-flash-lamp assembly that diverts part of the supply of electricity and thus shortens the flash time and reduces the total output of light. The primary function of the device is to provide automatic exposure control. Compare with thyristor.

quickie A motion picture made with minimum effort and budget.

quick return Applied to a viewing mirror in a single-lens reflex camera that promptly goes back, after the exposure is made, to the viewing position, so that the photographer is only momentarily prevented from viewing the scene. Syn.: instant return.

RRR

R

rack (1) (noun) A toothed bar engaged by a pinion gear, used in focusing devices for enlargers and view cameras. (2) (verb) To move a lens or film support by equipment defined in (1), as in "rack out" a lens. (3) A frame or hanger on which film is wound or attached with clips for handling during processing. (4) With "over," a device on a camera permitting a viewfinder to occupy the position normally occupied by the objective lens, thus compensating for parallax.

rack-and-tank A processing method in which film is fastened to supports and immersed in a suitable container holding the processing bath.

rad A measure of the radiant energy absorbed by unit mass of a substance. 1 rad is equivalent to 100 ergs per gram (0.01 joule per kilogram). For x-rays, 1 roengten = 0.88 rad. The rad is sometimes used as a measure of the energy absorbed by a photographic material when the radiation has very short wavelength, or in the recording of high-speed subatomic particles.

radar photography Image recording from the face of a cathode-ray tube that displays patches of light related to objects on the ground or in the air.

radial (1) On a line outward from a reference point or center. In photogrammetry it is usually the intersection of the lens axis and the image. (2) In optics, a type of astigmatism that worsens the image of a series of concentric circles as they become progressively larger.

radiance A measure of the energy emitted by a surface of unit area into a unit solid angle (steradian). For light, luminance is the analogous term. Unit: watts per steradian.

radiant (1) Having to do with energy transfer by electromagnetic waves. Radiant energy includes radio waves, infrared, light, ultraviolet, x-rays, and gamma rays. (2) As applied to flux, intensity, etc., signifying the inclusion of all electromagnetic energy regardless of wavelength. Distinguish from "luminous," which implies only light, i.e., visually effective electromagnetic energy.

radiation (1) The process of emitting electromagnetic energy. (2) Electromagnetic energy of whatever wavelength.

radiation dosimetry The technology of estimating the accumulated level of short-wave electromagnetic radiation and of high-speed ions or other subatomic particles. One method involves the use of specially prepared photographic films, the developed density of which is a measure of the accumulated energy. The intent is to detect possibly harmful environmental conditions.

radiation temperature That temperature of a standard blackbody which causes it to produce the same total flux (output power) as a sample source, the two sources having the same area.

radiator A source of electromagnetic energy.

radiography The production of photographic images by means of x-rays or gamma rays, directly or by the interposition of a fluorescent screen. The latter process is also known as fluorography.

radiolucent Relatively transparent to x-rays or gamma rays.

radiometer (1) Any instrument used to estimate the level of electromagnetic radiation being received, i.e., the irradiance. (2) A globe containing air at low pressure and a set of vanes mounted so as to turn. Each vane has one shiny and one dark side. When receiving radiation, the dark sides are warmer than the shiny ones, and air molecules near the dark sides move faster, thus pressing against them, causing the set of vanes to turn. The instrument, although usually considered a toy, is a model of a measuring device.

radiopaque Having high relative absorption for x-rays or gamma rays.

radiophotography The production of images on sensitive materials by x-radiation.

rail Part of a camera support in the form of a rod or similar metal part, along which the lens board and back may be moved. Especially used in view cameras, which may have two rails or a monorail.

rain In motion-picture film, fine abrasions caused by cinching the film (pulling too tightly on the roll) and by repeated projection.

Raman effect A type of radiation scattering that is accompanied by a weak fluorescence.

Ramsden circle The exit pupil in visual instruments such as telescopes, measured as the diameter of the emergent focused disc of light. The magnification of the instrument is the ratio of the diameter of the objective lens to that of the Ramsden circle.

R and D Research and development, usually in the practical rather than in the theoretical sense.

random (1) Without detectable pattern, as of grains in a photographic image. (2) As applied to sampling, selection of items, etc., distributed in such a way as to ensure that each member of the population (entire set of items) has equal probability of being chosen. (3) Random access: capability of selecting any item of a group, as slides in a projector or frames of microfilm.

range (1) The difference between maximum and minimum values in a set of similar data. For example, temperature range. (2) The ratio of maximum to minimum values in a set of similar data. For example, luminance range of a scene. (3) The distance to an object of interest, as slant range in aerial photography.

rangefinder An optical device used to estimate the distance to a subject. Such devices commonly use movable mirrors or prisms to bring two images of the subject (each from a different viewpoint) into alignment. The required motion of the movable element is related to the distance. The motion may be translated, by way of a mechanical linkage, to the camera lens, so that when the images are aligned the lens is in the correct focal position. See coupled rangefinder.

rangelight An aid to focusing in poor illumination. Two spots of light are projected onto the subject; when they are made to superimpose, the lens is in the correct position. The optical arrangement is similar to a two-mirror rangefinder in reverse.

rapid-access General and loose term for any method of providing a photographic image for examination quickly after the sensitive material is exposed. Development in highly alkaline baths at high temperatures is a common method, allowing the production of images in a few seconds.

rapid-transport (1) Describing a lever on some still cameras that advances the film with one or two movements and typically cocks the shutter at the same time, making it possible to take a sequence of photographs in quick succession. (2) In motion pictures, a very fast pulldown produced by a claw mechanism.

rare-earth Identifying optical glass containing compounds of metals other than common ones such as sodium and lead, used for the manufacture of lenses and other optical elements.

raster (1) A systematic pattern of scanning, as in television; used also in transmitting photographs by wire, etc. (2) In three-dimensional projection or viewing, an arrangement of slits through which the proper image is presented to each eye of the viewer.

RAT formula The rule that when a surface is illuminated, the sum of the values for reflectance (R) and absorptance (A) and transmittance (T) must equal unity: $R + A + T = 1$.

rating See speed (3).

ratio Quotient, obtained by dividing one value by another. The lighting ratio is the factor by which the illuminance changes between two surfaces of interest. For example, if the lighting ratio is 3:1, there is three times as much illuminance on one area as on the other. The luminance ratio (often inaccurately called "brightness" ratio) is the factor by which luminance-meter readings change. For example, the average luminance ratio for outdoor scenes is about 160:1, meaning that the highlight has a luminance of about 160 times that of the shadow. A ratio is most clearly expressed by the use of a colon, as 1:2, but the same ratio may be written: 1 to 2; 1−2, or 1/2.

raw stock Unexposed film, especially motion-picture film.

ray In optics, a beam of light or other radiation of infinitely small diameter, represented by a line.

Rayleigh scattering The effect on light of small particles, such as those in the atmosphere. Short waves are affected more than long ones; thus the sky is bluish and the direct light from the sun, yellowish.

Rayleigh's criterion The smallest visually detectable resolution for an optically perfect system is 1/(wavelength x f-number). The rule is based on line images; for point images the numerator of the fraction is 1.22. (Note: Rayleigh's criterion, based on diffraction theory, is conservative. The geometry of the target in fact affects considerably the actual resolution, and Rayleigh's criterion should not be applied carelessly.)

RC Resin-coated. Identifying photographic papers treated so that they absorb little liquid during pro-

cessing. Thus, they may be washed and dried quickly, shortening the total processing time.

reaction shot In motion pictures, a scene in which one actor is shown responding to the words or action of another actor.

reader (1) A person who listens to a sound recording and measures the duration of sounds for later synchronization with the pictorial images. (2) An optical projection device for the examination of microfilm images. (3) A device that allows magnetic or optical sound recordings to be played back, thus permitting the marking of soundtracks for the preparation of cue sheets for animation or other purposes.

reader-printer An optical projection device that, besides permitting visual examination of microfilms, can produce enlarged copies.

reading The relative orientation of an image as compared with the original. A "right-reading" image resembles the original when viewed from the image side; a "wrong-reading" image resembles the original when viewed from the back.

readout The recall of stored information, as from a computer or from microfilm, in more usable form. A readout may be a display on a screen or cathode-ray tube, or "hard copy," i.e., a photographic print.

ready light A neon or other small light source on apparatus (e.g., electronic-flash units) to inform the user the apparatus is operational. Syn.: pilot lamp.

reagent (1) (noun) Any substance that takes part in a chemical action. (2) (adj) Applied to a chemical of a high degree of purity.

real (1) As applied to optical images, capable of being displayed on a surface, such as ground glass, film, etc. Such images are formed by convergent radiation, usually by positive lenses. Compare with virtual. (2) As applied to optical objects, involving divergent radiation. A real object in this sense may be a physical thing, or it may be an image formed by a preceding optical element. Compare with virtual. (3) With "time," almost immediate, as distinct from delayed. Television is a real-time image display system, whereas photographic images are at least to some extent delayed.

realistic Applied to photographs intended to portray "truthfully" the appearance of the subject photographed.

rear Identifying a behind-the-lens shutter. In motion-picture projectors, applied to a shutter placed between the light source and the lens system.

rear nodal point For an undeviated ray of light, the intersection of the emergent ray with the lens optical axis. Also called second nodal point. Focal and image distances are measured to this point.

rear projection Use of a translucent (rather than reflecting) screen for the display of optical images. In motion pictures, rear projection is the basis of process photography, a method of combining live action with filmed scenes. The projector is on the opposite side of the screen from the observer or recording camera. Syn.: back projection.

rear shutter A shutter, such as used in motion-picture projectors, placed between the light source and the lens system.

rebus layout An arrangement of photographs (or other images), typographic material, etc., in which the photographs are placed within the body of typographic copy, sometimes substituting for omitted words.

receding color A hue that is in the same physical plane as another but is perceived as being farther away. Blue hues are sometimes perceived as more distant than red hues at the same distance.

receptor General term for any device on which radiation falls and which responds to that radiation. Examples: photocells; photographic materials.

reciprocal (1) (noun) The result of dividing a number into unity. The reciprocal of 5 is 1/5, or 0.2. Photographic opacity is the reciprocal of the transmittance. If the transmittance is 40% (0.40), the opacity is 1/0.40, or 2.5. (2) (adj) Specifying a relation between two variables such that as one increases, the other decreases proportionally. For a constant exposure (H), the necessary illuminance (E) and time (t) are reciprocally related, since $E = H/t$.

reciprocity effect The experimental observation that equal exposures do not produce equal photographic images (densities and contrasts) if the time of exposure is unusually long or short (and the light level is correspondingly weak or strong). Syn.: reciprocity-law failure. (The term "reciprocity effect" is preferred by those who correctly think that a "law" should not fail.)

reciprocity law (failure) The law is a statement that the photographic response (usually density) will be constant if the quantity of light received by the photosensitive material is constant, regardless of the rate at which the energy is supplied. In practice, the reciprocity law implies that the density of the image will be the same at a camera setting of 1/1000 second at $f/2$ as at 1 second at $f/64$. The law does not hold in general for the developed image made by exposure to light; hence the term "reciprocity-law failure" (RLF). The practical consequence is that adjustments in camera settings and often development time need to be made whenever exposure times are unusually small or large, the adjustments being best determined by experiment. (It is a com-

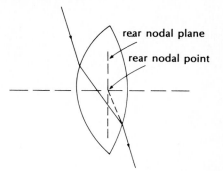

rear nodal plane (point)

rear nodal plane
rear nodal point

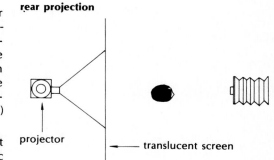

rear projection

projector

translucent screen

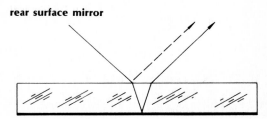

rear surface mirror

mon misapprehension that the defining equation, Exposure = illuminance x time, is a statement of the reciprocity law. The equation in fact defines photographic exposure, and in that sense never "fails.")

reclaim To make available for reuse, as silver from fixing baths and scrap photographic material.

recognition In visual perception, the ability of the observer to identify the stimulus. The observer must be able to see the details that distinguish one object from another, as a truck from an automobile. The Snellen chart, composed of letters of the alphabet, is one visual test involving recognition. Also see detection; localization; resolution (2).

recondition To clean and repair, for example, motion-picture films after projection. To restore used equipment to good working condition.

reconnaissance A military term for the act of obtaining information about terrain and the adversary's operation. Photography often plays a major role in such activity.

record (1) Generally, a photographic image, especially one intended for use in data analysis as compared with a pictorial image. (2) In color photography, a separation negative or positive, as red record. (3) A sound trace on film, tape, etc. (4) A written or graphic account of procedures, etc. (5) (verb) To make or prepare any of the above.

recording galvanometer In motion-picture sound recording, a device that responds to an electrical signal from the microphone and amplifier, and exposes the film soundtrack by reflecting a beam of light from a movable mirror.

recording head The device that applies an audio (sound) signal to film or tape in sound recording.

recovery time That interval needed for a photographic device to come back to a state of readiness after having been activated. In an automatic slide projector, for example, the time interval after advancing a slide before the next slide can be brought into position.

rectification In printing a negative or positive transparency made other than perpendicularly to the important subject plane, to arrange the projection system so that the image appears in correct perspective. Used especially in mapping.

rectifier An electrical device that produces a direct current from an alternating current. Rectifiers are used in charging batteries, such as are used for electronic-flash power supplies.

rectilinear (1) As applied to a lens, reproducing straight lines in the subject as nearly straight lines in the image. Relatively free of optical distortion. (2)

As applied to functional relationships (graphs), involving a straight line. Linear.

recycle (1) (verb) To reuse, as air for drying film, or water for washing photographic materials. (2) (adj) As applied to electronic flash, specifying that time needed for the electrical system to reach the required level of charge after use.

red (1) As applied to a hue, associated with long spectral waves, beyond about 650 nm. (2) As applied to a filter, having major absorptance for short and middle wavelength of light, i.e., from about 400 to 600 nm. (3) One of the three primary additive colors.

red blindness A type of defective color vision, properly called protanopia.

red dot A setting for infrared photography on some lens-focusing scales. Because most lenses are not corrected for the long wavelengths of infrared, an adjustment from the normal lens position for focusing light is needed for accurate focusing of infrared rays.

redevelopment In processing reversal photographic materials, a stage during which silver halide that has been exposed or chemically fogged during the process is converted to silver. Such a stage is also used in some toning and chemical-intensification processes.

red eye In flash and electronic-flash photography, a pink appearance of the pupils of persons or animals in color photographs, or unusually light pupils in black-and-white photographs. Red eye is caused by light reflected back from the retina when the light source is near the camera axis, and may appear because the iris of the eye, open for the ambient light, does not have time to adjust to the sudden brilliance of the flash.

red-green blindness A type of defective color vision, involving the inability of the person to distinguish hues of red from green.

redox potential (Same as reduction-oxidation potential or reduction potential.) Measure of the tendency of an electrical current to flow between two electrodes placed in a solution in which a transfer of electrons may occur between two different chemicals. The chemicals may be a developing agent and silver bromide, in which case the redox potential of the developing agent may be found. No simple relationship exists between redox potential of a developing agent and its usefulness in a practical situation.

reduce (1) In photographic printing, reproduction photography, etc., to make an image smaller than the original. Example: making 16mm motion-picture prints from 35mm originals. (2) To lower

image density (usually with accompanying loss in contrast) by chemical methods. (3) To lower the viscosity of a substance by adding solvent. (4) To convert the exposed silver halides in an emulsion to metallic silver by chemical means. Syn.: develop.

reducer A chemical bath which is used to remove silver from a processed negative or positive, to lower its density. Example: Farmer's reducer (potassium ferricyanide and sodium thiosulfate mixed in solution). Since the bath removes electrons from the silver, it functions chemically as an oxidizer.

reducing As applied to a lens, negative, i.e., producing a small virtual image from a real object. See reduction lens.

reduction (1) The opposite of magnification. The scale of reduction is the ratio of a linear dimension in the object to the corresponding dimension in the image. If the scale of reduction is 2X, the scale of reproduction is 1/2. (2) A chemical method of removing silver or dye from a processed image. In negatives, the result is decreased density and usually lowered contrast. In positive prints and transparencies, the method is used to make highlights lighter. (3) In chemistry, gain of electrons, as by silver ions converted to metallic silver during development. (Note that definitions (2) and (3) above are chemically opposite in nature.) (4) Preceding "potential," same as redox potential.

reduction lens A negative (divergent) optical device that produces an image smaller than the object. A reduction lens is a component of many camera viewfinders; also used, for example, by artists to see how a drawing will reproduce in a smaller format.

reduction print In motion pictures, a smaller (e.g., 16mm) positive made from a larger (e.g., 35mm) original.

reel (1) A support on which processed motion-picture film is wound. (A spool is a reel that has light-tight flanges to protect unexposed film from accidental exposure to light.) (2) A measure of motion-picture-film length, corresponding to the length that can be wound on an ordinary support. (3) A device to hold roll film during processing, typically two spiral tracks made of stainless-steel wire or plastic: each track holds one edge of the film. Some are adjustable for films of different widths.

re-expose In processing a reversal photographic material (e.g., color transparency), to cause uniform radiation to fall on the material after the development of the first image. The purpose is to make the silver halide not previously exposed developable in order to form the final positive image. (Chemical fogging agents are now often used as a substitute for re-exposure.)

reference (1) A motion-picture print that has been approved for quality by the director and producer. (2) A standard color print kept as an aid to judging color balance of production prints.

reference beam In holography, that radiation which falls directly on the photosensitive material, as contrasted with the beam that is first directed onto the subject and then to the material.

reference white In television, a neutral object having a reflectance of about 0.6 and placed in the fully lighted portion of a scene. Such an object is useful in monitoring the output of the system. For good reproduction, film for television should reproduce such a white at a density of 0.3-0.4.

reflectance Reflection factor.

reflectance meter Misnomer for luminance meter. (Reflectance factor is the ratio of reflected to incident light; such a ratio is not measured by the so-called reflectance meters.) Syn.: Reflected-light meter.

reflectance ratio The extent to which subject areas vary in their ability to reflect light. A white surface may have a reflectance factor of 0.8 and a dark surface one of 0.1. The reflectance ratio would be 8:1. Distinguish from luminance ratio (often called "brightness" ratio), which includes the lighting ratio in addition to the reflectance ratio.

reflected-light (exposure) meter Preferred term: luminance meter. A light-measuring instrument with a restricted angle of acceptance. The reading is proportional to the luminance (intensity per unit area) of the source of light, whether it emits or reflects light. A spot meter is a luminance meter with a very narrow angle of acceptance. See exposure meter.

reflection Deviation of energy at a boundary between two different materials, such that the direction of the energy flow changes but the energy remains in the first material. See diffuse (1) and specular (4).

reflection density Logarithm of the reciprocal of the reflection factor (reflectance), often with reference to the reflectance of the base as 1.00. Used for describing print tones, i.e., changes in lightness without regard to hue.

reflection factor ($|\rho|$) (1) The ratio of energy, usually light, returning from a surface to that falling on the surface, expressed as a decimal fraction or a percentage. (2) Operationally, the ratio of energy returning from the surface of a sample to that returning from a reference surface, as measured by a specific apparatus. In photographic applications, the reference is often the base of the photographic printing material. (The term reflection factor is now

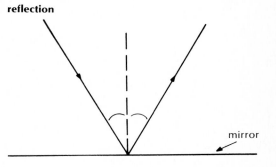

reflection

mirror

recommended instead of the more usual reflectance.)

reflectivity Limiting reflection factor for a colorant layer so thick that additional thickness makes no change in reflectance.

reflector A device used with light and radiation sources to direct the energy by reflection in the desired direction. In film and slide projectors, a reflector is used to direct light back to the lamp, from which position the light is imaged by the condenser lenses at the projection lens. Reflectors are also used with studio lights and flashbulbs, etc., to illuminate the subject appropriately.

reflector flood An incandescent lamp with a built-in mirror so designed that the lamp illuminates a relatively wide field, as distinct from a reflector spot.

reflector spot An incandescent lamp with a built-in mirror so designed that the lamp illuminates a relatively narrow field, as distinct from a reflector flood.

reflex (1) As applied to a camera, fitted with a 45° mirror (and/or a prism) and a ground glass or equivalent to permit observation of the image. (2) Specifying a method of contact printing, used especially in office copiers. Light or other radiation falls first on the back of the sensitive material, passes through it, and falls on the original. The energy reflected from the original varies with the reflectance of the different areas. The method is necessary for copying originals without a camera when there may be writing, etc., on both sides of the original.

reform To make fit for use capacitors (condensers in electronic-flash units) that have deteriorated due to standing idle for a long time. A few alternate charges and discharges are required.

refraction That behavior of light rays associated with a change in velocity when there is a change of optical medium. All rays except those perpendicular to the surface between the two media will be deviated, i.e., changed in direction. Lens designers use refraction as the basis for most of their work, computing the necessary surface curvatures and separations as well as the types of glass, etc., to be used in the manufacture of the lens.

refractive index See index of refraction.

regenerate To make fit for reuse, as a processing bath. Fixing baths, for example, may be regenerated by the removal of silver, the addition of hypo, and adjustment of the pH.

region Section or part, especially of the D-log H (D-log E) curve, as in toe region, straight-line region, region of underexposure, etc.

register The correspondence of copy or images with the desired position for them, especially applied to superimposed successive images, as in dye transfer, photomechanical reproduction, and microelectronics.

register marks Fine lines, often crosses, outside the image area, used to detect the failure of successive images to superimpose.

register pin A protruding part of a printer, processor, camera, etc., that fits into a film perforation, aiding in correct placement of the film.

regression (1) As applied to the latent image, decay with time. (2) In statistics, a computed functional relationship between input and output variables. A line of regression may be computed for a single input variable, or a plane or curved surface for two input variables. The method may be extended to more complex situations.

rehalogenization Chemical change of silver to silver halide, used in some color processes, etc.

rehearsal A practice session for actors, crew, etc.

relative aperture The quotient of the lens focal length to the effective aperture (diameter of the entering beam of light that passes through the lens). Syn.: f-number, e.g., f/5.6. Lenses of the same relative aperture are said to have the same speed; i.e., they produce images of essentially equal luminance. The relative aperture affects exposure, depth of field, depth of focus, and image quality. See f-number.

relative humidity (RH) The relation between the concentration of water vapor present in a gas (especially air) to the maximum that could be present at a given temperature. The relation is of importance in photography because it is a factor in keeping qualities of photographic materials and latent images, and because it affects physical properties such as brittleness, curl, and dimensions.

relative log H (E) In sensitometric testing, input data (log exposures) in circumstances in which the actual exposures are unknown but the relationship between exposures is known. Relative data may be obtained by the use of a transmission or reflection gray scale, or from subject luminance measurements. (Note that in this context the logarithm is usually to the base 10, and that thus the mathematical expression is properly relative \log_{10} H.)

relay lens An optical element used normally at 1:1 scale of reproduction, often in a series of lenses, as in apparatus for the medical photography of body cavities, etc.

release (1) A document signed by a model (or parent or guardian) permitting the photographer to sell or publish photographic images of the model. (2) In motion pictures, identifying a completed negative or

refraction

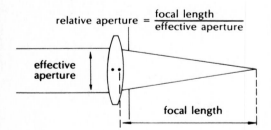

air
glass

relative aperture

$$\text{relative aperture} = \frac{\text{focal length}}{\text{effective aperture}}$$

effective aperture

focal length

set of sound-and-picture negatives ready for making final prints. Also, motion-picture prints prepared for exhibition. (3) The device (lever, button, etc.) that trips the shutter of a still camera, as in cable release, etc.

relief (1) A photographic image consisting of raised portions, as in some dye-diffusion processes. (2) Preceded by "bas-," an image obtained by slight misregister of negative and positive images of the same subject, giving the impression of sculpturing. (3) In photomechanical reproduction, letterpress.

Rembrandt lighting Three-quarter portrait lighting in which the shadow side of the face is toward the camera, resembling some portraits painted by Rembrandt van Rijn.

rem-jet Antihalation film backing containing carbon, requiring mechanical methods of removal after processing.

remote control Electrical or other means of operating a camera, projector, etc., located at a distance from the operator.

render To reproduce or simulate, as in the terms "tone rendering," "color rendering," etc.

rep Representative. (1) An agent who handles the business affairs of a photographer, usually on a commission basis. (2) An agent for a photographic or other manufacturer, e.g., sales rep, tech (technical) rep.

repeat In animation, a series of drawings made so that the last joins with the first. By shooting the series over and over, an action can be prolonged for any desired footage. See loop (2).

repeated identity A type of continuity for a motion-picture, filmstrip, picture series, etc., in which a common element (e.g., an antique automobile) is represented in each scene or photograph.

repeating back On a view camera, a film holder or plate holder used to make several small images on a large piece of photographic material. A slide containing an aperture is placed successively in different positions in front of the film, or the film is moved to different positions behind a fixed aperture.

replacement (1) A method of animation in which one cutout or object is substituted for another. When puppets are used, facial expressions may be changed by replacement heads, each with a slightly different phase of the expression that is desired. (2) A short length of motion-picture film inserted as a substitute for a damaged portion of an existing print.

replenish (1) To add chemicals in solution to a processing bath, especially a developer, to compensate in part for the changes produced when the bath is used. (2) In electrophotography, to add a concentrated mixture of toner and carrier to replace that used up in the process.

replenishment A method of counteracting the changes that occur in processing baths (especially developers) with use, and to keep the baths at a controlled level of ingredients.

report In motion pictures, a sheet prepared by the assistant cameraman, indicating to the film laboratory what is to be printed.

reportage "Objective" journalism. Photoreportage is intended to represent a situation or event truthfully and without bias.

reproducing head That part of a sound-reproduction device which detects a magnetic field, as distinct from a recording head and an erasing head.

reproduction (1) Generally, the act of forming an image from an original, as by a photographic or mechanical method. Also, an image formed by such a method. (2) Preceded by "tone," the relation between the luminances of an original and the luminances of an image, usually in the form of a graph.

reproduction gamma (1) The slope of the straight line of a graph in which the log luminances of the final image (print or transparency) are plotted against the corresponding terms for the original subject. (2) The product of the straight-line slopes of the factors that affect the reproduction of log luminances, such as camera flare, negative material, printer optics, print material, etc. Thus, $\gamma_r = \gamma_c \times \gamma_n \times \gamma_{po} \times \gamma_p$, the subscripts indicating the various factors. (Note: The concept of reproduction gamma has only limited usefulness because many factors are not linear, and because straight-line reproduction does not assure pictorially pleasing images.)

reprography (1) "The technology of producing and reproducing visual communications in an in-plant operation." *Graphic Arts Progress,* May 1969. (2) A process of making multiple copies of an original, usually in an office or in engineering-drawing reproduction, etc., by a relatively simple method, as contrasted with the relatively complex methods used in commercial photomechanical reproduction.

rerecording Transfer of sound from one tape, film, or disk to another, in order to combine several records into one, or to make desired changes in sound level or sound quality.

research file See swipe file.

reseau Fine grid, formerly used in screen color processes (now obsolete). The term is now used to identify a similar grid used for measurement purposes.

resection In photogrammetry, the determination of the camera location and orientation with respect to the subject of the photograph.

resolution

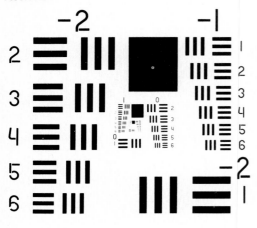

reticulation

M. Ornstein

residual (1) Remaining, especially applied to hypo or other chemical substances left in a photographic material after processing. (2) A continuing fee paid to actors, etc., for the use of a film or tape after its initial use, as in reruns of television films.

resist Any coating applied to a substrate (base) that protects it from chemical action, as in etching. Photosensitive resists are used in the fabrication of microelectronics and in photomechanical reproduction processes. See photofabrication.

resolution (1) The result of an experiment in which a target consisting of groups of adjacent light and dark lines is imaged and the closest visually distinguishable set is determined. The unit of measure is lines per millimeter (l/mm), in which a "line" is a light-dark pair of elements. As so measured, the resolution is dependent upon every significant factor in the experiment, such as target contrast, optics, photographic material, and conditions of observation. (2) In visual perception, the reciprocal of the angular separation between two elements of a test pattern when they can barely be seen as separate. Resolution is one aspect of visual acuity. Also see detection, localization, and recognition.

resolving power The ability of a lens or photographic material, etc., to reproduce adjacent close elements (usually lines) as separable. Resolving power, measured in lines per millimeter, is found in an experiment in which what is being tested is the limiting factor. For example, if the resolving power of a lens is to be found, the other factors in the experiment must affect the measured resolution insignificantly. See resolution.

resonance (1) The property of absorption of only a narrow band of wavelengths. Sodium vapor absorbs from a continuous spectrum only the wavelength(s) the vapor would generate at a higher temperature. Dye molecules absorb a limited wavelength range by resonance. The concept is important in the theory and technology of dye sensitization of photographic emulsions. (2) In sound reproduction, reverberation, as from a speaker enclosure or room with sound-reflecting surfaces.

response (1) General term for the output from a receptor, such as current from a photocell. (2) For photographic materials, often density of silver, dye, etc., or "speed," which see under definition (3). (3) For human beings, a reaction to a stimulus.

responsivity For a radiation detector (photocell, film, etc.), the signal output for unit power input. A cyclic signal is implied, the power being a root-mean-square value. Responsivity varies with the frequency of the signal, and the value is unaffected by the noise level.

restitution In photogrammetry, the determination of the location of object points from the photographic record.

restoration The process of improving the appearance of faded, stained, or otherwise damaged images by retouching, copying, or other methods.

restrainer A chemical that reduces the rate of development. Antifoggants are restrainers that are useful in practice to reduce the rate of fog formation selectively, as compared with the rate of image formation. Potassium bromide is the commonest example.

retake In motion pictures, to rephotograph a scene, or to remake a sound record.

reticle (1) In an optical system, a measuring scale or other pattern that is superimposed on the image or is seen projected onto the subject. (2) In motion pictures, a screen on which the field of view is marked, such as Academy aperture, TV cutoff, etc.

reticulation Small-scale random wrinkling of the emulsion, usually caused by abrupt changes of temperature during processing. Reticulation is sometimes induced deliberately for pictorial effect, but is rare with modern well-hardened emulsions.

retina The inner lining of the back of the eye, containing light-sensitive elements (rods and cones).

retinal A substance, formerly known as vitamin A, which combines with a protein to form rhodopsin (visual purple), the photopigment in the rods of the retina.

retinal rivalry The alternation of the dominance of one eye over the other, typically occurring at a relatively constant frequency. For most persons, one eye dominates the other, but nevertheless a shift occurs from the left to the right eye and back again.

retouching The technique of modifying a photographic image by manual methods of adding colorants, by abrading or bleaching the image, or by airbrushing.

retractable Applied to a pilot pin in a motion-picture camera or printer that is made to enter the perforation as the film comes to rest and is withdrawn just before the film is moved to the next frame. Opposed to a fixed pilot pin, onto which the film must be placed.

retrieval General term for any technique of locating stored photographic information.

retrofocus Specifying a type of lens design in which the distance from the rearmost lens surface is considerably larger than the effective focal length. Inverted telephoto. Such a design is used for some lenses of short focal length and wide angle on single-lens reflex cameras, so that the lens will not interfere with the movement of the mirror.

reuse fee In advertising photography, an additional charge made for a photograph, the reproduction of which is not limited to the time or other conditions specified by the photographer in the original agreement. Contrast with one-time use.

reverberation The continuation of a sound by multiple reflections (echoes), sometimes deliberately introduced for effect in a sound recording, either by acoustical or electronic means.

reversal (1) Identifying a type of film, paper, or process by which positive images are made directly from a scene or a positive original, as distinct from negative-positive and nonreversal. Chemical reversal processing generally consists of the following sequence: image exposure, development, bleaching, uniform re-exposure or chemical fogging, second development (redevelopment), fixation, washing, drying. See Albert effect. (2) An image resulting from extreme overexposure, i.e., solarization. (3) Applied to exposure effects whereby a second exposure reduces the effect of a previous imaging exposure. Examples: Clayden effect; Herschel effect; Sabattier effect.

reverse (1) An image in which the dark tones of the original are reproduced as light, and conversely. Syn.: negative. (2) In photofabrication, etc., an image that when viewed from the image side is a mirror image of the original. Also called "wrong reading." (3) In motion pictures, to run the film in the camera or projector opposite to the normal direction. Reversing is used in cameras for intentional double exposures, fades, etc., and in projectors to permit viewing a part of the film more than once without rewinding and viewing the entire film again. Also see reverse action.

reverse action A special effect in motion pictures, usually intended to be humorous, secured by running the film in the projector in a direction opposite to that in the camera. Reverse action may be obtained by actually running the camera backwards; or by holding the camera upside down with the film running forward (practical only when using double-perforated film); and by optical printing.

reverse angle In motion pictures and television, a change in the camera viewpoint opposite to that of the preceding shot, as in showing the second person in a face-to-face dialog.

reverse polarity The result of an exchange of electrical terminals. In television, the use of reverse polarity can make a negative produce a positive image, and conversely.

reversible Identifying a camera back (film support) that may be placed on the camera with the longer dimension in either a horizontal or a vertical position. Distinguish from revolving back.

reversibility In optics, specifying the principle that if a refracted or reflected ray of light is reversed in direction, it will retrace its original path. A drawing of light rays throughout an optical system may be reversed. The principle may be applied to photographic images and objects. See conjugate.

revolving Identifying a camera back (film or plate support) that can be rotated without being removed from the camera to obtain either a vertical or horizontal format. A 360° revolving back (fully-revolving back) can be used in any intermediate position. Distinguish from reversible (back).

rewind (1) To return motion-picture film, a length of still film, magnetic tape, etc., to its original support, such as a reel, cassette, etc. Used in terms such as rewind knob. (2) One of a pair of spindles with cranks held on a support, used to transfer motion-picture film from one reel to another.

RH Relative humidity.

rheostat A variable electrical resistor used to control lamp intensity, motor speed, etc. Distinguish from variable transformer, which performs similar functions by varying voltage instead of resistance.

ρ (Greek letter rho) Internationally-accepted symbol for reflection factor (reflectance).

rhodopsin Preferred term for visual purple, the photosensitive pigment in the rods of the retina.

rhythm In a subject or photograph (or other image), the more or less regular repetition of a design element, intended to convey a visual impression analogous to the beat in music.

ribbon matte (mat) An adjustable set of thin metal bands used to mark out in a viewfinder the area being recorded.

rice A size of crystal, especially of hypo (sodium thiosulfate), resembling the cereal.

Ricco's law In visual perception, for small angles of view the stimulus luminance for threshold perception is inversely proportional to the area of the stimulus. The law applies to areas of the retina outside the fovea and to the dark-adapted eye.

ride In motion pictures, a drift or unsteadiness of one image with respect to another when double exposures have been made. Ride is often seen in titles superimposed on a background scene.

rigging A general term for the devices used on a stage set for handling scenery, lights, etc. Rigging includes framework, pipe racks, ropes, sandbags, etc.

right-angle attachment A mirror or prism, at 45° to an optical axis, used to change the orientation of an

rhythm

W. Billings

rim lighting

E.A. McGee

roof prism

image, as in an overhead projector or in some projection printers. The device is also used on cameras, for purposes of candid photography, to permit the photographer to appear to be aiming in a direction other than that in which the photograph is being taken.

right reading Specifying an image that resembles the original in orientation when viewed from the image side (but that is reversed when seen from the rear).

rim Applied to a type of back lighting in which the subject appears to be outlined with light.

ring Applied to a type of "shadowless" lighting. A group of lamps may be arranged in a circle about the camera-lens axis, or an annular (ring-shaped) lamp (fluorescent, electronic flash) may be used.

ringaround A set of tests, in which selected factors are varied in all possible directions from a starting point. Examples are in the use of several different color-correction filters in color printing and the use of different paper grades and exposure times in black-and-white printing.

rinse A brief treatment of photographic material in a liquid during processing. A water rinse may be used to reduce contamination of a following bath, or as a substitute for a thorough wash in rapid processing. An acid rinse (stop bath) may be used to stop the action of a developer preceding a chemical treatment (typically, fixing).

ripening In the manufacture of silver halide emulsions, holding them at an elevated temperature after the precipitation of the silver halide crystals. Syn.: digestion. Physical ripening (Ostwald ripening) occurs before the emulsion is washed in the presence of a solvent for silver halide; during this digestion the average grain size increases, and the size distribution changes. Chemical digestion, after washing, occurs in conditions that permit the formation of silver sulfide, metallic silver, and frequently gold, thus increasing sensitivity with little change in grain size. (In some formulas much physical ripening takes place during precipitation.)

ripple dissolve A special effect in motion pictures, by which one scene is replaced by another with a wave-like motion. Often used as a transition to or from a dream sequence, or from the present to the past and vice versa.

riser A low platform used on a set to elevate a performer, model, or prop.

rising (front, or back) Often, rising-falling. On a view or other camera, an adjustment permitting the photographer to raise or lower the film support, or the lens holder. By a change in the relative positions

of the lens and the film, the photographer can modify composition, reduce the need for cropping the negative, and reduce or eliminate the convergence of vertical lines in the image.

RLF See reciprocity law (failure).

rms Root mean square.

rocking The technique of agitation of the tray during processing of sheet film, plates or prints by lifting and lowering its sides and ends. The standard method of agitation for such processing. (See ANSI Standard PH4.29-1962.)

rod A light-sensitive element in the retina, responsive especially at low light levels but without hue discrimination. Distinguish from cone.

roentgen (1) (adj) Identifying electromagnetic radiation shorter in wavelength than ultraviolet and longer than gamma rays; x-rays. (2) (noun) The unit of measure of such radiation, based on the extent of ionization of air under standard conditions.

roll (1) Applied to film, paper, and magnetic tape in long strips, wound on a spool, reel, etc. (2) (verb) The command of the motion-picture director to the camera operator to begin filming.

roller blind A type of focal plane shutter.

roller gate In a continuous motion-picture printer, a method of ensuring contact between original and print material by the use of smooth rotating metal cylinders that minimize scratching.

roller In motion pictures, a series of titles or an explanatory text, usually of considerable length, that moves upward and off the screen at the top.

roller transport In automatic processing, the use of rotating cylinders to move film and paper through the process, simultaneously providing agitation. Syn.: friction drive (2).

roll number (1) A means of identifying a portion of a motion picture. In the film cutting room where the camera original or work print is broken down into separate scenes and takes, each roll is assigned a number for ease in retrieving any desired take. (2) In still photography, one means of identifying and filing negatives and transparencies.

roof Applied to a type of prism with inclined planes (flat surfaces) that produces a double inversion of the image. Used in reflex cameras to produce an image of correct orientation as seen in an eye-level viewfinder. See pentaprism; Porro prism.

room tone The characteristic basic sound of a motion-picture set, recorded at the conclusion of a session for use in spacing out dialog with silence.

root mean square An average value that is geometric rather than arithmetic. A root-mean-square value is

found by squaring a set of numbers, averaging the squares, and then taking the square root. Standard deviation is such a value, as is Selwyn granularity.

ROP Run of press, applied to newspaper color printing.

Ross effect Changes in size and location of small adjacent images associated with tanning of gelatin, caused by strains in gelatin produced by the tanning action of developers.

rotambulator A motion-picture dolly that permits rotation of the camera platform in a small arc.

rotary A camera used for the recording of documents, etc., in which the original is in motion during exposure. Compare with planetary, a similar camera involving documents at rest during exposure. Syn.: flow camera.

rotating-mirror (prism) camera A photographic apparatus that incorporates a turning reflecting or refracting element, the motion of which compensates for the image motion that would otherwise degrade the record.

rotogravure Photogravure (which see) involving cylindrical printing plates.

rotoscope In animation, to use the camera as a projector in order to make accurate tracings of previously photographed drawings for the preparation of traveling mattes, etc.

rough cut In motion pictures, an early stage in the editing process in which sequences are assembled in approximately the final form.

rough-in In lighting a set, the approximate placement of lamps, to be refined later.

Royal Photographic Society of Great Britain (RPS) A worldwide association of photographers.

rubber cement An adhesive used for the temporary mounting of prints or fastening of paper, etc. It is unsuitable for the permanent mounting of photographic prints, since it deteriorates and causes stains.

rule of thirds In composition, the principle that the most effective division of a dimension is in a 1-to-2 proportion. For example, according to the rule, the best placement of a horizon line in a photograph is one-third of the distance from the bottom or top.

run (1) In motion pictures, one pass of the film through the camera. A double run would involve a double exposure. (2) In a statistically designed experiment, one test at a single treatment combination. Nine runs are needed to complete an experiment in which each of two factors is tested at three levels, i.e., 3^2. See ringaround.

runner A part on a view camera, etc., that is attached to and moves along the bed, supporting the front or back of the camera.

running gag A humorous incident that is shown repeatedly in several scenes of a motion picture.

running shot In motion pictures, a scene photographed by a camera moving with the subject.

running time In motion pictures and television, the number of minutes needed to project a given production.

running zoom In animation, an approach to the artwork with the camera in continuous operation, as contrasted with a frame-by-frame exposure.

runout In motion pictures, unused film footage in the camera or projector that is made to pass through the equipment to finish the reel.

run-through In cinematography, a rehearsal.

runup Film or tape in a motion-picture camera, printer, etc., that is used to bring the mechanism up to proper speed.

rush (print) In motion pictures, a positive image made from each day's production for evaluation purposes. Syn.: daily.

SSS

S

S (1) Short, applied to films intended for use at relatively short exposure times. (2) Slow, identifying a flashbulb that reaches its peak output in about 25 ms (thousandths of a second) as compared with M (medium) and F (fast) which peak at shorter times.

S_v (1) American National Standard Speed (Logarithmic). (2) Speed Value, as used in the APEX system of exposure determination.

S_x American National Standard Speed (Arithmetic).

Sabattier effect Partial image reversal associated with the following sequence: primary exposure, partial development, fogging exposure, continued development, followed by completion of processing. Distinguish from solarization, which involves reversal caused by very great exposures.

saccadic Describing relatively large and rapid motions of the eye, associated with different points of fixation while a scene (photograph, etc.) is being examined.

safe area In motion-picture films for television, that portion of the frame which will be seen on the majority of television receivers. The safe action area is specified as 90% of the width and height of the total transmitted area, the safe title area as 80%.

safelamp (light) A light source for areas where photosensitive materials are handled, of a color that will have little effect on the material. A yellow filter is used for blue-sensitive emulsions (such as ordinary photographic papers) because the yellow filter absorbs the blue light from the bulb. A red filter is used for orthochromatic materials, which are insensitive to red light. For panchromatic materials, no color of light is really safe, but a dim green light is sometimes used because the eye is highly sensitive to green light.

safety (1) A film base that ignites with difficulty and burns slowly. (2) Applied to a shutter on a motion-picture projector that closes when the film stops moving, thus preventing heat damage to the film.

safety coating On flashbulbs, a covering of lacquer, etc., that prevents shattering of the glass envelope if it should break.

safety shot A photograph made as insurance against loss of or damage to another. Syn.: insurance shot.

SAG Screen Actors Guild.

sagittal (pronounced saj'i-tal) (1) In optics, specifying a fan of light rays that intersects the lens in a line perpendicular to a plane containing the lens axis and the object point. (2) Identifying one of the two line images formed by a lens having astigmatism. Each point of the line is formed by a fan of rays as in (1). The sagittal line image is parallel to a line drawn from the center of the image to the margin. Compare with tangential.

salon An exhibition of photographs, often competitive, typically devoted to pictorial photographs by members of camera clubs, etc.

salt effect An increase in developed density when unreactive chemical substances, such as sodium sulfate, are added to the developing bath. The cause of the density increase is thought to be a change in the electrical charges on the gelatin of the emulsion.

sample (1) In motion pictures, a print that is made for approval or to see whether changes in print exposure are needed. (2) In statistics, a portion, selected for examination, usually from a much larger lot (the population or universe). Examples: part of a developing bath taken for analysis; sections of a production roll of film used for testing. One of the major aims of applied statistics is to make valid inferences about the population from sample data.

sandbag Part of the rigging on a motion-picture set, consisting of a canvas sack filled with sand. It may be used as a counterweight to stabilize a top-heavy prop, etc.

sagittal

axis · object · lens · ray intersection · image

sandwich Informal term for two or more negatives superimposed for double printing, which see; also two or more transparencies superimposed for viewing or projection.

sans serif Applied to typefaces in which the characters have no thin strokes finishing off the main elements.

saturated (1) As applied to a solution, containing the maximum possible amount of dissolved material under the given conditions. (2) As applied to a gas, especially air, containing all the water vapor possible at the given temperature and pressure. At 100% relative humidity. (3) As applied to a color, vivid. Opposite of gray or washed out. Fire engines are usually painted a saturated red. (4) As applied to a phosphor, especially in a television receiving tube, at maximum brightness, such that additional energy will cause no increase in light output.

saturation (1) That aspect of color which distinguishes a perception from a gray of the same lightness; vividness. Spectral colors have maximum saturation; grays have zero saturation. Syn.: chroma. (2) The condition of maximum content, applied to a solution. At saturation, no more of a soluble chemical can be made to dissolve in a solution in the presence of undissolved chemical. At saturation, the relative humidity of air is 100%.

save 'em On a motion-picture set, a command to the electrician to turn off the lights.

scale (1) The ratio of exposures, or range of log exposures, to which a photographic material responds. A soft photographic paper has a long scale in this sense. (2) The range of tones (densities) that a photographic material can produce. A glossy photographic paper produces a long scale in this sense. (3) Preceded by "gray," a set of tones often used for test purposes. A reflection gray scale may be included in a scene as a standard test object. A transmission gray scale is most often called a step tablet, or "step wedge." (4) The ratio of a linear dimension on a photograph to the corresponding dimension in the subject. Scale of reproduction.

scale down To reduce in size, as, in optical printing, to scale down 35mm to 16mm.

scale index The log-exposure interval required to cause a photographic paper to produce defined minimum and maximum densities. The scale index is roughly inversely related to paper-grade number: soft papers (grades 0, 1) have large scale indexes; hard papers (grades 4, 5) have small scale indexes. To a first approximation, the scale index should equal the negative contrast for the production of a good print.

scale of reduction The reciprocal of the ratio of a linear dimension in the image to the corresponding dimension in the subject. A scale of reduction of 10X means that the image is one-tenth as large as the subject.

scale of reproduction Ratio of image dimension (linear) to the corresponding dimension in the subject.

scan To examine an image systematically by eye or with a small spot of light or other radiation. Pictorial images are scanned in television and in facsimile transmission by telephone or wireless. Sound images on film are scanned in the reproduction of sound. Scanning is sometimes used in the production of photomechanical plates.

scanning point The aperture on a continuous motion-picture printer.

scattering Diffusion of radiation, especially light, by reflection from small particles or other structures. Scattering accounts for the presence of skylight, and is important in density measurement. Some photographic images consist of tiny bubbles that scatter light (see vesicular).

scenario In motion pictures and television, the outline of a play or other story.

scene (1) The subject matter of a photograph, usually implying a broad aspect, as in outdoor photography. (2) In motion pictures, a shot, i.e., a single run of the camera.

scenery (1) Especially in outdoor photography, the overall appearance of a place. (2) On a set, flats, drapes, etc., as distinct from furniture and properties.

scene tester In motion pictures, a printing apparatus used to make short test lengths under different exposure conditions, to determine the correct exposing light level (or time) and color balance.

Scheimpflug rule In imaging an object plane that is not perpendicular to the lens optical axis, maximum sharpness is obtained when the planes of the object, lens, and film (etc.) intersect in a single line.

Schlieren Identifying an optical system sensitive to small differences in the index of refraction (or thickness, etc.) of the medium. Most Schlieren systems use a pair of mirrors and two knife-edges so placed as to intercept almost all the light. Slight differences in air temperature or pressure cause sufficient change in the light passing through the system to form an image. Such a method is used in the photography of airflow around objects.

Schmidt Identifying a mirror optical system of relatively great aperture and angle of view, especially used in astronomical photography and for the projection of television images on a large screen.

scale index

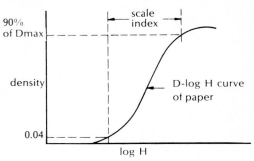

scale index

90% of Dmax

density

D-log H curve of paper

0.04

log H

Scheimpflug rule

subject plane

lens plane

film plane

line of intersection

Schlieren photography

R. Palum

Schmidt system

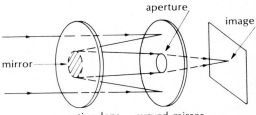

aperture

image

mirror

correcting lens curved mirror

Schufftan process A method of making a composite motion picture. A mirror is used to reflect portions of the set; in places the silver is removed to allow other parts of the scene to be photographed directly. A special form of glass shot, which see.

Schumann Identifying a type of silver halide emulsion with so little gelatin that the surface silver halide grains are nearly bare of gelatin. Such emulsions are used in photography using shortwave ultraviolet radiation which would be absorbed by the gelatin in ordinary emulsions.

Schwarzchild's law Developed density is a constant if the term $E \times t^p$ is a constant (where E is the illuminance, t the exposure time, and p a value approximately 0.8). The "law" was an attempt to predict reciprocity-law failure, but was found to apply only over a limited range of illuminances and times.

scintillation (1) Twinkling, like the appearance of stars seen through a turbulent atmosphere. (2) In phosphorescence, a flash of light (or a sequence of such flashes) associated with the effect of a moving high-speed particle.

sclera The white of the eye.

scoop A small incandescent light source in a reflector shaped as indicated by the term. It produces a soft, diffuse light.

score Music for a motion-picture film or television show.

scotopic Specifying a light level so low that the cones of the human retina are insensitive and only the rods function. At such a light level, the ability to distinguish hues (red, green, blue, yellow, etc.) is lost or greatly diminished, and only brightness discrimination remains. Also see Purkinje phenomenon. Distinguish from photopic and mesopic, which see.

scrape To remove a narrow strip of film emulsion from the base, preparatory to making a splice in motion-picture film, etc., to obtain better adhesion.

scraping block That part of a film splicer which carries a blade used to remove a narrow strip of emulsion preparatory to making a splice.

scratch-off In animation, the stepwise removal of a part of an inked cell between exposures, reducing the number of separate drawings that must be made. For example, a line may be made to appear to shrink (or by reversing the film, to expand) by making a single drawing of the whole line and then removing portions little by little.

scratch print In cinematography, a positive image that has been deliberately defaced so that unauthorized duplicates cannot be made. A scratch print is used for the selection, by the potential user, of the desired footage.

screen (1) In additive color-photography processes, a random or ordered array of red, green, and blue minute filters that lie on a panchromatic film. After exposure, reversal processing produces an image that simulates the scene when observed through the screen. (2) In photomechanical processes, an array of fine lines, crossed lines, or other assemblages of repetitive structures, used to convert a continuous-tone image into a set of discrete elements. (3) A surface onto which an image is projected. (4) Preceded by "texture," a transparent sheet containing a pattern. Used in making prints to simulate the textures of fabrics and to obtain other effects such as graininess. (5) British term for filter. (6) (verb) To project an image for viewing, especially a motion picture. (7) Preceded by "intensifying," a fluorescing surface (or lead foil) energized by x-rays, used to reduce the required total x-ray energy in making radiographic images. (8) Preceded by "head," an opaque shield, used to reduce the light on a portion of the subject. Syn.: gobo.

Screen Actors Guild (SAG) An association of film performers.

screen angle In photomechanical color reproduction, the number of degrees of rotation of the line of dots in one plate as compared with that in the other plates. The intent of adjusting the screen angle is to minimize the appearance of a moire pattern, and to control the amount of ink overlap.

screen direction Movement of the subject, in motion pictures, with reference to the borders of the picture area.

screening dye An absorbing substance added to a photographic layer to control the penetration of light.

screenless lithography A method of preparing plates for photomechanical reproduction processes without the use of the usual overlay transparent sheet of lines or dots, etc. Use has variously been made of random grains of the photographic emulsion, of a finely-grained metal printing plate (photogravure), and of reticulated gelatin (collotype). Each of these methods produces from a continuous-tone original image the small discrete elements needed for half-tone reproduction processes.

screen test In motion pictures, a short film made to evaluate the acting ability and appearance of a potential performer.

screen time In motion pictures and television, the duration of a film.

screw-in Threaded; applied to lens mounts and attachments. Contrast with slip-on and bayonet mount.

screw mount A device consisting of matched threaded rings used for the attachment of lenses to camera bodies.

scribe In the production of artwork in photofabrication, to remove mechanically, as with a knife, portions of an opaque coating from a support.

scrim A translucent sheet of gauze, or similar material used to diffuse light, sometimes used as a background.

script Written instructions for the production of a motion-picture or television show. It includes detailed description of the scenes, action, and dialog. A sound script similarly details the sounds to be included.

scum (1) In a processed image or on processing tanks, etc., a whitish deposit, typically associated with incomplete washing or improperly compounded (or overworked) solutions. The problem often arises when the water is too hard. (2) As applied to a photoresist, a residue in an area intended to be free of resist (a window).

s-curve An arrangement of the visual elements of a photograph or other image that resembles the shape of the letter "S". A traditional belief about composition is that such a curve conveys the impression of grace and beauty.

seamless Applied to a background material, especially paper, large enough to be extended from the floor up a wall with no visible break.

second (1) (noun) A unit of time, as the time of exposure. 1/60 of a minute. Symbol, ("). (2) (adj) Identifying a print or other photographic image made from the original camera image. Usually "second-generation." (3) Indicating a second-choice photograph, print, or photographic material or product, due to failure to meet the highest standards, while remaining usable.

secondary (1) Derived, as a standard. Compare with primary, which is fundamental. For example, tungsten lamps may be secondary standards of light, whereas the primary is a cavity in a black material (carbon) maintained at a specific temperature. (2) As applied to colors, formed by additive combination of primary colors (which are usually red, green, and blue.) Yellow may be produced by the addition of red and green light; magenta from red and blue; cyan from blue and green. Thus yellow, magenta, and cyan are additive secondary colors.

secondary spectrum That chromatic (color) aberration remaining in an achromatic lens—one that has been color-corrected for two chosen wavelengths. An apochromatic lens is corrected for three colors and thus has no secondary spectrum.

second cover The inside of the front cover of a publication, as distinct from the (outside) front, and the third and fourth (back) covers. The second, third, and fourth covers are considered to be choice positions for advertisements, which commonly include reproductions of photographs. In mass magazines, the covers are typically printed in color.

second-generation As applied to an image, two steps away from the original. The original may be a subject, or in copying, a photograph. (Thus a second-generation copy is a reproduction of a reproduction of the original photograph.)

second nodal point Rear nodal point.

second unit In motion-picture production, a crew of persons responsible for photographing exterior scenes, as distinct from the first unit, which works in the studio.

sector disk (wheel) A rotating opaque circular plate in which an aperture has been cut. A type of shutter, used especially in sensitometers (precision exposing devices used in testing and research).

seesaw In tray processing of roll film, the agitation technique of moving the film from end to end through the developer. The film is held in a "U" shape with one end in each hand and the bottom of the U in the developer. Agitation is produced by alternately raising one hand while lowering the other, hence the name.

segue (pronounced seg'-way) In motion pictures and television, music used as a transition between one scene and the next.

selective focus An effect obtained by using a chosen image distance or object distance in relation to a controlled shallow depth of field, so that some parts of the subject are sharp in the image and other parts obviously unsharp. Selective focus is used to emphasize part of a scene, to increase the appearance of depth, etc. Syn.: differential focus.

selectivity (1) That characteristic of a developing agent by which it produces little development fog. Technically, the ratio of the rate of image development to the rate of development of chemical fog, a "signal-to-noise" factor. (2) Of colorants, variation in properties with wavelength, as distinct from nonselectivity. A surface may appear neutral but nevertheless absorb different fractions of different wavelengths of light. Such a neutral is selective. Most neutral density filters have this characteristic.

selenium An element used as the photosensitive material in many light meters and in xerographic plates. The conductivity of the selenium changes when it absorbs radiation.

selenium toner A bath used for black-and-white

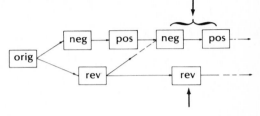

second generation

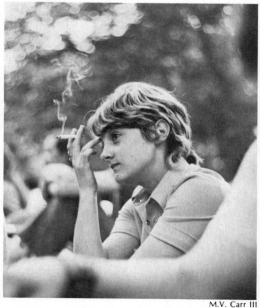

selective focus

M.V. Carr III

prints to modify the color of the image and to protect the silver image against chemical damage caused by airborne sulfur compounds. The tone obtained varies with dilution, time of treatment, and the photographic paper used, from warm sepia to cold purplish black. There is a slight intensification of shadow density and contrast.

self-absorption In radiography, the process by which some of the radiation produced within a body of radioactive material is unable to penetrate the overlying material. Thus, the external intensity of radiation is reduced below that which would be ordinarily calculated.

self-capping Applied to a focal plane shutter in which the slit aperture closes as the curtain is rewound in order to prevent accidental fogging of the film.

self-cocking (self-setting) As applied to a shutter, requiring only a single motion of a lever to generate tension in a spring and also to release the shutter. Most conventional shutters require separate motions to accomplish the same result.

self-inking In animation, the use of an outline color like that which will be used to fill in the enclosed area, as contrasted with black outlines.

self-timer A device that provides a lapse of several seconds between pressing the shutter release and the actual exposure, such a time lapse permitting the camera operator to enter the scene. See delayed action.

selsyn Self-synchronous, applied to motors so linked electrically that one performs like the other. Used especially in motion pictures for combining live scenes and rear projection backgrounds, etc. Syn.: interlock.

Selwyn granularity A measure of small-scale variations in density in a uniformly exposed and processed area. The standard deviation of density values multiplied by the square root of the aperture of the microdensitometer. According to Selwyn's law, the value is independent of the aperture, but in practice, light scattered within the emulsion causes a departure from independence.

semiconductor A substance that in electrical properties is intermediate between metals (conductors) and nonmetals (nonconductors). Some semiconductors change in electrical characteristics when they are exposed to radiation; such a change is the basis for electrostatic (xerographic) image-forming methods. Semiconductors are used in transistors, widely used in modern electronic components of cameras, sound recorders, etc.

semigloss A paper surface having a sheen intermediate between glossy and mat, but closer to glossy.

semimat(te) A paper surface having a sheen intermediate between glossy and mat but closer to mat.

semireflective (-transparent) Applied to a mirror having only a thin metallic coating, such that part of the incident light is transmitted and part reflected. Such mirrors are used as beam splitters and to observe and photograph persons without their awareness.

senior A very large spotlight equipped with a Fresnel lens, usually employed as a key light.

sensation Direct response of a person to a stimulus; e.g., visual sensation is a response to light. Distinguish from perception, which, involves (besides sensation) memory and thought, and which results in recognition, understanding, etc.

sensitive Responsive, as to radiation; affected by radiation or other energy. Often used in compounds such as light-sensitive, photosensitive, etc. Some silver halide emulsions are pressure-sensitive.

sensitivity The measure of the ability of a receptor (photographic material, eye, photocell, etc.) to respond to radiant energy. Film speed is a type of measure of radiation sensitivity. See spectral sensitivity.

sensitivity guide A transparent step tablet, so called by workers in photomechanical reproduction.

sensitivity speck A small (hypothetical) spot on or within a silver halide grain that acts as the site at which the latent image begins to be formed.

sensitize To cause a photographic material to increase its response to radiation, as by an increase in crystal size (optical sensitizing), by the addition of a dye (dye sensitizing), or by the addition of small amounts of various chemicals (chemical sensitizing) such as gold salts.

sensitizer Any substance that, when added to a photographic emulsion, increases the response of the emulsion to radiation. Many dyes and substances such as sulfur and gold are sensitizers for silver halide emulsions.

sensitometer An instrument for producing on a sample of photographic material a series of different exposures. Such an instrument consists of: (a) a source of radiation whose output is precisely known and well stabilized; (b) a shutter or similar device of known characteristics; (c) a modulator, often a step tablet, for producing a series of different illuminances (light levels) on the sample. The D-log H (D-log E) curve for the material may be plotted from such an exposure series.

sensitometric curve (1) A graph obtained by plotting the logarithms of a series of exposures (quantity of light per unit area) received by a photographic material and the corresponding resulting densities. (2) A graph similar to (1), but with the logarithm of the energy (quantity of radiation per unit area) as the input. Used for photographic materials normally responsive to radiation other than light, such as x-ray films. Such graphs are used to determine information such as base plus fog level, speed, contrast index, useful exposure range, and maximum density. Syn.: characteristic curve; D-log H (D-log E) curve; H and D curve.

sensitometric strip A sample of photosensitive material exposed in a special device (sensitometer, which see) for test purposes.

sensitometry That technology devoted to the estimation of the response of photographic materials to radiant energy. Sensitometry includes methods of exposing, processing, measurement, and data evaluation.

sensor Generally, any device that detects a change in light, temperature, pressure, etc. A temperature sensor may be used in a charging unit for electronic-flash batteries to reduce the charging rate when the temperature reaches a specified value. Sensors may be used in automatic processors to estimate replenishment rates, pH, etc.

separable Said of a lens assembly containing subassemblies that may be used independently to obtain different focal lengths. Often called convertible.

separation (1) In color photography or photomechanical reproduction, the act of photographing a scene or, more often, a colored original such as a painting, drawing, or color photograph through each of several colored filters, typically red, green, and blue. The intent is to record on each of the negatives (or the following positives) only the effect of the red or green or blue light from the different parts of the original. (2) The image so produced, as a red separation negative. (3) In a photograph, the distinguishability of subject from background, foreground from distant parts of the scene, tone from adjacent tones, etc.

SEPDUMAG A code word used in international exchange of television programs to identify a picture film with two magnetic soundtracks on a separate tape. Derived from "separate dual magnetic." One of a group of such code words recommended by CCIR (International Radio Consultative Committee).

sepia A yellowish-brown color. Some toning processes for prints produce such a color.

SEPMAG A code word used in international ex-

change of television programs to identify a picture film with sound on a separate magnetic tape. Derived from "separate magnetic." One of a group of such code words recommended by CCIR (International Radio Consultative Committee).

sequence A series of related images, such as slides, motion-picture scenes, or a set of pictures deliberately used together for a picture story, an exhibition, etc.

sequence camera A photographic apparatus capable of making a series of pictures in a short time. Used in motion study, sports, etc.

sequence programmer In showing slides, etc., an apparatus that controls the order and rate at which the images appear.

sequential-card camera An exposing apparatus used for the production of lists, such as directories, catalogs, etc. A series of cards, arranged in order, is automatically photographed by the equipment.

sequential processing (recording) The use of a single channel for handling data (as in scanning processes), as contrasted with parallel recording, in which multiple channels are used simultaneously.

serif (1) In printing type, a thin line used to finish off a main stroke of a letter or number. (2) In photofabrication, an extension of a corner, as of a resolution-test target bar, to retain a square corner in the image.

serigraphy See silk screen.

servo control The use of a motor supplied with an electrical current that varies with the position or speed of a mechanical part of a system, used to stabilize the operation of cameras, etc.

set (1) A scene constructed for making a photograph, motion picture, etc., including background, furniture, and properties. (2) In psychology, a state of readiness to respond in a specific manner; associated with expectation. Visual perceptions, for example, are affected by the set of the observer. (3) (verb) To coagulate into a semisolid, as a gelatin dispersion in water when it is cooled. In the manufacture of photographic emulsions, the emulsion is set before it is shredded and washed.

setback In animation, a miniature setting placed behind cells, to produce a three-dimensional background.

set light A spotlight or floodlight used to illuminate the scenery in a set, as distinct from lamps used to illuminate the principal subject of the photograph.

setoff In photomechanical printing, unwanted transfer of ink from one printed surface to another surface, caused by imperfect drying of the ink. Syn.:

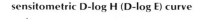

sensitometric D-log H (D-log E) curve

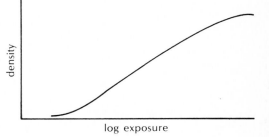

density

log exposure

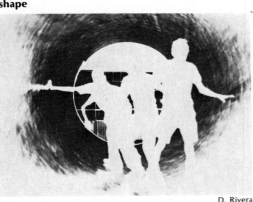

shape

D. Rivera

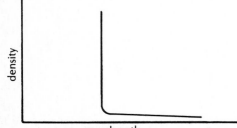

sharp cutting filter

density

wavelength

offset (not to be confused with offset printing or lithography).

settings Preceded by "camera," f-number and exposure time, as indicated by markings on the lens housing or camera body. Similar terms are shutter setting and aperture setting.

setup (1) An arrangement of props, lights, scenery, etc., made in preparation for photography. (2) A camera position with respect to a scene. (3) A photographer's resources in terms of equipment, studio, darkroom, business arrangements, etc.

seventy-millimeter (70mm) A motion-picture-film and still-film width, the widest normally used for motion pictures.

SFX Sound effects.

shade (1) A color differing from another in lightness, as in shades of gray. (2) Loosely, a synonym for color. (3) Hood. A shield of conical or other shape used to prevent unwanted light from falling on a lens.

shadow (1) An area that is shielded from the direct light from a source. Also see cast shadow. (2) A dark area of a scene or the corresponding area in an image or reproduction, as opposed to highlight.

shadowboard A black screen (gobo) with a hole in the center for a camera lens, used so that unwanted reflections will not be recorded.

shadowgraph A record of an object field by illumination from the rear, which may include, besides silhouettes, variations in the atmospheric index of refraction.

shape Two-dimensional outline of a subject or part of a subject, as distinct from form, which implies a three-dimensional quality.

shape constancy A property of vision by which objects are seen as having their "true" configuration regardless of the actual visual image. A coin is recognized as a circular object, even when observed obliquely so that the visual image is an ellipse.

sharp cutting Applied to a filter that distinguishes clearly between the region of absorption and that of nonabsorption. Shown by a filter curve with a high slope.

sharpening dye A light-absorbing substance added to a photographic emulsion to reduce the effect of scattered light within the emulsion, and thus to improve the image.

sharpness That subjective quality of an image associated with the distinctness of boundaries between adjacent objects. Sharpness can be measured by asking a group of observers to rank images with respect to this quality. See acutance, the objective measure of edge quality that is related to sharpness.

sheen Glossiness, as of a photographic paper.

sheet-fed Applied to a printing press that accepts paper previously cut into appropriate sizes, as compared with web-fed in which a roll of paper, etc., is used.

sheet film Photographic material on a flexible transparent support, cut into individual pieces, as contrasted with roll film. Each sheet is normally used to make a single image.

shelf life The time during which photographic chemicals, sensitive materials, etc., may be stored without definite deterioration. The time depends markedly on the conditions of storage, such as temperature and humidity.

shift A change in color, as of a color photograph compared with the original image or with the subject. Also see lateral shift.

shift chart In animation, a guide that assists the animation tracer in placing a drawing in any of several positions so that movement will appear smooth.

shiving Deforming the edge of backing paper for roll film to produce a more effective light seal with the spool flange.

shoot To expose film in a camera. To take a picture or pictures.

shooting ratio In cinematography, a comparison of the amount of footage exposed to that used, such as 10:1.

shooting schedule In cinematography, the timetable for the production.

shooting script In motion-picture photography, a detailed description of the events to be photographed and the manner of photographing them.

short end In cinematography, a random length of film left in a magazine after part of a standard length is used.

shorthand sheet In animation, a condensed guide to the animator, less complete than a frame-by-frame breakdown of the action.

short pitch In motion-picture films, a perforation interval such that 100 intervals cover a distance of 29.94 inches. Compare with long pitch.

short stop A bath of dilute acid, usually acetic, that follows and arrests the process of chemical development and precedes fixing. The preferred term is stop bath.

shot (1) An exposure or a photograph. (2) In motion pictures, a single run of the camera, or the piece of film resulting from such a run.

shotgun mike A microphone that has a narrow angle of acceptance of sound, and therefore is highly selective in recording sound coming only from the

direction in which it is aimed. Syn.: directional microphone.

shot noise In vacuum tubes (used for sound amplifiers, densitometers, etc.), a background level of response associated with random thermal (heat) effects. The shot-noise level often sets an upper limit to the sensitivity of the device.

shoulder The high-density portion of the characteristic D-log H (D-log E) curve of a photographic material where the graph becomes progressively more nearly horizontal, indicating diminishing contrast. For other than reversal material, the shoulder involves very great exposures. Compare with the toe, which involves relatively small exposures.

shoulder pod A support for a motion-picture, television, or other camera. The support is placed on the cameraman's shoulder to steady the camera while permitting him to move about freely.

shrinkage A reduction in dimensions of photographic materials, associated with drying, or in films with loss of solvent. Such dimensional changes are troublesome in photogrammetry and especially in motion-picture films, since difficulty may be encountered in projection and printing.

shuffle (leaf) In tray processing of sheet film, continuous agitation involving bringing the bottom sheet of a stack to the top, then the next one, etc., typically throughout the processing.

shutter A device that controls the time of exposure. Between-the-lens (leaf) shutters comprise blades that open and close. Focal-plane shutters typically consist of slits in curtains moved laterally near the film. In motion-picture cameras and in some sensitometers, the shutter is a rotating disk with a sector aperture. Also see Kerr shutter.

shutter angle In motion pictures, the opening of the sector aperture in the shutter, measured in degrees, such as 120° (where 360° is the complete cycle). Syn.: shutter opening.

shutter bar (1) In television images of kinescope (film) recordings, slowly moving horizontal lines caused by synchronization errors in making the film. (2) In motion-picture prints, similar bars produced when the print is exposed through a slit so narrow that the small variations in the printer light (caused by operation on alternating current) affect the image exposure.

shutter calibration (1) In an optical printer or animation camera, marks that indicate the necessary settings for various lengths of dissolve. (2) In still camera shutters, the marked (or measured) exposure times to which the shutter can be set. (3) The act of measuring and perhaps adjusting the exposure times.

shutter opening In motion-picture cameras, the designation in degrees of the part of a complete cycle (360°) during which light is permitted to fall on the film. Fixed shutters commonly have a 180° opening; variable shutters may be adjusted over a range from 0° to approximately 180°. Syn.: shutter angle.

shutter release That part of a shutter mechanism that the operator activates to expose the film. Distinguish from cable release, which is a device for remote activation of the shutter mechanism.

shutter speed (1) The effective exposure time produced by a shutter, usually defined as the time interval between the half-open and half-closed positions of the shutter. Distinguish from total operating time and from fully-open time. In focal-plane shutters, the speed is controlled by varying the width of the slit and/or the speed with which it travels. (2) The marked exposure time on a shutter, which may differ significantly from the actual exposure time, caused by inaccuracy or by a change in the effective exposure time as the lens aperture is changed.

shuttle A sliding device, used in some motion-picture cameras and projectors, that moves the film intermittently, one frame at a time.

SI Système International d'Unités.

side kicker Slang for a modeling light aimed laterally across the subject.

side lap In aerial photography, overlap of photographs laterally to the line of flight, usually about 30%.

side light (1) Illumination on the subject approximately laterally perpendicular in direction to the camera axis, as distinct from front and back light. (2) The lamp used for (1). The use of a side light increases the modeling and texture of the image.

sigma (symbol σ) Greek letter symbolizing standard deviation, i.e., the measure of variation of a repetitive process. Often used in control charts that may have limit lines, ± three-sigma from the process average. Such limits will include almost all the values from an unchanged process controlled by chance. Thus, data falling outside these limits usually indicate a change from the expected performance. Granularity is based on sigma.

sign In visual communication, a mark that serves as a substitute for the thing represented and typically has a visual similarity to the object. For example, a road sign may indicate a curve in the road by the use of a curved arrow. Contrast with symbol.

signal A general term for any desired input to be recorded as a trace or other image, and for the resulting output, as distinguished from noise (an unwanted random disturbance). In photography, the

shoulder

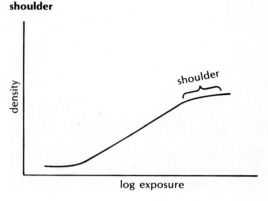

shutter speed

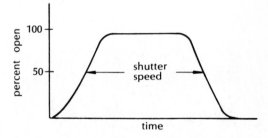

side lighting

H. G. Barton

silhouette

D. Rivera

sine

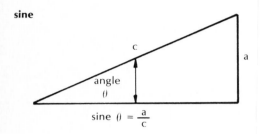

$$\text{sine } () = \frac{a}{c}$$

sine-wave test target

single frame (2)

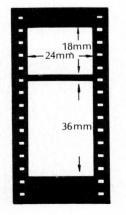

signal is initially the light from the subject (input); graininess is one type of noise.

signal-to-noise ratio (S/N) (1) The quotient obtained by dividing the power associated with the desired input to the power associated with the random disturbance that may interfere with the desired record. (2) In photography, often the density level of the record divided by the random fluctuations in density (Selwyn granularity, which see). (3) In sound reproduction, the ratio of the loudness of the speech or music, etc., to the loudness of any unwanted accompanying sound record.

silenced Identifying a motion-picture camera that has been prepared so as to reduce running noise so that it can be used for making sound films. See blimp; barney. Distinguish from silent.

silent (1) Identifying a camera used for photographing nonsound motion pictures. It makes so much mechanical noise (unless blimped—surrounded with sound-absorbing material) that it cannot be used for making sound motion pictures. (2) Identifying motion pictures with no accompanying sound record.

silent speed For amateur motion pictures, 18 frames per second. (The former 16 frames per second speed is virtually obsolete.) Most professional silent films in 35mm and 16mm format are exposed at the standard sound speed of 24 frames per second to permit the later addition of sound without complications.

silhouette An image in which only the outline shape of a dark subject appears against a lighter background, giving a flat two-dimensional effect.

silica gel A moisture-absorbing material, usually in the form of small granules, used in packing and storing materials and objects (cameras, lenses, etc.) that could be injured by dampness.

silk (1) A textured surface for a photographic printing paper, resembling a glossy fabric. (2) A diffuser used over lights. It may be made of spun glass, plastic, cloth, etc.

silk screen (1) A mechanical printing process in which ink is forced through a fine mesh, parts of which are blocked by a resist. Syn.: serigraphy. Such a stencil may be made by using a photosensitive material to form the resist. The term then becomes photoserigraphy. (2) The stencil used in the process.

silver A metal, some compounds of which are uniquely sensitive to radiation. Silver halides (compounds of silver with chlorine, bromine, and iodine) are components of most photographic materials. In black-and-white photography with these materials, the image consists of finely-divided metallic silver. Silver is used for mirrors because of its high reflect-

ance, which is nearly uniform throughout the visible spectrum.

silver halide Any compound of silver and a halogen, e.g., silver chloride, silver iodide, silver bromide. Crystals of such compounds are the radiation-sensitive elements of silver halide emulsions.

silver recovery Any process of reclaiming silver from processing (especially fixing) baths, waste emulsion, etc. From fixing baths, the silver may be plated out electrically or extracted by chemical methods (such as replacement with iron).

simple chronology A type of continuity for a motion picture, filmstrip, picture series, etc., in which the scenes or photographs are presented in the same order in which they were taken.

simplex A system of recording microfilm images of documents by which one side of each document is photographed on half the width of the 16mm film, the film is rewound, and the other side of each document is photographed on the other half of the film. Compare with duplex.

simultaneous contrast Enhancement of visual differences between areas of different luminance or color as seen at the same time in the same visual field. (Compare with successive contrast.) A dark object looks darker when placed on a light background than when placed on a dark background. The perceived saturation (vividness) of a blue object is increased when a yellow object is nearby.

sine In a right triangle, the ratio of the side opposite an angle to the hypotenuse of the triangle. One of the trigonometric functions of an angle. The sine of the angle appears in Snell's Law, in the definition of numerical aperture, and in many other mathematical formulations in optics.

sine wave (1) A simple, pure vibration, consisting of a single frequency. Such a wave would represent light that is wholly monochromatic (of a single color) and exactly aligned (in phase). Laser light approximates this situation. (2) As applied to a test target, producing a continuously varying luminance (as contrasted with a square-wave bar target). Sine-wave targets of different frequencies are used to find the modulation transfer function (which see) of an optical or photographic system.

sine-wave response An obsolescent term for modulation transfer function, which see.

single-frame (1) Applied to a device in a motion-picture camera or printer that permits the operator to expose one image area at a time. Used for animation, time-lapse photography, etc. (2) The standard 18 x 24mm motion-picture format on 35mm film, as distinct from the 24 x 36mm double-frame format in

many still cameras that use 35mm film. Sometimes called half-frame, since 24 x 36mm is the standard 35mm format for still photography.

single-jet In the manufacture of silver halide photographic emulsions, the addition of one solution through a small orifice in a pipe into a large volume of another solution. As the first solution is added, the chemical reaction changes because of a changing concentration of the components of the second solution. The result is a constantly varying size distribution of the silver halide crystals as they are formed. This variation has a great effect on the speed, contrast, and other characteristics of the resulting emulsion. Compare with double-jet, and with dumped-emulsion manufacturing methods.

single-lens reflex (SLR) A type of camera that is fitted with a movable mirror behind the lens, and a ground-glass or other screen for viewing the image. Just before the shutter opens, the mirror moves out of the way to permit the image to fall upon the film. SLR cameras usually include a reflecting prism to produce a correctly oriented image for viewing.

single-perf (-perforation) Identifying motion-picture film with a series of holes on one side only.

single-stroke Applied to a mechanism on a still camera by which one movement of a lever advances the film and, typically, cocks the shutter.

single system In motion-picture photography, the recording of sound and picture simultaneously, on the same film, during the original shooting.

single-weight (SW) Relatively thin photographic paper, as opposed to double-weight.

siphon A tube that drains a liquid from a higher level to a lower one over an obstacle. A siphon is often used to remove hypo-laden water from wash tanks and trays, and to transfer liquids from one container to another.

sitter A person posing for a portrait.

sixteen-millimeter (16mm) In motion pictures, a film width commonly used for commercial, educational, and amateur filming. Also used for double-eight and double-super-eight motion-picture cameras.

size (sizing) A substance used to make photographic and photomechanical printing papers smooth in order to improve image quality.

size constancy A visual phenomenon by which objects remain identifiable as large or small, despite their varying distance from the viewer. Size constancy holds only over a limited distance, which is greater horizontally than vertically.

skew In geometrical optics, specifying a ray of light that does not, even if extended, intersect the axis of a lens or lens system. Compare with meridian.

skewness In a step-and-repeat pattern of photomask images, the error, i.e., the difference between the specified and the measured distance between adjacent images.

skin flick Slang for a motion picture emphasizing partially or completely unclothed actors, often pornographic.

skin tone The appearance (lightness, hue and saturation) of an area of the face, or other part of a human subject that is illuminated by the main light but does not include a specular highlight. Proper reproduction of the skin tone is important in color photography, etc. A measurement of the skin tone is sometimes used in preference to that of a gray card as a reference for evaluating and controlling the density and color balance of photographs when (a) it is inconvenient to include a gray card in the scene, (b) it is impossible to match both tones simultaneously, or (c) it is considered more important to obtain a pleasing effect than an accurate reproduction of the gray card. When it is not possible to consider individual variations, it is assumed that the typical subject is Caucasian with a skin reflectance of about 36%. Syn.: face tone; flesh tone; in the zone system, zone VI.

skip frame In motion pictures, a method of speeding up action on the screen by printing only every other frame of the original. Other effects can be obtained by dropping other numbers of frames.

sky filter A smoothly graduated (clear to colored) filter, used in front of the camera lens to make sky reproduction more dramatic. A yellow sky filter makes skies darker in black-and-white; a bluish one makes skies appear bluer in color photographs. The filter is effective only if mounted somewhat in front of the camera lens. Not to be confused with skylight filter.

skylight (1) Radiation reflected from the atmosphere, which together with sunlight (direct light from the sun) makes up daylight. Skylight is generally bluish, and thus causes outdoor shadow areas to reproduce as bluish in color photographs. (2) A window, usually facing upward and northward, used as a source of light in some photographers' and artists' studios.

sky light A broad flood lamp, several of which may be used in the studio to illuminate the artificial background simulating the sky.

skylight filter A nearly colorless filter that absorbs mainly ultraviolet radiation (and a small amount of blue light) typically used over a camera lens when making color photographs of subjects in open shade that are illuminated by blue skylight. The result is a better color balance with daylight films, which tend to record ultraviolet radiation as blue.

size constancy

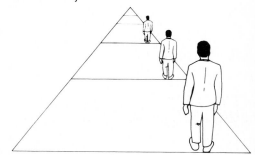

skyline The horizon or the terrain features that form the boundary between earth and sky.

sky pan A large lamp, in a shallow reflector (hence "pan"), several of which may be used to produce soft, uniform lighting on a backdrop used in the studio to simulate the sky.

slash Slang for an oblique beam of light across drapes or scenery from a spotlight.

slate In motion-picture photography, a card containing data, photographed at the beginning of a scene.

slave A supplementary flash or electronic-flash lighting unit that operates by detecting a pulse of light from the primary unit.

slide (1) A small transparency for viewing by projection. (2) An opaque panel which seals a filmholder to light, but which can be removed after the holder has been attached to a camera, thereby allowing the film to be exposed. Also known as dark slide. (3) In photomicrography, a piece of glass or other material used to hold the subject.

slidefilm A coordinated series of photographs on a strip of 35mm film that is viewed by projection as a sequence of still pictures. Syn.: filmstrip, the preferred term.

slide motion In motion pictures, the production of the effect of action by photographing still pictures using camera moves such as zoom, pan, dissolve, spin, etc. A filmograph uses similar camera moves plus very simple animation.

sliding back A camera device so arranged that part of a sheet of film can be exposed at a time. Syn.: split back.

sliding cell In animation, a wide sheet of acetate, etc., that can be progressively moved to simulate a panning action.

sliding pegs In animation, pins, for positioning cells, that can be moved laterally in a track to simulate a pan movement.

slip-in A mount for photographs in which the print is inserted under a cutout mat.

slip-on Involving a press fit, as of lens mounts and attachments, as contrasted with screw-in and bayonet. The slip-on fit uses friction to hold the lens or accessory in place. Few lenses have slip-on mounts, for obvious reasons, but they are found on some projectors, etc.

slippage In continuous printing, a relative movement of negative and print material, resulting in deterioration of image quality.

slit camera An apparatus for exposing film in which a narrow rectangular aperture is placed so that only a strip of film is exposed at a time, used in high-speed photography and occasionally for pictorial effects.

slope (1) For a straight-line graph, the trigonometric tangent of the angle made by the line and a horizontal. The slope can be found by choosing any two points on the line, computing the change in the output and input data for the two points, and finding the ratio of these changes. Gamma is the slope of the straight line of the D-log H (D-log E) curve. (2) For a curved graph, the slope at any point is found by constructing a straight line tangent to the curve at that point and finding the slope of the tangent. The toe of the D-log H curve is the region of increasing slope with increasing exposure; the shoulder is the region of decreasing slope. (3) In printing, the relationship between print density and negative density, affected by the "slope control" in the printer.

slop test The manual processing of a short length of motion-picture film for a quick check on possible malfunctions of the camera, etc. The preferred term is hand test.

slow cut In motion pictures, a dissolve involving only four frames, used as a scene transition. Syn.: slow pop; soft cut; soft pop.

slow motion In motion pictures, images made at more than 24 frames per second, up to about 128 frames per second, and projected at the normal rate of 24 frames per second. The technique is one of the special effects used not only to make rapidly moving objects appear to drift, but also to make photography of small-scale models more nearly realistic. (High-speed motion pictures involve exposures at more than 128 frames per second.)

slow pop See slow cut.

SLR Single-lens reflex.

sludge A precipitate in processing baths.

slug In motion pictures, a length of leader spliced into a work print as a replacement for damaged or missing frames. The intent is to maintain synchronization with the soundtrack until the work print can be repaired.

slur In photomechanical reproduction, blur associated with lengthwise movement of the paper, etc., relative to the plate.

SM Speed midget.

small-format Applied to still photography and cameras that use film sizes smaller than and sometimes including 4 x 5 inches. The 24 x 36mm photograph on 35mm film and the 2¼-inch-square roll-film negative are typical.

smear In television, a dark streak in the image.

SMPTE Society of Motion Picture and Television Engineers.

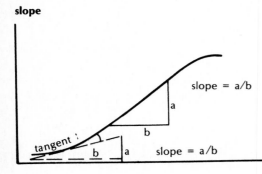

slope

slope = a/b

a

b

tangent

b a slope = a/b

SMPTE leader See Society leader.

SMT System-modulation-transfer.

S/N Signal-to-noise ratio.

snap Slang for brilliance or marked contrast in photographic images, especially in prints.

snapshot A casual photograph made with a hand-held camera.

Snellen chart A test of visual acuity, involving the ability of an observer to distinguish letters of progressively decreased size.

Snell's Law When light passes from one medium to another and undergoes a change in velocity, the ratio of the trigonometric sines of the angles of incidence and refraction is a constant. This law is the basis of refraction — the effect on light of lenses and other transparent optical devices.

snoot (snout) A cone, usually of metal, fitted to a lamp to produce a small spot of light on a subject or background.

snow (1) White spots on a print, associated with dirt flecks on the negative. (2) In television, random light spots in the image, caused by electronic and other sources of picture "noise."

SNR Signal-to-noise ratio. The preferred abbreviation is S/N.

Society leader A standard length of nonpicture film preceding the picture, recommended by the Society of Motion Picture and Television Engineers. The leader contains identifying data, and facilitates accurate shift from one reel to another in the projection of motion pictures. Now being replaced by the Universal leader.

Society of Motion Picture and Television Engineers (SMPTE) An organization of persons concerned with the science and technology of cinematography and television.

Society of Photographic Scientists and Engineers (SPSE) An organization of persons interested in the science and technology of photography, and in the applications of photography to data-collection methods.

sodium lamp An arc-light source involving an electrical discharge through an atmosphere of the vaporized element sodium. At low internal pressure, the light is confined almost wholly to radiation at about 590 nanometers, in the yellow portion of the spectrum. Such a source is often used for the measurement of index of refraction (and may be identified as the D line), and has been used for a safelight. Also called sodium-vapor lamp.

sodium thiosulfate A fixing agent, commonly called hypo. (Distinguish from amonium thiosulfate, also loosely called hypo, but more rapid in its action.)

soft (1) Identifying an image not in sharp focus. (2) In halftone plates for photomechanical reproduction, or prints from them, applied to fuzzy-edged dots. (3) Specifying a negative having low contrast — little density difference between shadows and highlights. (4) Identifying a "flat" print without light highlights and dark shadows, i.e., containing mostly gray tones. (5) For photographic papers, having a great scale index (useful log E range.) Such papers are usually graded 0 or 1. (6) For water, having little dissolved mineral content. (7) For x-rays, of relatively long wavelength, and therefore having little penetrating ability. (8) As applied to a lens, producing a somewhat unsharp image, often used in portraiture.

soft cut See slow cut.

soft-edge In motion pictures, identifying a matte (an opaque shield blocking out part of the image) that produces an indistinct boundary. A soft-edge matte is used in split screen processes, as when a single actor plays a dual role and is seen on both sides of the screen.

soft-focus Applied to a lens deliberately designed (usually having spherical aberration) so as to produce an unsharp image. The term is also used to identify the image so made, or made by the use of a diffusing disk, etc., with a lens that would otherwise give a sharp image.

soft-focus filter A glass, etc., having fine lines or reticulations, which when placed over the camera or projection lens slightly diffuses the image.

soft ink In letterpress halftone printing, ink that spreads on the paper after printing, forming a less-dark edge around each dot of the halftone screen pattern.

soft pop See slow cut.

software Text material, illustrations, etc., to accompany or to be used with hardware (apparatus or equipment). In audiovisual contexts, software includes films, scripts, etc., and hardware includes viewing and projection devices.

sol A relatively fluid form of a mixture of gelatin and water, etc., usually associated with an elevated temperature. Compare with gel.

solar Pertaining to the sun. Especially identifying batteries that can be recharged by radiant energy when placed in daylight or artificial light. Of possible use for supplying electrical energy to electronic-flash lamps, etc.

solarization A reversal of image tones, relative to subject tones, caused by gross overexposure of the photosensitive material. Distinguish from Sabattier effect, which is a reversal associated with a second exposure during development. See exposure effect.

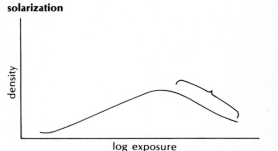

solarization

solenoid An electromagnetic mechanism, formerly used in apparatus to trip the shutter of a camera in synchronization with flash (now largely replaced by internal synchronization). Solenoids may be used to operate valves, etc., as in replenishment systems for automatic processors.

solid In photomechanical reproduction, an area of the print that is completely covered with ink.

solid angle The ratio of an area on a spherical surface to the radius of the surface. Unit: steradian (sr).

solid-state (1) A general term applied to processes occurring in materials other than in the liquid or gaseous phase. Solid-state physics is the study of small-scale events occurring in crystals and other forms of solid matter. In photography, one application is to the study of latent-image formation. (2) Identifying electronic devices such as transistors, thermistors, specific types of lasers, etc., which involve the electrical properties of semiconductors. Such devices are often substituted for vacuum tubes in electrical detectors and amplifiers.

solubility (1) The maximum possible number of grams of solute (dissolved material) per specified volume (or weight) of solvent (often water). (2) The relative ease and speed with which a chemical dissolves in a liquid.

solute A substance dissolved in another material, the solvent. Hypo, developing agents, etc., are solutes when made up into solutions.

solution A homogeneous mixture, typically liquid, of a dissolved material and a solvent. In photography the solvent is usually water. Processing baths (developers, fixers, etc.) are solutions.

solution physical development The deposition on the latent image of silver which originates in silver halide present in the film, and which is dissolved out of the film by a silver halide solvent in the developing bath.

solvent (1) That substance, usually a liquid, which holds another (the solute) in solution. Most photographic chemicals are dissolved in the solvent water. (2) In photomechanical printing processes, the volatile component of a printing ink.

SOM Small office microfilm (equipment).

sonoluminescence The transformation of sound and especially ultrasonic energy to light.

soot-and-whitewash Slang for an excessively contrasty print.

SOP Standard operating procedure.

sound advance In motion pictures, a longitudinal displacement of the picture and the corresponding sound, because of the necessarily different locations of the film gate and the sound-pickup head. The dis-

placement of the sound is 21 frames in front of the picture in 35mm and 26 frames in 16mm.

sound camera In motion pictures, an apparatus for recording pictorial images that has been silenced so that it can be used in making sound motion pictures. See blimp; barney. Syn.: silenced camera.

sound effects (SFX) Crowd noises, thunder, bells, whistles, etc., usually supplied from a record library and added to a motion picture or television tape.

soundhead That component of a motion-picture camera, printer, or projector, or of a recording or reproducing device, which converts an audible signal to a photographic or other track, or conversely, converts an audio recording to sound.

sound reader In motion pictures and television, a device used in a film-editing room, that enables the cutter to play an optical or magnetic soundtrack.

sound screen A surface for motion-picture projection that is perforated so that sound may be heard from speakers behind the screen.

sound script In motion-picture photography, a statement of the music, narration, and other audible records to be included in a motion-picture or television show.

sound speed For motion pictures, 24 frames per second. Syn.: synchronous speed.

sound stage A motion-picture studio that has been prepared for the production of sound motion pictures. Its essential feature is proper sound reproduction, usually secured by the use of sound-absorbing material.

soundstripe A narrow band of magnetic material on motion-picture films for sound recording.

soundtrack In motion pictures and television, a record of music, voices, etc., that is to accompany the pictorial record. Such a record may be made on a strip of magnetic material, or it may be photographic.

soup (slang) (1) A developing bath. (2) (verb) To develop (film or photographic paper, etc.).

source Origin, as light source, etc.

south The bottom of an animation camera field.

spacing guide In animation, marks put on drawings by the animator, to indicate to the assistant (in-betweener, etc.) how added drawings should be made.

spark source An illuminant of brief duration, dependent upon a short electrical discharge through air or other gas. Used in high-speed photography.

spatial filter A mask, consisting of point or slit apertures, that blocks out all except the desired spatial frequencies in the image. If a transparent image is placed in a collimated (parallel) beam of light,

periodic structures in the original give rise to discrete spots of light, as from a diffraction grating. A spatial filter is used to select or detect such periodicity.

spatial frequency Number of cycles per unit distance, often millimeter. Applied to resolution-test targets and to sine-wave targets, etc.

spec (1) Specification. (2) Speculation.

special effect (1) In motion pictures, any result obtained by altering normal procedures. Included are slow motion, diffusion, time lapse, fades and dissolves, montage, double printing, etc. (2) In motion-picture photography, the simulation of avalanches, fires, floods, and other such events, obtained by means other than direct photography of actual occurrences.

specification (spec) (1) A prescribed method of operation, as of agitation or development, or of bath composition, etc. (2) A prescribed result, as a densitometer reading of a standard patch. Such a specification will ordinarily include permitted tolerances.

specific gravity (sp gr) The mass (roughly, weight) of a given volume of a substance as compared with that of an equal volume of water. As measured with a hydrometer, a quick check on gross errors in mixing processing baths.

speck In latent-image theory, a center (considered to be silver atoms) formed as the result of the absorption of radiation, and serving as a site at which development begins.

spectral Having to do with the spectrum, especially variation in some response with the wavelength of radiation. (Distinguish from specular.)

spectral density The result of measurement of an image, especially a dye image, with narrow-band (ideally, monochromatic) radiation. To a first approximation, the analytical spectral density of a dye is proportional to dye concentration.

spectral-energy distribution A graphical display of the energy supplied by a source at various wavelengths, usually plotted as relative energy versus wavelength.

spectral luminous efficiency The measure of the human response to equal amounts of different wavelengths of radiation. Preferred term: luminosity function, which see.

spectral sensitivity A measure of the response of a photographic material to a narrow-band (ideally monochromatic) radiation. Sensitivity is inversely related to the quantity of incident energy per unit area of the material necessary to produce a defined response, often a fixed density of 1.0. Spectral sensitivity is usually presented as a plot of sensitivity versus wavelength. Distinguish from a wedge spectrogram, which displays threshold response to a specific source.

spectral sensitization The response of a photographic material to longer than normal wavelengths, obtained by adding to the emulsion a dye that absorbs these wavelengths. (Preferred to "optical" sensitization.) Syn.: dye sensitization.

spectrogoniophotometer An instrument for measuring spectral reflectance, etc., at different angles of illuminance and collection.

spectrogram A photographic record of the energy from a source of radiation dispersed (by a prism or diffraction grating) into a spectrum. A wedge spectrogram is a similar record made by attenuating the energy across the spectrum perpendicular to the wavelength axis.

spectrograph An apparatus used for recording spectra. A wedge spectrograph includes a means of varying the energy across the spectrum, such as a continuous or stepped neutral filter.

spectroheliograph An instrument used to photograph the sun by the use of any desired wavelength emitted by the sun.

spectrometer An apparatus used for the measurement of wavelengths of radiation.

spectrophotometer An apparatus for the measurement of energy (or of relative energy) within the spectrum, especially the visible spectrum. Such an apparatus may be used to measure the reflectance or transmittance of an object (e.g., filter) for different wavelengths, and thus to measure color in the physical sense.

spectroscope An instrument used for visual examination of a spectrum. It comprises a prism or diffraction grating for producing the spectrum, and a telescope and wavelength scale to permit visual observation.

spectrozonal Applied to a method in which several filters are used, each one for a record of the subject in a narrow band of the spectrum. The purpose is to obtain data about the spectral reflectance of the subject. Syn.: multispectral, multifilter; to which spectrozonal is preferred.

spectrum A display of radiation along a scale of wavelengths. The electromagnetic spectrum contains all radiation, from the shortest gamma radiation to the longest radio waves. The visible spectrum includes only those radiations to which the human eye is sensitive. The "photographic" spectrum includes those radiations which affect photosensitive materials: gamma and x-radiation, ultraviolet, light, and infrared radiation.

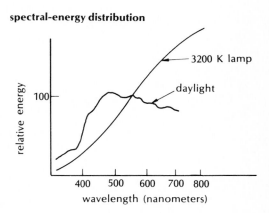

spectral-energy distribution

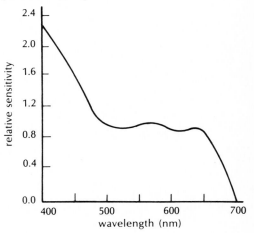

spectral sensitivity

specular (1) Mirrorlike reflection, as specular highlights. (2) Unscattered, collimated, as specular illumination. (3) In densitometry, a measurement involving incident radiation confined to a narrow angle, and recording only the directly transmitted radiation. (Note: This term is often confused with spectral, which see.)

speculation (spec) Making photographs with the hope of later sale. Often, on spec.

speed (1) As applied to a lens, a measure of its capacity to admit light to the image. Lens speed is usually expressed by the f-number (the ratio of the lens focal length to the diameter of the cylindrical bundle of light that can pass through the lens). Lens speed is inversely proportional to the square of the f-number. Thus, an f/2 lens is four times as fast as an f/4 lens. Also see T-number. (2) In microscopy, the numerical aperture, which is the sine of the angle formed by the perpendicular ray and the extreme ray that can pass through the optical system. (3) For photographic materials, a number based on the reciprocal of the exposure needed to produce a desired effect. Very many speeds have been devised, differing mainly in the specification of the desired effect. The present speed criterion for amateur black-and-white pictorial negative materials (usually called the ASA speed) is based on the exposure needed to produce a density of 0.10 above base plus fog for a specified degree of development. Other speed methods apply to color materials and to films used for radiography, etc. (4) In motion pictures, the number of frames per second exposed in the camera. (5) In motion-picture processing, the rate of movement of the film in feet per second. (6) As applied to a shutter, the effective time of exposure. See shutter speed. (7) In motion pictures, an announcement from a crew member that the camera or recorder, after having been started, is running at the proper rate.

speedflash, speedlamp, speedlight A reusable source of light and other radiation involving a brief discharge of electricity through a gas-filled tube. The preferred term is electronic flash (which see).

speed lines Marks used in animated cartoons to indicate fast action. They also help to bridge between consecutive drawings, reducing flicker.

speed midget (SM) A type of flashbulb that has a relatively low total light output with a short time to peak and short duration.

sp gr Specific gravity.

spherical aberration A lens (mirror) defect associated with the failure of parallel rays of light falling on the lens at different heights to have a common focal point. In practice, this defect causes the distance to the plane of sharpest focus to change with lens aperture.

sphericity The amount of curvature of an optical surface or a wave front.

spider (1) A three-legged brace which is used to prevent camera tripod legs from spreading inadvertently. (2) A type of portable camera dolly. (3) See spider box.

spider box A set of electrical receptacles fed by one or more main cables. Fixtures on lesser cables can be plugged into the box.

spill (1) Stray (usually unwanted) light from a source. (2) Light near the edges of the angle of coverage of a floodlight, spotlight, etc., sometimes used when relatively weak illumination is desired on the subject. The light source will then be aimed somewhat away from, rather than directly at, the subject. See feather (1).

spill rings Sheet-metal tubes placed in front of a studio lamp to prevent unwanted stray light.

spin coating In photomechanical reproduction and photofabrication, the rapid rotation of a flat sheet (glass, metal) while or after a liquid (emulsion, photoresist, etc.) is poured on the surface. The intent is to produce a uniform coating of the liquid.

spindle A shaft that fits the hole in a film reel or spool to hold it firmly while allowing it to rotate, as on a motion-picture projector.

spin shot In motion pictures and television, a special effect by which the image rotates on the screen, then stops in the usual position, or conversely.

spirit photography The process of making pictures of alleged ghosts and other psychic manifestations. The practice flourished in the 19th century and has recently been revived.

splice (1) To join, by cementing or other methods, sections of motion-picture film, magnetic tape, etc. (2) The joint so made.

splicer (1) A device for facilitating the making of joints in film or magnetic tape or paper. (2) A person who operates such a device.

split back In a sheet-film camera, a means of making two or more small images on a single sheet of film. Syn.: sliding back.

split developer See divided developer.

split-diopter Applied to a supplementary lens designed to affect only a portion (e.g., half) of the field of view of the camera lens. The effect is to produce in-focus images of both near and far objects located in different areas (e.g., the left and right sides) when the depth of field is insufficient without the supplementary lens. Object points near the dividing line

spherical aberration

light rays

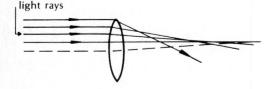

between the areas are reproduced as superimposed in- and out-of-focus images, similar to the images produced with soft-focus lenses. When the out-of-focus image is grossly unsharp, it merely contributes flare light to the image.

split-field Characterizing a rangefinder in which the viewed image is divided into parts by a fine line. Distinguish from superimposed-field. Syn.: split-image rangefinder.

split focus A lens distance setting at a position correct for an object plane between two objects at differing distances from the camera. Adequate depth of field then causes both objects to be imaged with sufficient sharpness. Also see hyperfocal distance; depth of field.

split-image See split-field rangefinder.

split reel (1) In motion-picture photography, especially in editing and in projection, a support for a roll of film having one side removable, so that the film can be transferred without being rewound. (2) A length of motion-picture film on which more than one subject has been recorded.

split screen (1) A projection surface divided into two parts, in each of which a different scene may appear. The technique is also used in television. (2) In motion pictures, two separate scenes or shots blended into one, as when a performer plays a dual role, or when a full-scale and miniature set are made to appear as one. A soft-edge matte is often used for this purpose.

split 35mm In still cameras, a frame size of 18 x 24mm as compared with 36 x 24mm for conventional 35mm still cameras. Syn.: half frame; single frame.

split tone A print effect or defect, depending upon intention, consisting of different colors in areas of different densities, obtained with some toners when the process is not carried to completion.

spoking Twisting of motion-picture film when it is curled and loosely wound on the reel.

spool (1) A cylinder with flanges at both ends, used for holding an unprocessed roll of film. The flanges keep the film aligned and protect it from accidental exposure. (2) In film-processing machines, a flanged wheel over which the film passes.

spot (1) Short for spotlight, a lamp from which the emitted light is confined to a small angle. (2) In retouching, to cover small defects on an image with dye (pigment, etc.) to blend them into the surrounding tone. (3) In television, a short commercial or other advertising promotion; also the time for such a presentation.

spot meter A luminance meter ("reflection"-type "exposure" meter) with a very narrow angle of ac-

ceptance so that it can measure a small subject area at a considerable distance. Most spot meters are photoelectric, but some are of the comparator type.

spray processing A method of supplying fresh solution (especially developer) to a photographic material by forcing the solution through a nozzle in a fine mist, directed forcefully against the material being processed. Used in some rapid-access techniques.

spreader A device for holding tripod legs firmly on a hard, smooth surface. It consists of three arms with receptacles for the leg points.

spread function A description, usually in the form of a graph, of the image of a point or line. A lens never produces an ideal point image from a point object; the spread function of the lens characterizes the actual image. The emulsion spread function is associated with the extent to which light is scattered within the emulsion. See: point spread function; line spread function; chemical spread function.

spreading effect A visual phenomenon by which dark areas next to a given color make that color look darker, and adjacent light areas make it look lighter. An effect contrary to simultaneous contrast. See centration (2).

sprocket (1) A tooth that engages a film perforation. Wheels having many such teeth are used to drive film through a camera, projector, or processor, and to operate counting devices. (2) Short for sprocket wheel, a circular device having projecting teeth.

sprocket-hole effect Streaks on processed film associated with the perforations. Such streaks are an indication of imperfect agitation.

SPSE Society of Photographic Scientists and Engineers.

spurious resolution In the image of a lens test object (resolution test chart), the appearance of moderately distinct lines, fewer than those in the test object. Spurious resolution is often associated with an error in focusing.

sputtering The process of evaporating a substance, especially a metal, and redepositing it on a surface, often glass. Semitransparent mirrors and some neutral-density and color filters are so made.

square-law detector A device that responds to a wave form of energy in proportion to the intensity of the wave. The intensity is proportional to the square of the amplitude of the wave. Photosensitive materials are square-law detectors.

square-root-of-2 Applied to a series of exposures, especially in a sensitometer, in which the exposure changes by a factor of 1.4X per step. Such a change is equivalent to a log change of 0.15, and to a half stop.

split-field rangefinder

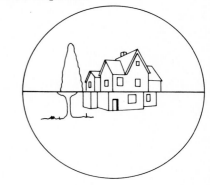

spread function

square wave A variation in luminance (light level) such as originates from a set of dark bars against a light background. The light abruptly changes periodically from a high level to a low level, as distinct from a sine wave, which involves a gradual change. A resolution test target is a set of square waves.

squeegee (1) To remove excess water or solution from a photographic material, by stroking with a soft blade, by rolling, etc. (2) A device used for removing excess water or solution from a material, such as a rubber wiper, air blast, etc.

squeeze As applied to a lens, producing a smaller scale of reproduction from side to side than from top to bottom. Used in some wide-screen motion-picture processes. See anamorphic (1).

squeeze motion The result of shooting in an animation camera a sequence of still photographs of an action taken a few seconds apart. The effect is of staccato, jumpy action.

sr Steradian, the unit of measure of an angle in three dimensions.

stabilization (1) A process that reduces unwanted changes in a material over long periods of time. The addition of chemicals to improve the keeping characteristics of emulsions, negatives or prints, mixed developer powders, prepared baths, etc. (2) Reduction of the image degradation caused by the motion of the camera during exposure, especially in aerial photography. (3) Reduction of dimensional changes in films and prints. (4) Conversion by chemical means of the silver halide remaining after development into compounds that are little affected by radiation. The process shortens processing time, at the expense of long-range image permanence. (5) Identifying a photographic printing process involving a paper that contains developing agents within the emulsion, and treatment of the exposed paper in two solutions (an activator and a stabilizer) in a roller-transport device.

stage (1) A support, as for a microscope slide, microfilm reader, etc. (2) In cinematography and television, a building or area within which a set is built.

stagnant Specifying development of photographic materials with no agitation. Used especially for photolithographic films after the first few seconds of development. Syn.: still.

stain (1) In black-and-white images, especially prints, an unwanted color, often yellow, caused by use of exhausted developer, contamination, or by incomplete fixation or washing. (2) In color prints, a faint color in areas that should be white. Analogous to fog.

stainless steel Any of a variety of alloys of iron that are relatively resistant to corrosion and to attack by chemical reagents. Used in the fabrication of processing tanks, etc.

staircase A step tablet used especially in television applications for testing the tone-reproduction characteristics of equipment.

stand A support for a camera, projector, etc.

standard (1) A part of a view camera that connects and holds the front or back of the camera to the corresponding runner. (2) In the physical sciences, the basis of a set of units of measurement. The international standard of length is the meter, defined since 1960 as a number of wavelengths of a specific kind of light. The international standard of mass is a metal object—the standard kilogram. See Système International d' Unités. (3) In photography, a document published by the American National Standards Institute (ANSI), formerly the United States of American Standards Institute. Such standards describe recommended film dimensions, chemical purity, methods of processing, etc.

standard deviation The most common statistical measure of variation within a set of measurements. Granularity (which see) is proportional to the standard deviation of density variations in a uniformly exposed and processed sample. Standard deviation is also used in process control: control limits are often set at $\pm 3\sigma$, i.e., at three times the standard deviation from the process average.

standard operating procedure (SOP) The series of precautions and procedures thought to be necessary for the proper functioning of an apparatus such as a machine processor, densitometer, etc.

stand-in A substitute person or prop used to aid the cameraman in arranging setups and lighting, and in working out camera moves in motion pictures.

stand-upper In television and documentary motion pictures, a sound shot of a reporter, usually at the beginning and end of a sequence.

star test In lens inspection, the examination of the image of a small (point) source of light as produced by the lens. The shape of the image is an indication of the quality of the lens.

start mark In motion pictures, a signal placed on the pictorial or sound record as an aid to editing and synchronizing picture and sound.

start-up (noun and adj) The initial period during which a continuous process is brought into conformance with specifications; for example, when an automatic developing machine, after having been shut down, is again operated.

state of the art At a given time, the best obtainable process, device, or system. The invention of a better

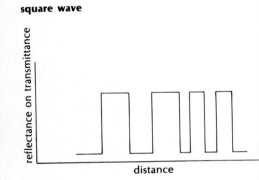

square wave

reflectance on transmittance

distance

process is said to advance the state of the art.

static (1) Without movement or the effect of movement. Applied to a dull composition in still photography, as well as to a shot in motion pictures during which the camera is not moved. (2) Short for static electricity.

static eliminator A device or substance intended to reduce the formation of marks associated with the discharge of electricity, and to lessen the accumulation of dust attracted by static electricity on films, etc.

static marks Spots, often branched, on photographic materials, caused by the discharge of electricity. In still photography, often caused by too rapid rewinding of 35mm film.

statistic A value obtained from a sample, such as sample average, sample standard deviation, sample range, etc. Such values only approximate the population parameters (see population; parameter) and are better approximations as the sample size is increased (assuming proper selection of the sample). See sample (2).

status filters Light-absorbers used in densitometers to produce a spectral response correct for a given purpose. Examples:

FILTER STATUS	PURPOSE OF MEASUREMENT
A	Color transparencies intended for viewing.
D	Color prints.
G	Inks used in photomechanical reproduction.
M	Color negatives.
V	Visual densitometry.

steadiness In motion pictures, the absence of unwanted shifts of the image position during projection.

steep (1) Strongly curved, as a lens surface. (2) Having a great slope, as the D-log H (D-log E) curve of a lithographic film.

Stefan-Boltzmann Law The rate of emission of radiant energy from a blackbody (standard source) increases as the fourth power of the absolute (Kelvin) temperature. A small temperature rise produces a very great increase in radiation. Mathematically, $J = kT^4$ where J is the emitted power, T is the absolute temperature, and $k = 5.709 \times 10^{12}$ watts/cm^2/degree.

step (1) An exposure interval (factor or multiplier), as in a sensitometer. A commonly used step is $\sqrt{2}$, i.e.,

about 1.4X. Syn.: increment. (2) A patch of a wedge used for test exposures, as in "11-step tablet," or "the 11th step of a 21-step tablet." (Note that the number of patches is one more than the number of increments.) (3) One of a series of baths or procedures used in processing images, as in three-step color process.

step-and-one-half A low platform having two levels (such as 4 and 8 inches) used in motion-picture studios to raise actors, cameras, etc., to suitable heights.

step-and-repeat camera (printer) An exposing apparatus by means of which multiple precisely spaced images can be produced from a single negative or positive.

step-down (-up) Applied to a ring for holding filters over lenses designed to allow the use of a smaller (larger) filter than would normally fit the lens.

step printer An exposing apparatus used in reproducing motion pictures, filmstrips, etc., in which exposures are made frame by frame. Compare with continuous printer.

step tablet A device for testing a photographic material, consisting of a set of patches having different absorptions of light. When a sample of photographic material is exposed to such an object, the sample receives different intensities of light (illuminances) and thus different exposures. Also known as step wedge, but step tablet is the preferred term.

steradian (sr) The unit of measure of a solid angle. An area on the surface of a sphere equal to the radius squared (r^2) subtends an angle of 1 steradian at the center of the sphere. Since the area of a sphere is $4\pi r^2$, there are 4π steradians in a whole sphere. An ideal source of intensity equal to 1 candela (new candle) produces a flux of 1 lumen in an angle of 1 steradian.

stereo Short for stereoscopic, as in stereophotography or stereophotographic, or for stereophonic (sound recording and reproduction).

stereo camera A photographic device capable of making two photographs of a scene simultaneously, as by two lenses or by a beam splitter. Typically, the viewpoints for the two images are separated by the approximate distance between the eyes of an observer. When the images are properly mounted and viewed, they appear to merge, forming a simulation of the scene in three dimensions.

stereogram A pair of photographs of the same subject, taken from different viewpoints and mounted for viewing so that a simulation of a three-dimensional image is obtained.

stereo pair Two images of the same scene, which,

static marks

L. Stroebel

when placed in a suitable viewer, simulate three dimensions.

stereophotogrammetry The technology of making measurements by the use of two photographs of the same scene made from different viewpoints.

stereophotography The simulation of three-dimensional effects by the preparation of two images from different viewpoints, each presented to the appropriate eye for examination.

stereoplanigraph An apparatus for making contour maps from aerial photographs.

stereopticon A dual projector, so arranged that one view is replaced by another by means of a dissolve.

stereoscope A device for viewing stereo pairs, typically photographic.

stereoscopy The presentation to a viewer of two images of the same scene taken from different viewpoints, so that a simulation of three dimensions is seen.

Sterry process A chemical method of producing more nearly normal prints from negatives that are too contrasty for the paper being used. After exposure, the print material is bathed in a solution of potassium dichromate, and then developed.

sticks (1) Short for clapsticks, a device used in motion pictures as an aid to sound-picture synchronization. (2) A command from the cameraman to the assistant that he is to move into the scene and clap the sticks together. (3) (slang) Tripod.

stigmatic Of a lens or other optical system, producing a point image from a point object. Free from astigmatism. Syn.: anastigmatic.

stilb A unit of luminance, equal to 1 candela per square centimeter of surface, i.e., 10^4 nits.

Stiles-Crawford effect In vision at normal light levels, light passing through the edge of the pupil of the eye is less effective in producing a visual effect than that passing through the center of the pupil. The significance of the effect is that measurements of pupil diameter do not reliably give information about response to light falling on the retina.

still (1) (adj) In processing, without agitation. Used especially for photolithographic materials, after the first few seconds of development. Syn.: stagnant. (2) (noun) An apparatus for purifying water by evaporating it and then condensing the vapor. (3) Identifying a single photograph, as distinguished from a motion picture.

still life An assemblage of inanimate objects or a photograph of such a scene.

stimulus (plural stimuli) A physical condition that may be detected by a sensory system. In vision, the stimulus is the radiant energy received by the retina.

stippling In spotting and retouching, the act of making small adjacent dots with the intention that they will be blended by the eye at normal viewing distances.

stirring rod A long cylindrical object of inert material, used for mixing solutions, etc.

stock (1) Unexposed film, especially motion-picture film. (Also, raw stock.) (2) Characterizing a photograph held for future use or an agency specializing in such pictures. (3) A solution, usually concentrated, from which portions are drawn. (4) A reserve supply of film, paper, chemicals, etc. (5) A support for a camera, held against the shoulder, similar to a rifle stock.

Stoke's law In fluorescence, the wavelength of the exciting radiation is shorter than that of the emitted radiation. By this law, for example, fluorescence in the blue spectral region requires that ultraviolet (or shorter) radiation be supplied to the fluorescent material.

stop (1) An aperture that limits the size of the light beam which can pass through an optical system. (2) An object that limits the movement of some part of a device, e.g., an infinity stop on the focusing mechanism of some cameras. (3) An exposure increase or decrease, especially in a camera or projection printer, by a factor of 2; e.g., as produced by a change in f-number from $f/4$ to $f/5.6$.

stop (bath) An acid or acid-forming solution, used to halt development in silver halide photographic processing by lowering the pH below that at which the developing agent functions. Syn.: shortstop. Stop bath is the preferred term.

stop down To reduce the aperture of a lens. The converse of open up. Syn.: close down.

stop frame In motion pictures, a special effect produced py printing a single frame several times. The image is frozen on the screen. Syn.: hold frame; freeze frame.

stop-motion Single-frame photography, in motion pictures, of objects that are shifted in position between frames. The process is distinguished from time lapse in that there is no fixed time interval between frames.

story (1) In motion pictures, plot, or development of a theme as in documentary films. (2) In still photography, a series of photographs connected by a common theme and forming a unified whole. Especially used in photojournalism. Syn.: picture story.

story board In preparing for motion pictures, filmstrips, and sometimes a picture series, a set of sketches, prints, or captions arranged to indicate the required sequence of images. Especially used in the preparation of animated pictures.

straight Without manipulation, as in making a print. A straight print has not been dodged or otherwise specially treated. Straight photography brings a similar directness to all parts of the photographic process, from shooting through printing.

straight cut In motion-picture editing, an abrupt transition between two scenes in a picture film, with a simultaneous transition at the same point on a separate sound film or tape. Syn.: editorial cut.

straightener A device or solution used to flatten curled prints. Syn.: print flattener.

straight line (of a D-log H curve) That part of a characteristic curve which is linear. Over a limited range, many photographic materials display such a plot. Within this range, the image contrast (density difference) is proportional to the contrast of the original (subject or negative, etc.). Many modern photographic materials have no straight line, or a double straight line. Straight-line reproduction in the negative does not ensure print excellence, since print materials on paper bases have only an inconsequential straight-line portion or none at all.

strand A loop or strip of film in a film-developing machine.

streak camera A photographic apparatus in which the image and film move relative to one another in one direction. The camera usually incorporates a slit, in which case the record is one of the event as seen through the slit, changing with time in accordance with the relative motion of slit and film. The apparatus is used in high-speed motion-picture photography and for pictorial effects.

streamers A more or less regular flow of developer over film that is processed with inadequate agitation. Also, the resulting streaks in developed film. Streamers are often found in tank development of sheet film, and especially in motion-picture processing.

Strehl intensity The energy at the center of an optical image of a point source of light. If the shape of the image is constant, this intensity is a measure of the quality of the image-forming optical system.

stress marks Defects in processed film caused by pressure, etc., before processing.

stretch printing In adapting silent films made at 16 frames per second to projection at 24 frames per second (the standard sound rate), every second frame in the original is repeated in printing.

strike (1) In motion pictures, to dismantle a set. (2) To cause an electrical arc to form. In starting carbon-arc lamps, the two carbon rods are made to touch and then are slightly separated. The arc strikes when the current continues.

string In motion pictures, to insert a short length of

cord into a film perforation to mark the beginning and the end of a section of film that is to be printed. String-to-string identifies a length of film so marked. Thin slips of paper are used for the same purpose. Syn.: paper; cord.

stringer Slang for a free-lance photographer who is employed occasionally by an agency, a publication, etc.

strip camera Photographic exposing apparatus, used especially in aerial photography, in which a long moving ribbon of film is exposed through a slit aperture at the focal plane, resulting in a continuous (rather than a frame-by-frame) record.

stripe A narrow band of magnetic material placed on motion-picture film for sound recording.

strip To remove completely an area of photoresist. Also see stripping.

strip light An illumination device consisting of several lamps arranged in a line.

stripping (1) In photomechanical reproduction processes, the act of arranging negatives or positives in appropriate positions, preparatory to plate-making. (2) Specifying a photographic material that can easily be peeled from its base. The application is to the assemblage of different images in preparation for platemaking.

stripup In microfilming, the procedure in which short lengths of film are attached to a transparent support for use in viewing or printing.

strobe (1) Short for stroboscopic. (2) A well-established misnomer for electronic flash (speedlight). (3) In animated pictures, a disagreeable flicker, typically when contrasty vertical scene elements move too fast laterally. The flicker is more noticeable in animation because the drawings do not have the blur characteristic of live-action photographs.

stroboscopic (1) As applied to a light source, capable of producing a series of short pulses of light. Used in high-speed photography. (2) Identifying a photograph, or series of photographs, made with a pulsed light source.

stroboscopic effect In motion pictures and television, the odd appearance of a moving object caused by the intermittent exposure of the film. A common example is the apparent reversal of rotation of a spoked wheel.

strong perspective Giving the impression of great depth, i.e., of marked separation of foreground and background. Syn.: forced perspective.

structure (1) General term for small-scale image characteristics. Image structure can be measured in terms of granularity, acutance, resolution, etc. (2) In relation to pictures, the distribution of visual

stroboscopic photograph

D. Krukowski

strong perspective G. De Wolfe

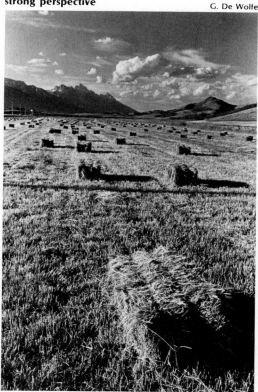

elements in the picture area. See composition (1).

studio (1) (noun) A room especially designed for making photographs. (2) (adj) An apparatus (camera, lights, etc.) intended for use in a room designed for taking photographs. (3) (adj) Photographs made in such a room. e.g., studio portraits as distinct from those made elsewhere.

study A carefully composed still photograph. Especially figure study, an artistic photograph of the nude.

stump In retouching, a blunt paper cone used to smooth out pencil marks.

style In a photograph, a distinctive, especially an original, quality that tends to be associated with the photographer. To those familiar with his work, a photograph by Karsh, for example, is instantly recognizable because of his unique style.

subbing (1) The process of coating a support (glass, film base) with a layer that facilitates the adhesion of a following, usually photosensitive, layer. (2) (adj) Identifying the layer coated for the purpose defined in (1).

subimage See sub-latent.

subject An object, scene or person chosen for photographic representation.

subject contrast (1) The ratio of luminance values from highlight to shadow in a scene. The average value for outdoor scenes is 160-1. (2) The logarithm of the luminance ratio. For outdoor scenes, the average value is 2.2. (3) In finding the modulation transfer function (which see), the maximum difference in target luminance divided by the sum of the minimum and maximum luminances.

subject failure In printing from a color negative or positive, the presence in the original of an excessive area devoted to a single color, such that the usual assumption that the image averages to a gray does not hold. The presence of subject failure requires a manual override on the automatic-printer exposure estimation.

subjective (1) Characterizing data obtained by visual examination of an image. Graininess, sharpness, and definition are subjective qualities of image structure. Compare with objective, implying instrumental means of obtaining data. Granularity and acutance are objective measures of image quality. (2) In a photoplay, the use of the camera as if it were one of the players by means of eye-level placement, and by moving the camera as a person would be expected to move.

subject luminance range The ratio of extreme-highlight to extreme-shadow readings made with a light meter measuring light reflected or emitted per unit area in a given direction. Ignoring optical problems, the subject luminance range determines the range of exposures that the photographic material will receive in the camera. The logarithm of the subject luminance range, under these circumstances, will determine the difference in log H (logarithm of the exposure).

sub-latent Specifying an image (formed by the absorption of radiation) that is insufficient to initiate development.

subliminal Applied to a stimulus that is below the intensity required for conscious perception. In vision, a subliminal image may be one presented for too brief a time for recognition to occur. It may nevertheless make some impression on the viewer.

subminiature (1) Still cameras that use film smaller than 35mm; for example, 16mm hand cameras. (2) A class of very small flashbulbs, having about 1/6 the volume of miniature bulbs but producing about the same light output. Subminiature bulbs are available individually (all-glass, i.e., without a metal base) and in flashcubes.

submount In displaying a print, a surround of color different from the mounting board, to set off the print from the board.

subproportional Applied to a chemical reducer or reduction that removes a smaller fraction of silver (dye, etc.) from dense areas than from thinner areas.

substandard Identifying motion-picture film widths less than 35mm. Now more often called narrow-gauge.

substantive Specifying a dye that is adsorbed to a substance without the use of a mordant, as opposed to adjective which requires a mordant.

substitute (substitution) reading A light-meter measurement of the photographer's hand, a gray card, etc. (instead of the subject itself). Such a reading may be used because of the inaccessibility of the subject, or because the substitute serves as a standard test object.

substrate A material, having an appropriately shaped surface, to which another material (often a resist) is applied in a thin layer. Substrates may be metal (as in photofabrication), glass, plastic, etc.

subtitle (1) In motion pictures, explanatory written material within the film, i.e., not part of the main titles. (2) Especially, in foreign-language films, a translation of the speech superimposed on the image, usually near the bottom of the frame.

subtractive (1) Identifying a color photographic process in which the final image consists of superimposed dyes, pigments, etc. The dyes are typically yellow (blue-absorbing), magenta (green-absorbing),

and cyan (red-absorbing.) Thus each of the dyes removes by absorption more or less of each of the three primary regions of the visible spectrum, as opposed to the additive process. (2) Identifying an optical or contact printing apparatus in which color balance of the image is achieved by the use of filters inserted into the light path, usually with a single exposure. Compare with additive printers.

subtractive reduction (reducer) A chemical treatment for negatives and prints that is supposed to remove equal amounts of silver from all areas. Image contrast is unchanged and, for a negative, only printing time would change. If a print is made darker than normal, highlight contrast is increased since highlight tones are moved to the right on the D-log H curve, to a region with greater steepness. Subtractive reduction may then be used to lighten the print, while still retaining the increased highlight contrast. Compare with proportional, subproportional and superproportional reduction.

successive contrast Enhancement of visual differences between areas of different luminance or color viewed sequentially. Compare with simultaneous contrast.

successive exposure In motion-picture photography (animation, etc.), the process of making black-and-white color-separation negatives, each of three adjacent frames being exposed with an appropriate filter.

sun arc A very large and brilliant artificial light source, capable of simulating outdoor illumination.

sunlight Illumination (on a surface) coming directly from the sun, without admixture of skylight or other scattered illumination. In the open, sunlight is always mixed with other light. Brightly lighted portions of a forest floor will be lit primarily by sunlight. Daylight is a mixture of sunlight and skylight. As compared with skylight, sunlight is relatively rich in long waves (red) and deficient in short waves (blue). The correlated color temperature of standard sunlight is 5400 K.

sunshade Lens hood, a device for reducing stray light falling on a camera lens. Syn.: lens shade.

sunspot An exceptionally brilliant spotlight.

super Short for superimpose(d), as a title or other image upon another.

superachromatic (also **superchromatic**) Identifying a lens corrected for four or more (rather than three or fewer) wavelengths of light.

superadditivity In the processing of silver halide photographic materials, an increase in the rate of development when two developing agents are used together, as compared with the sum of the rates of development when the developing agents are used

separately. Metol and hydroquinone are far more active in combination than would be predicted from their separate activities.

super coat A thin layer placed in manufacture on top of a photosensitive layer for protection or to facilitate retouching. Syn.: overcoat.

super 8 An 8mm motion-picture film with a frame size of 0.224″ x 0.166″, as distinguished from the smaller (original) 8mm frame size, 0.188″ x 0.138″. Super 8 film is perforated differently from standard 8mm film.

superimposed-field (-image) Characterizing a rangefinder that shows two images of the scene, one usually of a different color from the other, that are brought into coincidence when the subject is in focus. Compare with split-rangefinder field.

superproportional Characterizing a reducing bath or a chemical treatment of negatives that lowers the high densities far more rapidly than the low densities.

supersaturated Specifying a solution that for time being contains more solute (dissolved substance) than could normally be contained. Such solutions are unstable; some of the solute will precipitate out when they are physically disturbed or when they are seeded with some of the solute.

supersensitization A joint effect of two sensitizing dyes on the photographic response that is greater than the sum of their separate effects.

super 16 A motion-picture film with a single row of perforations and with an increased image area as compared with conventional 16mm films. The image can be increased to an aspect ratio of 1.65 if the area normally used for a soundtrack is devoted to the pictorial record.

supplementary exposure A controlled amount of light or other radiant energy allowed to fall on a photosensitive material either before or after the main image-forming exposure, to achieve a desired effect such as altering the contrast or density of the resulting image. See bump exposure, flash exposure, fogging exposure, hypersensitization, and latensification. Syn.: auxiliary exposure.

supplementary lens An optical element or assembly placed in front of a camera lens to change its effective focal length.

support A base, such as glass, paper, plastic, or metal, on which a photosensitive material is deposited.

suppressed-field Identifying a method of photographing a television-screen image with motion-picture film whereby the exposure is made during only one of the two interlaced scans, the pulldown

superimposed field (rangefinder)

occurring during the other scan.

surface (1) The sheen, tint, and texture of a printing paper. Sheen ranges from glossy to mat, texture from smooth to rough. The surface determines the range of tones that the paper can produce: for glossy, smooth papers the range may be more than 100-1, whereas for mat papers the range may be 30-1 or less. (2) Specifying a latent image that can be developed in a bath containing no silver halide solvents. It is believed that such a latent image is on, rather than within, the silver halide crystal. Also, identifying such a developing bath. (3) In perception, an object seen as reflecting light, as distinct from one seen as a source of light. The term "lightness" is applied to surfaces, "brightness" to sources.

surfactant A substance that affects the boundary properties of two other materials. Examples are wetting agents, emulsifiers, and detergents.

surrealism A school of art, and hence, of photography, that is based on Freud-inspired experimentation with automatism and accident, that especially emphasizes imagery related to dreams and the unconscious.

surround Region, e.g., background, within which an object of interest is seen or photographed.

suspension Finely-divided particles or droplets in a

surrealism D. Rivera

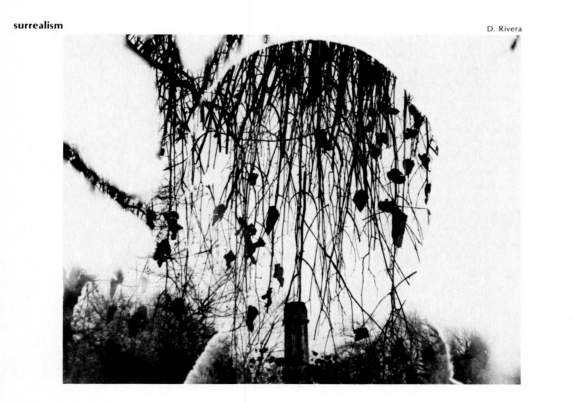

dispersing medium, that settle out only very slowly if at all. Silver halide "emulsions" are suspensions of silver halide crystals in a gelatin or other medium.

SW Single-weight.

sweep stage A miniature or full-scale setting where the horizontal plane of the background is continuous with the vertical plane, eliminating a break or table line. A sweep stage is commonly made of seamless paper, translucent plastic, or of a more nearly permanent material, such as wood or plaster. Such an arrangement is often inaccurately called a cyc (pron. sike), short for cyclorama, a well-established misnomer.

swelling The increase in volume of gelatin when it is wetted with water or water solutions. Swelling facilitates the penetration of photographic processing chemicals but makes the emulsion softer and thus renders handling more difficult.

swing (1) (noun) An adjustment on a view camera that allows the lens board or the camera back to be rotated about a vertical axis. When the lens board is so rotated, the plane of sharp focus in object space rotates in the same direction (but by a larger angle). When the camera back is so rotated, the plane of sharp focus in object space rotates in the opposite direction, and also the scale of reproduction changes from side to side, altering image shape. Such adjustments can be used to increase effective depth of field and to improve the image composition. Distinguish from tilt, which is a rotation about a horizontal axis. (2) (verb) To rotate the lens board or camera back as in (1).

swipe file Slang for a collection of tear sheets, etc., maintained by a photographer as a source of ideas for future photographs. Syn.: research file.

swish pan In motion-picture photography, a rapid rotation of the camera in a horizontal direction, to blur the image. It is used as a scene transition.

symbol In visual communication, a mark that signifies a thing or concept without resembling it, as contrasted with sign. The peace symbol is an example.

symmetrical Identifying a lens with similar front and rear elements.

symmetry (bilateral symmetry) A mirrorlike repetition of design elements (e.g., shapes) on either side of a line in a photograph or other image. The human face has approximate symmetry about a line down the center. Symmetry can be more than bilateral, as in a sphere or other form that repeats on more than one axis (spherical symmetry).

sync Short for synchronized, synchronization, etc.

sync cord The electrical wire that links a flash or

electronic-flash unit to a camera shutter. Syn.: flash cord.

sync generator In sound motion-picture photography, an electrical device that produces a series of pulses that control a camera and a sound recorder, keeping them in step with each other. Also see sync motor.

synchroballistic A type of image-motion compensation, used especially in the photography of missiles or other rapidly moving objects, by which the film is moved in accordance with the optical image of the object.

synchro-flash shutter See synchro shutter.

synchronism In sound motion pictures, the relationship between the picture and the corresponding sound (a) in terms of position on the film, or (b) the time at which the picture and sound are perceived. See camera synchronism; editorial synchronism; projection synchronism.

synchronization Correspondence in time, especially of sound and image in motion pictures, and of flash-lamp and shutter in flash photography with still cameras.

synchronizer In editing motion pictures, a device used by the film editor to keep two or more films in step, frame by frame.

synchronous (sync) speed 24 frames per second, in motion pictures. Syn.: sound speed.

synchro-shutter A camera timing device (shutter) containing a mechanism that opens the shutter at the appropriate time to utilize the light from a flash source. Syn.: synchro-flash shutter.

synchro-sun Outdoor photography with supplementary synchronized-flash illumination, to add light to the shadow areas and thus reduce the subject luminance ratio appropriately.

sync mark In sound motion pictures, any visible indication on the film or soundtrack that shows the relationship between the two records.

sync motor In cinematography, an electrical device

for driving a camera, etc., which is locked into the 60-cycle ac supply in order to maintain synchronization between two or more pieces of equipment, as camera and process projector. Also see sync generator.

sync tone (beep) A reference sound on a magnetic-tape sound recording as an aid to sound-picture synchronization.

synopsis A summary of a motion-picture story, filmstrip, etc.; an early stage in the preparation of a scenario, or for use in film catalogs.

synoptic terrain photography The process of making photographs of the earth's surface that will serve several purposes, such as geodetic, geologic, and oceanographic.

synthesis In color photography, that stage of the process at which an approximation to the subject colors is produced. In color photography, the synthesis is typically subtractive. In color television, the synthesis is additive.

system camera See modular.

Systeme International d'Unités (SI) A set of measurement units derived from the metric system, intended to be simpler and more rational than the metric system.

system-modulation-transfer acutance (SMT acutance) A measure of image quality that permits evaluation of the importance of the several factors (such as lens quality, film granularity, etc.) that affect the image. It is subjective in character, and normalized so that a score of 100 represents perfection and 70 a passable image; a difference of 2 to 3 units is detectable in the comparison of pairs of images.

syzygetic Side by side, as of a pair of density measurements with two adjacent apertures. The syzygetic density difference across an edge is important in the appearance of the edge with respect to visual sharpness.

TTTTTTTTTTTTTTTT TTT

T

T (1) Time (shutter setting). (2) Transmittance.

t (1) Temperature. (2) Time, as in the defining equation for exposure: $H = E \times t$ (exposure = illuminance × time), formerly $E = I \times t$.

tabletop (1) A subject for a photograph consisting of miniatures or models, intended to simulate reality. (2) Synonymous with still life.

tachometer A device that measures the rate of rotation of a motor or shaft, used to monitor the speed of a motion-picture camera, processor, etc.

tacking iron A heating device used to attach mounting tissue at a few spots to a print and then to a support. The first step holds the tissue in position on the print during trimming; the second holds the print in position on the support when it is placed in a heated (dry mounting) press for permanent adhesion to the support.

TAGA Technical Association for the Graphic Arts.

tail end (TE) That section of a motion-picture film which is to be projected last.

tail leader A section of blank film following the end of the motion-picture reel, often partly black so that inspection will show which way the reel is wound.

tails up In motion pictures, a reel of film that must be rewound before it is projected.

take (1) In motion-picture photography, an attempt at making a satisfactory photographic record of a scene. Also, a length of film resulting from such an attempt. Many takes may be made of a given scene, and each identified on the camera report as good or bad. (2) The response of an actor to a situation, as in double take.

take-up That part of a camera, film magazine, projector, processor, etc., which winds up film after it has passed through the rest of the apparatus.

taking (1) As applied to a lens, one used on a camera to produce an image on film, as distinct from a viewing, enlarging, projection, etc., lens. (2) Applied to that one of several lenses mounted on a turret that is actually being used.

talbot A unit of light energy, equal to a lumen-second.

talking head In television and (especially educational) motion pictures, a closeup of someone speaking. Overuse of talking heads makes for visual dullness.

tangential (1) In optics, specifying a fan of light rays that intersects the lens in a line parallel to a plane containing the lens axis and the object point. (2) Identifying one of the two line images formed by a lens having astigmatism. Each point of the line is formed by a fan of rays as in (1). The tangential line image is perpendicular to a line drawn from the image center to the margin. Compare with sagittal.

tank (1) (noun) A relatively deep container for a processing bath, as distinguished from tray. Rectangular tanks are used for sheet films held in hangers. Cylindrical tanks are used for roll films held on spiral reels. (2) (adj) Specifying development carried out in a deep container. Sheet film is supported by metal hangers, and agitation is carried out by the manual lift-and-drain technique. Roll film is wound on a support, spiral fashion, and the film is agitated by rotation of the support or rocking and turning the tank.

tanning In processing a gelatin emulsion, the hardening of the gelatin where an image exists. When untanned (soft) areas are removed, a relief image results that can be used in printing processes.

tape (1) (noun) A long, narrow strip of material coated with a magnetizable substance (commonly iron oxide) used for making sound and image recordings. (2) (verb) To make records on a material defined in (1). (3) (verb) To measure the distance

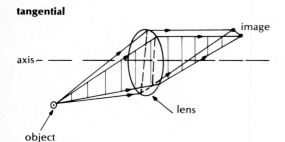

tangential

image

axis

lens

object

from camera to subject for the purpose of accurate focus. (4) (noun) A strip of paper, cloth, etc., with adhesive, used for temporary fastening or sealing, e.g., gaffer's tape.

target (1) (noun) A test object, such as a resolving-power target, reflection gray scale, etc. (2) (Followed by "audience") Identifying a group of persons for whom a film, slide presentation, or other program would be expected to have a special appeal. In preparing such material, the production staff should have a clear concept of the target audience. (3) In photogrammetry, a distinctive mark on the ground to identify the position of control points. (4) In microfilming, an aid to indexing, usually consisting of symbols large enough to read with the unaided eye. (5) In an x-ray tube, that part of the anode on which electrons fall, and from which the x-rays are produced.

target-object contrast (TOC) The ratio of the transmittance (or reflectance) of the light and dark areas of a resolution test object. High-contrast transmittance targets may have a ratio of 1,000 to 1, low contrast 2 to 1. Since measured resolution varies with target contrast, useful data are obtained only when the contrast is appropriately chosen.

taste The subjective ability to distinguish good from bad quality, especially in photography as an expressive art. Good taste involves a sense of what is fitting, appropriate to the purpose, etc. Taste is largely determined by cultural factors, and is neither uniform from person to person or culture to culture, nor constant in time.

τ (Greek letter tau) Internationally-accepted symbol for transmission factor (transmittance).

TE (tail end) That section of a motion-picture film which is to be projected last.

tear sheet A page, usually containing one or more pictures, removed from a periodical, for display, for instructional purposes, or for filing for future use.

tear strength See tensile strength.

teaser A small screen (gobo) placed horizontally in front of the camera, but high enough so that it does not appear in the photographed image. The purpose is to shield the camera lens from extraneous light.

Technical Association for the Graphic Arts (TAGA) A society of persons concerned with the technology of photomechanical methods of reproducing images.

technical photography The specialization of making photographs of objects and events in order to acquire information, as distinct from pictorial, commercial, etc., photography. Photogrammetry, high-speed photography, and photomicrography are among the numerous branches of technical photography.

technique (1) The complex of procedures that make up a craft or technology. (2) Skill in the use of equipment and materials, in posing models, etc., leading to a desired photographic result.

Ted Lewis A lamp snoot (cone or cylinder) that can be formed to produce differently shaped spots of light. The term comes from the crumpled top hat used by the performer, Ted Lewis.

telecentric Applied to an optical system so designed that only rays of light parallel to the optical axis can pass through. Especially, the use of a stop at the focal point, to increase depth of field and eliminate the effect of parallax in visual optical systems. The principle is used in the optical superposition of reticles on an image.

telecine (1) Short for television film. (2) Applied to a special projector having an intermittent movement such that film can be properly shown via television. (3) Identifying the department that handles film projection in television.

telecopier A device that transmits pictorial images or text (especially office documents) over telephone, radio, etc.

telephoto lens A long-focal-length lens having a shorter lens-to-film distance than a conventional lens of the same focal length, obtained by placing a positive element in front of a negative element, the two being separated by a space. A similar arrangement, reversed end-for-end, the inverted telephoto or retrofocus lens, is used for wide-angle lenses when a long back-focal distance is required, as for single-lens reflex cameras.

telephotography The specialization of making photographs of objects at great distances, usually with lenses of long focal length.

temperature coefficient For a given film and developer, the ratio of the rate of development at a given temperature to that at a temperature 10 C lower. The temperature coefficient varies from slightly more than 1 to about 5, depending on the film-developer combination. In many cases, if the temperature is lowered from 25 C to 15 C the factor is about 2, i.e., the required time of development about doubles.

template A cutout pattern, as of a circuit, used, for example, to expose a photoresist layer on a conductive substrate.

temporal fusion The process by which successive, somewhat different, images separated by a short time interval are perceived as connected. The process is basic to motion-picture photography.

tendency drive A method of moving film through a

processor without the use of sprockets, with automatic control of film tension.

tensile strength That property of a material by which it resists being torn or pulled apart. Tensile strength is important in film base, which must not be damaged in being handled or run through cameras, processors, etc.

tension (1) Pull, especially in a length of film or paper being moved through a processor, projector, etc. The amount of tension must be regulated to keep the material properly engaged in the apparatus, without excess pull which could stretch or otherwise damage the material. (2) To prepare a spring-driven mechanism for use, as to tension a shutter (syn.: cock), or to wind an interval timer.

tent Especially in the photography of polished metal (silverware, etc.), a structure of diffusing material placed over the subject and lighted so that only soft, diffuse lighting results. Translucent material (mat plastic, etc.) may be lighted from the outside. Opaque white sheets of paper, flats, etc., may be used, with lights placed inside and directed outward toward the tent structure.

tenth In microphotography, short for one ten-thousandth of an inch. In this usage, 5 tenths means 0.0005 inch.

terminal (1) An end, especially of an electrical connector as of a battery or dry cell. (2) A spring clip or other device for making an electrical connection. (3) Followed by "threshold," that light level so high that a further increase produces no increase in visual response.

tertiary spectrum The residue of uncorrected color (chromatic) aberrations in lenses after correction for three spectral wavelengths.

test (1) Generally, any experiment intended to determine the quality or character of a material, process, or device. Examples: lens test; test for residual hypo; test of washing effectiveness. (2) Specifically, in motion pictures, a short length of film exposed and processed to find out whether or not the result is satisfactory.

test chart An arrangement of lines or other elements used as a target to estimate the performance of lenses, films, etc.

test strip An exposure series on a single piece of photosensitive material, especially in projection printing, made to determine the correct exposure time, paper grade, etc.

tetartanopia One of four basic types of defective color vision (color blindness) in the dichromatism category, the other three being deuteranopia, protanopia, and tritanopia. A person with this defect (a tetartanope) sees all spectral colors as red or green, with both ends of the spectrum appearing red. Very rare.

text Written material as distinct from photographs or drawings. There is a further distinction between text (the body of the writing) and captions, titles, headings, etc.

texture A small-scale surface characteristic related to tactile quality or to continuous visible pattern, as of fabric, skin, etc. Roughness, smoothness, etc.

texture screen A semitransparent piece of glass, plastic, etc., containing a pattern so that when a print is made through it the appearance of canvas, etc., is imitated.

theatrical In motion pictures, films intended primarily for showing commercially in theaters as distinct from films intended for other use, such as educational, for television, etc. Compare with nontheatrical.

theme (1) In a picture story or sequence, the coordinating or linking concept that is common to the series. (2) For a single picture, the major subject emphasis, e.g., serenity.

thermal (1) Having to do with heat, as thermal development, thermal expansion, etc. (2) Having to do with infrared radiation, as in thermal photograph. (Note: Since the confusion between heat [degree of molecular motion] and infrared [radiation just longer than red light] is widespread, only context will indicate which of the two usages is being employed in a given instance.)

thermal coefficient of expansion Change in a dimension of a unit length (or volume) with a 1-degree temperature change. Of importance in the dimensional stability of films, papers, etc., when the temperature changes.

thermal development Production of a visible image merely by the elevation of temperature (without chemical processes). Used, for example, with vesicular processes.

thermal imaging device Applied to a photographic material that responds to infrared radiation.

thermistor An electrical resistor, the conductivity of which varies with its temperature. Thermistors are used in some processors for the measurement and control of temperature.

thermocouple A temperature-sensitive device consisting of two dissimilar materials (usually metals) that produce a measurable voltage when at a temperature above the rest of the circuit. A blackened thermocouple is often used to measure small quantities of radiation, as in the measurement of spectral-energy distribution of light sources.

thermography (1) Image formation by the direct

absorption of infrared radiation, as in some office copying machines. The image may be produced by the melting of small capsules containing dye or pigment. (2) Especially in medical photography, the use of infrared radiation to produce an image in a scanning device similar to a television tube; the image is usually recorded photographically. The method is used to detect areas of unusually high or low temperature in the patient's body. (3) In photomechanical processes, printing with an ink containing a powder that melts when it is heated. The effect is that of raised letters. The technique is used for wedding invitations, calling cards, etc.

thermoluminescence Production of light at elevated temperature but below that of incandescence.

thermometer A device for measuring temperature, of especial importance in controlling development, and of only lesser importance in fixation, drying, etc.

thermopile A group (series) of thermocouples, i.e., temperature-measuring devices that function by producing a small but measurable electrical voltage at an elevated temperature. The use of several thermocouples in a thermopile increases the sensitivity of measurement at the expense of increased size. Thermopiles are sometimes used in fundamental measurements of light sources, as in the process of finding the spectral-energy distribution of a light source.

thermoplastic Specifying a material that softens at elevated temperature. In a thin layer, and under the influence of an electrostatic field, such a material can be used to produce an image, sometimes called a frost image because of its appearance.

thermostat A device for sensing temperature changes, as in a processing bath, and originating a signal for a compensating change in case one is required.

thick (1) Applied to a lens of which the surfaces are far enough apart that their separation must be considered in lens computations. (Contrast with thin lens.) Lens assemblies are usually treated as thick lenses; object distance is measured to the front nodal point; image distance and focal length are measured to the rear nodal point. In thin lenses, these points are close enough together to be considered one point, and that point is at the lens. (2) Applied to an emulsion used, for example, to record the tracks of high-speed (nuclear, etc.) particles. Such an emulsion may be about 1 millimeter thick, and may be used in a stack of several layers. The intent is to record the passage of high-energy particles that would go through an ordinary emulsion layer almost undetected.

thin (1) As applied to a negative, having too small a density (too little silver or dye, etc.). If the negative shadow areas are too thin, the negative is underexposed—supplied with too little light during exposure. If the highlights are too thin, the error is usually in development. (2) As applied to a lens, one in which the separation of the lens surfaces is small enough to be neglected in computing image distances, magnification, scale of reproduction, etc. Measurements may be made to the lens without concern about position within the lens. Contrast with thick lens.

thin-lens formula A relationship between object distance (u), image distance (v), and lens focal length (f), as follows: $1/f = 1/u + 1/v$. A thin lens is one for which such measurements may be made to any part of the lens (front surface, center, or rear surface) without significant error. Lenses used for eyeglasses, and most supplementary lenses used on cameras, are thin lenses. Complex lenses, usually employed for camera and projector lenses, are not thin.

thinner A solvent, as for photoresists, inks used in photomechanical printing processes, etc.

third cover The inside of the back cover of a publication, as distinct from the front, second, and fourth covers. The second, third, and fourth covers of magazines are considered choice positions for advertisements, which commonly include reproductions of photographs.

thirty-five millimeter (35mm) A commercial motion-picture and still-film width.

thixotropic Applied to a viscous material that flows when pressure is applied to it. Developers may be made into such forms to be used in viscous processing.

thought photography A process alleged to result in pictures of memories or other mental images, dating back at least to 1893 and revived in the 1960s. The photographer obviously must be especially gifted.

thread To insert a film into a camera, projector, printer, processor, etc.

three-d (3D) Short for three-dimensional. Strictly, a process of presenting to the viewer two different views of a subject, taken from two different points of view, as in a stereoscope or by the use of polarizing spectacles, for the purpose of creating the illusion of depth. Loosely, a large-format presentation on a wide screen.

three-quarter view (1) In portraiture, an image that includes the head and torso. (2) A viewpoint intermediate between a front view and a side view. In portraiture, between "full face" and profile.

threshold (1) A level of response, as in photography or vision, just above no response whatever. A threshold speed is based on a minimum density above base

thumb mark

screen → right

screen → ʇɥƃᴉɹ (●)

viewing projecting

tilt

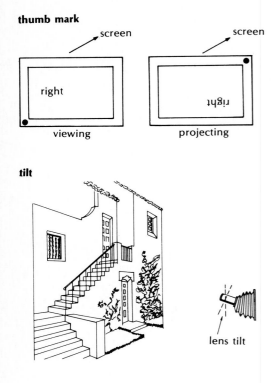

lens tilt

tilt top

time contrast-index curve

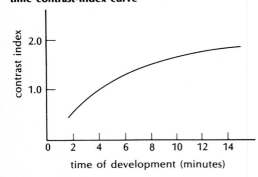

time of development (minutes)

plus fog. (2) Preceded by "terminal," a light level so high that a further increase produces no change in visual response. At the terminal threshold, the light is dazzling.

throughput The total amount of material, etc., that passes through a device or process, such as an automatic film or paper processor.

through-the-lens (1) Identifying a light meter placed in such a position as to sample the light energy at any of various positions within the camera body, sometimes that falling directly on the film. Contrast with meters which are used to measure the light falling on the subject (incident meters) or that coming toward (but outside) the camera lens ("reflected-light") meters. Through-the-lens meters have differently-sized receptors. Some may be moved about near the film plane to estimate the light energy at different positions within the image. (2) As applied to a view-finder, through-the-lens indicates that the camera lens is part of the viewfinder optics, eliminating parallax.

throw (1) In projection, the distance from the lens to the screen. (2) The practicable distance limit at which an artificial light source can be used to illuminate a subject.

thumb mark For a slide or transparency, a spot used to indicate the manner in which the slide should be placed in the projector. If the spot is in the lower left-hand corner of the slide when it is correctly oriented for normal viewing, it is in the correct position for projection when the spot is in the upper right-hand corner. The spot also identifies the viewing side (usually the base side) of the slide.

thryristor An electronic device used in electronic-flash circuits to stop the capacitor discharge when the photosensor indicates that enough light has reached the subject for correct exposure. Compare with quenching tube.

tie-down A device for preventing a tripod from tipping over on an inclined surface. It consists of a bridle and chain, etc., with a hook that fastens to a loop on the floor.

tie it off An instruction to a (motion-picture) crew member to tighten an adjustment on a piece of equipment, such as a light stand, or to fix the position of a tripod or dolly.

tight (1) Close to the subject, as a camera. (2) In tight shot, tight cropping, with the subject filling the frame. (3) As applied to a spotlight, illuminating only a small area of the subject. (4) For motion-picture film, firmly wound on the reel, as opposed to loosely wound.

tilt (1) (noun) An adjustment on a view camera that allows the lens board or camera back to be rotated about a horizontal axis. When the lens board is so rotated, the plane of sharp focus in object space rotates in the same direction (but by a larger angle). When the camera back is so rotated, the plane of sharp focus in object space rotates in the opposite direction, and also, the scale of reproduction changes from top to bottom, altering image shape. Such adjustments can be used to increase effective depth of field and to improve the image composition. Distinguish from swing, which is a rotation about a vertical axis. (2) (verb) To rotate the lens board or camera back as in (1). (3) In aerial photography, the angle between the camera lens axis and a perpendicular to the earth's surface. X-tilt is associated with aircraft roll and Y-tilt with aircraft pitch.

tilt top A camera support, attached to a tripod or other support, that permits a change in angle of elevation.

time (1) Identifying a camera exposure shutter setting in which the shutter is manually opened and later closed, usually involving an interval of several seconds or more. (Symbol T.) Distinguish from bulb (B), a prolonged exposure setting which opens the shutter when pressure is applied to the release, and closes it when the pressure is lifted. (2) In pricing photographs, a fee paid by the client based on the number of hours or days needed to complete the work. Also see timing.

time-averaging Applied to a photographic record made with long duration, so that the effects of transient changes are minimized.

time-contrast-index curve A plot of the contrast index (average slope of the D-log H (D-log E) curve over the most-used portion) versus time of film development. The graph is useful for determining the required time of development for a specific development contrast.

timed print In motion pictures, a positive or negative that has been corrected for variations in the density of the original.

time-gamma curve A plot of the gamma (straight-line slope of the D-log H (D-log E) curve) versus time of development. Now being replaced by a corresponding plot of contrast index versus time of development. The graph is useful in determining the necessary development time for a given development contrast.

time lag (1) As applied to a flash lamp, the interval between the initiation of the operation of the lamp and a specified point on the time-light curve of the lamp. The time lag may be measured to the beginning of light output, to the peak, or to one-half or

one-third peak. (2) In process control, the interval between the detection of a fault in the process and the correction of the fault. Process control is improved as this time lag is reduced. In automatic temperature control, appreciable time lag results in cycling of the actual bath temperature. (3) In picture-making, the interval between the decision to trip the shutter and the actual exposure. Factors include human reaction time and delay caused by mechanical linkages. Also see time parallax.

time-lapse In motion pictures, single-frame exposures, with relatively uniform intervals of time between frames. Upon projection, an event that takes a long time in reality appears in a short time on the screen. The time-lapse technique has often been applied to showing the growth of plants, changes in atmospheric conditions, etc. Distinguish from stop-motion photography, in which the time interval between exposures is not necessarily uniform or consistent. Time-lapse photography is the converse of high-speed photography.

time-light curve For a flash lamp, a graph of the light output in lumens plotted against the number of milliseconds (thousandths of a second) after the initiation of lamp operation. From such a curve, the necessary performance of the shutter for correct synchronization can be estimated. The area under the curve shows the total light output of the lamp.

time magnification In motion pictures, the ratio of the duration of the projected image to the duration of the actual event. High-speed photography produces great magnifications of time, since an event that occurs in a short time appears to occur in a long time in the image. The converse is true of time-lapse photography.

time parallax A displacement between two images (or between an image and a scene) because they are not simultaneous. For example, with a rapidly moving subject, time parallax occurs because of the interval between the photographer's decision to operate the shutter and the actual exposure. Also see time lag.

timer (1) A clock especially intended for use in processing: a) a simple timer that shows seconds and minutes; b) an interval timer that can be set to signal at a given time; c) a switch timer that controls print exposures, etc., by turning a light source on for a specified time. (2) In high-speed motion-picture photography, an apparatus that places a code mark at known time intervals on the film, thus making possible the determination of velocities of objects photographed. (3) In motion pictures, a skilled person who makes decisions about the required exposure or color filtration for printing.

time resolution The smallest duration that can be recorded by a specific method of high-speed photography, and thus a limiting factor in the image resolution of objects that move relative to the camera during the exposure.

time-scale Identifying an exposure device (sensitometer) that produces a series of exposures by changing the time, as contrasted with one in which the illuminance is changed (intensity-scale). Now obsolete except for x-ray exposures and the like, for which the reciprocity law holds.

time-temperature (1) Specification of development by objectively measured factors, as compared with development by inspection. In the first case, one processes, for example, for 5 minutes at 68 F, other factors being constant; in the second, one processes until the image appears correct. (2) Followed by "chart," a graphical means of finding the correct time of development at a temperature other than standard.

timing (1) In motion-picture printing, the estimation of the printing time (i.e., time of exposure) needed for a given negative or other original. The intent is to ensure uniformity in the print from negatives of different characteristics. In color printing, the process of timing also includes the estimation of the required color filtration. (2) In motion-picture photography, the act of synchronizing spoken commentary to a pictorial image. (3) In animation, the art of determining the number of drawings needed to produce the effect of a specific motion or series of motions on the screen.

tint (1) That difference between two colors which may be produced by adding white pigment to pigments of noticeable hue. Also, the colors so produced. Tints of red are pinks. (Contrast with shade, which is that color difference caused by adding black pigment to other pigments.) (2) In photomechanical reproduction, a dot or line screen by the use of which less than the maximum amount of ink is deposited. (3) One of the three surface characteristics of photographic papers, the other two being texture and gloss. Specifically the color of the paper stock, such as white, ivory, etc. (4) (verb) To hand-color a photograph.

tissue (1) Thin paper. See dry-mounting (tissue); carbon tissue. (2) In photogravure, the photosensitive material, consisting of gelatin on a paper backing. The material is exposed to form an image, hardened in development, then applied to the printing cylinder. After the hardened gelatin is washed away, the cylinder is etched.

title (1) In motion pictures and television, explana-

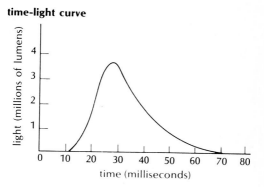

time-light curve

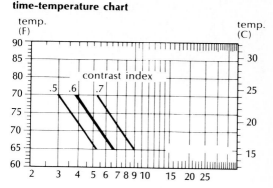

time-temperature chart

toe

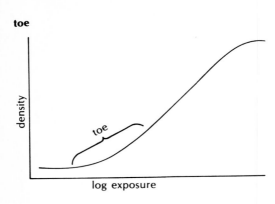

tone-line print

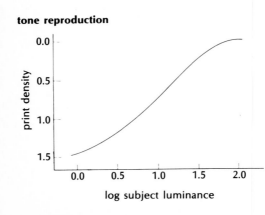

R.H. Thomas III

tone reproduction

tory text material. The main title identifies the production; the credit title identifies the staff; the cast title identifies the actors with the characters they portray; subtitles provide explanations during the show; the end title closes the production. (2) In filmstrips, a caption. (3) Identifying data, especially on aerial negatives, microfilms, and other data-storing photographic materials.

titler An apparatus for photographing identifying and explanatory text material, including a camera, lights, and support for the material to be photographed. Used primarily in motion pictures.

TL Through the lens.

TLR Twin-lens reflex.

T-number The f-number on an ideal lens (of 100% transmittance), which would produce the same image illuminance on axis as the lens under test at the given aperture. Syn.: T-stop. Unlike the f-number, the T-number takes into account the actual light transmitted by the lens. Thus, the T-number equals the f-number divided by the square root of the transmittance of the lens. Used mainly in motion-picture equipment; obsolescent in still-camera lenses since the advent of effective lens coating.

TOC Target-object contrast.

toe The region of the D-log H (D-log E) curve associated with small exposures (for other than reversal and direct-positive materials). The toe lies between the base+fog level and the beginning of the straight line. It is the region of variable contrast, the contrast increasing with increasing exposure. Compare with the shoulder, which is associated with large exposures, and in which increased exposure produces diminished contrast.

toe-in The angular convergence of the two optical systems in a stereoscopic system.

tolerance A part of a specification indicating the greatest permissible variation in the specified value. For example, in specifying the necessary temperature of a processing bath as 75 F, a tolerance of 1/2 F may be permitted. The specification will often be written as 75 F ± 1/2 F. (Tolerances are best put in terms of the allowable standard deviation of the specified value.)

tomography In x-ray photography, a method of showing parts that would normally be hidden. The x-ray source is moved through a circle whose center is the part to be photographed, and the film is moved similarly but in the opposite direction. Portions of the subject not at the center of the circle are blurred, whereas the point at the center is rendered with sufficient sharpness.

tonality The relationship between the photograph and the subject with respect to the reproduction of values (tones), and the effectiveness of this reproduction in producing the desired subjective effect upon the viewer of the image.

tone (1) A part of a subject or of an image identifiable in terms of its lightness, i.e., as related to a gray scale. A shadow is a dark tone; a highlight is a very light tone. (2) Luminance. Highlight tones have high relative luminance; shadows have low relative luminance. (3) In prints, a slight hue. Warm-tone prints are brownish; cold-tone prints are bluish. (4) (verb) To change the hue of a photographic image (negative or print) by chemical means. Examples: sepia tone; selenium tone. (5) The general lightness or darkness of a print, as in light-toned, dark-toned. (6) In photomechanical reproduction, the percentage of an area that is covered with ink. A 50% tone is approximately a checkerboard, half-covered with ink. (Black and white areas of the dot pattern are about equal.)

tone control Any method of altering image densities to produce a desired effect. Some or all of the following may be used: a change in the exposure level of the original record or of the print, etc.; a change in development conditions (time, bath composition, etc.); the use of an intermediate positive or negative; masking.

tone-line print An image consisting only of boundaries between areas (tones), giving the effect of a drawing. One method involves making a high-contrast negative and a positive, and printing them both together in near-register. Another method involves similar images, separated by a transparent thin spacer and mounted on a rotating turntable. A contact print made by using a small lamp off the axis of rotation contains only lines.

toner (1) A chemical bath used to change the hue of prints. Examples: sepia toner; selenium toner. (2) In electrophotography (e.g., xerography), a fine powder of resin plus pigment, deposited to form the image. Syn.: dry ink. (3) In photomechanical reproduction, an ink with a high proportion of pigment to varnish, oil, etc.

tone reproduction The study of the way in which different subject luminances are represented in an optical or photographic image. Tone-reproduction curves are plots of the functional relationship between input and output luminances, usually plotted logarithmically.

tone separation In a subject or image, the extent to which different areas are distinguishable. Tone separation may be increased by increasing lighting contrast, and by exposure and processing changes.

tongs An implement, commonly made of hard

rubber or plastic, used to handle prints during processing, to avoid wetting the hands.

tongue That part of the leader, or of the roll of film, which is cut in a shape to make threading easier.

tooth (1) The receptivity of a surface to ink or pencil, especially as applied to retouching. (2) A pointed projection on a sprocket wheel, etc., which engages a perforation on a film in order to transport it through a camera, printer, projector, etc.

top Applied to lighting from above the subject, as distinct from side and front lighting. In portraiture, top lighting often produces unpleasant shadows.

top-top In animation photography, the uppermost cell layer when there are more than three levels. Syn.: double-top.

toric Identifying a lens surface shaped like part of a doughnut, most often used for eyeglasses.

tormentor A sound-absorbent screen, used to reduce echo effects in sound recording.

torpedo An apparatus for underwater photography, consisting of a waterproof housing containing a camera, propelling motor, and light sources.

total color blindness Monochromatism.

total darkness The complete absence of light. The term is used in preference to "darkness" in order to emphasize the danger of exposing some photographic materials to even extremely low levels of white light or to safelight illumination.

total internal reflection The complete reflection of rays of light approaching air from glass, plastic, water, etc. If the angle of incidence exceeds a specific value (the critical angle), the ray cannot escape from the optically denser material. The principle is used in reflecting prisms and in fiber optics, and is a cause of halation in films.

totally diffuse density An image measurement made with light falling on the sample throughout a hemisphere, and with a receptor that captures practically all the light passing through the sample. Preferred term: doubly diffuse.

toxic Poisonous, injurious. Some developing agents and other photographic chemicals are toxic.

track A sound record on motion-picture film, magnetic tape, etc.; soundtrack.

tracking (1) The process of following a moving object to keep the image within the field of view of the camera. Syn.: trucking. (2) In processing long strips of film, ensuring that the strips go correctly through the processing apparatus.

tracking shot In motion pictures, an appearance of motion toward or away from a scene, accomplished by moving the camera or by the use of a zoom lens.

trade show An exhibition of photographic products and equipment, for the purpose of advertising, and of informing prospective customers.

trailer (1) A length of blank film at the end of a reel of motion-picture film, used to protect the last few feet of the picture from damage. (2) A short film used to advertise a coming attraction.

transceiver An apparatus for sending and recording facsimiles of documents or other images by wire, radio, etc.

transducer (1) General term for any device which produces one kind of energy from another kind, or which produces one type of signal from another type. (2) In electronics, a device that generates an electrical output whose strength is related to a change in temperature, pressure, vibration, etc. Transducers are used in automatic control systems.

transfer (1) The process of causing an image to move, by contact, from the original support, to another support. Examples: dye transfer; diffusion transfer. (2) In sound recording, to make a duplicate of a soundtrack, or to convert it, as from a magnetic to an optical record.

transformer A device that alters the voltage of an alternating (or fluctuating direct) electrical current.

transillumination (translighting) Providing light from the rear, as in viewing or copying transparencies.

transistor A device used to control an electrical current, similar in function to a vacuum tube but making use of the properties of semiconductors. Such solid-state electronic devices may be used for signal detection and amplification, as in densitometers.

transition In motion-picture photography, a change from one scene to another, usually accomplished by a cut, wipe, or dissolve.

translucent Permitting the passage of light but scattering it so that objects behind cannot be easily distinguished. Ground and opal glass are translucent.

transmission The penetration of energy, especially light, through a material.

transmission factor (T) (1) The ratio of energy, especially light, passing through an object to that energy which falls upon the object. Expressed as a decimal fraction or as a percent. (2) Operationally, the ratio of the irradiance recorded by a receptor (e.g., photocell) without and with a sample in the light path. (Transmission factor is recommended instead of the more usual transmittance.)

transmissivity For a nonscattering material, the transmittance of unit thickness, ignoring any surface reflection effect.

transmittance Transmission factor.

total internal reflection

transparency An image (usually positive) intended to be observed by light that passes through the image and base as on a viewer or by projection.

transparent Clear; having little absorption and producing little scattering. Optical glass is very transparent.

transport A general term for the process or method of moving film through an apparatus such as a printer, processor, or camera.

transposition (1) The act of changing the tonal values of an image from negative to positive, or conversely. (2) The act of changing the relative positions of the images in a stereophotographic pair.

transverse Identifying a wave motion in which the medium moves perpendicularly to the direction in which the wave travels. Light and other radiation consists of such waves. In sound waves, on the other hand, the medium oscillates in a direction parallel to that of the wave motion.

trap (1) A site in or on a silver halide crystal, etc., at which electrons previously freed are firmly held. Traps are important in latent-image theory, and in the theory of operation of solid-state devices, such as transistors. (2) See light trap.

travel In pricing photographs, the inclusion of costs going to and from the location as part of the fee to be paid by the client.

travel ghost In motion pictures, a streak caused by the failure of the shutter and the film transport mechanism to synchronize.

travel (ing) matte In motion-picture photography, a mask that changes from frame to frame, used to block out a portion of a scene. A complementary mask is then used to print the remainder of the scene.

traverse In motion-picture photography, a sidewise motion of the camera during a scene.

tray (1) (noun) A shallow container for solutions used for processing small quantities of film or paper. (2) (adj) A type of agitation involving rocking a shallow container that holds the developer and a sheet of film or paper. The present standard method for processing photographic prints.

treatment (1) In motion-picture photography, a preliminary state in the preparation of a script; a brief account of the plot or story. (2) Following "after-," the use of an intensifier, a reducer, a toner, etc., to change the characteristics of a processed image. (3) A style used by a photographer in dealing with a subject.

trial print In motion pictures, an edited, assembled version of sound and pictorial images in projection synchronism, prepared for evaluation.

triangle A device used on a smooth floor to pin the legs of a tripod and prevent them from spreading.

triboluminescence The transformation from mechanical energy (as by friction) to light at low temperature.

trichromatic Three-color. (1) Applied to a color photographic process that comprises three sensitive materials, each sensitized to a different major region of the spectrum (blue, green, and red). The final image consists of varying amounts of three different dyes (yellow, magenta, and cyan). (2) Identifying a theory of color vision that assumes the presence in the eye of three different sensors, each responsive to a different region of the visible spectrum.

trick (1) In motion-picture photography, applied to an optical printer, which is capable of producing many different special effects, such as enlargement or reduction, wipes, dissolves, etc. (2) Also applied to the result of such an operation, as in trick shot and trick effect, or to the use of an unusual camera angle, etc. (3) In still photography, any of a variety of techniques for producing special effects, such as using a long exposure time to make moving objects disappear from a scene.

trickle Applied to a slow rate of charge, as in recharging batteries used for electronic flash. The use of a trickle charge reduces the risk of damage from overcharging.

tricolor Identifying processes and equipment (cameras, filters, etc.) used to produce the three separation negatives used in color-reproduction processes. The three filters are necessarily blue-, green-, and red-transmitting. Tricolor cameras (one-shot cameras) contain beam-splitters and the requisite filters.

trigger To cause to begin to operate, as a shutter, lamp, camera, etc. A triggering circuit is used to cause several lamps or cameras to function at appropriate times.

trihedral mirror An assembly of three reflecting surfaces held at right angles to each other, as an inside corner of a cube. Any ray of light that is reflected from all three faces is reflected back upon itself.

trim (1) To adjust the position of the rods in a carbon-arc lamp. (2) In motion-picture photography, a length of film discarded in the editing process. (3) To cut a print or mount to the desired size, or to remove borders. (4) To shape the tongue or leader of film to fit a take-up spool or reel.

trimetrogon Especially in aerial photography, the use of three cameras, one aimed vertically downward and each of the other two aimed obliquely. The

trihedral mirror

result is lateral coverage of the earth's surface from horizon to horizon.

trimmer (trimming board) (Often preceded by "print.") A device intended for cutting off the margins of a print or to crop it preparatory to mounting for display or other use. It consists of a support for the print, rulers, and guidelines, a stationary blade and a sharp hinged knife or rotary blade. Trimmers may be used for other cutting operations, as on mount boards, etc.

trimming guide A metal form used to obtain the desired shape when cutting the leading end of a roll of film for proper feeding into a take-up mechanism.

trip To release a shutter, etc.

tripack Three emulsions of different color sensitivity on a single support, used in color photography. Syn.: monopack.

trip cord The electrical cord that links a flash or electronic-flash unit to a camera shutter. See PC cord. Syn.: flash cord; sync cord.

triple extension Specifying a camera with bellows sufficiently long that the lens may be moved away from the image plane to about three times its focal length. Used for photomacrography (the production of larger than 1-to-1 images in the camera) and to permit the use of lenses of greater than normal focal length.

triplet An optical system consisting of three lens components some of which may be other than single lenses.

tripod A three-legged camera support.

tristimulus value In the additive mixture of colors, that amount of one color needed in the mixture to obtain a visual match with a sample. Tristimulus values are data obtained in a colorimetric match. The components are usually red, green, and blue.

tritanomaly One of three basic types of defective color vision in the anomalous trichromatism category, the other two being protanomaly and deuteranomaly. A person with this defect (i.e., a tritan) requires more blue in a blue-green mixture to match a given blue-green than a person with normal color vision requires.

tritanopia One of four basic types of defective color vision (color blindness) in the dichromatism category, the other three being protanopia, deuteranopia, and tetartanopia. A person with this defect (i.e., a tritanope) sees purplish blue and greenish yellow as gray.

troffer A reflector, usually in the form of a trough, used especially with fluorescent lamps.

troland A unit of retinal illuminance. One troland is that retinal illuminance produced when the observer fixates a surface having a luminance of 1 cd/m^2, when his pupil area is 1mm^2. (The retinal illuminance does not, however, vary directly with pupil area.)

tropical (1) Identifying processes (especially development and hardening processes) intended for use at high temperature and humidity. (2) Identifying a type of packaging for photographic materials intended to protect them from high temperature and humidity.

trucking The process of following a moving object to keep the image within the field of view of the camera. Syn.: tracking. Distinguish from panning.

T-stop See T-number.

tune (1) As applied to a laser, to change the frequency of the output energy. (2) Generally, to adjust a process or a technique to produce the desired result. Also see tweak.

tungsten (1) The metallic element used as a filament in many artificial-light sources. Since it has a high melting point, it can be operated at a high temperature at incandescence, thus producing useful intensities of radiation in the visible spectrum. The spectral-energy distribution varies with the temperature of the filament. (2) The light from an artificial source using such a filament, in such terms as: tungsten light, tungsten film speed, etc. Note: Quartz-halogen lamps are tungsten lamps.

turbidity Cloudiness. Especially, that characteristic of a photographic material which causes scatter of energy within the photosensitive layer. One effect is to make edges unsharp.

turret A revolving support in which are fastened several lenses or filters, any one of which may be positioned for use in front of a camera or enlarger.

TV cutoff That part of a motion-picture or slide image that is not reproduced by a television system. Contrast with TV scribe or pumpkin, the part of the image visible on TV screens.

TV scribe In the viewfinder of a motion-picture camera, an outline indicating the portion of the scene that will be reproduced on most television screens. Syn.: pumpkin.

tweak A small adjustment made to a device or process, with the intent of improving its performance. A series of tweaks may be needed for the fine tuning of a delicate process.

twilight (1) An outdoor lighting condition that exists during the time between sunset and the arrival of night darkness. (2) Identifying a photograph made under the actual or simulated lighting conditions in (1).

twin-lens reflex (TLR) A camera equipped with two

lenses of similar focal length, one for viewing the image on a ground-glass or similar screen, and the other for making the photograph. As compared with the single-lens reflex, such a camera has the advantage that the image is always visible, and the disadvantage of parallax error because the two lenses have different viewpoints.

twist In motion-picture films, wavy edges produced when the film is loosely wound on the roll, emulsion side in.

two-bath (two-solution) developer See divided developer.

two-bath (two-solution) fixation The use of a pair of tanks or trays of fixer, the second of which is relatively fresh and uncontaminated. The method improves the keeping characteristics of prints especially, and is more economical than the use of a single bath. When the first bath is near exhaustion, it is replaced by the second, and a fresh bath is used for the second treatment.

twos In animation or stop motion, to shoot on twos involves exposing two frames of each drawing or pose, for the purpose of reducing the required number of drawings or poses for a given projection time.

two-shot A motion-picture scene in which two persons appear.

two-step A platform having two levels, used for the placement of actors, props, etc.

two-way (mirror) See semireflective.

Tyndall effect The scattering of light by small particles suspended in an otherwise clear medium. Such scattering is more effective for short waves (blue light) than for long ones, especially if the particles are very small. The Tyndall effect accounts for the blue appearance of the sky, of smoke, etc.

UU

U

u Object distance

UCL Upper control limit.

UCS Uniform Chromaticity Scale.

ultra high-speed Identifying a photographic system operating at over 1,000,000 frames per second, or with writing rates more than 10mm per microsecond, or at an exposure time for a single frame less than 10^{-7} second.

ultramicroscope A device for obtaining unusually high magnifications, as much as several tens of thousands of times. Specially designed electron microscopes may produce such magnifications.

ultraminiature Applied to a still camera that uses a film width of 16mm or less.

ultrasonic In the spectrum of sound waves, of length shorter than normal persons can hear. Ultrasonic vibrations are used for cleaning purposes, and very short ultrasonic waves can be detected photographically.

ultraviolet (UV) Radiation similar to light, but of shorter wavelength and invisible. Ultraviolet radiation consists of wavelengths from about 400 nm down to about 10 nm. Most photographic materials are very sensitive to ultraviolet radiation. Good sources of UV are mercury and carbon-arc lamps and daylight. (UV is sometimes called black light or ultraviolet light. Both phrases are inappropriate since, by definition, light is visible.)

ultraviolet filter (1) An absorber for ultraviolet radiation, ie., electromagnetic energy just shorter in wavelength than the shortest (blue or violet) visible radiation. See skylight filter. (2) An absorber for radiation other than ultraviolet, i.e., one that transmits radiation just shorter than the shortest visible radiation but absorbs light and infrared radiation. (Note: Only the context will indicate which of the two opposite senses is meant.)

umbrella A light reflector, often used with studio lamps, constructed like a parasol. It has an inside surface that is white or aluminized, so that it reflects and diffuses light. It is usually supported by an adjustable stand.

unconditional match That characteristic of two colored samples by which they have a similar visual appearance under any circumstances, e.g., even if the color of the light source is changed. Samples match unconditionally if they have identical spectral absorptions. Syn.: isomeric (pair).

uncorrected As applied to a simple lens, having all aberrations such as astigmatism, color defects, etc. Capable of producing a reasonably sharp photographic image only at small apertures.

undercolor removal In four-color photomechanical reproduction processes, the use of a black printer to reproduce desaturated, dark colors. The method saves colored inks and may improve the quality. Example: a brown color may be reproduced by appropriate amounts of the three colored inks, yellow, magenta, and cyan, the last in reduced amount compared with the other two. When undercolor removal is used, the brown can be reproduced by using less yellow and magenta, and some black ink.

undercorrected As applied to a lens system, designed so as to compensate only partially for a particular defect. Undercorrected spherical aberration, for example, implies a residual defect in the image associated with this specific aberration. The situation arises because of the necessity of compromise in lens design.

undercranking In motion-picture photography, operating the camera at fewer frames per second than the ultimate projection speed. The result is faster-than-normal movement on the screen. The term originated with early hand-operated cameras.

undercutting

Uniform Chromaticity Scale diagram

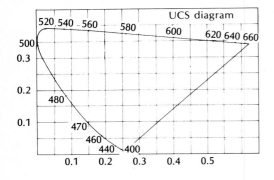

unwanted absorption

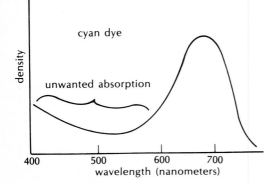

undercut In motion-picture projectors, etc., an alteration in the shape of the sprocket teeth, caused by wear. Undercut teeth can damage film.

undercutting In photofabrication, the sidewise etching of a protected area at the edge of the photoresist.

underdevelopment Processing a photographic material for too short a time, at too low a temperature, with insufficient agitation, or in a weak developer. The effect is lower-than-normal image contrast, and sometimes lowered effective speed of the material.

underexposure The provision of too little light for a correct response of a photosensitive material. In a negative exposed in the camera, the effect is too little density and contrast in the dark tones of the subject, and thus insufficient shadow detail. Underexposure in the print causes the dark tones to be too light, and the light tones to have too little contrast and thus insufficient highlight detail.

underground Applied to a motion picture made by amateurs or semi-professionals, typically made on a small budget and having a plot that makes it not ordinarily acceptable for commercial showing.

underlighting (1) Too little light to produce a good exposure. (2) Illumination from underneath; trans-illumination.

undervoltage A less-than-normal electromotive force, applied to an electrical device. Ordinarily, studio lamps operate normally at 120 volts. The use of lower voltage greatly increases the working life of tungsten lamps, at the expense of lowered total light output and especially less energy in short (blue) wavelengths. The converse is true for overvoltage.

undressed Applied to a (motion-picture) set without properties.

unexposed Identifying photosensitive material (film, paper, etc.) that has received no radiant energy to which the material is sensitive. Unused.

Uniform Chromaticity Scale (UCS) Applied to a diagram that shows the results of color-matching experiments, and in which the scales are adjusted so as to make equal distances on the diagram represent approximately equal visual differences.

unipod A camera support having a single leg.

unit In motion pictures, a team of cameramen and other technicians assigned to a film production.

unit amount That concentration of a dye which produces a density of 1.0. (Note: Since color densities are variously defined, the unit amount of a dye will vary with the type of density being used. See analytical density; equivalent neutral density.)

unitized Applied to a single microfilm frame mounted in a card, etc.

unity (1) In a photograph, the impression on the viewer of coherence and the fusion of the compositional elements of the photograph so as to emphasize a single concept or idea. (2) In mathematics, equal to 1.

universal (1) Applied to a lens focal setting such that both very near and very far objects are imaged with acceptable sharpness. Universal focus is used especially for simple, fixed-focus cameras, in which case the lens is set for the hyperfocal distance. (2) As applied to a developer, suitable for both films and papers.

Universal leader In motion pictures, a standard length of nonpicture film preceding the picture, replacing Society leader.

unmodulated Unchanged; unaltered, as a section of a soundtrack in which no record has been made. Equivalent in terms of sound to unexposed in terms of radiant energy.

unsaturated (1) Containing in a solution less than the maximum possible amount of dissolved material (solute) at a given temperature and pressure. (2) As applied to a color, not vivid; dull or pale. Visually neutral colors (grays) are completely unsaturated. Brown is a relatively unsaturated orange; pink is an unsaturated red.

unsharp (1) Applied to an image in which edges are not distinct. (2) Specifically, applied to a mask made by exposure from an original through a spacer or diffuser, so that fine details are not clearly reproduced. Such a mask reduces large-area contrast, but retains small-area contrast. When a print is made from the masked negative, sharpness will be improved as compared with an unmasked negative. The use of unsharp masks also eases the problem of registering the masks with other images.

unsqueeze Slang for deanamorphose. In projection on a wide screen, to use a cylindrical lens system to produce a greater magnification in width than in height, thus undoing the squeezing in width that occurred in taking the picture.

unsymmetrical Having parts that differ on the two sides of a reference line. Especially, in a lens, having different elements on either side of the center of the lens. The term is also applied to the composition of the elements of a photograph: quite different shapes, colors, etc., lie on either side of a central line. Syn.: asymmetrical.

unwanted absorption As applied to dyes, that characteristic by which they reduce the level of radiation at wavelengths for which ideal dyes would be completely transparent. For example, magenta dyes are

used to absorb green light but have an unwanted absorption for blue light. Yellow dyes have a slight unwanted absorption for green light and cyan dyes for green and blue light. Unwanted absorptions of dyes cause problems in color reproduction and in the use of filters, as in color printing.

up Following a number, at the same time, or in the same frame. Example: to expose six up means to expose six step-and-repeat images in a single frame.

upper control limit (UCL) That line on a process control chart below which the process (when it is stable) usually functions. A value above the UCL indicates an abnormality that should be corrected.

upstage (1) In motion-picture photography, away from the camera, as distinct from downstage (toward the camera). (2) To behave (as an actor) so that another performer is obscured.

usage fee In advertising photography, an additional charge made for a photograph that is to be given wide distribution, e.g., on network television or in major periodicals.

USASI United States of America Standards Institute, former name of the American National Standards Institute (ANSI). Previously called the American Standards Association (ASA).

useful duration For a flash lamp, the time interval between two points on the time-light curve at halfway up to the peak. (For electronic flash, the points are usually one-third peak.) An approximate measure of the effective exposure time when the lamp is used on open flash.

useful exposure range The interval between the minimum and maximum exposures that will produce a satisfactory image. The useful exposure range may be expressed as a ratio (e.g., 1,000:1) or, more appropriately, as the log of the ratio (e.g., 3.0). For photographic papers, the scale index is one measure of the useful exposure range.

useful life The length of time over which a lamp, processing bath, etc., can be employed with little change in performance characteristics. For example, the useful life of a tungsten lamp is about half its rated life before complete failure.

USP United States Pharmacopoeia. A listing of chemicals intended for medicinal use. The purity of chemicals so labeled may or may not be appropriate for photographic use.

UV Ultraviolet.

useful duration

useful exposure range

V

v (1) As a subscript, specifying light, as distinct from radiation generally. L_v signifies luminance. Also, in the APEX system, value. (2) In lens formulas, image distance. (3) Volts; electrical pressure.

VA Variable area, a type of photographic soundtrack.

vacancy In a crystal, such as of silver halide, a space in the crystal lattice that is empty of an ion that would normally be present. Vacancies in such crystals affect their response to radiation.

vacuum back (board, frame) A device for holding film or other photogaphic material in a fixed position by the use of air pressure. Air is removed by a pump from the space between the material and a reference surface to which the material is firmly held by air pressure on the other side.

vacuum deposition The transfer of a material in a thin coating to a suitable surface by evaporation and condensation in a chamber at low pressure. The method is used for lens coating, manufacture of interference filters, etc. Syn.: sputtering.

vacuum ultraviolet Radiation of such a short wavelength that it is strongly absorbed by air. Photographic images made with such radiation must be exposed in the absence of air, i.e., in a vacuum. Vacuum spectrography is the technology of making such images in order to study the effects of the radiation.

value (1) In the Munsell system of color nomenclature, a numerical designation of lightness. White has a high value, black a low value. (2) To an artist, approximately the same as tone to a photographer. Used in this context in the zone system of photographic exposure and development, high values are relatively light, low values dark. (3) In the APEX (logarithmic) system of determining camera settings, a number assigned to film speed, exposure time, etc., used in computations.

valve In sound recording, a device that changes the light from a small lamp in accordance with the received sound energy. The change in the light produces the photographic soundtrack image.

vandyke Identifying a reproduction made on an emulsion containing iron and silver salts, whereby a brown positive image is produced from a negative original. Typically used as a proof before making a photomechanical printing plate. Syn.: brownline.

vane agitation A method of causing developing solutions, etc., to move relative to the material being processed, by the motion of narrow blades in the solution close to the material. Vane agitation is effective but is sensitive to small variations in design and operation.

vanishing (1) In perspective, applied to that distant point to which a set of parallel lines appear to converge, or the image of that point in a photograph. (2) Applied to a line that is the locus of all points to which all sets of parallel lines parallel to one plane seem to converge.

Van Kreveld's law If two or more exposures that differ in spectral energy distribution (color) each produce the same density at the same exposure time, then any fractions of these exposures that sum to unity will also, when combined, produce the same density. Syn.: additivity law.

vapor lamp A source of light or other radiation usually caused by an electrical discharge (arc) in a tube containing a gas. The color of the light is determined mainly by the nature of the vapor, but is to some extent affected by pressure, temperature, etc. Examples: sodium vapor lamp; mercury arc; xenon (electronic-flash lamp).

vapor process A method of development making use of a gas rather than a liquid. Especially applied to the processing of diazo materials.

variability In a repetitive operation of measurement or of a process, the inability to obtain the same value or the same product. Random variability (i.e., associated with chance causes) is often called experimental error, and is often measured by the standard deviation. Changes in a process caused by factors that can be identified are related to assignable causes. One of the applications of statistics is in experimental methods designed to distinguish between chance and assignable causes.

variable (1) Changeable, as a shutter on a motion-picture camera that can be adjusted so as to alter the exposure time per frame. (2) (noun) In an experiment or process, a factor that can be changed (input variable) or a result that changes (output variable). In development, input variables include time, temperature, agitation, and developer ingredients. Output variables include density, gamma, contrast index, etc.

variable-area (VA) That type of photographic sound-track which in the print consists of a relatively clear area bounded by two relatively opaque regions. The width of the clear area and the shape of the boundary are altered in accordance with the loudness and the quality of the sound being recorded.

variable color filter A combination of a neutral polarizer and a colored one that polarizes different wavelengths of light to different degrees. Rotation of one polarizer relative to the other changes the degree of absorption of the pair to some wavelengths more than others, and thus changes the saturation of the filter set.

variable-contrast (1) In a print material on a paper base, the use of two superimposed or mixed emulsions that differ in spectral sensitivity (response to different wavelengths of light) and also in scale index (contrast). Different print-contrast characteristics can be obtained by the use of different colors of light in exposing the material, as by the use of filters. In this way, different paper grades can be obtained from a single material. (2) As applied to a developer, especially a paper developer, a two-solution formula that, when mixed in different proportions, changes the image. Often one solution contains a contrasty-working developing agent (such as hydroquinone) and the other contains a low-contrast developing agent (such as metol).

variable-density (VD) In motion pictures, applied to a photographic soundtrack recording in which the image has a constant width, and in which the concentration of the image deposit changes in accordance with the received sound. The record consists of horizontal bars; the size of the bar is related to the sound frequency, and the density to the loudness.

variable resistor See rheostat.

variable shutter In motion-picture photography, a rotating sector disk, the aperture of which can be altered to change the effective exposure time per frame.

variable transformer An electrical device that can produce any voltage from zero up to a maximum. Such a device is used as a light dimmer, or for controlling the speed of some electrical motors. Distinguish from rheostat, a variable-resistance device that performs similar functions.

varifocal As applied to a lens, capable of being adjusted in focal length. Includes both convertible and zoom lenses, which see.

varioscopic cinematography In motion pictures, the capability of changing the image size and format for esthetic and other effects.

varnish (1) The fluid component of inks used in photomechanical reproduction, especially offset. (2) A glossy coating applied to a photograph or to a print made by photomechanical reproduction.

VD Variable density (soundtrack).

vectograph A method of stereophotography that involves two superimposed images on a single support. The images are polarized at 90° and viewed through polarizing spectacles, with the two filters arranged so that each eye sees the appropriate image.

vector A line having specific length and direction. Such lines may represent intensity of light emitted by a source at a specific angle, shifts in color reproduction (as on a chromaticity diagram), etc.

veil Slight fog, most noticeable in the light areas of a negative or print.

venetian blind A light-controlling device, placed over a light source, consisting of a set of narrow slats that can be moved so as to cover more or less of the source. The device avoids the color change that is produced when either a dimming rheostat or a variable transformer is used for this purpose.

vent To release gas or vapor from a battery when heat produces excess pressure.

vernier A movable graduated scale used as an aid to measurement, as of focal position on camera beds. The correct position is accurately known when two lines (one on a movable scale and one on a fixed scale) are aligned. (2) As applied to visual perception, the ability of the eye to detect a small misalignment in two lines, the ends of which nearly touch. Visual vernier acuity is much better than visual resolving power.

vertex In optics, the point of intersection of the axis of a lens with the surface of the lens.

vector

light reflected from a semimat surface

vernier (1)

vertex

vertical In aerial photography, identifying a photograph made with the optical axis perpendicular to the earth's surface, as contrasted with oblique or horizontal.

very-high-speed Characterizing a motion-picture system operating between 10,000 and 1,000,000 frames per second, or between writing rates of 0.1mm to 10mm per microsecond, or at exposure times for individual frames between 10^{-7} and 10^{-5} seconds.

vesicle A small bubble. One photographic process is based on the formation of tiny bubbles in a thermoplastic sheet of film.

vesicular Applied to a heat-developed photosensitive film in which the image consists of small bubbles. When it is illuminated with specular (collimated) light, the image has sufficient contrast for viewing or for printing purposes.

VFC Video film converter.

vibrating Specifying colors which when near to each other produce a sensation of flickering movement. Adjacent saturated complementary colors often produce this effect.

vibrator In a portable electronic-flash unit, a device that chops a low-voltage direct current from a battery, and feeds this current to a transformer, from which a high voltage is produced to operate the flash lamp.

video (1) In television, the signal containing visual information, as opposed to audio, the signal containing the sound information. (2) Television.

video player An attachment to a television set that permits the reproduction of film or tape.

video tape A magnetic recording material to accept sound and picture signals for later use, as on a delayed broadcast.

view (1) A scene or an arrangement of subject material for a photograph. (2) (verb) To watch a motion picture, a TV program, an audio-visual program, etc.

view camera An apparatus for exposing film, typically having the following characteristics: large film size (usually in sheet form); ground-glass viewing to permit image composition and focusing; capability of lateral, vertical, and angular adjustments for the lens and the film-holding camera back; considerable bellows extension; accommodation for interchangeable lenses. Such a camera is generally used mounted on a tripod.

viewer (1) A device for examining images, especially small transparencies. Microfilm viewers are specially designed projectors, usually using rear projection. (2) A person looking at a photographic image, mo-

tion picture, etc., especially a subject for an experiment in visual perception.

viewfinder Any of various types of apparatus for displaying the limits of the scene to be recorded by a camera. Syn.: finder.

viewing distance The spatial separation between an observer and a scene or image. For correct perspective, the viewing distance for a contact print should be the same as the camera image distance (usually the focal length of the taking lens). For an enlargement, the camera image distance should be multiplied by the image magnification. For example, if a 10X enlargement is made from a negative produced with a 2-inch camera lens, the viewing distance for correct perspective is about 20 inches. Depth of field also varies with the viewing distance of the image.

viewing filter A piece of dyed glass or other material, used to examine a scene visually to judge the lighting, or to anticipate the rendering of different colors in black and white. Deep blue filters were formerly used. Now the filter is more often amber or neutral.

viewing lens In twin-lens reflex cameras, the optical system which forms an image that may be inspected by the photographer, as distinct from the separate taking lens that produces the image on the film. The viewing lens is matched in focal length to the taking lens, but need not be matched in optical performance.

viewing screen The ground glass (or equivalent) in the viewfinder of a reflex camera. Some cameras have interchangeable viewing screens, with different focusing aids, etc. Syn.: viewscreen.

viewing tube A device for examining a scene through the taking lens with a rackover arrangement.

viewpoint The position from which a scene is observed or photographed. The viewpoint in part determines the perspective of the image. (The lens focal length determines only the scale of reproduction if the viewpoint is held constant.) Also see center of perspective.

viewscreen See viewing screen.

vignette In making photographic negatives or prints, to cause the subject gradually to merge into a featureless surround. The procedure is used especially for portraits.

vignetting A rapid fall-off in image illuminance near the edges of the image. The cause is reduction in effective aperture by the barrel of the lens.

Villard effect A partial reversal of an image formed by x-rays when a second exposure is given to light.

violet Name for the color seen under ordinary

view camera

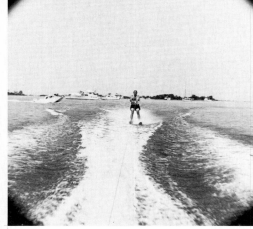

R. Palum

vignetting

R.F. Pierce

circumstances near the extreme limit of visibility of the shortwave end of the spectrum. Extremely short waves look slightly reddish-blue, as compared with somewhat longer waves, which look bluish.

virtual In optics, an image (or object) at which no image-forming light is actually present but which is constructed from the extension of light rays. One's image as formed by a flat (plane) mirror is virtual, in that no light is found where the image is located. Contrast with real images, which consist of the intersection of actual light rays, and which can be cast on a screen or film.

viscosity As applied to liquids, resistance to motion, measured by the force needed to move an object through the liquid, or by the length of time it takes a given volume of liquid to pass through a given opening at a specified temperature. The viscosity of materials (emulsions, etc.) is an important characteristic in coating processes.

viscous processing Application of chemical agents in a thick fluid, used in some soundtrack development and in some rapid-access photography.

visible light A redundant phrase, to be avoided, inasmuch as light itself is defined as the radiation capable of serving as a stimulus for the normal eye.

visibility function Obsolete term for luminosity function.

visual (1) Having to do with the human eye. (2) In the context of instruction or education, short for visual aid.

visual aid A general term for any drawing, photograph, or other graphic construction used to inform, educate, or entertain an audience.

visual communication The art, craft and technology of conveying information and emotion by the use of graphic and pictorial methods, as distinct from the use of written and spoken words.

visual cortex That part of the brain which governs seeing.

visual density The absorption characteristic of an image (silver, dye, etc.) measured in terms of its effect on a standard human eye. Visual density is measured directly by an instrument that requires the matching by eye of a comparison and a reference field. Alternatively, visual density may be estimated by computations based on the standard eye luminosity (visibility) curve.

visual literacy General acquaintance with, and comprehension of, methods of conveying information and emotion through the use of graphic and pictorial images, as distinct from the use of written and spoken words.

visual purple The reddish-blue pigment found in the rods of the retina. It is bleached by the action of light, and is thus one of the chemical substances directly concerned with vision. Syn.: rhodopsin.

vitamin A A food substance related to visual purple, and from which that pigment of the retina is formed. Syn.: retinal, the preferred term.

VLS In motion pictures, a very long shot; i.e., a scene in which the important subject matter is at a great distance from the camera.

v-number Properly, ν-number. ν is the Greek letter nu, which see.

voice-over (VO) In motion pictures, the sound of a commentator superimposed on a previously made pictorial and/or sound record.

voice track In motion pictures, a record of spoken words that later may be mixed with music and other soundtracks for the completed production. Syn.: dialog track.

volatile Easily converted into a vapor, as alcohol, ether, etc. Many film-cleaning liquids are volatile.

volt (V) The measure of electrical pressure (electromotive force). A dry cell produces only a weak pressure, typically about 1-1/2 volts. Some electronic-flash units operate at thousands of volts.

voltage Electrical pressure; electromotive force.

voltage regulator A device for ensuring a constant electrical pressure (voltage) despite variations in the supply lines. Such equipment may deliver a voltage that is nearly constant at 120V, even if the lines vary from 90 to 140 volts. Voltage regulators are useful in supplying printers and measuring equipment to make their output more nearly stable. They are effective only if they are operated at near their rated wattage.

VTR Video-tape recorder (recording).

W

W Watt.

wafer A thin layer of semiconductor crystal used in the manufacture of microcircuits. A desired pattern is produced by the use of photoresists.

waist-level Applied to a viewfinder, as on a twin-lens reflex camera, in which the image is comfortably seen if the camera is held near the photographer's midriff.

walk-on In motion pictures, a very small (bit) part for an actor.

walk-through A rehearsal, as for a photoplay.

wall camera An apparatus for exposing plates, etc., especially for photomechanical reproduction purposes: the lens bellows is mounted in a sealed opening in a darkroom partition so that film can be placed in the back of the camera without having to load it into a film holder.

want list A documented series of descriptions of photographs needed by a publication, sent to freelance photographers either routinely or upon request.

wardrobe The costuming for a motion picture.

warm Having a red, orange, or yellow hue.

warm-toned Tending to produce images that are slightly yellowish or reddish, as distinct from neutral or cold-toned (slightly bluish). Applied especially to printing papers.

warmup Applied to the time needed for equipment or material to reach a stable condition prior to use. Electronic densitometers may need a 45-minute warmup time. Film packages, after refrigeration, may take several hours to reach room temperature.

washed-out Characterizing a photograph, or a part of a photograph, that is too light in appearance. Such images usually lack highlight detail and satisfactory dark tones.

washing The process of bathing films and papers in water to remove unwanted soluble chemicals. Such chemicals, if not removed, cause deterioration of the image.

washing aid An alkaline or salt bath that increases washing effectiveness without reacting with the hypo or other fixing agent. See hypo elimination.

washoff Applied to photographic processes in which exposure causes a change in solubility or in tendency to harden (tan) in an appropriate developer. Exposed areas are more resistant to being dissolved in water.

water-bath development A process, for negatives or prints, involving immersing the material first in a conventional developing bath and then in plain water. In the denser areas of the image the remaining developer is soon exhausted, whereas in the less dense areas, development continues in the water bath. The effect in prints is supposed to be enhanced highlight detail without loss of shadow detail; in negatives, the converse. Water-bath development is probably more effective with negatives than with prints.

waterfall effect A process by which a person's visual perceptual system adjusts to steady movement of a stimulus so that reverse movement is seen when movement of the stimulus is stopped. For example, a spinning spiral that appears to be expanding is perceived as shrinking when it is stopped. Syn.: movement adaptation.

Waterhouse stop A fixed round hole in an opaque plate, used to limit the aperture in an optical system, especially in cameras used for photomechanical reproduction purposes. A series of such plates, with holes of various diameters, may be used instead of an iris diaphragm.

water jacket A double-walled container for pro-

cessing baths. The space between the walls is filled with water, typically in circulation, at a controlled temperature, the presence of which reduces temperature fluctuations of the baths.

waterproof Applied to a photographic material on a paper base that has been treated during manufacture so as to absorb little solution during processing, thus facilitating washing and drying.

water spots Defects in processed films, caused by differential drying rates. Where a droplet of water remains on the film, the gelatin remains soft, permitting migration of silver granules to the sticky edge of the drying area. Such defects cannot be completely remedied by rewashing. Before drying, the use of wetting agents and careful squeegeeing of the image reduce the defects.

water-white Applied to glass without the greenish tint characteristic of ordinary glass.

watt (W) A unit of radiant or electrical power. The rating in watts of a piece of electrical equipment is directly associated with the cost of operation. The energy associated with ultraviolet and x-rays is often measured in watts.

watt-second A measure of electrical energy. In electronic flash, the available stored electrical energy, and a rough indication of the light emitted per flash.

wavefront The locus of points on a set of light rays, analogous to the crest or the trough of a ripple on water. Such a locus can be obtained with coherent light. Wavefront reconstruction is accomplished through the use of holograms.

wavelength The distance between two corresponding points in an oscillation that moves in space. For electromagnetic radiation, wavelength is the chief physical distinction between light, infrared, ultraviolet, etc. A spectrum consists of a display of such radiation according to wavelength. For light, wavelength is associated with color, long waves ordinarily appearing red, middle waves green and short waves blue. In photographic contexts, wavelength of light is measured in nanometers (billionths of a meter).

wax (1) A type of adhesive used for paste-up and mounting. (2) A substance applied to a print surface to make it more glossy. (3) A substance applied to motion-picture print films to reduce friction and prolong useful life.

weak (1) As applied to perspective, conveying little impression of depth. (2) For prints or negatives, lacking in density or contrast. (3) As applied to a chemical bath, having little activity, or containing only a small amount of active ingredients. (4) As applied to a lens surface, only slightly curved, i.e., having a large radius of curvature. Contrasted with steep.

weave The sidewise movement of film in a motion-picture camera or projector when it is inadequately guided.

web As applied to a printing press, fed from a roll of paper, as compared with sheet-fed. Also see web processing.

Weber's (Weber-Fechner) law A just-perceptible increase in sensation (response) requires a stimulus increase that is in constant ratio to the whole stimulus. An alternative statement is that the response is proportional to the logarithm of the stimulus. The law is the basis for the use of logarithmic scales in, for example, the D-log H (D-log E) curve. In fact, the "law" holds for vision only over a limited range of stimuli, and fails both at very low and very high light levels.

web processing Application of chemical solutions from an absorbent belt to a photographic material by contact.

wedge (1) A filter that has varying absorption at different positions, used in sensitometers (exposing devices) to produce a series of exposures on a photographic material, and in visual densitometers (measuring devices). Continuous wedges change smoothly in absorption with position; stepped **wedges change by discrete values. Stepped wedges are often called step tablets, the preferred term. (2) A thin triangular prism, used to change the direction of light by a few degrees. (3) A device** attached to a camera tripod head, etc., to permit a greater amount of tilt than would otherwise be possible. (4) A tilt, as of a lens element in an optical system, caused by errors in the edging of the lens or in machining of the lens barrel.

wedge spectrogram See spectrogram.

wedge spectrograph See spectrograph.

weight (1) Thickness, as of photographic paper, in the terms "single-weight" and "double-weight." (2) An object of known mass used on a balance to measure the quantity of a substance (usually solid), in the preparation of processing baths, etc. In the obsolescent English system, weights are specified in ounces, pounds, etc. In the SI (metric system), the specification is in grams, kilograms, etc.

weighted Applied to a measurement process that emphasizes important data and reduces the emphasis given to less important data. For example, a through-the-lens light measurement may be designed so as to record primarily the light in the center of the scene rather than at the edges, resulting in a center-weighted measurement.

west The left-hand side of an animation field.

wet-collodion process The use of a photographic material typically coated on glass plates, consisting

wavefront

plane wave / lens / wavefront after refraction

wavelength

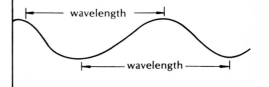

wavelength / wavelength

of silver chloride suspended in a nitrocellulose solution, which must be exposed and developed before the emulsion dries.

wet-plate See wet-collodion process.

wet process A development method requiring the use of water solutions, as for conventional silver halide materials. Contrast with dry processes, which include electrostatic methods of image formation, as well as some diazo or heat-developable materials.

wetting agent A chemical substance added to processing baths or rinse baths to improve the adhesion of the liquid film to the surface of the material being processed, and thus to improve the uniformity of processing and drying. Syn.: surfactant.

whirler A coating device, similar to a phonograph turntable, on which is placed a sheet of glass, etc. A photosensitive material in liquid form is poured on the sheet before or while it is rotating, thus producing a moderately uniform coating. Such a method is employed especially for coating plates used in photomechanical reproduction processes.

white (1) As applied to a reflecting surface, highly reflective, nearly neutral, and diffuse. A surface coated with magnesium oxide is the closest approximation to a perfect white. (2) As applied to a visual sensation, of high lightness and without identifiable hue. Such a sensation may be produced in many ways, among them a proper mixture of red, green, and blue lights. (3) As applied to light sources, producing energy well distributed throughout the visible spectrum. Among such sources are daylight, tungsten lamps, fluorescent lamps, xenon flashtubes, etc. (4) As applied to noise, containing equal amounts of all frequencies, an idealized concept. The Wiener spectrum of white noise would be represented graphically by a straight horizontal line.

white-core Identifying a motion-picture traveling matte having a clear center and a dark surround. The complementary matte, which has a dark center and a clear surround, is identified as a black-core matte.

white-flame arc A carbon-arc light source of high luminance and rich in short-wavelength radiation (blue and ultraviolet).

white glue An adhesive, often used for the permanent bonding of prints to mount boards and other supports. It is fast-drying and nonstaining.

whitener A fluorescent substance added to a photographic printing paper to increase the lightness of the highlights, and thus to increase the possible tonal range of the image. Syn.: (optical) brightener.

white-out In animation, if a recognized error is made by the cameraman, the exposure of the incorrect

wide-angle photograph

L. Stroebel

frames to a white card to blank them out. Correct exposures are then made with fresh unexposed film.

whiter than white In a separation negative, the reproduction of a hue at a density greater than for a white, caused by fluorescence of the color or by a masking method.

white space In an advertising layout, etc., a blank area around a photograph or block of type, usually treated as a design element.

wide-angle Specifying a lens with significantly greater covering power than a normal lens of equal focal length. The angle of coverage of wide-angle lenses is typically between 80° and 100°.

wide-band Use of spectral energy over a relatively great range of wavelengths. Applied especially to filters.

wide-screen In motion pictures, a greater than normal width-to-height ratio of the image. The normal ratio is about 1.33 to 1.

Wiener spectrum A graphical display of amplitude versus frequency, obtained by the analysis of a complex trace treated as a wave form. The photographic application is the study of small-scale density fluctuations in a uniformly exposed and processed area of an image. Nonrandom effects may be uncovered by such an analysis. Syn.: noise spectrum.

Wien's law As the temperature of an incandescent solid or liquid is raised, the light emitted becomes relatively richer in short (blue) waves, and relatively less rich in long (red) waves. The peak wavelength shifts toward short wavelengths.

wild (1) In motion pictures, applied to a variable-speed electrical motor controlled by a rheostat, as distinct from a synchronous motor. (2) In motion pictures, applied to a pictorial or sound record made without synchronism with the other record. For example, street noises may be recorded wild and later incorporated with the voice track, which is synchronized with lip motions.

window (1) An opening on some cameras for seeing numbers or other markings, especially on the paper backing, so as to check the number of exposures that have been made on roll film. (2) In stereoscopy, the boundary of the visible field. (3) In photofabrication, an opening in a resist coating that permits etching of the substrate. (4) In the spectrum, region of relatively little absorption. Seawater has a window in the blue-green region of the visible spectrum, since its absorption is much less there than in the ultraviolet and red spectral regions. (5) In photomechanical reproduction, a clear area on a line negative over which a halftone negative is stripped in. Also a cutout area in a goldenrod to accommodate a negative.

winterize To prepare a camera for cold-weather use. Lubricants that serve well in warm temperatures should be removed.

wipe (wipe-off) In motion pictures, a special effect by which transition from one scene to another involves a line between the images that moves across the frame. The scenes themselves, unlike in a push-off, do not move in relation to the frame.

wipe-on plate A plate used for offset lithography to which the photosensitive layer is applied from a soaked sponge.

wire sensitivity A measure of the response of a photographic material used for radiography (image production by the use of x-rays, gamma radiation, etc). Wire sensitivity is found by testing the ability of the material to produce acceptable images of metallic wires of varying diameter. The method is similar to a resolution test.

working Applied to a bath ready for use; usually prepared by diluting a stock solution to a given stock-solution-to-water ratio.

work print In motion pictures, an assembly of prints in temporarily finished form, used as a guide for cutting (editing) the original film for making final release prints.

worm's-eye Low point of view. Converse of bird's-eye.

wow A cyclical, slow variation in pitch caused by variations in the speed of the recording or reproducing system. Wow is distinguished from flutter by rate of cycling, flutter being faster.

wrap In motion-picture equipment, the angular extent to which the film makes contact with a sprocket wheel.

wraparound (1) A malfunction of an automatic processor in which the film fails to move properly through the transport system, and instead clings to a single roller. Also, a serious camera jam. (2) Identifying a style of lighting in which the light level on the subject gradually changes from side to side, producing a bright highlight on one side and a dark shadow on the other.

wrapup (slang) Completion, as of a day's shooting in motion pictures.

writing rate In photorecording such as oscillography, the velocity of the spot of light across the sensitive material when the trace is made.

wrong reading Applied to an image that is reversed as seen from the image side of the record, but in correct orientation when examined from the rear. Converse of right reading.

wrong set (slang) In motion pictures, an indication that shooting has been completed, as in "we're on the wrong set."

XXX YYYYYYYYYYYYYYYYYYY

XY

X (1) A synchronization setting in internally synchronized shutters, intended for use with electronic flash. The same setting may be used for class F (fast) flash lamps at slow shutter speeds. (2) Degree of enlargement, as in 4X enlargement.

X axis (1) In graphs, the left-right line, on which are placed values for the input data. (2) In maps, the east-west direction. (3) In aerial photography, in the direction of the line of flight.

X-diss Short for cross-dissolve.

xenon A nearly inert gas used in some arc lamps, especially electronic flash.

xerography A photographic process using a semiconductive plate charged with static electricity. The charge is partly dissipated where radiation falls on the plate. The image is usually made apparent by permitting colored particles to adhere to the still charged portions of the plate. Such particles may be transferred to a receiving sheet, such as papers, where they are fixed by heat.

x-rays Electromagnetic radiation shorter than ultraviolet and longer than gamma radiation. Produced by impact of high-velocity electrons on a target. X-rays vary in length from approximately 100 nm to 0.00001 nm.

X (exposure) sheet In animation, the cameraman's shooting script, which contains a detailed account of the order in which the cells are to be photographed, the length of time to be taken up by a given movement, and a description of the accompanying sound.

X-tilt In aerial photography, a deviation of the camera axis from the vertical because of aircraft roll.

X-Y Capable of lateral movement in any direction; applied to plate holders, sample holders in microdensitometers, etc.

X-Y-Z mount A support for an optical system, etc., that permits movement of the system in any of three mutually perpendicular directions.

y Symbol for luminosity, i.e., the response of the standard human eye to radiation. The luminosity function of the standard eye is a plot of y against the wavelength of the radiation.

Y axis (1) In graphs, the up-down (vertical) line on which are placed values for the output data. (2) In maps, the north-south direction. (3) In aerial photography, the direction laterally across the line of flight.

yellow (1) Color name for the hue associated with wavelengths of light between green and red, i.e., near 580 nm. (2) One of the three colorants (pigments or dyes) used in color photography, having the property of absorbing blue light. (3) Identifying a blue-absorbing filter. (4) Applied to a small spot in the retina that is exceptionally sensitive to light at normal levels, the macula.

yield Following "quantum," the number of affected particles (molecules, atoms, or electrons) in a photosensitive material per absorbed unit (i.e., quantum) of energy. The quantum yield is sometimes specified inappropriately in terms of the incident, rather than the absorbed, radiation.

Young-Helmholtz theory of color vision The hypothesis that there are in the retina three different sensors, each sensitive to a different color of light: blue, green, and red. Recent evidence in favor of the hypothesis involves the discovery that such sensors do exist.

Y-tilt In aerial photography, a deviation of the camera axis from the vertical caused by the pitch of the aircraft.

ZZZ

Z axis (1) In a three-dimensional coordinate system, one of the three mutually perpendicular lines defining the system. Conventionally, the Z axis is considered as perpendicular to the plane containing the X and Y axes. (2) In aerial photography, vertical to the line of flight.

zenith That point in the heavens which is directly overhead, opposite to the nadir.

zenith camera A photographic exposing device used for the accurate determination of position, as for surveying, mapping, etc. The camera is aimed upward, and the star field so photographed indicates the camera position.

zero (1) A position on a dial indicating no reponse, as on a densitometer. (2) (adj) Applied to an adjustable knob that brings a dial needle to a null position. (3) On a view camera, the position of the adjustments such that the lens and back are not tilted, swung, or moved laterally or vertically from their normal position. (4) (verb) To perform the actions of (2) or (3).

zero cut In making motion-picture prints, a procedure by which two rolls of negative film may be intercut without the loss of any frame. The procedure requires a printer with a very fast response.

zeta potential The difference in electromotive force between two liquid layers, one adhering to a solid, and the other free to move. Of importance in development theory, in which the charges on the surface of the silver halide crystal affect the extent to which the developing agent ions can approach the crystal surface.

zigzag sheet In animation, a simplified guide to the cameraman, where frame-by-frame instructions are not needed.

zincography The production of plates for photomechanical reproduction on the metal zinc.

zirconium A metallic element used in some flashlamps and arc lamps, notably "point-source" arc lamps.

zone A ring concentric with the center of a lens and the lens axis. For a simple lens, different zones have different focal lengths, thus causing the defect known as spherical aberration. Also see zone system.

zone focusing In the photography of moving objects, or in photography at estimated distances, the practice of setting the lens focus at a fixed position such that moderate movement or displacement of the subject toward or away from the plane of most accurate focus will not produce an insufficiently-sharp image. The photographer relies on depth of field to produce an acceptable photograph.

zone plate An optical element consisting of concentric light and dark rings of specific widths. From the wave theory of light, such a plate acts in some respects like a lens.

zone system A method of making pictorial photographs based on the concept of a visual change in negative exposure of one stop (a factor of 2X). Such a change is called a zone. Most prints contain about 9 zones. Zone V is a middle gray in the print. The method was invented by Ansel Adams and further developed by Minor White.

zoom (1) Identifying a lens having some movable elements, such that the focal length of the system can be changed without an appreciable change in focal position or f-number. (2) In motion pictures, applied to a shot made with such a lens as the focal length is varied, thus changing the scale of reproduction and the apparent distance to the subject.

Z-axis

zone

zone plate